ARTIFACTS
FROM ANCIENT ROME

James B. Tschen-Emmons

Daily Life through Artifacts

AN IMPRINT OF ABC-CLIO, LLC
Santa Barbara, California • Denver, Colorado • Oxford, England

Library of Congress Cataloging-in-Publication Data

Tschen-Emmons, James B.
 Artifacts from ancient Rome / James B. Tschen-Emmons.
 pages cm — (Daily life through artifacts)
 Includes bibliographical references and index.
 ISBN 978-1-61069-619-7 (hardback : alkaline paper) —
ISBN 978-1-61069-620-3 (e-book) 1. Rome—Antiquities.
2. Rome—History. 3. Rome—Civilization. I. Title.
 DG77.T75 2014
 937—dc23 2014014819

ISBN: 978-1-61069-619-7
EISBN: 978-1-61069-620-3

18 17 16 15 14 1 2 3 4 5

This book is also available on the World Wide Web as an eBook.
Visit www.abc-clio.com for details.

Greenwood
An Imprint of ABC-CLIO, LLC

ABC-CLIO, LLC
130 Cremona Drive, P.O. Box 1911
Santa Barbara, California 93116-1911

This book is printed on acid-free paper ∞
Manufactured in the United States of America

CONTENTS

TOOLS AND WEAPONS

TRANSPORTATION

PREFACE

Artifacts from Ancient Rome explores the history of 45 artifacts that cover most areas of Roman life, from dress to cooking, from dice games to theater, from bakers' ovens to the baths. Chronologically, most of the artifacts covered here date to the last centuries BCE and the first centuries CE, but since many of these object types enjoyed long lives in the Roman world, they can tell us a great deal about the centuries before and after this period too. In some respects, the age of the items is an accident of history, of what has survived and what we have found. Many, for example, hail from the ashes of Pompeii and Herculaneum, the famous cities buried by volcanic ash in 79 CE. These artifacts can act as primary sources—that is, as documents written at the time—and can be used in much the same way not only as windows into a culture, but also as examples and evidence in assignments. Several things about these items may be striking. Some artifacts, such as razors, have changed little in the last 2,000 years; others, such as strigils, are no longer used or recognizable. Cosmetic containers are still much the same size; togas, on the other hand, have been out of fashion in the Western world for centuries. Thus, the objects that people used in the past are at once familiar, since we are people too, and foreign, since today's world is so different in key ways from that of Rome.

ORGANIZATION

The book is organized into two chief sections. In the first section, there is an Introduction that provides a brief examination of the period covered by the artifacts within this volume. Since many of the artifact types were in use for decades, if not centuries, the Introduction covers in broad strokes the origins of Rome in the eighth century BCE to the retaking of Italy by Emperor Justinian in the sixth century CE. The Chronology of Events, which sets out selected dates and their significance, provides further information about this history. Few of the individual artifacts, if any, in this book were in constant use during the span of Roman history, but each is representative of its type,

and many objects had long histories. Votive offerings, such as the terra-cotta male torso, were used by ancient patients in search of divine aid for centuries and well after the Roman world had transformed into the medieval world.

There is also a "How to Evaluate Artifacts" section that provides the reader with tools for gaining a greater appreciation of the artifacts they will encounter in the book and elsewhere. Artifacts, even when recognizable, require us to interpret them. For example, the *gladius,* the legionary's sword, is recognizable as a sword, but there is much to learn from the materials from which it was made as well as from its size, its shape, where it was found, and who—if we know—carried it.

For each of the 45 entries in the second section there is an introduction, a description of the artifact itself, and a discussion of its significance. Many artifacts are not well known and will thus open up areas of history not covered in many other works. Each entry also has a list of sources for further information and, where appropriate, Internet sources. To the extent possible, each entry covers the span of that particular artifact's use in the Roman world from its first appearance to its last, who used it, and why. One advantage of this approach is that it provides a glimpse inside not only the general culture, but also into individual lives. The aedicule memorial, for example, is typical of its type but tells us specifically about a woman named Paccia Helpis.

Each entry explains and expands upon the cultural significance of the artifact depicted. Artifacts are divided into thematic categories and together provide a composite look at daily life in ancient Rome. The categories are

- Communications and Record Keeping
- Cooking and Food
- Entertainment
- Grooming, Clothing, and Accessories
- Household Items
- Religion and Funerary Practices
- Tools and Weapons
- Transportation

These categories make it easy to browse and to find associated artifacts. If one is interested in researching the lives of Roman students, for example, the section "Communications and Record Keeping" has several entries, such as "Wax Tablet" and "Inkwell" that reveal key aspects of student life. I have cross-referenced sections and entries as well. For example, the "Wax Tablet" entry contains a cross-reference to the "*Toga Praetexta*" entry in the "Grooming, Clothing, and Accessories" section, as the toga entry covers other aspects of young men's lives, and the "*Toga Praetexta*" entry contains

a cross-reference to the "Bulla" entry. Taken together, these entries provide an examination of the lives of Roman youths through the objects they used every day.

In terms of what makes something significant or not, most artifacts are important for a variety of reasons; it depends on how one defines the term and in what context one works. In a work this size, it is not possible to cover all the possible ways that any one item is significant as an object of history. Any author has to be selective, but in deciding what to focus upon, I have opted in most cases for what follows most directly from the object itself. For example, with the Roman "milestone" entry the major topic is Transportation and how Roman roads were so critical to the spread of peoples, ideas, and products. On the other hand, some objects, such as sandals, could be taken in different directions. One of the more iconic pieces of footwear is the *caliga,* or legionary's boot, so much of the significant section for that entry focuses on footwear in the army and related military equipment. In each case, however, there is a relationship between the artifact and the chief significances discussed.

OTHER FEATURES

Many entries also contain primary sources, excerpted and separated in sidebars, that shed light on artifacts. This can be a powerful tool, for the study of artifacts with associated primary sources and explanations is a multifaceted way to gain a tangible view of ancient life; it is a visual way of relating to the past. After all, one can "read" an artifact as well as a primary source, but to view an object as one reads a piece from the time that describes its use or user evokes a clearer, more vivid idea of the past. These primary sources are also excellent places to begin further study.

Other sidebars within entries may include short definitions of key terms or people. Words in Latin or Greek are translated, as are those few objects with inscriptions. In translating the latter, I have opted to try to capture both the feel of the Latin and a readable English version. Inscriptions were highly abbreviated and assumed a familiarity with conventions particular to writing succinctly on stone, so they make for challenging if interesting reading. Words within brackets are supplied to help reader makes sense of passages.

The value of this approach for students is twofold: they get all the benefits of a reference work with explanations and mention of primary sources, but also they see, right there on the page, the very object that brings a particular aspect of the Roman world to life. General readers with an interest in ancient history will likewise benefit from this approach.

ACKNOWLEDGMENTS

A work like this, which covers so much ground over such a long period of history, owes much to the expertise, time, and assistance of many people. At ABC-CLIO, I would like to thank David Tipton, managing editor and old friend, who first encouraged me to work on this project and was a constant source of support as well as a great sounding board; Jennifer Hutchinson and Elisabeth McCaffery, my editors, who advised me on everything from the selection of artifacts to managing all the hurdles that impede the writing process; and Ellen Rasmussen, who did such a wonderful job tracking down interesting, significant, and eye-catching images.

Several friends and colleagues also came to my aid when I was especially challenged by certain topics. My thanks to Beth Digeser of UC Santa Barbara, her doctoral student James Conrad, Michael Proulx of the University of North Georgia, Dr. Geoff Lowrey, Jeff Richardson, and James Coffman, all of whom either shared their knowledge of Roman numismatics or put me in touch with colleagues who did. I am also grateful to Hal and Kathy Drake for their willingness to answer thorny questions about Latin inscriptions.

A special thank-you goes to Aneta Worley for her help in communicating with the Czartoryski Museum in Kraków, Poland, and to Kinga Głazek and Dr. Dorota Gorzelany, who so generously answered my many questions about the Roman stamps in their collection.

To my family, especially my wife LiAna, our two sons, and my mother Patricia, who so often looked after the boys while I wrote, I owe a particularly grateful thank you for your patience and support during the writing of this book.

INTRODUCTION

In many cases we do not know when the Romans started or stopped using a particular artifact, but for the entries in this volume I attempt to give a chronological overview of each one. Most of those pictured date to the last centuries BCE and the first centuries CE. This places them squarely in that dynamic period when the old republic was transforming into an empire controlled by a single ruler.

Some understanding of these traditional divisions of Roman history and the Roman Republic, which began in 509 BCE with the ouster of the last king, and of the Roman Empire, which began with the reign of Emperor Augustus—Julius Caesar's adopted heir Octavian—is necessary to appreciate the world where these items were used and of the people who used them. The end of the Roman period, known as the fall of Rome, is not a topic addressed within these pages. The Chronology section ends with the reconquest of Emperor Justinian, but less because his reign signals any particular idea of the fall of Rome and more because few artifacts within this volume survived as objects in the daily lives of most Romans by this time.

THE ROMAN REPUBLIC

According to Roman legend, the history of Rome began with the founding of the city by Romulus. Rome, however, was one tiny village among many Italic settlements and in its earliest days was overshadowed by more powerful neighbors, such as the Etruscans. From these obscure origins, Rome came to rule not only Italy but also the Mediterranean, Europe, parts of Southwest Asia, and North Africa. There are many reasons that Rome was successful, but several key developments within Roman culture stand out as particularly important. First, unlike most ancient peoples, the Romans developed an abstract idea of citizenship, one that could and did incorporate non-Romans. Second, Rome had a policy of aggressive defense, which is to say that the Romans viewed their expansion as self-protection as much as conquest. Generals in such a system garnered great power over time and by the first century BCE began to exercise that power for their own

aggrandizement and at the expense of political stability. Ultimately this led to a series of destructive civil wars and rule not by a senatorial aristocracy but instead by an imperial autocrat.

Rome began as a village of mud huts. The Romans were one of many peoples, such as the Oscans and Umbrians, who spoke Italic languages and dominated central Italy. Tradition places the origins of the city in the eighth century BCE, and archaeologically speaking the hills of Rome were occupied at least that early. Early Roman historians, such as Fabius Pictor (active in the third century BCE), a historian who used earlier sources, believed that this was the period in which Roman history began. By the sixth century BCE Rome was under the control of the Etruscans, a federation of cities that by 500 BCE ruled Italy from the Campania region to the Po River. The literary record reflects this period of Etruscan suzerainty as well. Livy's *Ab Urbe Condita* (*From the Founding of the City*, ca. first century BCE), discusses the reign of Rome's early kings, at least several of whom were Etruscan. The last king, Tarquinius Superbus (Tarquin the Proud), was ousted in 509 BCE, and a republic was instituted instead. Removal of one king, however, was part of a larger process, for by 396 BCE the Romans had taken control of most Etruscan territories. Key to their success was incorporating the people they conquered.

Livy recounts a number of instances in which the Romans brought non-Romans within their community. One of the most famous is the "Rape of the Sabine Women" in which wily Romans duped the Sabines out of their wives and daughters at a banquet, but the Romans also invited anyone without a home to their city. This approach to citizenship and community is one reason that Rome was able to topple not only the Etruscans but also other Italic peoples. One consequence of this policy of inclusion was that Rome was able to call upon manpower reserves even when suffering defeats that would have ended, permanently, the ambitions of most other peoples. The issue of citizenship—from the Social War to the attempt of Julius Caesar to make senators of non-Romans to the extension of citizenship to all within the Roman Empire by Emperor Caracalla in 212 CE—is a theme that runs throughout the course of Roman history.

Republican government centered upon the Senate, a body of noble statesmen from whose ranks two were chosen annually—the consuls—to carry out some of the duties of the old kings, chiefly leading armies. This office lent to consuls *imperium*, the power to command. Early in Rome's history there was a struggle between the patricians, the city's ruling class, and the plebeians, or most everyone else. In 494 BCE the plebeians formed their own organization with special officers, the tribunes of the plebs, who had the power of veto. These officers were sacrosanct, and the plebeians pledged their lives to protect them. In 450 BCE the Twelve Tables were promulgated, which set down for the first time the customary laws that until then

were known only to certain patricians. The last step in the Struggle between the Orders, as this conflict is called, was in 287 BCE, when the plebeians left Rome—a tried-and-true tactic—to force the patricians to treat with them. The Senate dispatched Quintus Hortensius as dictator, a temporary emergency position with authority to fix a crisis. His solution was a new law, the Lex Hortensia, that gave decisions made in the Plebeian Assembly the force of law. This solution granted political equality to the plebeians and led to the creation of a new aristocracy, the *nobiles* (those who are "known"). After this, the terms "patrician" and "plebeian" ceased to have as much meaning.

Externally, Rome struggled first against other Italic peoples and neighbors such as the Gauls and then against major powers such as Carthage. Livy, one of our chief sources for early Roman history, recounts Rome's many wars as ones of defense, a slightly disingenuous portrayal. Many of Rome's conflicts resulted in horrific losses, but thanks to its manpower reserves the city was able to survive defeats that weakened its enemies. Pyrrhus (d. 272 BCE), a Greek general, won many battles but suffered great losses and lost to Rome. Likewise, the Carthaginians, with whom Rome fought three major wars, eventually succumbed to Roman might despite winning key battles. With Carthage, Rome's only real commercial and territorial rival in the western Mediterranean, conquered, Rome became the dominant power. This power soon led to the slow domination of the eastern Mediterranean. When Philip V (d. 179 BCE) looked to march against Pergamum and Rhodes, the latter called upon Rome for help. Only 40 years later Rome controlled nearly all of the Mediterranean world.

Expansion, however, brought new challenges. Rome ruled its extensive territories through provincial governors, who were attracted to these positions for the opportunities they provided for these governors to grow rich. Likewise, generals who spent years in the field often came to lead armies more loyal to them personally than to Rome. Coupled with the spoils of war, these men became extremely powerful and influential, enough so that they could put demands upon the government. One of the first was Marius (d. 86), who was followed by Sulla (d. 78) and finally by Caesar (d. 44). These men demonstrated how easily wealth and a private army could threaten Rome. They were also able to force through legislation that was popular with the people, but at the expense of their senatorial compatriots. Caesar pushed things further than either Marius or Sulla. Eventually made dictator for life, Caesar made some senators suspicious that he had monarchical ambitions, and in 44 BCE they conspired against him. On the Ides of March (March 15), they assassinated him. Rome was plunged into another devastating civil war. When it was concluded in 31 BCE, the Roman world had changed. Many of the institutions, councils, and magistracies remained, but they were vastly altered. Augustus emerged from the civil war as master

of the Roman world. He controlled the armies, had the backing of Caesar's faction among the people, ruthlessly suppressed any remaining opposition, and filled the Senate with men loyal to him. Outwardly Augustus portrayed himself as simply a first among equals, as the restorer of the republic, but he ruled a very different Rome. With his rule, the Roman Empire began.

THE ROMAN EMPIRE

The Roman Empire, as a territorial designation, actually began well before rule by a single man was reintroduced by Augustus. It is with the reign of Augustus, however, that we usually mark the beginning of the imperial period. The development of the office of emperor was gradual and emerged from the bloody period following the death of Julius Caesar. The civil war that followed the assassination of Caesar in 44 BCE witnessed the rise and eventual success of Caesar's adopted heir, Octavian, as Emperor Augustus. Having learned from his uncle's example, Augustus was careful to avoid the same mistakes and ruled a long time, from 31 BCE to 14 CE.

A clever politician and strategist, Augustus made good allies and garnered support as a relative of Caesar, who despite senatorial dislike was beloved by the people for his largesse in distributing booty from the war in Gaul. Augustus portrayed himself and his administration as a restoration of the old republic. He maintained a clever facade that in outward appearance resembled much of the traditional system of rule. Augustus took well-established offices and championed old-fashioned values, all in an attempt to conceal his autocratic rule. For example, in 27 BCE he made his *beau geste*, a symbolic laying down of his powers. The Senate, stacked with his own men, immediately begged him to resume them. This act of propaganda made it appear that the Senate still had power, but also sent a message to the army that it was not the only reason he was ruler. Augustus was the *princeps,* a title that had once denoted an honor accorded to the "first man" of the Senate, not a *rex* (king). Augustus claimed that he excelled no one in *potestas* (power), only in *auctoritas* (authority). The reality was that control of the army was vital, a fact that the military came to realize in later years.

The Julio-Claudians, as the dynasty inaugurated by Augustus is known, ruled in much the same way, playing lip service to the Senate while possessing the power of the army. Several of these rulers, particularly Caligula (d. 41) and Nero (d. 68), were notorious, but Roman rule was secure even under them. Though technically still *princeps,* the Julio-Claudians slowly began to rule more as monarchs, and when Nero died in 68 it become clear not only that the army was the power behind the throne, but also that the ruler himself was far more than a first among equals. That year, the Year of the Four Emperors, was one of bloody civil war in which generals vied for the purple. Significantly, many of the would-be rulers were not born in Rome; they were born in the provinces. Galba, for example, was from Spain.

This meant that emperors might be made elsewhere and set a dangerous precedent. Vespasian, first of the Flavian emperors, won this contest and brought peace in his 10-year rule. Nerva, the first of the so-called Five Good Emperors, not only ruled over a relatively peaceful empire but also began a tradition of choosing capable heirs. For Edward Gibbon, whose *Decline and Fall of the Rome Empire* (1776) charted the long story of Rome, this was the happiest period in history. Gibbon saw these men ruling as enlightened, just monarchs, ideas very much in keeping with Enlightenment sensibilities.

Only one of these men, the last, Marcus Aurelius, had a son and, not surprisingly, designated his son as heir. This man, Commodus, was a poor ruler, and when he died in 192 civil war once again gripped the empire. Septimius Severus (d. 211), the third emperor to rule in that year, began the Severan dynasty and returned order to the Roman world. Under the Severans, the emperors emerged clearly as military dynasts. The senate's influence was diminished, men of equestrian rank enrolled in more administrative positions, and the old Praetorian bodyguard was removed and replaced with more dependable men from the legions. When Alexander Severus, the last of the Severans, died in 235, Rome was plunged into a destructive period of war, the time of the Barracks Emperors.

Over the next 50 years various emperors rose and fell and, in the process, further damaged traditional concepts of rule and laid waste the countryside. This horrific period ended in 284, when one of these soldier-emperors, Diocletian, beat his rivals and restored order. As the first emperor of the period we call the Dominate, he made important changes in the concept of the ruler. Diocletian and his successors created new sources of legitimacy, in particular emphasizing a personal connection to the gods (Jupiter was Diocletian's patron god) that did not rely on either senatorial or military backing. In a bold but strategically clever move, Diocletian also divided the empire into two halves, each headed by an "Augustus" (senior emperor) and a "Caesar" (junior emperor). This system, the Tetrarchy (Greek for "rule by four"), did much to secure the empire inside and out. However, when Diocletian retired, civil war erupted yet again, first leading to two emperors, one east and west, and finally to only one, Constantine, in 312.

Constantine's reign begins a new chapter in Roman history in several key ways. First, he managed to keep the entire empire intact, not only against internal threats but also from encroaching Germanic peoples who had been pressuring the borders for several centuries. He also kept in check the Sassanid Perisans, the only imperial power to rival Rome. Constantine's most enduring and life-changing innovation was the legalization of Christianity. A Christian himself, Constantine, just as Diocletian had done, emphasized his role as God's agent on Earth. This bolstered his own authority, but it did something more, something new: it gave recently disenfranchised Christians imperial patronage. With one exception—Emperor Julian

(d. 363), who tried to revive paganism—Roman emperors from this time on were all Christian. Less than 75 years later, Theodosius the Great (d. 395) made Christianity the official religion of the empire. He was also the last emperor to rule the entire empire, for he divided the empire and put his two sons, Arcadius and Honorius, in charge of the eastern and western halves, respectively.

Any examination of the Roman world entails a look at the fall of Rome, a topic of perennial interest. Historians from Gibbon down to today have often viewed the fall of Rome as an event, and there have been myriad theories with specific dates and reasons for Rome's demise. Some have argued that Rome fell in 476 when Romulus Augustulus, the last western emperor, died. Others argue that Emperor Justinian (d. 565)—who from the capital that Constantine founded, Constantinople, reconquered much of the former western empire in an amazing campaign—marks the fall of Rome. Most historians today, however, increasingly look at the fall of Rome not as an event but rather as a process, one in which Rome gradually transformed into three new polities. Various Germanic kingdoms in the west, all of whom looked to Rome for inspiration and many of whom considered themselves heirs to Rome, are one heir. The Byzantine Empire—whose people referred to themselves as the Romanoi (significantly, they called themselves "Romans" in Greek)—lasted until the 15th century and was another heir. The last heir to Rome were the Islamic peoples. Starting in the seventh century, Islamic forces swept from Arabia into the west and east, creating a new civilization that likewise looked back to Rome in many ways. These heirs, each of which kept alive something of Rome, preserved aspects of Roman culture at the same time that they created what became the three chief cultures of the Middle Ages.

HOW TO EVALUATE ARTIFACTS

Historians traditionally focus their analysis on the written word. Such sources take two forms: primary documents produced at the time under study by people of that time, such as a letter of Cicero, and secondary sources, works that contain specific historical facts and interpretation, such as this one. These categories are convenient but misleading, as secondary sources can refer to histories written in the past too, such as that of Tacitus. Today historians continue to rely on the written word, but they also look to additional resources to investigate the past. Some of the richest sources are artifacts, objects from past cultures.

WHAT IS AN ARTIFACT?

Artifacts have been defined a number of ways. At its simplest, an artifact is any object made or used by humans. Of note, this broad definition includes objects *not* made by people but used by them, such as bones, nuts, and seeds. These are sometimes termed ecofacts. All of the artifacts within this book, however, were made by ancient people. Larger groups of artifacts, such as the bakery ovens in Pompeii, are often called features. Archaeologists emphasize the connection between artifacts or groups of artifacts and culture. If the term "artifact" is hard to define, the term "culture" is infinitely more so, but we might view culture as those rules of behavior that a community holds and follows and that help define the community. The study of artifacts is thus a window into a particular culture.

WHAT CAN ARTIFACTS TELL US?

All artifacts require interpretation, but in general there is some basic information that they convey. Material objects and features can tell us how houses and settlements were laid out, what people did for a living, what they used, and with whom they may have traded or fought. We might also learn the relative size of a population, what they ate, and perhaps what diseases they had to contend with, assuming remains are found and uncontaminated. However, even with these general observations, one is soon in the realm of interpretation.

CHALLENGES IN INTERPRETATION

Interpreting an artifact is no easy task. There are a number of considerations even before evaluating the specific object. Critical in most cases is the context in which an artifact was found; where something is discovered—what surrounds it—can be as important as what is found. Often, however, artifacts lack this vital information. Those discovered long ago, especially by early collectors, or that were uncovered before archaeologists made as careful a study of context as they do now must be evaluated solely on their own merits.

Until recently, archaeologists were more interested in temples, palaces, and other elite sites. These are important to be sure, but focusing solely on the ruler or well-to-do individuals or populations prejudices our idea of the past. Most people did not live in palaces, and most lacked expensive tableware that was more likely to be saved and to survive, so to focus only on the elite portions of society is to ignore most everyone else. In fairness, those with fewer resources often left less behind; at least less survives in many cases. Items of wood or leather, unless preserved in anaerobic conditions, break down over time, whereas a hoard of silver plate might last centuries. Iron tools and weapons tend to rust; the *gladius* in this book, for example, rusted in such a way that it melded with parts of its scabbard. There are a number of elite items covered here, but so too are public toilets, horse bits, dice, and other artifacts that the population at large used regularly.

Not everything survives, and so any picture we gain from artifacts is at best an incomplete picture. In recent decades archaeologists have also been keen to preserve as much of archaeological sites as they can, partially in hopes that future techniques will be better than those we possess now. As a result, what they uncover is often restricted to a small sample. At its best, archaeology is like working on a puzzle where many if not most pieces are missing. We get an idea of the past, but we cannot recover it completely.

Regardless of how much information an artifact conveys or is associated with it, historians and archaeologists must interpret that information. Sometimes this is relatively simple. A weapon, for example, especially if it conforms to a well-known type such as a sword (see the entry ***Gladius***), allows one to make certain conclusions by analogy if it is not already obvious. There are times when interpretation is more difficult. A votive figure discovered at a healing shrine, for instance, tells us something about religious practices and medical concerns, but the artifact itself may be more difficult to interpret. We may not know what specific ailment it was meant to help alleviate or how it was meant to appeal to the gods. While the item's purpose and use may have been obvious to the people of the time, this is not always the case for us. There are also artifacts for which we are left with more questions than answers. Various attempts have been made to explain Roman dodecahedrons of bronze or stone found all over the empire. Some

theories are plausible, but without further information we cannot say for sure what purpose they served.

INTERPRETATION

There are different ways to approach the study of an artifact, but most methods begin with the basics: What is it? What is its origin? What is it made of? Who made it? It is typical? How old is it? What purpose did it serve? Answers to these questions are not always readily apparent, but in some cases the artifact can provide such information. The Roman milestone discussed in this book is a good example. Because we can know the language on the stone, Latin, we can translate it and discover the answers to several of these basic questions. We cannot say who made it, but we do know who commissioned it: an emperor and his son. We know when that emperor ruled, so we can posit a date range for when the milestone was placed. We know where it was found and what sort of stone was used. We also know, from the words on the stone and other sources, what the stone was for: marking the distance from one place to another.

These are first steps. Next, we must ask additional questions: So what? Why is this stone significant? What does it tell us about the people who made it and used it? This is far more difficult and normally requires additional investigation. Combing through primary and secondary sources to search for ancient references or images and to see what other scholars have had to say about an artifact is often the next step. Most scholarship is built upon the work of those who have previously studied a topic—one might have something new to say about it, but a thorough look through what has already been said is a must. This saves time and effort but also prevents duplication of work and provides the researcher with a solid foundation upon which to start his or her own study of an artifact.

The research phase also helps frame additional questions. Once one has a basic knowledge of an artifact, it is easier to investigate what are often more difficult topics, such as manufacture and purpose. One can often determine, for example, whether an item was most likely the product of a small workshop or was mass-produced and, perhaps, where it was made. Details about use and traditions associated with an artifact may also emerge. A particular votive item, for example, may have been described in a source or depicted in art and indicate more precisely how the object was used. It is often during the research phase when one also learns about conventions surrounding an artifact. For instance, there is an entire field of study in ancient inscriptions, from letter styles to abbreviations, and more often than not one must consult works on these topics in order to translate and make sense of even short inscriptions. Returning to the milestone example, while only a few sentences long, this inscription employs a lot of formulaic language, such as imperial titles, that appear in many similar examples. By acquainting oneself with

the conventions in imperial nomenclature, it is far easier to decipher the milestone's message.

ARTIFACTS AND SIGNIFICANCE

Ultimately the goal in studying an artifact is to learn something about the people who made, used, and valued it. All the time spent in research, all the time spent examining the artifact itself, serves to answer one question: What does this object tell us about this society? As you will see in the following pages, artifacts can tell us quite a lot, but a word of caution is in order too. It is sometimes easy to conclude that a specific artifact was somehow responsible for the success or failure of a people. A classic example for Rome is the old theory that lead pipes poisoned the population and brought down an empire. Despite plenty of evidence to the contrary, one will still hear this theory!

Perspective, thus, is important. For example, the adoption of the *gladius,* a short sword, by Roman legionaries was not, all on its own, the reason for their success in battle. However, the changes to the military in adopting that weapon and in adding different defensive equipment, throwing spears, and more mobile fighting teams *did* make a difference. The *gladius,* therefore, symbolizes a major shift in Roman military thinking, one that ended up making all the difference for many centuries to come.

As you examine the artifacts presented in this book, consider not only the artifact itself but also what it suggests, what it demonstrates about Roman life, customs, and culture. What does it tell you about those who made, bought, and used the object? Artifacts are a physical link with the past, a conduit through which we can enter, if only briefly and remotely, another time, another culture. They are thus an ideal way to investigate and experience history.

FURTHER INFORMATION

Dancey, William S. *Archaeological Field Methods: An Introduction.* Minneapolis: Burgess, 1981.

Morley, Neville. *Writing Ancient History.* Ithaca, NY: Cornell University Press, 1999.

Thomas, David Hurst. *Archaeology.* 2nd ed. Fort Worth, TX: Holt, Rinehart and Winston, 1989.

Voss, Barbara. "Image, Text, Object: Interpreting Documents and Artifacts as 'Labors of Representation.'" *Historical Archaeology* 41(4) (2007): 147–171.

Websites

"Artifact & Analysis." Smithsonian Education, http://www.smithsonianeducation.org/idealabs/ap/.

"Interpreting Artifacts." McCord Museum, http://www.mccord-museum. qc.ca/en/eduweb/interpret/.

"What Is Material Culture?" National Park Service, http://www.nps.gov /archeology/afori/whisar_matc.htm.

CHRONOLOGY OF EVENTS

BCE EVENTS

1200	Etruscans are established in Italy.
800–500	Greek colonial ventures occur in southern Italy.
753	Romulus founds Rome.
753–509	Period of the kings:

 Romulus (ca. 753–715)

 Numa Pompilius (ca. 715–673)

 Tullus Hostilius (ca. 672–641)

 Ancus Martius (ca. 642–617)

 Tarquinius Priscus (ca. 616–578)

 Servius Tullius (ca. 578–535)

 Tarquinius Superbus (ca. 534–509)

509	Roman revolt against the last king, Tarquinius Superbus; founding of the Roman Republic.
458	Lucius Quinctius Cinncinatus leaves his farm and serves as dictator to save a Roman army. He rescues the army and surrenders his imperium, all within 16 days.
ca. 450	The first Roman laws, the Twelve Tables, are promulgated.
396	Roman capture of the town of Veii.
390	Gallic capture of Rome.
366	Lucius Sextius becomes the first plebeian consul.
343–341	The First Samnite War. Two additional phases, during 328–304 and 298–290, bring more of southern Italy under Roman control; the Samnites, however, remained a challenge, siding with both Pyrrhus and Hannibal in later conflicts.
282–272	War against Pyrrhus.
265	Rome occupies the Italian peninsula.

264–241	The First Punic War.
218–201	The Second Punic War. Hannibal, the leader of the Carthaginian Army, nearly defeats Rome.
216	Battle of Cannae. A Carthaginian army destroys a Roman army of 60,000; this is one of the worst defeats Rome ever suffers.
202	Battle of Zama. The Romans defeat a Carthaginian army in North Africa.
184	Marcus Porcius Cato, better known as Cato the Elder, one of the most conservative voices in Roman history, is elected censor.
149–146	The Third Punic War. This final struggle destroys Carthage and makes Rome master of the western Mediterranean.
133	King Attalus III of Pergamum dies. He wills his kingdom to the Roman people, and thus Rome acquires its first Asian province.
133	Tiberius Sempronius Gracchus becomes one of the tribunes of the plebs; his proposal of land reform leads to a riot in which 300 people, including Tiberius, are killed.
123	Gaius Sempronius Gracchus, brother of Tiberius, becomes tribune. Gracchus too proposes land reform and is eventually murdered.
106	Birth of Marcus Tullius Cicero.
100	Birth of Gaius Julius Caesar.
90–88	The Social War. Rome fights its Italian allies, who desire Roman citizenship.
73	Revolt of Spartacus, a Thracian gladiator.
63	Consulship of Cicero. A *novus vir* (new man), Cicero is the first in his family to win the consulship.
63	The Conspiracy of Cataline. Cataline is prosecuted by Cicero.
59	Julius Caesar is elected consul.
58–50	The Gallic War. Julius Caesar invades and conquers Gaul.
50	Caesar is recalled to Rome to account for his extended campaign in Gaul.
49	Caesar crosses the Rubicon River with an army and ignites a civil war.
49–45	Civil war occurs between the forces of Caesar and Pompey.
44	Caesar is made dictator for life. He is assassinated by a conspiracy on the Ides of March (March 15) who wish to restore the republic, a move that fails.

44–31 Intermittent civil war occurs between Octavian, Caesar's heir, and Mark Antony.

31 The Battle of Actium. Octavian is victorious.

31–14 Octavian becomes Augustus, "revered one," and the first emperor.

CE EVENTS

14–68 Reign of the Julio-Claudians:
> Tiberius (14–37)
> Caligula (37–41)
> Claudius (41–54)
> Nero (54–68)

33 Crucifixion of Jesus and the beginning of Christianity.

64 Great Fire in Rome.

69–96 Reign of the Flavian Emperors:
> Vespasian (69–79)
> Titus (79–81)
> Domitian (81–96)

79 Eruption of Mt. Vesuvius and the destruction of Pompeii and Herculaneum.

96–180 Reign of the so-called Five Good Emperors:
> Nerva (96–98)
> Trajan (98–117)
> Hadrian (117–138)
> Antoninus Pius (138–161)
> Marcus Aurelius (161–180)

122 Construction of Hadrian's Wall in northern England begins.

212 Construction begins on the Baths of Carcalla. Roman citizenship is extended to all people living within the confines of the empire.

235–285 Third-Century Crisis. Multiple emperors, few who survive assassination attempts, rule. This period of chaos ends with the ascension of Diocletian.

271 Construction begins on the Aurelian Wall around Rome. The wall extends 12 miles and is 60 feet high.

284–305 Reign of Diocletian.

293 Diocletian reorganizes the Roman Empire. His system, the Tetrarchy, divides administration of the empire into western and eastern halves, each run by an "Augustus" (a senior

emperor) and a "Caesar" (a junior emperor), who in theory would replace the "Augustus" upon his retirement.

301 The Edict on Prices is issued by Diocletian.

312 Battle of Milvian Bridge. Constantine becomes the first Christian emperor and legalizes Christianity in the Roman world.

324–337 Reign of Constantine.

325 Council of Nicaea. Orthodox Christian doctrine is defined by a council of bishops.

330 Constantine inaugurates the new capital of Constantinople.

360–363 Reign of Julian "The Apostate." The Romans are unable to defeat Persia. Julian dies on campaign.

378 Battle of Adrianople. The Visigoths defeat the Romans.

380 Emperor Theodosius makes Christianity the official religion of the Roman Empire.

382 Roman emperors give the title "pontifex maximus" to the bishops of Rome.

383–387 Revolt of Magnus Maximus. British legionaries under Maximus strive against Valentinian II, Emperor Theodosius's choice for the western empire. Theodosius's forces capture and kill Maximus.

395 Death of Theodosius. His sons Honorius, the eastern emperor, and Arcadius, the western emperor, permanently divide the empire.

395–423 Reign of Honorius in the western empire. The Vandal general Stilicho, his son-in-law and commander of the troops, is a key support.

396–402 Stilicho battles the Visigoth Alaric.

406 Several Germanic tribes—the Vandals, Alans, Suevi, and Burgundians—overrun Gaul.

407 Roman forces withdraw from Britain.

408 Stilicho is assassinated.

409 Alaric's Visigoths invade northern Italy. They establish an independent region in defiance of Honorius and the eastern emperor.

410 The Visigoths, led by Alaric, sack Rome. Saint Augustine of Hippo pens *The City of God.*

425 Theodosius II sends an army whose troops kill Johannes, a usurper, and install Valentinian III as the western emperor.

429–431 The Vandals establish an independent kingdom in Roman Africa.

439 The Vandals conquer the city of Carthage.

476 Romulus Augustulus, the last western emperor, is deposed by the Germanic warrior Odoacer.

493 Italy is incorporated into the barbarian Kingdom of the Ostrogoths.

527–565 Reconquest of Justinian (eastern Roman emperor). He reconquers Italy in a series of campaigns far more destructive than those of any Germanic army.

Communications
and Record Keeping

Abacus

Calendar

Graffiti

Inkwell

Seal Ring

Wax Tablet

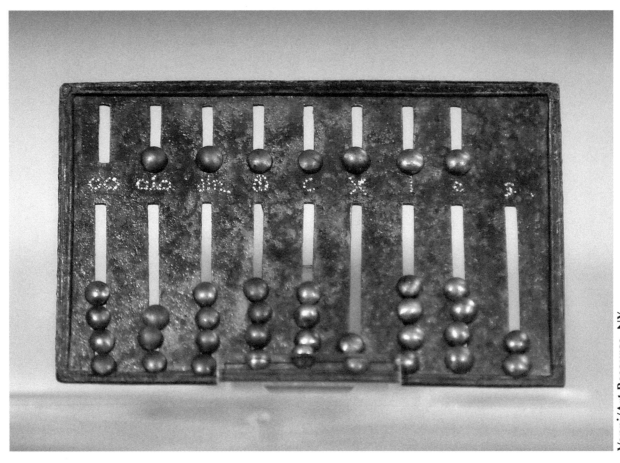

Abacus

Roman
Imperial Period

INTRODUCTION

In order to build the aqueducts, buildings, monuments, and temples that gave shape to the Roman world, engineers had to be able to calculate accurately complex formulae and computations. One of the chief instruments by which they did this was the abacus, a simple counting board. In other areas of Roman life, perhaps especially in commerce, the abacus was equally helpful. What is less well known, however, is that even without a simple calculating device, the Romans were able to count quite high and all on their fingers. Finger numbers, which enjoyed a long history, were no doubt a fundamental part of basic Roman education. Our surviving sources and the testimony of a number of archaeological finds suggest that use of finger numbers was widespread and used by all manner of Romans.

DESCRIPTION

This bronze abacus is typical of small, portable abaci used by Roman merchants, engineers, and money changers. Also referred to as counting boards, abaci were already ancient by the time the Romans adapted them. The Egyptians and Greeks, among other peoples, had been using similar systems. This style, however, was a Roman innovation. A portable device for calculating complicated mathematical computations had wide appeal and was probably a favorite of Roman schoolboys too.

The counting beads were grooved in the middle so that they could slide up and down the abacus easily. The bottom register of slots, which are longer, contained four beads each and represented units of one. The top register, of smaller slots, had one bead, each of which was equal to five. The seven columns, looking left to right, were used for numerals, and the rightmost two columns were for fractions. The third column from the right was for units (the 1's place), the next over for 10s, then 100s, each of which is marked I, X, and C, the Roman numerals for these respective numbers. The other columns employ symbols no longer used in modern counting. One [∞] represented thousands, the next [((|))] ten thousands, the next [(((|)))]

hundred thousands, and the last [a three-sided box around X] millions. When the abacus was in use, the person moved the beads upward; any beads left at the bottom of a column were left out of calculations. This system allowed one to count as high as 10 million.

Less portable abaci were also used. These consisted of a board with several channels for sand; failing that, the user would draw columns in the sand. One could either draw marks into the sand or use stones to make calculations. A cumbersome design in many respects, this style of abacus would have been difficult to maintain as one proceeded to count. If, for example, one had filled up the right-hand column to the total of 10, one would then have to remove all those stones to place another in the next column, the 10's spot. While the Romans do not seem to have used beads upon a wire, portable hand abaci like the one pictured here simplified this laborious process significantly. The ability to calculate numbers so high with ease presupposes not only that the Romans had a conception of zero, but also that they understood negative numbers. Considerable debts, for example, when calculated would make obvious the idea of the sum owed, that is, an amount not actually in possession of the debtor. Some of this even emerges in a poem by Catullus (mid-first century BCE) that has been read as the poet numerating his lover's kisses as if using an abacus. The poet likens the number of kisses with his lady-love, Lesbia, by hundreds and thousands but in the order one might use on an abacus. Further support for this comes from the use of language equally applicable to business. At the end, so as not to invite envy and perhaps so he can begin counting again, Catullus suggests that they confuse the numbers. The word he uses, the verb *conturbare,* "to throw in disorder," can also mean "to ruin or make bankrupt."

SIGNIFICANCE

The Romans were accomplished engineers as well as successful businessmen. In both fields a nimble, mathematical mind is a great boon, but few people were counting prodigies, and we know from the sources and the archaeological record that tools such as the abacus were common. In addition to this simple computer, however, the Romans also employed an ingenious system of counting using the hands and fingers. Though some have contended that this system was used primarily so that business might be conducted when the parties involved spoke different languages, it is more likely that this particular use was a by-product, when it happened, of a common day-to-day way of calculating numbers. Finger numbers, as they are sometimes called, were probably learned from an early age, and since the system was effective, people continued to use it. By way of a modern analogy, many people in modern China employ a similar if less complex system of finger numbers, one where it is possible to count to 10 on each hand. While knowledge of this system is useful in crossing language barriers, it is

CATULLUS, POEM 5

Let us live and love, my Lesbia, and a farthing for all the talk of morose old sages! Suns may set and rise again; but we, when once our brief light has set, must sleep through a perpetual night. Give me a thousand kisses, then a hundred, then another thousand, then a second hundred, then still another thousand, then a hundred. Then when we shall have made up so many thousands, we will confuse the reckoning, so that we ourselves may not know their amount, nor any spiteful person have it in his power to envy us when he knows that our kisses were so many.

[Walter K. Kelly, trans., *The Poems of Catullus and Tibullus, and the Vigil of Venus* (London: Henry G. Bohn, 1854).]

APULEIUS, APOLOGIA 89

As to Pudentilla's age, concerning which you lied so boldly as to assert that she had married at the age of sixty, I will reply in a few words. It is not necessary to speak at length in discussing a matter where the truth is so obvious.

Her father acknowledged her for his daughter in the usual fashion; the documents in which he did so are preserved partly in the public record office, partly in his house. Here they are before your very eyes. Please hand the documents to Aemilianus. Let him examine the linen strip that bears the seal; let him recognize the seal stamped upon it, let him read the names of the consuls for the year, let him count up the years. He gave her sixty years. Let him bring out the total at fifty-five, admitting that he lied and gave her five too many. Nay, that is hardly enough. I will deal yet more liberally with him. He gave Pudentilla such a number of years that I will reward him by returning ten. Mezentius has been wandering with Ulysses; let him at least prove that she is fifty.

To cut the matter short, as I am dealing with an accuser who is used to multiplying by four, I will multiply five years by four and subtract twenty years at one fell swoop. I beg you, Maximus, to order the number of consuls since her birth to be reckoned. If I am not mistaken, you will find that Pudentilla has barely passed her fortieth year. The insolent audacity of this falsehood! Twenty years' exile would be a worthy punishment for such mendacity! Your fiction has added a good half to the sum, your fabrication is one and a half times the size of the original. Had you said thirty years when you ought to have said ten, it might have been supposed that you had made a slip in the gesture used for your calculation, that you had placed your fore-finger against the middle joint of your thumb, when you should have made them form a circle. But whereas the gesture indicating forty is the simplest of all such gestures, for you have merely to hold out the palm of your hand—you have increased the number by half as much again. There is no room for an erroneous gesture; the only possible hypothesis is that, believing Pudentilla to be thirty, you got your total by adding up the number of consuls, two to each year.

[Harold Edgeworth Butler, trans., *The Apologia and Florida of Apuleius of Madaura* (Oxford, UK: Clarendon, 1909), http://classics.mit.edu/Apuleius/apol.4.4.html.]

commonly employed by the Chinese in their daily lives. There is even a children's counting game based on it.

There are a number of references to finger numbers in extant sources, from Greek plays to the works of the Church Fathers. No one source, unfortunately, covers this method of counting systematically or completely, but from the aggregate references there is much we have been able to piece together about it. Archaeologically, some of the best evidence hails from small round tesserae that depict the hand or finger number on one side and the Roman numeral on the other. This evidence too is incomplete but does give testimony for the numbers 1 through 15 (minus 11). Early medieval sources, such as by the writer Bede (d. 735 CE), record later versions of this tradition, but there is often some discrepancy between systems.

As one might expect, such a versatile system had a great range of applications. There are examples of Romans using these finger numbers in the arena, in law courts, in public gatherings, in the church, and at market. The value of this system, which required no other tool than one's hands, is seen in the fact that one could calculate numbers and be understood, even when at a short distance from others or when it was noisy. One powerful example of this comes from Dio Cassius. He relates how a crowd greeted the emperor Marcus Aurelius with the number eight displayed on their hands, a quiet but powerful reminder that he had been away from Rome for eight years. Another example comes from the author Apuelius (d. after 170 CE), who in 158 or 159 was tried on accusations that he had used magic to induce a rich widow to marry him. He was acquitted, but his *Apologia* (Greek for "defense") records much about the trial. In one section, he deflates the prosecution's assertions that Apuleius's wife, Pudentilla, was 60 when he married her. His description of how his accusers calculated her inflated age mentions specifically finger numbers.

The abacus and finger numbers both survived the Roman period. They were, in fact, key ways of computing at least into the early Middle Ages for finger numbers, while the abacus continues to be used in some parts of the world even today.

FURTHER INFORMATION

Alfoldi-Rosenbaum, Elisabeth. "The Finger Calculus in Antiquity and in the Middle Ages: Studies on Roman Game Counters, I." *Fruhmittelalterliche Studien* 5 (1971): 1–9.

Fredricksmeyer, Ernest A. "Observations on Catullus 5." *American Journal of Philology* 91(4) (October 1970): 431–445.

Levy, L. Harry. "Catullus, 5, 7–11 and the Abacus." *American Journal of Philology* 62(2) (1941): 222–224.

Maher, David W., and John F. Makowski. "Literary Evidence for Roman Arithmetic with Fractions." *Classical Philology* 96(4) (October 2001): 376–399.

Menninger, Karl. *Number Words and Number Symbols: A Cultural History of Numbers.* Cambridge, MA: MIT Press, 1977.

Turner, J. Hilton. "Roman Elementary Mathematics the Operations." *Classical Journal* 47(2) (November 1951): 63–74, 106–108.

Williams, Burma P., and Richard S. Williams. "Finger Numbers in the Greco-Roman World and the Early Middle Ages." *Isis* 86(4) (December 1995): 587–608.

Websites

McManus, Barbara F. "The Roman Abacus." VROMA: A Virtual Community for Teaching and Learning Classics, http://www.vroma.org/~bmcmanus/abacus.html.

Stephenson, Steve. "The Roman Hand-Abacus." Ryerson University, http://www.ee.ryerson.ca/~elf/abacus/roman-hand-abacus.html.

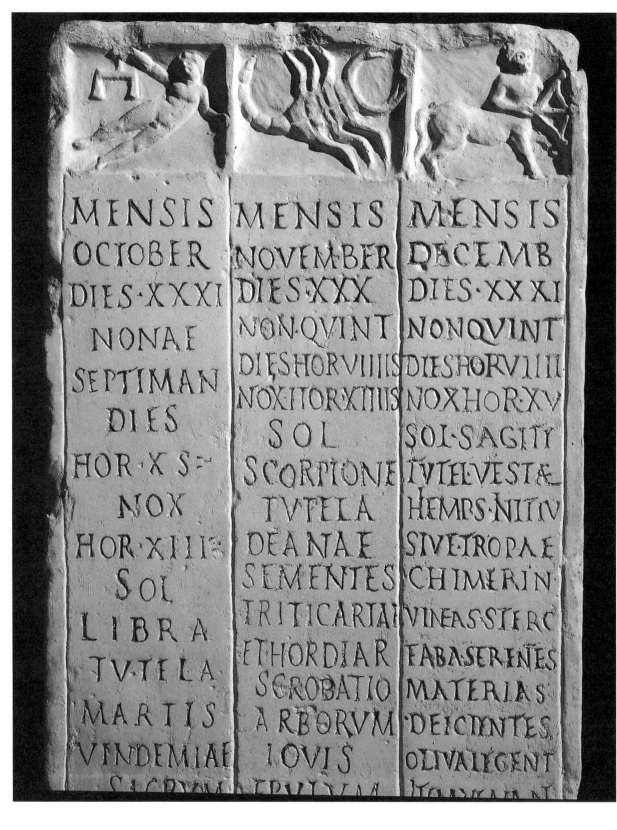

MENSIS	MENSIS	MENSIS
OCTOBER	NOVEMBER	DECEMB
DIES·XXXI	DIES·XXX	DIES·XXXI
NONAE	NON·QVINT	NON·QVINT
SEPTIMAN	DIES HOR VIIIS	DIES HOR VIIII
DIES	NOX IT OR XIIIIS	NOX HOR XV
HOR·X S:	SOL	SOL·SAGITT
NOX	SCORPIONE	TVTEL·VESTÆ
HOR·XIIIS	TVTELA	HEMPS·NITIV
SOL	DEANAE	SIVE TROPAE
LIBRA	SEMENTES	CHIMERIN
TVTELA·	TRITICARIAI	VINEAS STERC
MARTIS	ET HORDIAR	FABA SERENTES
VINDEMIAE	SCROBATIO	MATERIAS
SACRVM	ARBORVM	DEICIENTES
	IOVIS	OLIVA LEGENT
	EPVLVM	

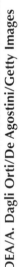

Calendar

Rome, Italy
Second Century CE

INTRODUCTION

The organization of the year, months, and weeks in our calendar is so much a part of our lives than we rarely stop to wonder at what an achievement it is. The Romans likewise regulated the year by calendars and the key dates in them. The Roman calendar centered not only around the agricultural cycle but also the great public festivals, events that embodied social, political, and religious meanings. Thus, the Roman calendar served farmers by helping them plan for the seasons of sowing and harvest and also served the wider community, because the state, as an institution organized to maintain the *pax deorum* ("the peace of the gods"), devised a calendar to help ensure that the rites and festivals were celebrated at the appropriate time. With so much to arrange, the Roman calendar was complex. From its origins in the early republic to the empire, the calendar underwent significant evolution. For example, those responsible for it worked to make the calendar fall more in line with the astronomical cycle but also with the changing values of the culture. The major festivals in the Roman calendar, especially festive ones such as Saturnalia and Lupercalia, were both religious celebrations and occasions for joy and merrymaking. The separation in modern society between politics, religion, and society, however, did not exist in the Roman world: the fabric of society was woven seamlessly of these elements.

DESCRIPTION

The calendar here, known as the Menologium Rusticum Colotianum, now in the Museo Archeologico Nazionale di Napoli, is a rustic calendar discovered near the Campus Martius, Rome, and probably dates to the last century BCE or the first century CE. Like the other famous extant rustic calendar, the Menologium Rusticum Vallense, this one was based on a common predecessor, but dating it is difficult. The most important clue is that the month of August (not on view here) is named for Emperor Augustus, which means that his reign serves as a *terminus post quem*; that is, these calendars were probably made either during his reign (31 BCE–14 CE) or after it.

The calendar is slightly above 2 feet in height (65.5 centimeters) and 16 inches in width (41 centimeters). It is made of marble and depicts three seasons on each side for a total of 12 months. This calendar, called a rustic calendar, was intended to help farmers and others not only in observing the proper season for various agricultural duties but also to know when to celebrate key festivals. The old republican calendar, having been intercalated so much, was no longer a sure guide to either set of dates. To assist the reader, each month lists its astrological sign at the top followed by the name of that month, its total number of days, the position of the sun, the hours in the days and nights, the agricultural tasks to perform, and the chief festivals of the Roman state.

SIGNIFICANCE

Since early civilizations were reliant upon agriculture, they had to develop systems for knowing when to sow and harvest their crops. Romulus, the legendary first king of Rome, was credited with providing the first calendar to the Romans. Based on the phases of the moon and the four seasons, this calendar began the year in spring (in March) and ended in December, 10 months later, thus the name of December (Latin *decem,* "ten"). This was the month in which farmers might plant the last crop before the onset of winter. Perhaps because the calendar was primarily concerned with the agricultural cycle, winter was not counted in the 10 months of the year. Numa, the second king of Rome (r. 715–673 BCE), reformed the calendar and added 2 additional months, making a total of 12. In order to do this, Numa had to intercalate 50 new days into the calendar. This led to some complicated math and in time to a calendar increasingly out of sync with astronomical events. In effect Numa took 1 day from each of the 6 months that had 30 days; the remaining 4 months, which had 31 days, he left as is because odd numbers were believed to be lucky. January and February, the 2 new months, however, had 28 days each, both even numbers. Moreover, when added to the other months, the year became 354 days long, another even number. So, another day was added to January so that it might have an even number. This also made the year 355 days long. However, February remained an even-numbered month and was from that time on considered an unlucky month. According to several authorities, such as Livy and Ovid, Numa also established the college of pontiffs or priests to manage the calendar and the festivals and rituals associated with it. This was vital, since failure to observe the rites at the correct and most auspicious time could upset the delicate balance between humanity and the gods.

Since the calendar reckoned days and months by the moon and reckoned the year by the sun, it was only a matter of time before the calendar started to show major discrepancies. The solar year and the lunar month do not match up exactly. The cycles of the moon run their course in 29.5 days; Earth rotates

around the sun in about 365.25 days. To make up for the gap of 11 days be-tween Earth's rotation and the 355 days of the calendar, the college of pontiffs inserted additional days, that is, the process of intercalating. By the time of Julius Caesar (d. 44 BCE), the state calendar's months did not always match up with the festivals meant to be celebrated during them. In fact, the official calendar was three months ahead of the solar year. If observing festivals at the right cosmic time was important, this was a major problem.

One of the assignments that Caesar undertook when elected pontifex maximus (the chief priest and head of the college) was to fix the calendar. He intercalated 90 days for the three-month gap and brought the total days for the year to 445. This long year with extra months was termed the "last year of confusion." Next, Caesar inserted dates into the shorter months and brought the official calendar more in line with the solar year, an idea that he may have borrowed from the Egyptians. The new calendar had 365 days like the modern calendar; however, to stay in sync the Romans added a day between February 23 and 24 in the leap year to help ensure that the official calendar was in line with the solar year (February 24 happened twice in those years—we insert February 29 in our leap year). Helpful as Caesar's emergency steps were, by the time of Augustus, the priests miscounted, and the Roman calendar had an excess of days. Augustus, like his uncle, fixed it in 8 CE, and from then until the 16th century, the so-called Julian calendar (named for Julius Caesar) was *the* calendar. This changed in 1582 when Pope Gregory XIII corrected the Julian calendar, which like its predecessors had fallen out of sync with the solar year. With some editing, the Gregorian calendar is still in use today.

Since the official calendar had so many days and festivals out of line with observed astronomical and seasonal phenomena, the Roman people, whether in cities or in the country, developed other means by which to calculate the key days in the religious and agricultural cycle. As major festivals were run and determined by the state, the average person could do nothing, but when it came to farming and other duties, the Romans used a calendar very much like this one that followed more closely what they observed in the sky and in the seasons. This calendar, which we call a rustic calendar to differentiate from the state calendar, was used in conjunction with the official calendar. Even though incorrect in many matters, the state schedule of festivals de-tailed when these vital events in civic life were to take place. That they did take place was the main thing. This would, one hoped, please the gods, but many festivals were also fun and a good break from the tasks that most of the population woke up to each day. People were happy to let the priests manage the gods; with a calendar that followed the sun and stars, the people could manage planting and harvesting.

In addition to the basic literacy that many Romans must have had to use a calendar like this, from the information on it we can deduce that the

Romans, and perhaps especially their farmers, had a thorough understanding of the stars. Successful farming required knowing the best times to plow, sow, and harvest. More than that, however, most people had long used the movements of heavenly bodies to regulate their lives. The division of each day into daytime and night, of daylight hours into before and after noon, did not require deep knowledge of the heavens.

Feriae ("festivals," sing. *feria*) were a key part of the public calendar, and the Romans had a great number of them throughout the year. The ancient state was first and foremost a religious institution—the ancient state existed to serve the gods. In order to maintain the *pax deorum,* official ceremonies meant to honor and propitiate the gods had to be performed at the correct time and in the proper way. Public festivals were popular with the people because they were one of the few breaks from work that the populace enjoyed and were also a good source of meat. Many *feriae* included banquets, and while the populace was not compelled to attend, free meals no doubt convinced many to do so. On festival days the law courts closed, slaves might be free from work that day, and certain agricultural duties might be suspended. Most of all, festivals allowed one to have a good time while ensuring that the gods were happy.

There were many festivals and holidays, and generally people divided them into *stativae* ("fixed festivals"), festivals celebrated on the same day each year; *conceptivae,* which changed each year and were announced by the appropriate priest or official; and *feriae imperativae,* mandatory festivals that were usually an order from top magistrates either to appeal to the gods or thank them during or after a crisis. Others honored a specific god such as Mars, whose various rites between February and March marked the onset of the military campaign season. Many other festivals, not surprisingly, were a part of the agricultural celebrations. Most took place outside of the appropriate temple and included prayers, sacrifices, and other ritual practices, such as purifications.

Saturnalia was one of the most popular festivals. Observed on the winter solstice, this celebration honored the god Saturn and was an occasion of joy. It was so looked forward to that despite the fact that it was originally held only on December 17, people began celebrating it over several days. Like many festivals, the rites began outside of the Temple of Saturn in the forum and included a large public feast. Saturnalia meant that no one worked; even slaves often swapped places with their masters. In addition to the rites, people visited family and friends, exchanged gifts, and went to parties.

Another popular festival, Lupercalia, was celebrated on February 15. February was an unlucky month, and this festival was meant in part as a purification rite. While individual families cleaned their homes, the city was also purified by a parade of young men who ran through the streets lashing people with strips of goat hide. The audience was a key part of this

spectacle. Women in particular did not shun the goat hide, as they believed that undergoing this mock beating increased fertility. Lupercalia was a festive occasion even though in origin it concerned bad luck and the attempt to prevent the potential evils of February.

The Roman calendar, both rustic and official, provided a road map for the key festivals and major events of the farming seasons. The holidays and agricultural tasks in the calendars provide a wonderful glimpse into the daily life of the Romans. For much of the subsequent history of Europe, the Roman calendar helped guide people through holidays, farming, and religious festivals. The Roman calendar, which was so effective at regulating the year, is the basis, albeit much altered, of our calendar today.

FURTHER INFORMATION

Broughton, Annie Leigh. "The Menologia Rustica." *Classical Philology* 31(4) (October 1936): 353–356.

Fowler, William Warde. *The Roman Festivals of the Period of the Republic: An Introduction to the Study of the Religion of the Romans.* London: Kennikat, 1969.

Johnson, Van. *The Roman Origins of Our Calendar.* Oxford, OH: American Classical League, 1978.

Michels, Agnes. *The Calendar of the Roman Republic.* Princeton, NJ: Princeton University Press, 1978.

Richards, E. G. *Mapping Time: The Calendar and Its History.* New York: Oxford University Press, 2000.

Salzman, Michele R. *On Roman Time: The Codex-Calendar of 354 and the Rhythms of Urban Life in Late Antiquity.* Berkeley: University of California Press, 1991.

Scullard, H. H. *Festivals and Ceremonies of the Roman Republic.* Ithaca, NY: Cornell University Press, 1981.

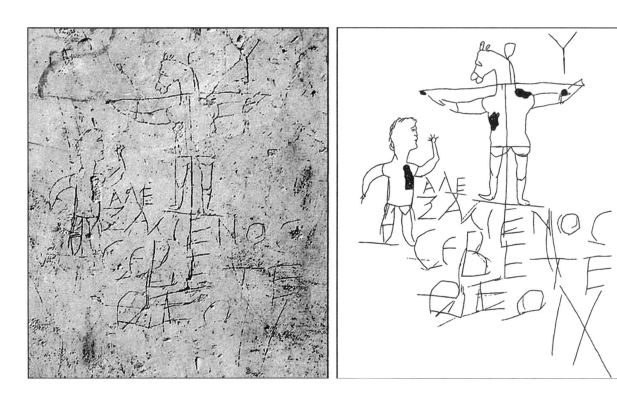

Graffiti

Rome, Italy
Circa First through Second Centuries

INTRODUCTION

It might seem strange that the casual words and sentences inscribed or inked onto the walls of Roman buildings and objects might be considered artifacts. Graffiti, unlike other written sources, is most often informal, often spontaneous, and concerned with day-to-day concerns, be the writer a lover reeling from rejection or a prankster fond of jokes. The language is usually the language of the street—what people spoke every day, not the elegantly turned phrases of orators and poets. Graffiti can be as simple as a memento that one had visited a certain spot or as developed as humorous anecdotes about the cost of services at an inn. Given the extent of graffiti and the nature of the language, it is highly likely that the average degree of literacy in the Roman world was higher than one might think. Much of the language is unpolished, the product of those who had little formal education or who had picked up Latin as an additional tongue. In any case, graffiti is a wonderful source for social history, students of paleography, and philologists.

DESCRIPTION

One of the most well-known pieces of graffiti from the Roman world, the Alexamenos Graffito as it is called, was carved sometime during the Severan period (ca. 193–238 CE) and reflects a popular non-Christian misunderstanding of Christianity. In it, we see a donkey- or horse-headed man crucified on a t-shaped cross; another man below, his right arm outstretched toward the crucified figure; and an inscription in poorly rendered Greek that reads "Alexamenos sebete theon" (Alexamenos worships God). This caricature mocks a man, Alexamenos, who was probably a slave in the Pedagogium, a school for slaves in imperial service on the Palatine Hill in Rome. The clothing that Alexamenos wears, and which we see from the back, is a *colobium,* a simple tunic that slaves wore (they could not wear togas; see the entry **Toga Praetexta**). Significantly, the figure on the cross likewise wears a *colobium.*

There is much as yet unknown about this particular piece of graffiti. The tradition of viewing the cross as a Christian symbol, for example, does not

15

appear until the fifth century and was relatively rare until the seventh century CE. The donkey- or horse-headed man has some precedents in both Roman misunderstandings of Christianity and in popular mimes but also remains a bit mysterious. Taken together, however, it seems clear that this graffito was meant to mock a fellow slave for his Christian faith. Tertullian (d. ca. 220 CE), an early theologian, mentioned the rumor that Christians worshipped a donkey-headed god, as did Minucius Felix (second or third century CE), author of the *Octavius,* an eloquent defense of Christianity in the form of a dialogue. As for the cross, since this was a form of punishment reserved for noncitizens and criminals but was also the way in which Christ was executed, the graffiti artist more than likely meant it as an insult, a way to suggest that Alexamenos worshipped not only a beast-headed god but one punished in a way reserved for the lowest of the low. In this sense, it is less a cross as a Christian symbol and more a cross as a symbol of low-status punishment.

SIGNIFICANCE

There are a number of ways in which graffiti generally and this graffito specifically are significant. The Alexamenos Graffito, with its presence in a building associated with the education of slaves in the imperial service, reveals that so-called pagans and Christians lived and worked alongside one another. It is also evident from this caricature and other sources that the relationship between pagans and Christians was often hostile. Persecution by the state, however, was rare, and by the time that this graffito was scratched into the wall, there had only been three relatively significant attacks on Christians: during Nero's reign (54–68), under Domitian (81–96), and under Marcus Aurelius (161–180). If the date for this graffito is correct, if it was made sometime in the late second century or the third century, then it is possible that this caricature reflects popular support for persecution. The fact that there is another piece of graffiti related to Alexamenos, in a building next door to the one under discussion here, supports this view. The other reads "Alexamenos fidelis" (Alexamenos the faithful, that is, Alexamenos the Christian). One school of thought holds that since the donkey- or horse-headed cartoon was carved in a former training facility for imperial guards, one of Alexamenos's military comrades was attempting to denounce him. This is possible, of course, but is impossible to prove.

It is undeniable, however, that graffiti such as this highlights the sometimes tempestuous relationship that Rome had with early Christians. For the most part, the Romans considered Christianity to be a *superstitio* (superstition) rather than a religion. As educated men such as the historian Tacitus (d. ca. 120 CE) knew, Christianity was an offshoot of Judaism. While they might respect a foreign faith, especially an old one such as that of the Jews, they were suspicious of new cults. The fact that Christianity had wide

appeal with the poor did little to improve it in official eyes. Never truly comfortable with groups that met privately, let alone in secret, it is perhaps little wonder that the Roman government was mistrustful of Christians.

Many officials, such as Pliny the Younger (d. ca. 112 CE), who was governor of Bithynia and Pontus under Trajan, knew little about Christians. Pliny thought them harmless enough, but when they failed to sacrifice to the emperor he executed them, as much for their stubbornness as for the offense. Some of the criticisms leveled at Christians included that they ate people or sacrificed babies and that they engaged in deviant sexual practices (one of their ceremonies was the agape, or love feast, and they called each other "brother" and "sister"), and of course as Celsus (second century CE), a major detractor, mentioned, they were predominantly from the underclass. The eating of people and the agape (from the Greek *agapē* for "love" but in the sense of charity or unselfish, spiritual love vs. *erōs,* or erotic love) were obviously misunderstandings about the evolving rite of the Eucharist. Many pagans believed that the underclass was where the gods wanted them to be—if the gods favored them, they would not be poor. Traditional Roman religion was very contractual. The concept was *do ut des* ("I give so that you give"), the idea that one sacrifices so that the gods will be benevolent. Jesus turned this concept of *do ut des* upside down, so it is understandable how the average Roman might raise an eyebrow. The other component is that religion was communal—if anyone in the community was not honoring the gods, the gods might punish everyone. So from that perspective, the authorities had to do something with a group full of new ideas who were accused of immorality and worse and who refused to honor the gods and the genius of the emperor.

One thing to take away from examples such as the exchange between Pliny and Trajan was that even after a century, administrators could know next to nothing about Christians. Here is a Roman official, ca. 111–113 CE, who does not know much about Christians at all, a fact that should disabuse anyone of the idea that Rome had some great empire-wide plan to eradicate Christians from day one. Trajan's response is interesting too; he could care less, really, what they believe so long as they are faithful. Herein was the problem. For non-Christian Romans (Jews excepted), one could believe in as many gods of whatever type one wished so long as one honored the state gods too. It was not just a religious issue but a political one, and this is hard for us to understand, as we live in a world where the idea of separating church and state is common. There was no such thing for the Romans— church and state, as it were, were one. The state was a religious institution, the apparatus through which a community managed the *pax deorum* ("peace of the gods") via rites, sacrifices, and festivals. Because Christians could not participate in those public sacrifices, they were, in essence, traitors. Pliny tests them this way too; as governor, his concern was whether

they subversive or not. If they threw incense on the fire and renounced their *superstitio,* he let them go; if not, then they were enemies of the state, and he had them executed.

With the victory of Constantine in 312 at the Battle of the Milvian Bridge, a victory he credited the Christian God with, the fortunes of Christians empire-wide began to change. Constantine legalized Christianity the next year, a major event for those Christians who remembered the major persecution under Diocletian (d. 305 CE). While the emperor's program was intended to unite all Romans under the "highest God," however they might define it, Constantine's involvement in church issues, particularly in theological controversies, made this unifying policy difficult if not impossible to maintain. With one exception, the reign of Emperor Julian (r. 361–363), the emperors of Rome from the time of Constantine on were Christians. By the end of the century, in fact, Theodosius the Great mandated (391) that Christianity be the state religion. From at least the late fourth century, to be Roman increasingly meant that one was Christian, and the fusion of these two cultures with a third, that of Germanic culture, gave rise to the European Middle Ages that followed in the wake of Rome.

As this one piece of graffiti demonstrates, the day-to-day scribbling of average Romans can reveal much about the world in which they lived. This is true with both verbal graffiti, which consists of words alone, and nonverbal graffiti, which consists of pictures. The example here employs both styles. Surviving examples provide unique windows into local politics, the devotion of chariot racing factions, the popularity of victorious gladiators, the love lives of citizens, and the jokes and humor of the time. More than this, since most graffiti was written by the average citizen, we have a record of colloquial Latin that, apart from bits and pieces in a few literary works, we would not otherwise have. Not everyone talked like Virgil or Tacitus. Graffiti thus is one of our best sources for social history. It is also valuable in the study of paleography, that is, the study of ancient writing and letters. As one sees in the Alexamenos Graffito, not every letter was formed perfectly. People had different levels of education and may have learned Latin or other tongues later in life, and thus they did not always use standard vocabulary, spelling, or letter forms. This is vital information for the evolution of the Latin language, for the development of our alphabet, and for the study of the relationship between different forms of writing in the Roman world.

FURTHER INFORMATION

Bagnall, Roger S. *Everyday Writing in the Graeco-Roman East.* Berkeley: University of California Press, 2011.

Baird, Jennifer, and Claire Taylor, eds. *Ancient Graffiti in Context.* New York: Routledge, 2012.

Bodel, John, ed. *Epigraphic Evidence: Ancient History from Inscriptions.* New York: Routledge, 2001.

Chadwick, Henry. *The Early Church.* New York: Penguin, 1993.

Cooley, Alison E. *The Cambridge Manual of Latin Epigraphy.* Cambridge: Cambridge University Press, 2012.

Fox, Robin Lane. *Pagans and Christians.* London: Penguin, 2006.

Harris, William V. *Ancient Literacy.* Cambridge, MA: Harvard University Press, 1989.

Lynch, Joseph H. *Early Christianity.* New York: Oxford University Press, 2010.

Macdonald, M. C. A. "Literacy in an Oral Environment." In *Writing and Ancient Near Eastern Society: Papers in Honour of Alan R. Millard,* edited by Piotr Bienkowski, Christopher Mee, and Elizabeth Slater, 49–118. New York: T and T Clark, 2005.

MacMullen, Ramsay. *Christianizing the Roman Empire, AD 100–400.* New Haven, CT: Yale University Press, 1984.

Milnor, Kristina. *Graffiti and the Literary Landscape in Roman Pompeii.* Oxford: Oxford University Press, 2014.

Inkwell

Oulili, Morocco
First through Third Centuries CE

INTRODUCTION

Writing and reading were essential skills in the Roman world and not only for those who comprised the ruling class. The average Roman usually had some facility with both reading and writing, if only to conduct business. The use of scrolls or book rolls and later the codex, the place of pen and ink, and the importance placed on books and the accuracy of their contexts are all major legacies of Rome to the subsequent cultures that followed it.

DESCRIPTION

The inkwell and *stili* (sing. *stilus,* "stylus, pen") seen here date from sometime in the first three centuries CE. They are of bronze and were discovered in the Roman city of Volubilis (present-day Oulili), a site near Meknes, Morocco. The Romans employed several methods of writing and used a variety of media, including wax tablets, papyrus, linen, wooden planks, palm leaves, and parchment. Ink came from different sources as well. The term *atramentum,* for example, applies to most any black coloring on an object, but it also referred to ink. Writing ink was termed *atramentum librarium* or *atramentum scriptorium,* the first term referring specifically to books, *librarius* ("of or pertaining to books") and the second term referring to writers, *scriptor* ("writer").

Ink had long been in use before the Romans adopted it. There is little mention of ink in Roman sources specifically until the dramas of Plautus (d. 184 BCE), but after his time, we find mention of it in other writers such as Cicero (d. 43 BCE). While most writing was penned in black ink, there were other colors. Red, for instance, was often used for initial letters, a practice that persisted into the medieval period. Pliny the Elder, whose *Natural History* covered so many aspects of life, discusses how ink was made— soot, especially from pine, was one source, but so too was most any smoky resin from fires. Hypocausts provided another source for soot-based inks. Other sources included the lees of wine and cuttlefish. Roman inks, unlike

modern ones, tended to be thicker and less viscous, one reason perhaps that they have so often survived the centuries.

In terms of pens, the Roman *stilus* was very often of metal. Bronze was a favorite material, but *stili* might also be made of other substances, such as wood or ivory. The *calamus,* a type of reed, was also used for ink writing. The advantage of reeds as writing implements was that they were relatively less expensive, provided one lived in an area such as Egypt where they were plentiful, and could easily be resharpened with a knife when the tip became dull. These *calami* were similar to modern fountain pens or the early modern quill pen; when *calami* were dipped in ink, the hollow of the reed held the ink, and the split at the tip helped guide it onto the page.

While many materials provided the Romans with a decent writing surface, most books were written on papyrus. These books, however, were different than the codex, the shape of the modern book, and were more like scrolls. Papyrus could also be used for shorter works such as letters, but when ancient authors discuss books they most often refer to scrolls. The Egyptians had first used papyrus as early as the third millennium BCE, but its use spread quickly due to its superiority as a medium for writing. It was also relatively easy to make, though some details are not perfectly understood. The papermaker took the papyrus stalks, opened them up, and then rolled them out. Once flat, one layer was overlaid on the other at 90 degrees and pressed—the sap within the plant fibers would then act as a glue and hold the sheets together. This provided not only a tighter writing surface but also some strength. Once formed, the sheets were laid out in the sun to dry and be bleached. The last step was to connect the sheets together to form a book roll, or scroll.

With many book rolls having survived, scholars have been able to determine much about the typical book roll. Most book rolls were anywhere from about 8 to 13 inches in height. The length of the roll depended on the length of the work in it, but book rolls average about 20 to 26 feet, or 6 to 8 meters. The writer wrote from left to right in columns and along the length of the roll. The title of a work was often added last, as a tag, and since book rolls were stored by inserting them into a shelf, one could then read the tag to know which book was which. With such a long length to read or write upon, book rolls were less easy to use than the later codex. The writing is often small and the words are unseparated, which makes them difficult to read. On account of this, some scholars believe that book rolls, in addition to their obvious uses, were also symbols of elite culture, for only those trained to read them would have been able to do so with any real facility. Most people would not be able to afford very many such books unless they were possessed of considerable means as well.

The book roll was eventually replaced by the codex. The term "codex" originally applied to a collection of bound wax tablets, but it began to apply

to books formed in the same way, only with parchment, sometime in the first century CE. There is some thought that its popularity may be connected with the rise of Christianity for which textual authority became increasingly important. It is easier to thumb through a codex for a passage than to unroll a scroll. Regardless, by the fourth century the codex was well on its way to replacing the scroll as the dominant form of book.

SIGNIFICANCE

Ancient books are valuable for many reasons. Their content shares with us not only the literary gems of the past but also details about daily life. The letters of men such as Cicero, while highly polished and meant to be read, nonetheless tell us about aspects of the Roman world that we might not otherwise know. For example, discovering an ancient scroll can provide us with a text and can tell us something about how ancient books were made, but incidental details within that text can tell us how books were shared, sold, and edited. Cicero's letters to Atticus, for example, who did so much to publish the famous orator's work, reveal the importance of book borrowing in order to obtain copies. Friends loaned one another copies of a work and had them copied by professional copyists; this was one of the key ways in which a book caught on. We also learn that not all copyists were the same and that writers such as Cicero lamented copying when they ran across it.

The fact that the book trade rested on copy making also helps explain the discrepancies one often sees between different copies of the same book. The reasons for these differences vary. In some, the copyist miscopied a word or wrote a letter in such a way as to confuse the next reader. In others, perhaps a tired copyist left out a line. Still another possibility was authorial editing; again, Cicero is a good guide to this habit. We know, for example, that he reworked part of his *Academica* but that despite his efforts to have only the newer version out, both survived. Another problem was that there was no real sense of copyright. Unauthorized copies circulated right alongside legitimate ones.

Publishing was not entirely reliant upon one's friends and good copies. Patronage was a plus, as it was in so many aspects of Roman life. There were a number of famous literary patrons. In exchange for a dedication from the author and the fame of being a man of letters, the patron would help fund and get the word out about one's latest project. Very often an author launched his latest work with a public recitation too. It was good press, but also good entertainment. Moreover, if one's literary-minded friends were in attendance, one might receive good criticism well enough in advance to edit the work before copies were made.

There remain many questions about the exact way in which copies were made. While household slaves trained for the task might have supplied some of the labor, there were also publishers with staff for copying. Both

booksellers and copyists were originally referred to as *librarii* (sing. *librarius*) and played a key role in book distribution. Many of these publishers even specialized in newer or rare authors. While it is possible that these outfits had copyists listening to a reader and taking down the work en masse, it is also possible that copying was less systematic and centralized. One model proposes that an author had copies made and then gave those copies to friends, who in turn had copies made and so on, until the books were in general circulation.

An important question that arises from the world of publication is who was reading these books. Clearly those in aristocratic circles, who had the requisite education, were often readers as well as writers. However, there is good evidence to suggest that literacy was not confined to the ruling class. Many slaves could read and write, and from memorial inscriptions, graffiti, letters, and other contexts we know that many Romans could read and write even if their Latin was less elegant than that of Cicero or Quintilian, indeed even if it was rather rudimentary. Reading, however, was at times more of an exercise for the Romans. Many scholars emphasize the fact that the ancients read aloud. One piece of evidence for this comes from medical texts that list reading as one of the beneficial ways to stay healthy, the idea being that one had to regulate one's breathing and gesticulate. While this was no doubt true, it is also likely that people read quietly and to themselves.

Though many people could read and write, especially for the day-to-day business of recording stock sold, wages, and business orders, not everyone could afford books. Libraries were largely privately owned and open only to one's friends. There were, however, plans for public libraries, though they did not appear until 37 BCE, when Gaius Asinius Pollio opened the first public library in the city. Others soon followed. Emperors in particular were patrons—Augustus, for example, built two libraries, and Trajan commissioned some libraries for the provinces. These were important institutions and extended many of the great works of Greece and Rome to the reading public. Generally most Roman libraries were bilingual too, having sections for Latin and Greek authors.

One of the lasting achievements of Roman writing, letters, and books was in bequeathing this literary culture to posterity. Our own alphabet derives from the Roman one, and much of English vocabulary, via Norman French, consists of words ultimately derived from Latin. More than this, the culture of the book persisted and has continued to do so to the present day. The codex, first used by the Romans, went on to be the dominant form of the book the world over, and only now as the technology for electronic books improves do we see a new potential evolution of the book. It is worth noting, however, that the e-readers of today mirror as closely possible the ways in which one reads a codex.

FURTHER INFORMATION

Bülow-Jacobsen, Adam. "Writing Material in the Ancient World." In *The Oxford Handbook of Papyrology,* edited by Roger S. Bagnall, 3–29. New York: Oxford University Press, 2009.

Gamble, Harry. *Books and Readers in the Early Church: A History of Early Christian Texts.* New Haven, CT: Yale University Press, 1995.

Harris, W. V. *Ancient Literacy.* Cambridge, MA: Harvard University Press, 1989.

Johnson, William A. *Bookrolls and Scribes in Oxyrhynchus.* Toronto: University of Toronto Press, 2004.

Johnson, William A., and Holt N. Parker, eds. *Ancient Literacies: The Culture of Reading in Greece and Rome.* New York: Oxford University Press, 2011.

Reynolds, L. D., and N. G. Wilson. *Scribes & Scholars: A Guide to the Transmission of Greek and Latin Literature.* New York: Oxford University Press, 1991.

Roberts, Colin H., and T. S. Skeat. *The Birth of the Codex.* New York: Published for the British Academy by Oxford University Press, 1983.

Seal Ring

Roman
Circa 40 through 30 BCE

INTRODUCTION

Jewelry for the Romans was a part of their everyday dress. Men wore rings and pendants on occasion, and women wore necklaces, bracelets, pins, and earrings. Some ornaments were functional as well as decorative. Seal rings, for example, were used much as signatures are today. Correspondence was often sealed with wax or clay that would then be impressed with an identifying mark. While personal letters were normally carried by hand, there being no civilian mail service, official business was eventually provided with a communication service called the *cursus publicus*. It was in effect a postal system but one restricted for government use, largely to gather information, and put a severe strain on the local populations where their stations were established.

DESCRIPTION

The exquisite seal ring depicted here is of red jasper intaglio and dates to the first century BCE. The bust is that of Mark Antony, who after the death of Julius Caesar vied with Caesar's adopted nephew, Octavian (later Augustus), for control of Rome and lost. If this belonged to one of Antony's supporters, we can further refine the date to that period in which Antony and Octavian split ways, roughly between 40 and 30 BCE. Of note, this type of ring, with a bust in relief, was often used as a *sigillum* (pl. *sigilla*), or seal.

Seals had been used for thousands of years by the time the Romans adopted them. Used in the ancient Near East as early as the Late Neolithic period, roughly 6000 to 3000 BCE, the first seals are thought to have been largely decorative. Designs were geometric, and since communities most likely lacked sophisticated governments that might require seals, most scholars believe that they were used to decorate cloth. When complex cities appear ca. 3500 BCE, and with them writing, we start to see seals used on official documents. Likewise they appear in commerce, where they often secured a sealed product. Within the next few hundred years,

many people adopted seals. Greece adopted their use early and employed several types.

There were a variety of seal forms. In Mesopotamia and the Levant, cylinder seals predominated. The Egyptians had long used the scarab, a seal in the shape of a dung beetle. Greek areas used lentoid seals, which are biconvex when looked at from the side, and amygdaloid or almond-shaped seals. Some were made of ivory, others were made of precious metals, and still others were made of hard stone such as chalcedony and cornelian. The seal's impression was normally an image rather than a word or phrase. Gods, animals, heroes, and portraits were typical.

From their origins as tools to imprint designs, seals found use in a variety of ways, from commerce to government administration, from letter writing to the sign of a witness. With objects of clay or with clay sealings (small lumps impressed with a seal either as a way to identify the owner or maker or to prove that a container had not been opened), the seal could be applied directly to the material to imprint it. The Romans sometimes added a case to protect a seal from breaking in transit, an occurrence that no doubt was common. With lead sealings, another form, this was less of an issue. Wax, which was often used for documents, was fragile, but apparently this was less of a problem, as most personal letters were hand-carried rather than thrown together with other parcels.

SIGNIFICANCE

One of the more important uses to which seals and seal rings were put was in sealing and identifying the writer of a letter or document. Despite the growth of a large government and the extension of political control first over Italy and then outward, the Roman Republic did not have an official government-run office for handling mail. There were examples of such systems. The Hellenistic kingdoms used them, the ancient Persian system was universally admired, and the Ptolemaic mail was perhaps the most developed until the modern era. In Rome, by contrast, official correspondence was carried by couriers known as *tabellarii* ("tablet men") and even by private citizens who were traveling to the destination of a particular dispatch. Within the legion, soldiers especially chosen to carry dispatches performed any message handling from the front or from their commanders. These systems did not disappear. Cicero had a staff of *tabellarii,* for example, and between friends and family such a method probably worked just fine. For private post, in fact, it remained one of the only options.

The first semblance of a postal system appeared with Augustus (d. 14 CE). A veteran of civil war and its attendant evils, Augustus knew well the value of information and how difficult it could be to obtain in a large empire. Suetonius, whose *Lives of the Caesars* provides much of what we know about the early emperors, claims that Augustus implemented a system

Primary Source

SUETONIUS, *LIFE OF AUGUSTUS*, CHAPTERS 49 AND 50

In order to obtain the earliest intelligence of what was passing in the provinces, he established posts, consisting at first of young men stationed at moderate distances along the military roads, and afterwards of regular couriers with fast vehicles; which appeared to him the most commodious, because the persons who were the bearers of dispatches, written on the spot, might then be questioned about the business, as occasion occurred.

In sealing letters-patent, rescripts, or epistles, he at first used the figure of a sphinx, afterwards the head of Alexander the Great and at last his own, engraved by the hand of Dioscorides; which practice was retained by the succeeding emperors. He was extremely precise in dating his letters, putting down exactly the time of the day or night at which they were dispatched.

[Suetonius, *The Lives of the Twelve Caesars,* translated by Alexander Thomson (Philadelphia: Gebbie & Co., 1889), http://www.perseus.tufts.edu/hopper/text?doc=Perseus%3Atext%3A1999.02.0132%3Alife %3Daug.%3Achapter%3D49.]

of relay runners, and later wagons, along roads chiefly used by the military to bring him information. One aspect of this arrangement was that the same men ran the relays between stations so that if the emperor had any questions, he might obtain answers from the one man who had performed the duty. This also entailed the added benefit of being able to read whatever the messenger was carrying. Since the primary purpose of the *cursus publicus* was intelligence gathering and more effective communication between government officials, the army increasingly took a larger role in operating it. The *speculatores,* or scouts, were favored for this role.

Though relay teams were a working adjunct to the imperial administration, Augustus further strengthened the teams by developing a reliable means for their conveyance. This system, the *vehiculatio,* was the nucleus of what was to become the *cursus publicus,* a term hard to render in English but one that refers to a public or state means of travel. The term is sometimes translated as "public way." We know from grave markers that carts, such as the four-wheeled *reda* (see also Horse Cart) and *carpenta* (see also Farm Cart), were often used when the burden of the messenger required more than a satchel or saddlebag. Since not every speculator carried much, smaller and faster vehicles, such as the two-wheeled *birota* or *cisium,* were also employed. Horses, or *equi publici,* used by the *cursus* were expressly forbidden to those not in this branch of service. Other animals, including donkeys, mules, oxen, and even camels, were used where appropriate.

In order to function, any messenger service required frequent way stations where *speculatores* might rest, obtain additional post, and either feed or acquire animals. Those traveling the *cursus* had to have a *diploma,* an official document designating that they were permitted to use this system. These were signed either by the emperor or one of his deputies assigned specifically to managing the *cursus.* Possession of such a document entitled one to the services of the various *mutationes,* or stations where one could obtain new transport, and at *mansiones,* the inns where messengers could find food and rest. Itineraries and maps helped the *speculatores* find these stations. Though much depended on terrain, on average the posts were about 25 to 35 miles apart. This was about the distance, again on average, that a fast-moving messenger might expect to go in one day.

With the burden of expense lifted off the messenger and with convenient watering stations, inns, and support along the road, the *cursus publicus* was attractive for anyone desiring to lessen the evils of travel and thus was open to abuses. No one outside the service was to use it, but on occasion exceptions, however unwarranted, were made. Even at the highest levels of government there were examples. Pliny the Younger (d. ca. 112 CE), governor of Bithynia and Pontus, for example, explained to Emperor Trajan—after the fact—that he had provided his wife with a *diploma* so that she might attend a funeral. Surviving sources indicate that this sort of infraction was common.

It was not, however, the only problem. Since its inception, the *cursus publicus* had placed a significant burden on the local population. Funding for the *mansiones, mutationes,* provisions, animals, fodder, and everything else devolved upon the people living in a given area. Their taxes were higher, and local business might be seconded to supply these needs. On occasion new facilities were built but generally only in remote areas where the *cursus* could not readily find inns and other amenities already in place. In such situations it was not uncommon for those with the *cursus* to take advantage of their protection and privileges. Various emperors tried to curb these abuses, but since legislation against them appeared into the late empire and since enforcement was difficult, the abuses continued and the burden on the people remained. There were a few temporary periods in which this burden was shifted to the imperial treasury, but such measures did not last. The *cursus* was expensive to run, and with so many demands on the treasury it was far more expedient to shift the burden to the populace.

The *cursus publicus* was an effective means by which the emperor acquired information, an equally adept system for disseminating orders, and a chief method of intelligence gathering. At the same time, the weight that it placed on the Roman people was great, and it was never popular. With the increasing costs, tax evasion, and political fragmentation in the western empire, the *cursus* eventually ceased to function effectively in the region. The

cursus was still in use, however, under the Ostrogoths in Italy during the late fifth and early sixth centuries CE and with the same abuses.

FURTHER INFORMATION

Black, E. W. *Cursus Publicus: The Infrastructure of Government in Roman Britain.* Oxford, UK: British Archaeological Reports, 1995.

Boardman, John, and Robert L. Wilkins. *Greek Gems and Finger Rings: Early Bronze to Late Classical.* London: Thames and Hudson, 2001.

Calinescu, Adriana, ed. *Ancient Jewelry and Archaeology.* Bloomington: Indiana University Press, 1996.

Casson, Lionel. *Travel in the Ancient World.* Baltimore: Johns Hopkins University Press, 1994.

Chevallier, Raymond. *Roman Roads.* Berkeley: University of California Press, 1976.

Higgins, Reynold A. *Greek and Roman Jewellery.* 2nd ed. Berkeley: University of California Press, 1980.

Ogden, Jack. *Ancient Jewellery.* Berkeley: University of California Press, 1992.

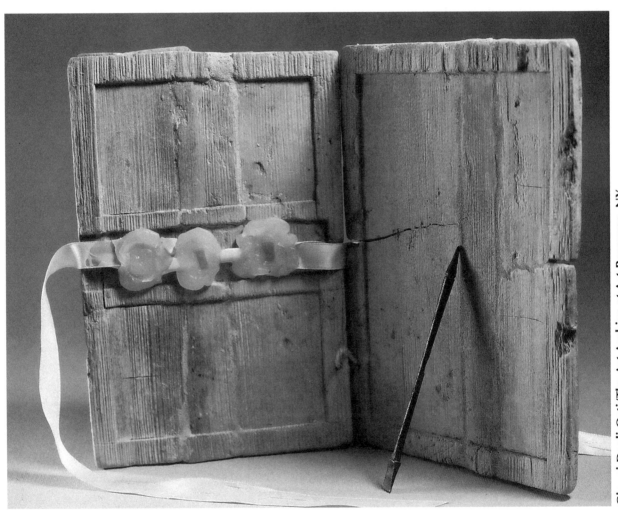

Wax Tablet

Roman
Date Unknown

INTRODUCTION

Temporary writing surfaces were an important part of the Roman world. While many objects, such as broken pottery and slats of wood, might serve as writing surfaces and often did, one of the most common writing surfaces was the wax tablet, in combination with a stylus as the writing tool. Small, easy to transport, and best of all erasable, the wax tablet was a favorite of students and men of letters.

DESCRIPTION

This writing tablet, now in the Archaeological Museum in Saintes, France, is a wonderfully preserved example of one of the most common writing surfaces in antiquity. The stylus (Latin *stilus*) photographed with it is likewise representative of those used with these tablets. Most commonly referred to as tabulae (sing. tabula, meaning "plank" or "board"), *tabellae,* or *pugillares* (since they could be held in the hand; this term is related to *pugnus,* meaning "fist"), these archetypical Roman writing surfaces enjoyed a long history and were used all over the Roman world. One can see examples in frescos, perhaps most famously in the so-called *Sappho* portrait of a young woman holding a tabula and a stylus and in the portrait of a couple, both holding writing implements, in the House of Paquius Proculus. Both frescos were uncovered in Pompeii.

Tabulae could be made of any wood. Samples have been found constructed out of beech and fir, but some expensive models were also made of more precious materials such as ivory. What provided a writing surface was a coating of wax inlaid onto one side of the wooden plank. Normally, several of these were bound together with wire to make a small codex, the usual collective known for multiple tablets put together and ultimately a later Latin word for "book." This also helped prevent what was written from being damaged, the wax being a relatively soft medium for writing and liable to being erased if bumped or scuffed. The model depicted here is a diptych, or two-tablet version. One wrote on the wax using a stylus. One end of the

33

stylus was sharper to inscribe letters into the wax, while the other end was round and flat and acted like a modern pencil eraser.

The use of these tablets predated the Romans—one is mentioned by Homer, for example—but they served a wide variety of purposes in the Roman world. Some tablets were like notebooks, the sort of convenient surface on which to record a quick note, a list, or an address. Many, however, were used for letter writing. In fact, those who used tabulae for this purpose would seal the entire thing with string and a wax seal. This practice must have been common, as the term "tabulae" became one of the words for "letter." One particular specialized version of the tabulae was the *Vitelliani*. Martial mentions these, and they seem to have been especially popular in writing love letters. This style was expensive and thus perhaps more suitable for such a purpose. One of the more fascinating uses to which tabulae were put was in legal documents. Wills in particular were written in wax or on wood. *Cera,* or "wax," was often used to refer to tabula or *tabella* and when combined with a number referred to specific pages of the will.

A number of tabulae have survived. One of the more impressive discoveries was made in England. At the site of an old Roman fort, Vindolanda, hundreds of tablets have been unearthed, many with wax, though most appear to have been written in ink on thin slices of wood. They provide a unique glimpse into Roman life. These tablets are a providential find. It is rare for documents made of organic material to survive in the ground. In rare cases, as with the tablets at Vindolanda, the clay and the tannins from organic material, both of which produce an anaerobic state (i.e., a condition with little oxygen), allowed for their survival. Many, however, were waterlogged, but actually this helped preserve them. Once out of the water, however, they disintegrate quickly, the ink especially, so new techniques were devised to prevent this. Using alcohol baths, the team was able to prevent the ink from fading; this technique, first used at Vindolanda, is now the usual method for preserving artifacts similarly waterlogged. Some are letters home, others discuss military business, and still others contain bits and pieces of literature. There is even a birthday invitation from one officer's wife to her friend. Most date to the late first and early second centuries CE and concern the two auxiliary units posted there. Some of the most important information they preserve, however, consists of everyday Latin language and handwriting.

Wax tablets were used into the Middle Ages. Paper was expensive and rare, and papyrus was more difficult to obtain in medieval Europe. Vellum, or sheepskin, was a popular medium but was likewise expensive. Wax tablets thus continued to be used for some time as expedient, inexpensive writing surfaces.

SIGNIFICANCE

In addition to the uses mentioned above, tabulae also served as one of the primary supplies of Roman students. Some of the earliest examples to date

of education in Italy, in fact, come from an ivory writing tablet, the Marsiliana Tablet Abecedarium (ca. seventh century BCE). This tablet preserves a 26-letter alphabet in Etruscan. It is not clear how widespread literacy was at that time or how much of education centered around the written word, but with models of writing tablets from a century later it may be that reading and writing were already a key part of education. Certainly by the end of the fourth century BCE literacy was probably an increasingly important aspect of a boy's education. By and large, throughout most of the Roman period it was only boys and then only boys whose families could afford it who received any formal education. Those destined to take over a family trade would learn that trade at a young age, and some trades required that one be able to read, but by and large only those within aristocratic circles moved much beyond elementary education (see also the entry *Toga Praetexta*).

In general terms, the Roman system of education borrowed much from the Greeks, not only because of philhellenic tendencies among many Roman elites, such as Scipio Aemilianus (d. 183 BCE), but also because of the influx of Greeks into Rome following Rome's victory in its wars with Macedonia. Many well-to-do families employed Greek tutors, and it became customary for centuries for highborn youths to learn some Greek alongside their Latin. Like the Greeks, many Roman families employed pedagogues to assist in educating their sons. While these men escorted pupils to and from school, they also provided some instruction. Private education remained a key aspect of Roman life, but schools began to flourish in the late third century BCE. The first school was opened by Spurius Carvilius, a freedman, at this time. Instruction focused on reading and writing.

For those attending such schools, always for a fee, there were several stages. Students started out with a *ludi magister* ("school master") but then might go on to work with a *grammaticus*. Much of this second state of learning centered upon literature, especially poetry, and was important for a solid grounding in the language, imagery, and stock phrases so necessary for oratory. To perfect these budding rhetorical skills, a student studied with a rhetor, and at first, when there were few treatises on Roman rhetoric, learned Greek traditions. By the first century BCE, however, Latin oratory became part of the curriculum as well. There were several of these that went on to have great influence in later ages. Cicero, to name one example, not only preserved much of his correspondence and speeches but also penned several texts about rhetoric such as *The Orator*. Another key text, from ca. 95 CE, was the *Institutio Oratoria* of Quintilian. As had happened with sophists in Greece, rhetors were initially met with suspicion. On more than one occasion they were told to leave the city, the first time in 161 BCE. The first rhetors were Greeks and thus as foreigners were perhaps the victims of a double prejudice, one ethnic, the other professional—teaching one to argue well did not necessarily mean teaching one to defend the moral high

ground. However, Latin rhetors suffered the same temporary fate in 92 BCE. In the later empire, however, the rhetor, whose skills in polishing future orators were esteemed as extremely valuable for a public career, enjoyed more prestige.

Teachers, while they might be respected, were generally of humble station. Many were freedmen. Pay could be decent, but as Juvenal remarked in his seventh satire, it could also be low and was grafted by pedagogues and others so that the teacher received less than he should. Schools were not normally in dedicated buildings but instead were in space either rented or owned when a public spot, even a sidewalk early in the morning, could not be found. They were noisy as well. Martial, in *Epigram* No. 9, complains of shouting teachers, the cracking of their whips as they disciplined lazy students, and the din of oratorical recitations. In the imperial period, there was some improvement for those such as rhetors who taught more advanced students. Several emperors, among them the more bookish such as Marcus Aurelius (d. 180 CE), set up official positions for academics, but generally even with improved status most instructors remained among the less elite in society.

The literary basis of Roman education persisted into late antiquity. Often referred to collectively as *paideia* (Greek for "education" or "training"), this style of education was geared primarily toward creating effective orators. It was much more than that, however, as it was also the way in which the ruling class understood the world, carried themselves, and readied themselves to lead their communities. Lines from Homer or Virgil and other allusions to the literary treasures of the Greco-Roman past not only helped them in speech making but also singled them out as members of a shared culture. Their mode of speech and deportment and the way they stood were paramount in a common code of behavior and values. More than this, the cult of letters as applied to civic life created a connection with the past, one that tended to reinforce tradition to provide a sense of stability.

Elocution was a must in Roman administration. From law courts to imperial panegyrics, from sermons to speeches made in the Senate house, the ability to speak well, to elicit the recognized feelings and ideas attached to classical motifs, and the ability to use persuasive language were highly prized. Of note, this education was valued not only by non-Christians in the later Roman world but also by Christians. *Paideia* was one of several places where educated Romans, whatever their religious outlook, met on common ground. This was not always an easy alliance, however, as the example of Saint Jerome (d. 420 CE) illustrates. In a dream he beheld Christ telling him that he was more a "Ciceronian" than a "Christian." Other Christians, though, could make eloquent defenses against non-Christian detractors who thought that the followers of Christ had no business with "pagan" literature. In his *To Youths,* Basil of Caesarea (d. 379 CE) advocated for the retention

of so-called pagan literature in the Christian curriculum, something that Emperor Julian (d. 363 CE) wished to take away from them. Roman learning in these centuries helped ensure that much of the classical past was handed down to Rome's heirs, the Byzantine Empire, the Islamic world, and the medieval West.

FURTHER INFORMATION

Bonner, S. F. *Education in Ancient Rome.* Berkeley: University of California Press, 1977.

Bowen, J. *A History of Western Education,* Vol. 1, *The Ancient World.* New York: St. Martin's, 1972.

Bowman, Alan K., et al. *The Vindolanda Writing-Tablets (Tabulae Vindolandenses II).* London: British Museum Press, 1994.

Brown, Peter. *Power and Persuasion in Late Antiquity: Towards a Christian Empire.* Madison: University of Wisconsin Press, 1992.

Bülow-Jacobsen, Adam. "Writing Material in the Ancient World." In *The Oxford Handbook of Papyrology,* edited by Roger S. Bagnall, 3–29. New York: Oxford University Press, 2009.

Clarke, M. L. *Higher Education in the Ancient World.* Albuquerque: University of New Mexico Press, 1971.

Harris, W. V. *Ancient Literacy.* Cambridge, MA: Harvard University Press, 1989.

Jaeger, Werner. *Early Christianity and Greek Paideia.* Cambridge, MA: Belknap Press of Harvard University Press, 1985.

Kastor, Robert A. *Guardians of Language: The Grammarian and Society in Late Antiquity.* Berkeley: University of California Press, 1988.

Marrou, H. I. *History of Education in Antiquity.* Translated by George Lamb. Madison: University of Wisconsin Press, 1982.

Reynolds, L. D., and N. G. Wilson. *Scribes & Scholars: A Guide to the Transmission of Greek and Latin Literature.* New York: Oxford University Press, 1991.

Robb, Kevin. *Literacy and Paideia in Ancient Greece.* New York: Oxford University Press, 1994.

Website

"Writing on Wood: Roman Writing Tablets." Vindolanda Tablets Online, http://vindolanda.csad.ox.ac.uk/tablets/TVI-2-2.shtml.

Cooking and Food

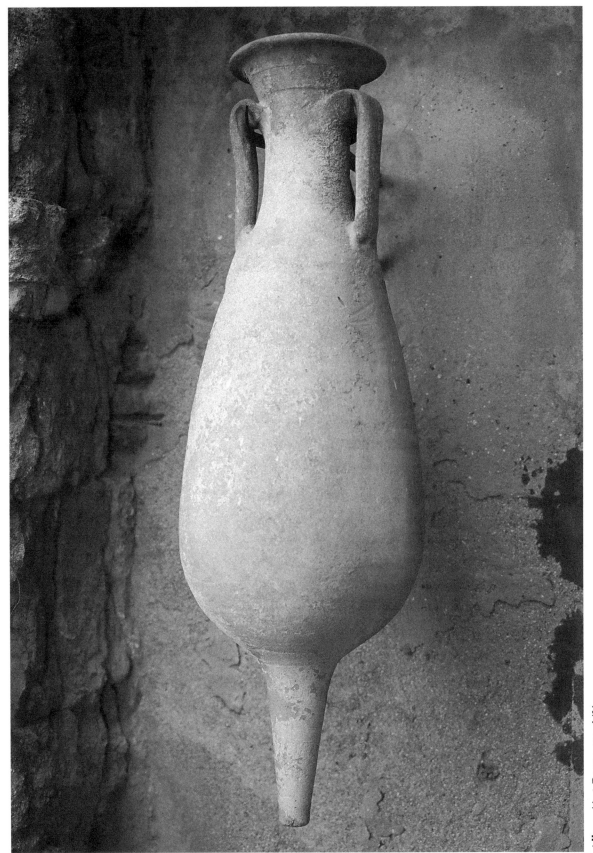

Amphora

Málaga, Spain
1 BCE through Second Century CE

INTRODUCTION

The amphora is almost immediately recognizable as a Greco-Roman pot. It was the quintessential packaging for some of the ancient Mediterranean's most important trade goods, among them wine, olive oil, and *garum,* a fish sauce. It is little wonder that amphorae appear in most movies, books, and cartoons that feature any reference to Greece and Rome. This versatile container took a variety of forms and in many ways served not only as packaging but also as advertising—even the shape could suggest its contents, though pictures painted on many amphorae were a surer guide. Derived from early Levantine vessels, the amphora became one of the most widely used trading containers for the better part of 12 centuries.

DESCRIPTION

The amphora shown here is from Málaga, Spain, and appears to conform to the features of the amphora designated as Dressel 8 by Heinrich Dressel, a German archaeologist who provided one of the classification systems still used today to identify various amphorae. These amphorae were in use from the late first century BCE until the second century CE. They are typified by a cylindrical neck, a somewhat radish-shaped body, a rounded spike on the bottom, and a bell-shaped mouth. While similar to many other models of amphorae in the Roman world, the Dressel 8 hails from the Baetican coast, that is, present-day Andalusia, where the provinces of Málaga, Cádiz, and Huelva in Spain are today. The production center for this style of amphorae was most likely Villanueva del Rosario, a town about 25 miles north of the port city of Málaga. These amphorae are found not only in the former West European sections of the Roman Empire but also in North Africa and the eastern Mediterranean.

Many of the Dressel 8 amphorae have *tituli picti* (sing. *titulus pictus*), literally "label pictures," essentially painted inscriptions that often tell us about a vessel's contents. These can also help identify where the amphorae came from, that is, who bought them to haul their products and where these

merchants were. Most of the Dressel 8 amphorae suggest fish sauce as the contents. Known by several names, including *garum* and *liquamen,* fish sauce was one of the major condiments in Roman cooking and was a lucrative business. Several such labels identify the particular sauce as made from "the best mackerel (*scombri flos*)." In addition to *tituli picti,* stamps were also applied in a number of places, typically along the rim, neck, handle, or spike of the amphora. Like the shape of the vessels they mark, these stamps can reveal a lot about Roman trade. Their exact function has yet to be determined, though there are some good theories. They may be simply maker's marks or a way of advertising a workshop's wares. They may have been used to help assess custom or shipping dues. Another theory holds that they were a quality control stamp, a way to say that a particular amphora made the cut. More than likely they may have served more than one purpose. What they do tell us, however, apart from the name of the maker, shop owner, or foreman—all three have been found—is how goods from one area of the empire got to another area. For example, many Baetican amphorae have been uncovered in what is now Germany and, what is more, with stamps that provide names from Spanish workshops. Moreover, it seems that many of the *tituli picti* in these German finds were fiscal control marks, which suggests that much of the oil in the Baetican vessels was part of the official supply for the military. From all of this we know that trade extended even to the borders of the empire and that it was carried out not only by ship, the usual method of long-distance trade, but by land as well.

The amphora, literally a container "carried on both sides" (from Greek *amphoreus,* a contraction of *amphiphoreus,* from *amphi-*, meaning "on both sides," and *phoreus,* meaning "bearer"), is one of the iconic images of the Greco-Roman world. In origin these jars derive from Canaanite versions popular in what is now Syria during the 15th century BCE. They were used by many peoples who found that they were a good size for shipping liquids. We first see them appear during the Late Geometric period (ca. 750–700 BCE) in Greece, where they were commonly used for transport not only from Attic sites but also from Asia Minor. Amphorae feature largely as well in Greek colonial and commercial ventures of the eighth century BCE and are often found side by side other more local ceramics.

Italic peoples were making amphorae in the Archaic period, but their heyday came with Roman expansion out of Italy in the late Roman Republic. This was a natural outgrowth of not only an expanding empire but also the economic opportunities that came with opening up new markets. A key development in this process was Rome's concern with feeding its citizens, a need felt by other large cities as well. In order to ensure enough supply, Rome looked to its provinces not only for taxes but also for food. We see this very concern reflected in the production and distribution of Roman amphorae, especially in the first two centuries CE when Roman production, already

on the rise in the late first century BCE, took off. Of note, much of this business was handled by both the Roman government and private companies, especially as regards shipping. For the first two centuries of the Common Era, it was the Baetican coast of Spain that dominated the market. The impressive man-made mountain of amphorae shards in Rome, the Monte Testaccio, a carefully planned waste site made of used olive oil amphorae, contains some 25 million to 50 million amphorae. Of these, an estimated 80–85 percent were made in Baetica, which in addition to amphora production also boasted a booming olive industry. Though Spain was eclipsed by North African centers of ceramic production in the third century, it continued to produce amphorae, as did most regions throughout the Roman period.

SIGNIFICANCE

From a single amphora one can learn a great deal about Roman manufacture, trade, and government regulation. The study of Roman pottery is vast and incorporates archaeology, paleography, and sophisticated scientific analysis of clay. Examining the chemical composition of a vessel works particularly well with coarser ceramics such as amphorae, because these, since they were storage jars and not fine dining ware, did not have their mineral inclusions removed to make them super smooth. Knowing the mineral content can help us track the origin of a container and assess how wide the distribution of one area's ceramics was. Since ceramics often survive in the ground, we have learned a lot about Roman trade from this sort of analysis, not only the composition of the amphorae but also, when lucky, their contents as well.

Amphorae were one of the most specialized forms of Roman pottery—they had to meet several requirements. First, they needed to be of a size both to hold enough of a product and still be manageable to unload. Second, they needed to be relatively sturdy so that they did not break in transit, something that happened more often than not if sites such as Monte Testaccio are any indicator. Third, they needed to be easy to store aboard ship. The Dressel 8 amphora pictured here is tall and relatively thin and has a protruding spike. One could not easily set such a container against a wall, but with that spike one might arrange many of them in stacks, close together, with less chance of tipping. In this way a shipper could more securely transport a lot of these amphorae in his ship or wagon. In other words, these amphorae were designed to be the most efficient way to convey a product successfully. That they were easy to handle is clear from the fact that many of these vessels were left out in Pompeii as ersatz urinals—fullers would collect them and use the urine in cleaning clothes (the alkali in it helped separate dirt from the cloth).

Ultimately, what amphorae demonstrate most vividly is the extent and importance of trade for the Roman economy. Surviving pottery and ceramic shards are only some of our clues, of course, in trying to understand something as complex as a sophisticated state's economic system, but they

nonetheless indicate significant information for key trade goods. Rome's expansion into Europe, Africa, and Southwest Asia extended business opportunities for all concerned. Amphorae in Britain contained *garum,* wine, and oil, as was the case for those found in Rome, Syria, and other corners of the empire. Along with grain, these three items—all transportable via amphorae—were the four top products shipped from one end of the Roman world to another and beyond. One testimony to the importance of this trading network is the number of shipwrecks found in the Mediterranean. The number discovered that hail from the years 100 BCE to 300 CE is the largest group, more than those before or after until the Renaissance. For this level of trade to succeed, not only did shipping need to be highly organized, but there also had to be a relatively stable and peaceful environment (war and piracy are threats to trade even today), well-regulated ports, and a money economy. Even on the local level, trade thrived. Though Roman aristocrats professed disgust for and distanced themselves from trade and those who conducted it, there is good evidence to suggest that many aristocrats participated through intermediaries. This makes sense, as not only was there money to be made in trade, profit that would supplement the traditional income of the more respectable occupation of agriculture, but many elites had homes in cities as well as country villas. The bustle of commerce and the transport of goods even from one residence to another within one of these families might employ hundreds of people.

While amphorae are of interest on their own, so too are their contents. Much of what we know of their contents comes from the *tituli picti,* but chemical analysis of residues found within some excavated samples has likewise informed our picture of how amphorae were used. While any liquid might be and probably was carried in amphorae, for purposes of trade the ruling triad was olive oil, wine, and *garum.* Olive oil was versatile and was used in many areas of daily life, from cooking to athletics (see the entry **Strigil**) and from lighting to perfume. Another product transported via amphorae was wine, one of the staples of the Roman diet. Normally it was mixed with water, as unmixed wine was considered boorish and barbarian. The wine industry served not only those concerned with putting something decent to drink on the table but also connoisseurs and medical men alike. For wine enthusiasts, few vintners could compare with those who produced Falernian or Caecuban wine. When wine was used as a medicine, taste was less important than what a particular wine was reputed to remedy—Pliny the Elder, among other writers, devotes space to medicinal wines. Another key product was *garum,* a fish sauce used in cooking or as a condiment. *Garum* was extremely popular and was traded all over the empire. There are some who believe that Worcestershire sauce, the recipe for which the English picked up in India, may be a holdover from the *garum* once exported to India.

FURTHER INFORMATION

Blázquez, J. M. "The Latest Work on the Export of Baetican Olive Oil to Rome and the Army." *Greece & Rome,* 2nd series, 39(2) (October 1992): 173–188.

Brothwell, Don, and Patricia Brothwell. *Food in Antiquity.* Baltimore: Johns Hopkins University Press, 1997.

Callender, M. H. *Roman Amphorae.* New York: Oxford University Press, 1965.

Gold, B. K., and J. E. Donahue, eds. *Roman Dining: A Special Issue of the American Journal of Philology.* Baltimore: Johns Hopkins University Press, 2005.

Hornblower, Simon, et al., eds. *The Oxford Classical Dictionary.* 4th ed. Oxford: Oxford University Press, 2012.

Keay, Simon J. *The Archaeology of Early Roman Baetica.* Portsmouth, RI: Journal of Roman Archaeology, 1998.

Peacock, D. P. S., and D. F. Williams. *Amphorae and the Roman Economy: An Introductory Guide.* New York: Longman, 1986.

Shelton, Jo-Ann. *As the Romans Did.* New York: Oxford University Press, 1988.

Spence, Karen M. "Reconstructing the *Garum* Trade from Roman Provincial Hispania Baetica to Britannia: Transport Amphorae Bear Physical Testimony." Academia.edu, http://www.academia.edu/1454627/ Reconstructing_the_Garum_Trade_From_Roman_Provincial_Hispania_ Baetica_to_Britannia_Transport_Amphorae_Bear_Physical_Testimony_ by_Karen_M._Spence.

Wilkins, John, et al., eds. *Food in Antiquity.* Exeter, UK: University of Exeter Press, 1995.

Websites

"Archaeology in Rome: Monte Testaccio." ArcheoSpain, http://www .archaeospain.com/testaccio/testaccio1.htm.

"Roman Amphorae, a Digital Resource." Archaeology Data Service, http:// archaeologydataservice.ac.uk/archives/view/amphora_ahrb_2005/index. cfm.

"Wine and Rome." Encyclopaedia Romana, http://penelope.uchicago .edu/~grout/encyclopaedia_romana/wine/wine.html.

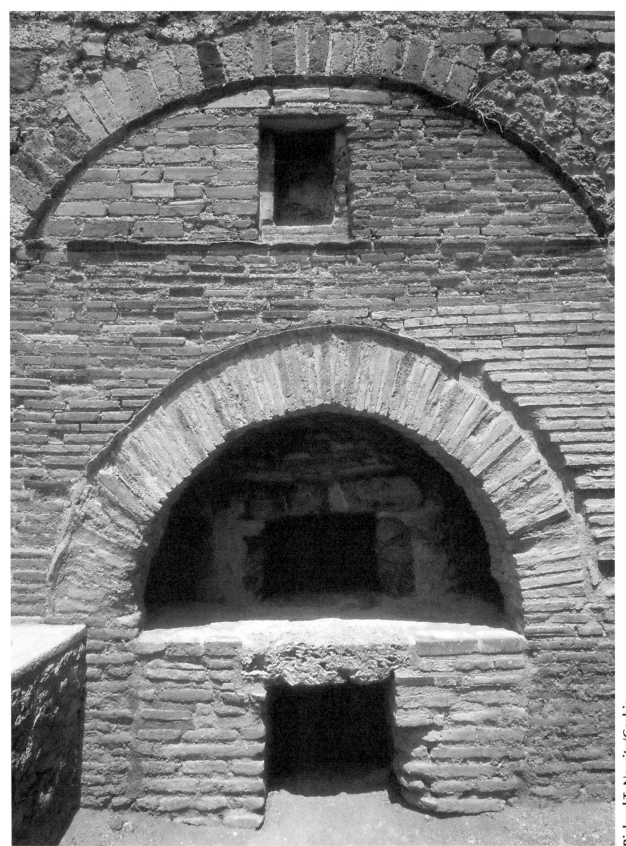

Bread Oven

Pompeii, Italy
First Century CE

INTRODUCTION

Aulus Cornelius Celsus (ca. first century CE), a Roman encyclopedist, once wrote "*plus alimenti est in pane quam in ullo alio*" ("there is more nourishment in bread than in anything else"). Bread for the Romans, like so many ancient peoples, was a staple and one of the main sources of nutrition. Most people obtained their bread from communal bakeries, though those with large households might have had ovens of sufficient size to produce the requisite heat for baking. Bakeries and mills were one and the same until the introduction of water mills in the first century BCE. Archaeologists have discovered a number of bakeries with associated mills, but those in Pompeii and Ostia have perhaps provided the best insight into these vital industries.

DESCRIPTION

The oven seen here is from Pompeii, section VI.6.17, and was buried by the ash from the eruption of Mt. Vesuvius in 79 CE. The oven was large, almost 12.5 feet in height (3.8 meters), and was thus commercial. To give a sense of the capacity of these ovens, excavators found 81 loaves of bread within an oven in the Bakery of Modestus, another bakery in the city. Constructed of brick, these ovens were similar to modern pizza ovens; the cupola, the main chamber, sat on a wide base with a site for fuel, usually wood, and smoke and heat escaped via a chimney. There was also an additional space under the door for storing fuel. Some door frames on Pompeian ovens were made of volcanic rock, which being more heat resistant probably held the iron doors better and absorbed some of the heat.

The bakery in which this oven sits was small and connected to a residence. It thus served, as so many Roman shops did, as both house and place of business. It contained three mills for grinding grain as well as a storeroom that may have been for storing grain or to house the animals that turned the mills. With 33 known bakeries, Pompeii was able to supply its citizenry with bread anywhere in the city. There were larger bakeries than this one in Pompeii, but both large and small bakeries performed in much

the same way. They ground the grain on-site, made bread, and sold it all in one spot.

The technology involved in milling reveals the great sophistication of Roman engineering. As early as the Bronze Age, the Romans were using simple saddle querns. These mills had a stone with a hollowed cup-shaped depression cut into it; the miller used a second stone and rolled it by hand back and forth over the grain to make flour. Even with the advent of more complicated mills and animals or water to do the turning, hand-powered mills remained common. One of the key changes was the inversion of the grinding stone. The millstones outside this oven, for example, were typical of those invented during the Hellenistic period. Starting around the first century BCE, they can be found in bakeries all over the Roman world. Those in Pompeii were made of tough volcanic rock, giving them durability, and were tall (about 4.9 to 5.6 feet, or 1.5 to 1.7 meters) and narrow, allowing for several of them to operate within a small area. The bottom stone, or *meta,* was conical, and the upper stone, or *catillus,* was hollowed out to fit over the cone. Wooden handles were inserted into the top stone and rotated either by people or mules. The ground grain was collected below in a specially made basin or by sweeping it into another container. The distance between *meta* and *catillus* was precise—too large and the grain would pass through unground, too small and the grain might clog the machine. Evidence from Ostia, the port city of Rome that boasted industrial bakeries, suggests that specialized craftsmen maintained these stones. At one bakery, one such man's tools have been discovered.

Many of the bakeries had either basins or terra-cotta pots for water. Bakeries needed water not only to make bread but also to cool the peel (a flat shovel used for placing and removing bread in large ovens), coat the bread to give it a harder crust, moisten the grain for grinding, and provide drinking water for workers and draft animals. While many bakers no doubt kneaded dough by hand, some shops had machines to do the kneading. These were also made of volcanic rock, the main portion of which consisted of a bowl in which both fixed and rotating blades mixed the dough. Animals might turn these as well. Not only are there reliefs showing donkeys or mules working millstones and kneading machines, but at some bakeries in Ostia the floors were worn by their hooves.

It was also in the first century CE that the power of water was harnessed to drive mills. While documentary evidence is scant for this key innovation, allusions in Lucretius and Vitruvius suggest that waterwheels were used for pumps or to move water from one area to another. Ostia again serves as an example. Though Ostia had factory-sized bakeries and many waterwheels, the latter only served to bring water to the baths. The earliest mill with a waterwheel was discovered in Chaplix, Switzerland, and dates to the mid-first century CE, which indicates how quickly this technology spread across

Definitions

Gracchi

Tiberius and his younger brother, Gaius, were the sons of an old noble family but were Popularists. Noticing that Rome's manpower reserves were declining when they needed it most—to enter the legions, one had to meet certain property qualifications at the time—Tiberius suggested the radical idea of giving land owned by the state to people for farms. Greedy senators, however, who made a pile from leasing out that land, opposed him. As tribune Tiberius was sacrosanct, but despite this he and several hundred supporters were killed in riots during his reelection (133 BCE). This introduced violence into Roman politics, but it also split the nobility into the Optimates, those who supported the Senate, and the Populares, those who turned to the popular assemblies for help.

Publius Clodius Pulcher

Pulcher (b. ca. 92 BCE) was the youngest son of Appius Claudius and an active participant in politics. Pulcher was implicated in several controversies, most famously the Bona Dea Scandal where he dressed as a woman to meet Caesar's wife, Pompeia. Pulcher managed to be "adopted" into the plebeian order so that he might become tribune in 58 BCE. In the course of his checkered career, he made a number of enemies and was murdered by a rival in 52 BCE.

the empire. In many cases, builders took advantage of natural features. The well-known mill on the Janiculum Hill in Rome was built so that the slope allowed water to turn the wheel continuously.

SIGNIFICANCE

The importance of bakeries rests not only in the high degree of engineering employed to run and maintain them but also in the fact that the Romans were able to support a large urban population. Even a modest commercial bakery like the one in Pompeii district VI.6.17 might boast an impressive oven, a series of mills, and a production capacity by some estimates able to supply 90 people with grain or bread. It is not easy to estimate the size of ancient cities, but Pompeii was by no means small. To mass-produce food argues for a great degree of organization and specialization and a money economy.

However much grain bakeries might produce, Rome faced an increasingly difficult challenge in feeding its citizens. By the time of the Gracchi (second century BCE), for example, when Rome may have had a quarter million people, it was impossible to live off of locally grown produce. There simply were too many people, and the land could not support them. For much of its early history, Rome had relied on local farmers and agricultural

merchants for its grain supply, but fear of famine and occasional shortages led to the state taking a hand in securing grain. So important did this become that citizens competing for magistracies would try to attract votes by promising extra shipments from allies or subject states. The Gracchi brothers, Tiberius and Gaius, established a monthly allotment of grain to citizens at a fixed price. Later, under the tribuneship of Publius Coldius Pulcher, payment of this allotment was taken on by the state (58 BCE). During the imperial period, the public grain supply, or *annona,* continued, though Augustus set limits on the number of people who might receive distributions. With the rich harvests of Egypt, not only were the state granaries full, but private investors and merchants made fortunes as well, especially as even with the dole most everyone still had to buy additional grain to feed their families. For this reason, it seems that a key aspect of the grain dole was symbolic. While it helped feed and keep the populace happy, it also showed the beneficence first of magistrates and later of emperors.

Much of Rome's population lived in *insulae,* or high-rise apartment buildings, which were comparatively cramped and always at risk of fire. Most were built out of wood and stucco, the bottom floor being open for shops and the upper floors used for residents. Risk of fire was high, and it seems unlikely that most people took their grain home to bake it; more likely they took it to the neighborhood baker in order to have bread made. There is evidence, however, that what people received was actually the finished product from the public supply. This accords with the concern over fire and a lack of ovens but also falls in line with evidence of imperial contracts. At first these may have been made with individual bakers, but later the state contracted with guilds. Two such guilds are known, one in Rome and one in Ostia, but other major cities probably had them too. The first, the Collegium Pistorum (Corporation of Bakers), appeared in Rome ca. 168 BCE. Membership was hereditary and for life. With government contracts and the protection of fellow tradesmen, all keen to protect their own stakes in the business, many bakers became quite wealthy. Perhaps the most famous was Marcus Vergilius Eurysaces, a baker who produced bread for the dole during the late Roman Republic. His tomb, just outside the Aurelian Wall in Rome, was large and depicted scenes of the baker's life. The inscription, over which many scholars have puzzled for years, reads "*est hoc monimentum Marcei Vergilei Eurysacis pistoris, redemptoris apparet*" ("here is the monument of Marcus Vergilius Eurysaces, Baker; it is clear he was a contractor"). It may be that Eurysaces was humorously alluding to how lucrative government contracts were—his tomb was certainly not modest and must have cost a fortune.

In the later Roman Empire, changes were made to the annona system, but it continued down into the fourth century. Olive oil was added to the ration by Emperors Septimius Severus and Aurelian, and the latter even added

pork and wine. When the capital shifted to Constantinople, the onus fell on local elites and the church to continue the tradition, though the public grain dole also survived in the Byzantine Empire.

FURTHER INFORMATION

Balsdon, J. P. V. D. *Life and Leisure in Ancient Rome.* London: Phoenix Press, 2004.

Brothwell, Don, and Patricia Brothwell. *Food in Antiquity.* Baltimore: Johns Hopkins University Press, 1997.

Carcopino, Jerome. *Daily Life in Ancient Rome.* New Haven, CT: Yale University Press, 1968.

Gagarin, Michael, ed. *The Oxford Encyclopedia of Ancient Greece and Rome.* Oxford: Oxford University Press, 2010.

Hornblower, Simon, et al., eds. *The Oxford Classical Dictionary.* 4th ed. Oxford: Oxford University Press, 2012.

Landels, J. G. *Engineering in the Ancient World.* Revised ed. Berkeley: University of California Press, 2000.

Miller, James Innes. *The Spice Trade of the Roman Empire.* Oxford, UK: Clarendon, 1969.

Moritz, L. A. *Grain-Mills and Flour in Classical Antiquity.* Oxford, UK: Clarendon, 1958.

D'Orta, Piemme, and Enrika d'Orta. *Together in Pompeii.* Pompeii: Falanga Edizioni Pompeiane, 1981.

Shelton, Jo-Ann. *As the Romans Did.* New York: Oxford University Press, 1988.

Sirks, A. B. J. *Food for Rome.* Amsterdam: J. C. Gieben, 1991.

Wilkins, John, et al., eds. *Food in Antiquity.* Exeter, UK: University of Exeter Press, 1995.

Websites

Bakker, Jan Theo. "The Mills-Bakeries of Ostia and the Distributions of Free Grain." Ostia, Harbour City of Ancient Rome, http://www.ostia-antica.org/dict/topics/bakeries/bakart.htm.

"VI.6.17: Pompeii, Bakery and Dwelling House." Pompeii in Pictures, http://www.pompeiiinpictures.com/pompeiiinpictures/R6/6%2006%2017.htm.

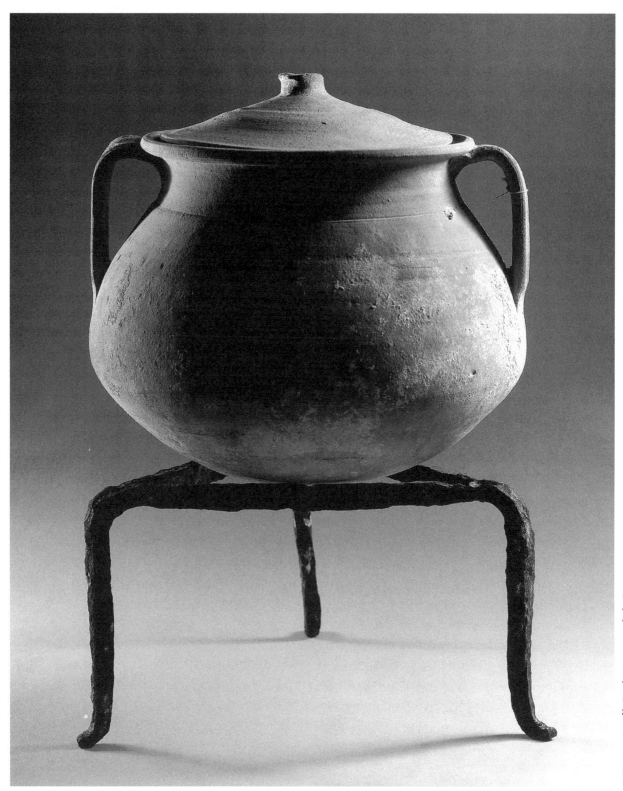

Cooking Pot

Pompeii, Italy
First Century CE

INTRODUCTION

Much about ancient Roman cooking would look familiar to modern eyes. Apart from cooking most meals over fire or coals and having a lack of decent refrigeration, many techniques and most of the cookware, utensils, and even some meals would look normal in today's kitchen. With only one extant cookbook, that of Apicius (full as it is of fantastical dishes), what we know of ancient cooking must be gleaned from references to meals in surviving sources and the evidence of archaeology. Both have helped inform what we know about Roman food preparation, though there is much yet to learn.

DESCRIPTION

The cooking pot pictured here, discovered in Pompeii, is terra-cotta and is representative of small household kitchenware; it is sturdy and built for daily use. The accompanying tripod kept the pot, which might crack if too close to the heat source, above the charcoal or fire over which most meals were cooked. This pot is most likely a *cacabus* (from Greek *kakkabos*) or *olla* (from the Latin term "pot" or "jar"), the most common form of Roman cookware and one of the most ancient forms. The mouth of the olla tended to be wide, making it easier to stir typical meals such as porridge and stews.

Most Romans cooked and ate at home. In cities, however, where many people lived in close quarters and fire was an ever-present danger, cooking fires had to be small. Using charcoal and a tripod or brazier was safer and offered the cook a number of options. Some simple meals, such as porridges, pulses, and stews, might simmer in the pot with minimal need for a large fire. Other dishes were cooked in a *clibanus,* or roasting pot, and still others might be pan fried. Bread was a staple, but few homes baked their own bread—most bread was purchased from private bakeries or obtained from the dole through bakeries with government contracts.

In terms of what the Romans ate, the typical diet was similar to the Mediterranean diet of today, that is, one consisting of vegetables, fruit, fish,

olive oil, whole grains, and some meat. Cereals (especially wheat and barley), legumes, olives (whole and as oil), and wine were all staples. Wheat and barley might be prepared in porridges or as bread. Quality varied and certainly the better bread was expensive, but by today's standards both high-quality and standard bread would be considered rather coarse. Pulses were common too—these were simple dishes made from beans, peas, lentils, or chickpeas. All have been discovered in homes within Pompeii, but they find mention in the sources too. Martial, for example, has a number of epigrams about foodstuffs. In one he remarks, "If the pale bean boils for you in the red earthenware pot, you may often decline the suppers of rich patrons." Good as beans might be, however, Martial clearly did not favor them over other pulses: "Receive these Egyptian lentils, a gift from Pelusium; if they are not so good as barley, they are better than beans." Lentils and beans were even baked into bread; this added some much-needed protein to the carbohydrates that Romans obtained from their bread.

Meat was not a common component of most meals. It was expensive, and the population at large most likely only had a chance to enjoy it during public sacrifices and festivals. Those in the country who kept livestock may have enjoyed meat more often, but descriptions of poor farmers' meals, literary conventions aside, tend to suggest that meat was rare for them too. Fish are a good source of protein, but because the Mediterranean Sea was less favorable to large populations of fish, at least in comparison to the oceans, fish tended to supplement rather than serve as a core element in the diet. Freshwater fish were sold in some areas, and people who lived near rivers and lakes might avail themselves of this option too. Eggs, poultry, pork, and some game, such as quail or pheasant, made it into many Roman dishes. Garden vegetables, especially cabbage, leeks, onions, turnips, radishes, and lettuce, were on the tables of most everyone, as was bread. Fruits, such as apples, figs, grapes, and pears, were likewise common fare. The amount, quality, and variety of food that a Roman obtained was directly related to his economic status—the rich ate far better than the poor and enjoyed some foods, such as meat, far more often. By some accounts, the legions perhaps had the most varied diet. Depending on where a soldier was posted in the empire, some types of food, wine, or spices might be more available. It is conceivable too that returning soldiers did much to introduce new flavors and cuisine.

Wine was one of the most common drinks. Usually it was mixed with water, as it was considered barbaric to drink wine straight. Even children drank wine. The Romans considered certain drinks such as milk and beer (which were both popular with the Germanic peoples) fit only for barbarians. Butter fell into this category as well; olive and sesame oil served instead. The most popular way to sweeten food was to add honey. Sugar, though known in the ancient world, was rare and extremely expensive.

Primary Source

OVID, *METAMORPHOSES,* BOOK 8:611–678, Lelex Tells of Philemon and Baucis

Near by those trees are stagnant pools and fens, where coots and cormorants delight to haunt; but it was not so always.

Long ago 'twas visited by mighty Jupiter, together with his nimble-witted son, who first had laid aside his rod and Wings. As weary travelers over all the land they wandered, begging for their food and bed; and of a thousand houses, all the doors were bolted and no word of kindness given. . . . At last, by chance, they stopped at a small house, whose humble roof was thatched with reeds and straw;—and here a kind old couple greeted them. The good dame, Baucis, seemed about the age of old Philemon, her devoted man; they had been married in their early youth, in that same cottage and had lived in it, and grown together to a good old age; contented with their lot because they knew their poverty, and felt no shame of it. . . .

Now when the two Gods, Jove and Mercury, had reached this cottage, and with bending necks had entered the low door, the old man bade them rest their wearied limbs, and set a bench, on which his good wife, Baucis, threw a cloth; and then with kindly bustle she stirred up the glowing embers on the hearth, and then laid tinder, leaves and bark; and bending down breathed on them with her ancient breath until they kindled into flame. . . . And all this done, she stripped some cabbage leaves, which her good husband gathered for the meal. Then with a two-pronged fork the man let down a rusty side of bacon from aloft, and cut a little portion from the chine; which had been cherished long. He softened it in boiling water. All the while they tried with cheerful conversation to beguile, so none might notice a brief loss of time. Swung on a peg they had a beechwood trough, which quickly with warm water filled, was used for comfortable washing. And they fixed, upon a willow couch, a cushion soft of springy sedge, on which they neatly spread a well-worn cloth preserved so many years; 'Twas only used on rare and festive days; and even it was coarse and very old. . . .

The good old dame, whose skirts were tucked up, moving carefully, for so she tottered with her many years, fetched a clean table for the ready meal—but one leg of the table was too short, and so she wedged it with a potsherd. . . . And here is set the double-tinted fruit of chaste Minerva, and the tasty dish of corner, autumn-picked and pickled; these were served for relish; and the endive-green, and radishes surrounding a large pot of curdled milk; and eggs not overdone but gently turned in glowing embers—all served up in earthen dishes. Then sweet wine served up in clay, so costly! all embossed, and cups of beechwood smoothed with yellow wax. So now they had short respite, till the fire might yield the heated course. Again they served new wine, but mellow; and a second course: sweet nuts, dried figs and wrinkled dates and plums, and apples fragrant, in wide baskets heaped; and, in a wreath of grapes from purple vines, concealed almost, a glistening honey-comb; and all these orchard dainties were enhanced by willing service and congenial smiles.

[Ovid, *Metamorphoses,* translated by Brookes More (1922), http://www.theoi.com/Text/OvidMetamorphoses8.html.]

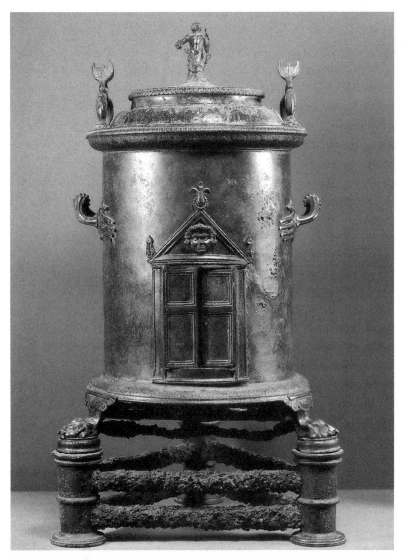

Food warmer, ca. first century CE, from the House of the Four Styles, Pompeii, Italy. (DEA/L. Pedicini/De Agostini/Getty Images)

Several authors, among them Pliny the Elder and Dioscorides, mention that it came from India but also suggest that it was used more in medicine than in cooking.

Spices were key ingredients in most dishes. They were popular and indicate widespread trade. By the time of Emperor Augustus, for example, there was direct trade between Egypt and India that allowed many new products to enter the empire. India provided cardamom, cinnamon, pepper, and turmeric. From China, the Romans obtained cassia, cloves, ginger, and nutmeg. Europe itself provided herbs such as basil, rosemary, sage, and thyme. Moreover, spices were versatile: they were used not only in cooking but also in medicine and perfumes and to flavor wine. More than 100 spices have been identified in ancient sources, though some were more popular than others. Many of the recipes of Apicius, for instance, list pepper, mint, cumin, and salt. If surviving recipes are accurate, the Romans preferred their food to be heavily flavored by spices and sauces. The latter, in fact, were customary and one of the more popular sauces was *garum,* a fish sauce. Studies of amphorae that once held this condiment indicate that it was one of the most favored and widely traded goods.

Preserving food was, as one would imagine in a time without refrigeration or many preservatives, a vital aspect of cooking. Salt was one method and was easily obtainable around the Mediterranean. Apicius, in Book 1 of his *De Re Coquinaria* (On Cooking), discusses 20 different ways to preserve various foods, from honey in danger of going bad to meat. One reason spices may have been so important was that they helped mask the taste of food that was less than fresh. For short-term preservation, say during a meal, the Romans used food warmers. These helped keep pests away from the dish but also kept the meal warm, an important ingredient in hosting a

successful dinner party. The food warmer depicted here, discovered in the House of the Four Styles in Pompeii, is of bronze and dates to the first century CE. The elaborate decoration and fine execution mark this as belonging to a more well-to-do family. The Gorgon's head above the little door, the handles in the shape of grasping hands, and the decorated lid display the skill and artistry of the maker as well as the resources available to the owner. Upper-class Roman meals could be lengthy, and it was important to keep dishes warm. While more modest families might use terra-cotta or less fancy bronze warmers, those with the means could keep food waiting in style. Most Romans, however, probably did not have the luxury of long meals.

SIGNIFICANCE

All peoples eat and most people cook, but the ways in which Romans did so, the ingredients they used, and the importance they gave to cooking and eating provide deep glimpses into the worldview of a society. At its simplest, we might learn about pottery manufacture and distribution. This style of cooking pot was to be found all over the Roman world and was in use for most of Roman history. Even today there are similar pots in Italian homes, and the pots are often full of similar dishes. The degree of quality in cookware and in diet tells us a lot about social stratification, economic differences, and how great an impact those differences could make in the quality of life. Compare, for example, the story Ovid tells of the impoverished old couple, Baucis and Philemon, with the lavish and overblown meal offered by Trimalchio in Petronius's *Satyricon* (see the entry **Dining Couch**).

The variety of food available to the Romans demonstrates the size of the empire and the ease with which trade was carried out. Such a thing was only possible in a relatively peaceful state. The movement of people, goods, ideas, cooking techniques, and ingredients meant that foreign and local cuisine intermixed. It is hard to assess to what degree that was true, but we see glimpses of it in works such as the *The Deipnosophists* (Banquet of the Learned) by Athenaeus (ca. 200 CE). This work covers a lot of literary ground, but it also has references to food and spices, many from all over and beyond the Roman world.

For the Romans, rich or poor, there were also rules of propriety to be observed. Ovid is at pains to demonstrate what great hosts Baucis and Philemon are—here they entertain gods and offer them the best of everything they have (regardless of how poor it might be), and they do so because hospitality was important, because it might bring dishonor to themselves and even anger the gods. Providing food was central to being a good host. The conversation enjoyed before, during, and after a meal and the chance to meet new people, reunite with old friends, bond with family, or honor a guest were important to Romans of all walks of life.

FURTHER INFORMATION

Apicius. *The Roman Cookery Book: A Critical Translation of The Art of Cooking, for Use in the Study and the Kitchen.* Translated by Barbara Flower and Elisabeth Rosenbaum. Toronto: Harrap, 2012.

Balsdon, J. P. V. D. *Life and Leisure in Ancient Rome.* London: Phoenix Press, 2004.

Brothwell, Don, and Patricia Brothwell. *Food in Antiquity.* Baltimore: Johns Hopkins University Press, 1997.

Faas, Patrick. *Around the Roman Table: Food and Feasting in Ancient Rome.* New York: Palgrave Macmillan, 2003.

Gagarin, Michael, ed. *The Oxford Encyclopedia of Ancient Greece and Rome.* New York: Oxford University Press, 2010.

Hornblower, Simon, et al., eds. *The Oxford Classical Dictionary.* 4th ed. Oxford: Oxford University Press, 2012.

Martial. *Epigrams.* Transcribed by Roger Pearse. Tertullian.org, http://www.tertullian.org/fathers/martial_epigrams_book01.htm.

Miller, James Innes. *The Spice Trade of the Roman Empire.* Oxford, UK: Clarendon, 1969.

Sirks, A. B. J. *Food for Rome.* Amsterdam: J. C. Gieben, 1991.

Wilkins, John, et al., eds. *Food in Antiquity.* Exeter, UK: University of Exeter Press, 1995.

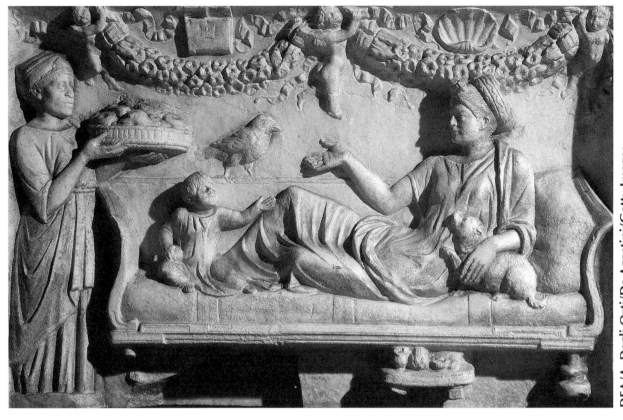

Dining Couch

Roman
Second Century CE

INTRODUCTION

While all Romans ate to sustain themselves during the day, food and dining then as now took on social aspects, be it just intimate time with family or elaborate gourmet banquets. Fine dining, in fact, was a pastime for well-to-do people, and descriptions of sumptuous meals, poems lamenting being passed over for an invitation, and mosaics and relief sculpture all provide us a glimpse inside the world of Roman haute cuisine. Popular images of Romans overindulging while the empire falls around them, as inaccurate as they are, do manage to highlight the importance of social banquets and commensality.

DESCRIPTION

The relief panel seen here hails from the second century CE and depicts a woman and child eating while a servant brings over a platter of food. The couch upon which the pair dines is typical of those used in the better-appointed Roman dining rooms. Much of what we know about dining comes from extant literature, and this colors our view of how the Romans ate. Most people did not have the leisure time to write or attend fine parties, so the details about meals, where and how people sat at tables, and even what they ate tends to reflect only what well-to-do people did. Even our picture of this can be exaggerated for literary effect. The truth is that most Romans used chairs, stools, or benches when at the table. Actual practice most likely varied, but there are a few general practices to which we can point. For example, earlier in Rome's history, women sat at their husband's feet but in time reclined just as men did. While it was not unheard of for children to recline at mealtime, as depicted on the relief sculpture here, some Romans believed that children and slaves should use a stool or chair.

In fine dining, host and guests reclined on couches. Reclining while one ate was considered refined as well as comfortable. In fact, the *triclinium,* or dining room, took its name from these couches, or *triclinia.* Dining rooms were typically twice as long as they were wide and affected how the room

was set. Placement around the table also reflected rank. Generally, three couches—assuming a small party—sat around three sides of a table, the fourth side (or one side if the table was round) being open for servants to bring dishes. The place of honor was the couch opposite the open side, the *lectus medius,* and even here the one sitting on the right side, in the *locus consularis,* occupied the top position. The next most favored couch, the *lectus summus,* was to the left of the *lectus medius.* The couch to the right, the *lectus imus,* was third in line. For larger parties—nine was normally considered a full dinner party—guests might sit on one large semicircular couch, a *stibadium.* This style of couch, sometimes referred to as a *lunar sigma* because of its crescent shape, seems to have usually accommodated an even number of guests, though some Romans considered an odd number of guests luckier. The Roman satirical novelist Petronius, in his *Satyricon,* describes guests as resting on their left elbows, their feet at the foot of the couch and thus able to converse easily. Much larger parties of guests would mean the addition of additional *triclinia* or *stibadia.* Wealthy Romans might have more than one dining room, though depending on the weather and season it was not uncommon to eat outside or in the garden. The average Roman, however, took his meals within his house and in the *insulae,* probably without the convenience of a separate dining room.

A number of authors provide us with an idea of how such formal meals typically progressed. First, invitations were either sent out or sought. Friends might be asked to join one for dinner after visiting the baths or via a formal invitation. Some Romans frequented public meeting places and the baths hoping to be invited. The poet Martial, for example, has a number of epigrams either bemoaning his own lack of invitation or laughing at others who lack one. If invited, it was important to look appropriate, and the fashionable Roman made sure to wear his *cenatoria* ("dining clothes"), lightweight in summer, heavier for winter. These were usually brightly colored no matter what season. Upon arriving at the house, the guests were announced and shown to their dining couch. Most dishes were eaten by hand—the fork had not yet been added to tableware—though each diner might also be given knives, spoons, toothpicks, or other utensils depending on what was served. The spoons shown here are of bronze and date from the first or second century CE. They are typical of Roman tableware. Of interest, many guests brought their own napkins, but they were usually provided one as well, more perhaps to protect the couch upon which they reclined than anything else. After the meal, guests sometimes used their own napkins to package up any leftover food.

The dishes at such dinners could be elaborate. Though perhaps exaggerated, Petronius's description of Trimalchio's banquet nonetheless gives a fair idea of the excesses and extremes that such fancy dinners could include. In Chapter 36 of *The Satyricon,* for example, the guests marvel at a tray, each corner boasting fish swimming in a spicy sauce, that contained stuffed

PETRONIUS, *SATYRICON,* CHAPTER 35

The applause was followed by a course which, by its oddity, drew every eye, but it did not come up to our expectations. There was a circular tray around which were displayed the signs of the zodiac, and upon each sign the caterer had placed the food best in keeping with it. Ram's vetches on Aries, a piece of beef on Taurus, kidneys and lamb's fry on Gemini, a crown on Cancer, the womb of an unfarrowed sow on Virgo, an African fig on Leo, on Libra a balance, one pan of which held a tart and the other a cake, a small seafish on Scorpio, a bull's eye on Sagittarius, a sea lobster on Capricornus, a goose on Aquarius and two mullets on Pisces. In the middle lay a piece of cut sod upon which rested a honeycomb with the grass arranged around it. An Egyptian slave passed bread around from a silver oven and in a most discordant voice twisted out a song in the manner of the mime in the musical farce called Laserpitium. Seeing that we were rather depressed at the prospect of busying ourselves with such vile fare, Trimalchio urged us to fall to: "Let us fall to, gentlemen, I beg of you, this is only the sauce!"

[Petronius Arbiter, *The Satyricon of Petronius Arbiter,* translated by W. C. Firebaugh (New York: Liverlight, 1922), http://www.gutenberg.org/files/5219/5219-h/5219-h.htm. The translation used here is really old but also appears in Petronius, *The Satyricon and the Apocolocyntosis of the Divine Claudius,* translated by J. P. Sullivan (London: Penguin, 1986).]

MARTIAL, *EPIGRAMS,* BOOK 2:11

You see, Rufus, how Selius wears a cloudy brow, how he paces up and down the colonnade late; how his heavy countenance silently bespeaks some melancholy thought; how his ugly nose almost touches the ground; how with his right hand he beats his breast and plucks his hair. Yet he is not lamenting the death of a friend or of a brother; each of his sons is living and I hope may live; his wife, too, is safe, and his chattels and his slaves; neither his tenant nor his steward has made default. His sorrow then what is the cause of it? He dines at home!

[Martial, *Epigrams,* Vol. 1, translated by D. R. Shackleton Bailey (1993), http://archive.org/stream/martialepigrams01martiala/martialepigrams01martiala_djvu.txt.]

birds and pork bellies in the midst of which was a hare dressed with wings as if it were Pegasus. Meals at dinner, however, varied with the event. Some dinners were divided into different stages, each of which, like Trimalchio's bash, might be accompanied by some theatrics. Entertainment was normal at such events, even if some of these activities seem odd today. Guests might read, watch dancers, hear music, or even write or dictate to a secretary. On the other hand, dinners could be simple, almost frugal. The poet Horace normally enjoyed a simple dinner—even if guests came to visit at supper time they received only what he himself was eating and without music or other entertainments.

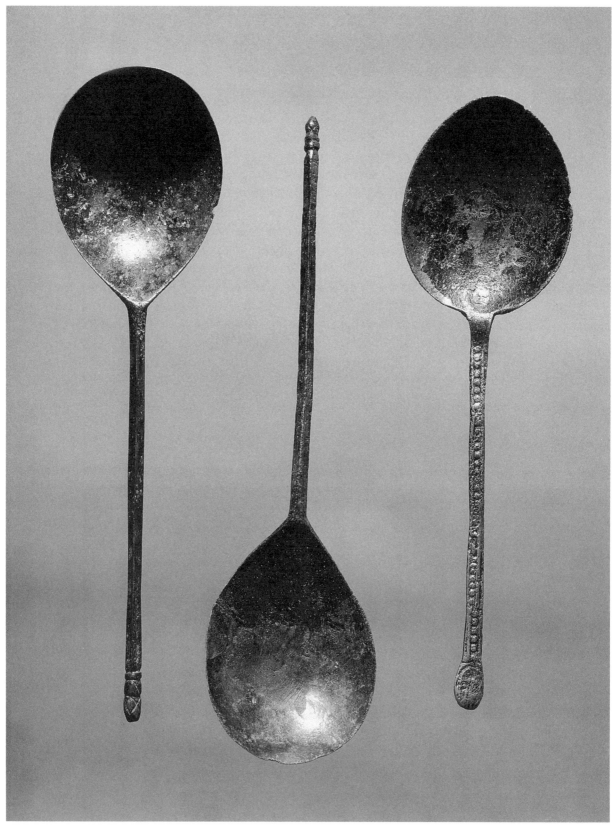

Bronze Spoons, ca. first or second century CE, now in the Museo Civico Riva del Garda, Italy. (Gianni Dagli Orti/The Art Archive at Art Resource, NY)

Apart from dinner, the most important meal in the Roman day, most meals were quick affairs, both breakfast and lunch being more like a snack break than a full meal. The number of meals a Roman enjoyed varied over time and by circumstance. Some gourmands were infamous for four meals a day, but three seems to have been standard. The first of the day was *jentaculum,* a light meal not unlike a Continental breakfast today. Early on *cena* was next, but in time it was replaced by *prandium,* or lunch, a noontime meal, and *cena* became dinner, normally taken in the evening. The Roman day was typically from dawn to dusk, so the hours of the day, divided into 12 *horae* ("hours"), varied with the seasons and by latitude. With the first two meals of the day being relatively light, it is likely that most Romans, especially if working, had snack breaks to help sustain them. Shops opened early and provided fare for those who did not bring their own food.

SIGNIFICANCE

Given the attention often dedicated to meals and dining in extant literature, it might be easy to assume that the Romans were obsessed with eating. Certainly there exist numerous references to gluttons, and if these sources are correct some men even lost fortunes in search of great meals. More than one observer, the historian Ammianus Marcellinus among them, was horrified by the indulgence he witnessed in some foodies. Even in legislation we see attempts to put limits on meal spending. One decree in 161 BCE set a ceiling on how much one might spend on dinner and how many guests one might invite. This law may have had less to do with concerns about overeating and more to do with the purposes to which such lavish meals might be put—Roman politics ran on personal connections and mutual obligation—but sumptuary laws were by no means rare either. Later consuls likewise enacted laws to fix maximum prices for expensive foods and wines and even on imported game. While there were infamous overeaters, such as Vitellius (the third of four emperors in 69 CE, the Year of the Four Emperors), most people either could not afford to overindulge or looked down on it. For every glutton there were hundreds who survived on little more than bread, so we must approach these sources with a degree of caution.

One important aspect of dining, especially aristocratic dining, is the ways in which it helped cement a sense of class identity and the ways in which it was political. The Romans who dined on dormice or imported fowl were members of a small percentage of society. The ability to entertain in high style set apart hosts and invited would-be friends and clients. Politically, this could help a patron win support in magisterial elections; dinner and conversation provided great avenues through which to sound out guests, curry their support, and make connections. Socially, it helped create and maintain the ties between the great families; it also gave newer noble families another way in which to establish their own position by being seen with others of their rank.

Outside of politics, the opportunity to gain the notice of a more powerful citizen might be beneficial. Within the small fraction of those who could afford to throw dinner parties, not all were aristocrats or those with political ambitions; some were freedmen who had made a pile in business. For these men the chance to attend a fine dinner might mean new opportunities for profit, but it also set them apart, much as it did nobles, from the average Roman. Such was the importance of these dinners that many men spent substantial time in their day trying to secure invitations to dinner. To be invited to the dinner of a well-to-do person might provide someone, such as a poet, with access to an audience and to those who were potential patrons. Martial, for example, wrote a number of poems that highlight the stress that social climbers and other ambitious souls felt at fishing for invitations, of the time spent hoping to be noticed and asked to dinner. Other hopefuls just hoped to eat better than they did at home. In all aspects of Roman life, it was this relationship between patrons and their clients that made things happen. Attending a patron's levy in the morning could mean work, a meal, help in court, or a loan; in return, the client would support his patron either by standing for him during election season or by performing some other service.

FURTHER INFORMATION

Ascough, Richard S. "Forms of Commensality in Greco-Roman Associations." *Classical World* 102(1) (Fall 2008): 33–45.

Balsdon, J. P. V. D. *Life and Leisure in Ancient Rome.* London: Phoenix Press, 2004.

Brothwell, Don and Patricia. *Food in Antiquity.* Baltimore: Johns Hopkins University Press, 1997.

Carcopino, Jerome. *Daily Life in Ancient Rome.* New Haven, CT: Yale University Press, 1968.

Cosh, Stephen R. "Seasonal Dining-Rooms in Romano-British Houses." *Britannia* 32 (2001): 219–242.

Gold, B. K., and J. E. Donahue, eds. *Roman Dining: A Special Issue of the American Journal of Philology.* Baltimore: Johns Hopkins University Press, 2005.

Hornblower, Simon, et al., eds. *The Oxford Classical Dictionary.* 4th ed. Oxford: Oxford University Press, 2012.

Shelton, Jo-Ann. *As the Romans Did.* New York: Oxford University Press, 1988.

Wilkins, John, et al., eds. *Food in Antiquity.* Exeter, UK: University of Exeter Press, 1995.

Entertainment

Dice and Tavern Game Board

Lyre

Mosaic of a Boxer

Theatrical Mask

Toys

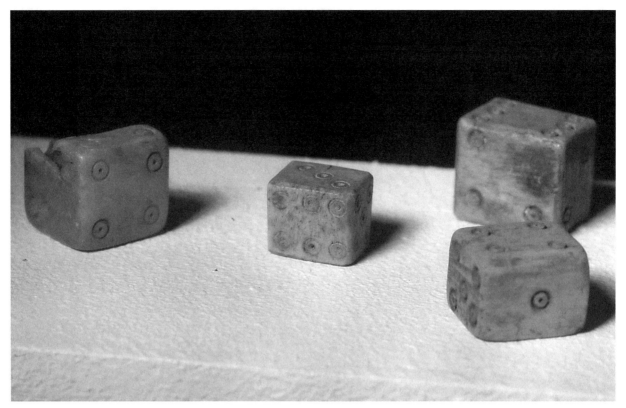

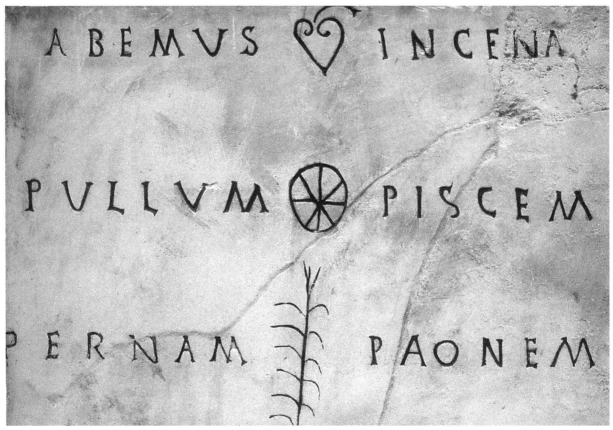

ABEMUS ♡ INCENA

PVLLVM ⊕ PISCEM

PERNAM PAONEM

Dice and Tavern Game Board

Gallo-Roman, France *Ostia, Italy*
First Century CE *Date Unknown*

INTRODUCTION

Leisure activities varied widely in Roman society. There were many public diversions: chariot races, gladiatorial events, and theater. Private pursuits were popular as well. The wealthier members of society had the time, money, and space to host private parties; most other people, especially men (who had more freedom to do as they pleased), congregated in public taverns and bars. Wine, song, and conversation were popular in both the homes of the rich and the neighborhood bars frequented by the average citizen, but common to both were a variety of games. Rich or poor, most Romans enjoyed *aleae* (sing. *alea*), or dice games and gambling. Even though gambling was technically illegal, Romans of all stations found ways to roll their dice and make bets, from back-alley contests to semidisguised game boards at inns. How people entertained themselves can tell us as much as how they worked, fought, or governed.

DESCRIPTION

The dice pictured here are made of bone and date to the first century CE. They were discovered within a sunken barge in the Rhone River in France. Dice are among some of the oldest known gaming pieces, some having been found in such places as Mohenjo-Daro in India (ca. 3000 BCE) and Egypt. A number of materials have been used in making dice, including bone (knucklebones of sheep and goats were popular), wood, ivory, bronze, and an array of stones. In addition to the number of dice found, there is the evidence of books on the topic as well as anecdotes about everyone from the man in the street to emperors throwing dice. Both Suetonius, a Roman biographer, and Emperor Claudius reportedly wrote works on dicing. Emperors, in fact, seem to have been as keen for gaming as their subjects. Augustus, for example, provided money for his guests to avert hard feelings and supposedly held back so as not to win too often.

The Romans used different types of dice, but the cubed dice pictured here, called *tesserae,* were common. *Tali,* or knucklebones, were another

oft-met type, though their shape gave these dice a distinctive character and use. Many games required a *fritillus,* or dice box, in which to shake the dice and an *abacus* or *alveus,* a board on which to play. One of the more popular games of the latter sort was *duodecim scripta* (meaning "12 lines" or "12 points"), with *scripta* here most likely referring to the markings on the dice. Game boards for this game are plentiful, especially in Rome, and consist of three rows of 12 letters, normally in rows and forming sentences, some of them rather clever. For example, the second image here, the tavern table, doubles as a *duodecim scripta* board and menu and reads "Shoppers: we have in the kitchen chicken, fish, pork and peacocks." Other signs are less functional but wittier, such as one that reads *sperne lucrem, versat mentes, insane cupido,* or, "Scorn wealth, insane greed disturbs minds." The fact that this was etched into a game board is ironic, but perhaps it was meant as a caution to gamblers.

Duodecim scripta boards also featured markings between the pairs of words, though their function is unknown. Each player used three *tesserae* dice and 15 counters for movement. One game board, discovered in Ostia, the port city of Rome, is arranged thus:

CCCCCC BBBBBB
AAAAAA AAAAAA
DDDDDD EEEEE

The theory is that this board describes the order for movement—the letters A, B, C, D, and E specifying the direction of play. The exact function of the markers and words and how the game was played remains a mystery, but from scattered references in the sources and extant boards it appears to have been similar to today's backgammon.

Tali in origin were bone, but the Romans manufactured artificial ones in the same shape, a testimony to their popularity. They had four sides—two wider, two narrower—and were rounded at both ends. Proper throws of these dice meant that they had to land on one of the four flat sides; those that landed on a rounded end then fell over were not considered good throws. Normally each player used four *tali.* As with most ancient games, there is much that is unknown about the exact nature of play and rules. What we do know is that *tali,* like *tesserae,* seem to have been used in many different dicing games. Each of the four sides had both a numerical value—1, 3, 4, and 6—as well as a name. The best throw one could win, a "Venus," was where each die came up on a different side. Conversely, if all four came up on the same side, this was the lowest throw, or *canis* ("dog"), sometimes referred to as "Four Vultures." Evidence from Greek and Roman contexts makes it clear that play varied considerably. While *canis* was a low throw, it was a key part in a game that Emperor Augustus enjoyed. He and his

Primary Source

SUETONIUS, *LIFE OF AUGUSTUS*, PASSAGE 71

1 Of these charges or slanders (whichever we may call them) he easily refuted that for unnatural vice by the purity of his life at the time and afterwards; so too the odium of extravagance by the fact that when he took Alexandria, he kept none of the furniture of the palace for himself except a single agate cup, and presently melted down all the golden vessels intended for everyday use. . . . He did not in the least shrink from a reputation for gaming, and played frankly and openly for recreation, even when he was well on in years, not only in the month of December, but on other holidays as well, and on working days too. 2 There is no question about this, for in a letter in his own handwriting he says: "I dined, dear Tiberius, with the same company; we had besides as guests Vinicius and the elder Silius. We gambled like old men during the meal both yesterday and to-day; for when the dice were thrown, whoever turned up the 'dog' or the six, put a denarius in the pool for each one of the dice, and the whole was taken by anyone who threw the 'Venus.'" 3 Again in another letter: "We spent the Quinquatria very merrily, my dear Tiberius, for we played all day long and kept the gaming-board warm. Your brother made a great outcry about his luck, but after all did not come out far behind in the long run; for after losing heavily, he unexpectedly and little by little got back a good deal. For my part, I lost twenty thousand sesterces, but because I was extravagantly generous in my play, as usual. If I had demanded of everyone the stakes which I let go, or had kept all that I gave away, I should have won fully fifty thousand. But I like that better, for my generosity will exalt me to immortal glory." 4 To his daughter he writes: "I send you two hundred and fifty denarii, the sum which I gave each of my guests, in case they wished to play at dice or at odd and even during the dinner."

[Suetonius, *The Lives of the Caesars,* Vol. 1, translated by J. C. Rolfe (Cambridge, MA: Harvard University Press, 1914), http://penelope.uchicago.edu/Thayer/E/Roman/Texts/Suetonius/12Caesars/Augustus*.html.]

friends each cast their dice. Whoever landed a *canis* or a 6 (the latter normally a decent throw) put money in the pot. The first person to land a Venus then took the lot.

SIGNIFICANCE

Technically, gambling outside of chariot racing and gladiatorial contests was illegal in Rome except for the week of festivals during Saturnalia. Those who were caught gambling faced at worst exile; at best, they paid fines four times the value of the stakes, though to what degree this crime was investigated and punished is impossible to say. It is clear that most Romans, despite the law, continued to play, so it is likely that enforcement was minimal. Of note, innkeepers who kept backroom gambling houses were not breaking the law but legally could not be compensated for damages to their inns due to gambling and upset patrons. Given the number of

references to gambling and to the many mosaics that depict people gaming, it is possible that by the early imperial period the legislation against gambling was effectively a dead letter. A modern analogy might be office football and basketball pools.

The Romans were well aware of their predilection for gambling. References to dicing and gambling abound in art and in our sources. There are, for example, a number of depictions of men throwing dice, often with humorous graffiti accompanying them. Game boards also attest to the popularity of dicing games. In some places, impromptu game boards were carved into sidewalks and porticos. This suggests not only widespread play but also that legislation against gambling was, again, rarely enforced. Sources too provide a window into Roman game play. Perhaps the most famous is Julius Caesar's famous line *alea iacta est,* or "the die is cast," supposedly uttered before crossing the Rubicon River with an army—technically an act of treason—to protect his interests. Given the Roman passion for gambling, Caesar's words highlight the great risk that he knew he was taking, that the stakes were high, and that winning or losing would make or break his fortune.

Many if not most societies have or have had games, dicing, and gambling, but why was it so popular in Rome? One reason, at least for Rome itself, might be that so many people within the city were poor, out of work, and idle. The growing population of urban poor was the result of a complex series of changes in Rome. Traditionally, the Romans saw themselves, and their ancestors especially, as hardy farmers who dropped the plow at need to defend the city. While this may have been true very early on, it was not the case during most of the republican period. As Rome expanded into Italy and beyond, those who owned land and were therefore eligible for military service were gone from home for longer periods of time. Between the devastation of farmland during wartime to the deaths of soldiers, many of those with smaller holdings lost them, either because the land was ruined or because the owner had died. Families would sell the farm and move to the city hoping to find a new life. Over time, rich landowners bought up more and more of the good farmland, concentrating wealth and property in a small percentage of the population and forcing most everyone else to find new places to live. Moreover, many landowners put slaves to work on these farms rather than the former farming tenants. As a result the population of Rome grew, and many people lived in *insulae,* blocks of crowded apartments that were the low-income high-rises of their day. Many who moved to Rome could not find work or worked occasionally, relied on the grain dole, and had time on their hands. This may account for some of the popularity of gambling. Then as now, desperate people will stake a lot or everything on the rare chance of winning big.

On a more positive note, dicing and gambling tell us a lot about the ways in which Romans spent their leisure time. That people had leisure time at all

is significant. Historically, most populations were involved in food production, and while the growing season afforded some off time, this was often spent working on other domestic projects. The pervasiveness of dicing in Roman culture demonstrates that despite the importance of farming, Roman society was heavily urbanized, and there were large sections of society with time to spend in private or public entertainments. While more shiftless portions of the city might naturally gravitate toward pastimes to wile away the hours, citizens of middle means and the rich also found time to play. Dicing, like gladiatorial combats and chariot racing, united Romans of all classes and backgrounds. It was a pastime, a habit perhaps, that they took with them wherever they went and that in some ways was a defining aspect of the Roman character.

FURTHER INFORMATION

Austin, R. G. "Roman Board Games I." *Greece & Rome* 4(10) (October 1934): 24–34.

Austin, R. G. "Roman Board Games II." *Greece & Rome* 4(11) (February 1935): 76–82.

Balsdon, J. P. V. D. *Life and Leisure in Ancient Rome.* London: Phoenix Press, 2004.

Carcopino, Jerome. *Daily Life in Ancient Rome.* New Haven, CT: Yale University Press, 1968.

Faris, Suzanne B. "Changing Public Policy and the Evolution of Roman Civil and Criminal Law on Gambling." *UNLV Gaming Law Journal* 3 (Fall 2012): 199–219.

Pack, Roger A. "Trimalchio's Game (Petronius 33)." *Classical Philology* 69(3) (July 1974): 214–215.

Shelton, Jo-Ann. *As the Romans Did.* New York: Oxford University Press, 1988.

Suetonius. *The Twelve Caesars.* London: Penguin, 1989.

Websites

"Duodecim Scripta." Dordt College, http://center.dordt.edu/266.543units/Roman%20Empire/Learning%20Center/Dou%20Scripta.htm.

"The Lines of the Twelve Philosophers." Aerobiological Engineering, http://www.aerobiologicalengineering.com/wxk116/Roman/BoardGames/sex.html.

"Roman Board Games." Classics Technology Center, http://ablemedia.com/ctcweb/showcase/boardgames3.html.

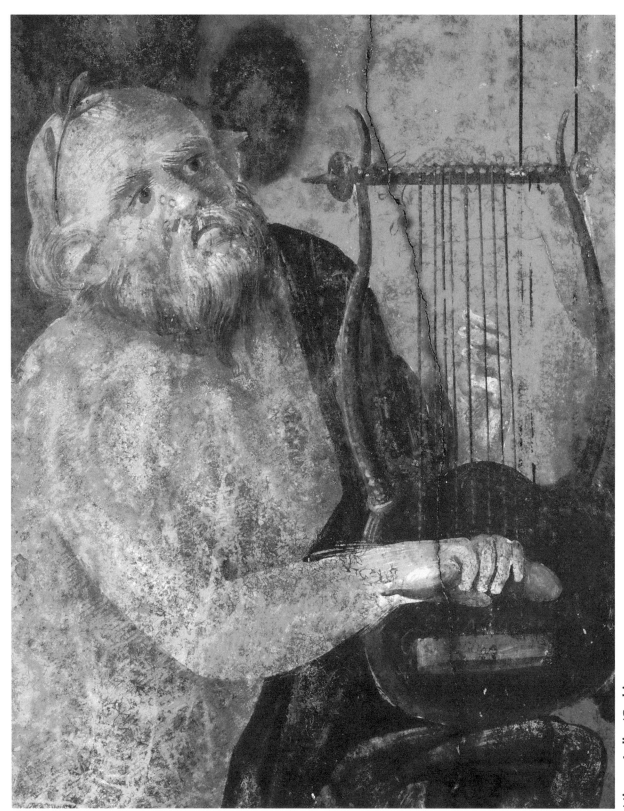

Lyre

Pompeii, Italy, Villa of the Mysteries
First Century CE

INTRODUCTION

The lyre was considered the most genteel of instruments, a sound and image associated with the poets Homer and Virgil. Though lyres varied in size, number of strings, and construction, they were well known from one end of the Mediterranean world to another.

DESCRIPTION

This painting of a Silenus, a type of Pan figure, playing the lyre is from the so-called Villa of the Mysteries in Pompeii. The house was originally built in the second century BCE, but after the earthquake in 62 CE it was remade. This scene is part of a larger set in a room famous for frescoes of what may be a Dionysiac initiation. They date to the first century BCE. Another theory posits that these scenes, while they borrow heavily from the Dionysian cult, were an allegory about marriage. There are other rooms in the villa with Dionysian symbols, but since most mysteries were carefully guarded by initiates, it is difficult to assess, assuming these panels depict an initiation, how much might be revealed. This room, a *triclinium,* was used for dining, so it is unlikely that any great secrets from the cult are on view here.

The instrument that the Silenus is playing, the lyre, is one of the oldest stringed instruments. The earliest evidence for the lyre hails from Mesopotamia and dates to the third millennium BCE. Its use spread quickly into Egypt, Asia Minor, North Africa, and Greece. There were several types of lyre. In Greece many were lightweight, such as the *chelys,* which used tortoise shell as the body of the instrument—skin was laid over the shell to form the resonator. Larger versions, such as the *kithara,* had bodies made of wood and were especially popular in musical competitions. A third type was the *phorminx.* It was also made of wood but had a rounded bottom and was probably of some antiquity, as Homer described lyres of this type. A fourth type, the *barbitos,* employed a sound box like the others but had much longer arms. The lyre and its variations might be different sizes and more or less well made. In a work titled *Rhetoric: To Herennius,* attributed to Cicero

but by an unknown author, the writer describes by way of analogy a lyre player. This section is not about music, but in it he paints an ideal picture of what such a player might have looked like on stage and how elaborate some instruments might be.

The number of strings on either instrument varied. Some sources say that the lyre had three strings, others say four strings, and still others say seven strings, but much probably came down to what the individual musician preferred. The seven-stringed lyre, or heptachord, introduced by Terpander of Antissa (seventh century BCE), a key figure in early Greek music, became standard in the Greco-Roman world. Musicians produced sound by strumming strings that ran across a resonator, usually of animal skin, that was stretched between two arms. Some musicians used a plectrum as well. There is considerable speculation as to how the lyre was played. One school of thought holds that the strings each made one note and were individually tuned. Another suggests that the musician could strum with one hand while changing the notes of individual strings at the same time; this would create a wider range of notes.

Stringed instruments were only one branch of those enjoyed by the Romans. Among woodwinds, the *tibiae,* or pipes, were another common feature of music. Most were more like clarinets than flutes in that they used a reed to produce sound. Many pipes used two reeds. Finger holes cut into the pipe allowed one to change the notes. Often pipes were played in pairs, though there is debate about just how this was accomplished. Some believe that one half of the popular double-pipe was a drone, akin to that on a bagpipe (also known in antiquity), while others believe that the two tubes were so designed as to allow for some harmonizing. In addition to the double-pipe, there was the so-called panpipe, with its various lengths of pipe. One blew across these to produce different notes. Another was the *tibiae impares* ("uneven pipes"), sometimes referred to as Phrygian pipes. The left side of this pipe was longer and terminated in a ball or upturned hook. In addition to woodwinds, the Romans used many instruments that today would fall into the brass category. Many of these were meant to be loud and were thus ideal for military applications. One of the most famous was the *lituus,* originally an Etruscan instrument that like most horns or *cornu* were mostly straight, long, and somewhat conical. In the case of the *lituus,* the end of the cone was slightly turned up. Another well-known Roman instrument from film, the Asterix comics, and many other sources is the *buccina,* another brass-style horn but one that wound up behind and over the shoulder of the player. The army used these much as they did bugles in more recent history for signaling, for maneuvering on the battle field, and to announce their arrival.

For percussion instruments, the Romans relied on a wide variety of items. Drums of different shapes, sizes, and sound were popular, as were clappers of wood. An excellent depiction of a Roman drum, this one a tympanum,

Primary Source

ANONYMOUS, *RHETORICA AD HERENNIUM* (CA. 86–82 BCE)

"Let us imagine a player on the lyre who has presented himself on the stage, magnificently garbed, clothed in a gold-embroidered robe, with purple mantle interlaced in various colours, wearing a golden crown illumined with large gleaming jewels, and holding a lyre covered with golden ornaments and set off with ivory. Further, he has a personal beauty, presence, and stature that impose dignity. If, when by these means he has roused a great expectation in the public, he should in the silence he has created suddenly give utterance to a rasping voice, and this should be accompanied by a repulsive gesture, he is the more forcibly thrust off in derision and scorn, the richer his adornment and the higher the hopes he has raised. In the same way, a man of high station, endowed with great and opulent resources, and abounding in all the gifts of fortune and the emoluments of nature, if he yet lacks virtue and the arts that teach virtue, will so much the more forcibly in derision and scorn be cast from all association with good men, the richer he is in the other advantages, the greater his distinction, and the higher the hopes he has raised." This Comparison, by embellishing both terms, bringing into relation by a method of parallel description the one man's ineptitude and the other's lack of cultivation, has set the subject vividly before the eyes of all. Moreover the Comparison is presented in the form of a detailed parallel because, once the similitude has been set up, all like elements are related.

[Cicero, *Rhetorica ad Herennium,* translated by Harry Caplan (Cambridge, MA: Harvard University Press, 1954), http://penelope.uchicago.edu/Thayer/E/Roman/Texts/Rhetorica_ad_Herennium/4C*.html. This translation credits Cicero with authorship, but this is no longer the scholarly consensus.]

which is not unlike a large Irish *bodhrán,* can be seen in the hands of a street performer in a mosaic from the House of Cicero in Pompeii. One of the more interesting percussion instruments, originally from Egypt and popular in the Cult of Isis among other places, was the *sistrum.* Usually of metal, these were spun in the hand in such a way to make metal disks or rods jingle (see the entry **Sistrum**).

SIGNIFICANCE

The Romans, like most people, were fond of music, and many of the activities they participated in daily were accompanied by music of some sort. Children sang at play, in games, and for entertainment. Adults did too. In Petronius's *Satyricon,* for example, Trimalchio's dinner banquet had musicians entertaining guests during almost the entire meal. While this may have been humorous, a way to show how over the top and pretentious Trimalchio was, it also indicates that music was a normal part of dinner parties. The guests or their host might play, just as they might recite poetry or read from a famous work, but it was standard to hire musicians too.

Song and music were integral parts of religious rites and festivals. Dramatic performances, like their Greek exemplars, often had singing as well as instrumental accompaniment, and pantomime, in which the actors did not speak, relied heavily on music. Competition was one element of many of the Roman religious *ludi,* or games (see the entry **Theatrical Mask**), and music was one of many categories where one might match skills against others. Even the gladiatorial arena, if mosaic evidence is any indication, must have resounded to the music of horns and *tibiae.* This should not surprise us, as today's movies and dramatic performances usually include musical scores to heighten emotion, announce changes in plot, and act as leitmotifs for specific characters.

Many of the major events in public and private life included music. Funeral processions had in their trains not only professional mourners but also musicians. Those celebrating triumphs likewise paraded through the city to the sound of instruments. As omnipresent as music was in Roman life, there was some ambivalence about both learning to play music and about those who played it professionally. For the most part, Roman education, at least for the aristocracy, did not include music as a core feature of the curriculum. What young men learned, if they learned at all, must have been from private teachers, relatives, or slaves who were musical. Both Cato the Elder (d. 149 BCE) and Varro (d. 27 BCE) mention that it was customary at some dinners to sing of the exploits of one's ancestors, so clearly singing at least was not uncommon. Other authors mention instruments and instrumental concerts at other dinners and parties. It is certain that music was a common entertainment, one that people of all stations enjoyed, and that many of the ruling class could play, perhaps most notoriously Emperor Nero. However, as a rule, musicians were viewed much as actors, gladiators, and other entertainers were, that is, as infamous and unsuitable to associate with outside of those venues where such performers were hired to entertain.

FURTHER INFORMATION

Anderson, Warren D. *Music and Musicians in Ancient Greece.* Ithaca, NY: Cornell University Press, 1994.

Barker, Andrew. *Greek Musical Writings,* Vol. 1, *The Musician and His Art.* Cambridge: Cambridge University Press, 1984.

Barker, Andrew. *Greek Musical Writings,* Vol. 2, *Harmonic and Acoustic Theory.* Cambridge: Cambridge University Press, 1989.

Comotti, Giovanni. *Music in Greek and Roman Culture.* Baltimore: Johns Hopkins University Press, 1989.

Habinek, Thomas. *The World of Roman Song: From Ritualized Speech to Social Order.* Baltimore: Johns Hopkins University Press, 2005.

Hall, Edith. "The Singing Actors of Antiquity." In *Greek and Roman Actors: Aspects of an Ancient Profession,* edited by Pat Easterling and Edith Hall, 3–38. Cambridge: Cambridge University Press, 2002.

Maas, Martha, and Jane McIntosh Snyder. *Stringed Instruments of Ancient Greece.* New Haven, CT: Yale University Press, 1989.

Re-Creations of Ancient Music

Ensemble De Organographia (Gayle Stuwe Neuman, Philip Neuman, and William Gavin). *Music of the Ancient Greeks.* CD. Pandourion Records, 1997.

Ensemble Kérylos (directed by Annie Bélis). *De la pierre au son: Musique de l'antiquité grecque.* CD. Productions K617, 1996.

Website

"Destruction and Re-Discovery." AD 79, https://sites.google.com/site/ad79eruption/.

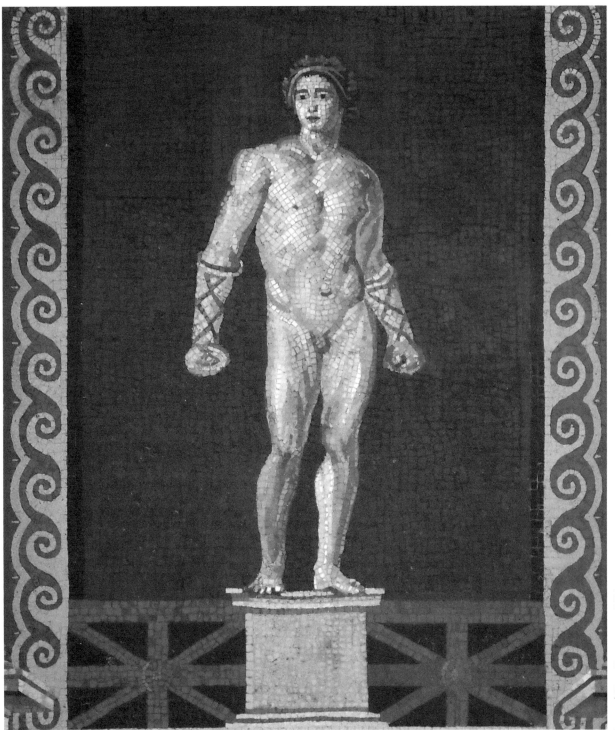

Mosaic of a Boxer

Pompeii, Italy
First Century CE

INTRODUCTION

In popular conception, few images are as iconically Roman as gladiators, professional fighters who often fought to the death in arenas to the cheers, or jeers, of the crowd. While most famous as spectacles, gladiatorial games had their origin in sacrifices made at the funerals of noble men. So popular did they become that politicians often held games, never an inexpensive venture, to court favor with the public during election season. Even in the imperial period, the games were important. They were a way to entertain the people and show an emperor's benevolence, but they were also a propaganda tool, a place where he might be seen, where he could demonstrate his power and authority.

DESCRIPTION

The first artifact, a glass mosaic, hails from Pompeii and is now in the Museo Archeological Nazionale in Naples, Italy. It is difficult to date precisely, but with the burial of Pompeii in 79 CE by volcanic ash from the eruption of Mt. Vesuvius, we know that it dates to at least the first century CE. It depicts a *cestus,* or boxer. In the second image, a more modern reconstruction of a Roman boxer's glove, we see the details of this purposefully vicious instrument. Unlike modern boxing gloves, those of the Roman *cestus* were designed to inflect considerable damage. Boxing was popular in athletics, among the legions for hand-to-hand fighting practice, and in the arena as one of many combat sports.

Boxing has probably been around in one form or another for much of human history. The earliest depictions, in the Western world at least, hail from the Near East and Egypt. Rules, however, while they no doubt existed for the Sumerians and Egyptians, have not surfaced yet, so Greece provides the first evidence for how such contests were conducted. The boxers fought until someone lost or until one man admitted defeat. They wore leather straps across their knuckles from an early date—Homer mentions them—but by the fourth century BCE these straps had additional leather along the fist to intensify the blow. They were brutal and helped make boxing one of the

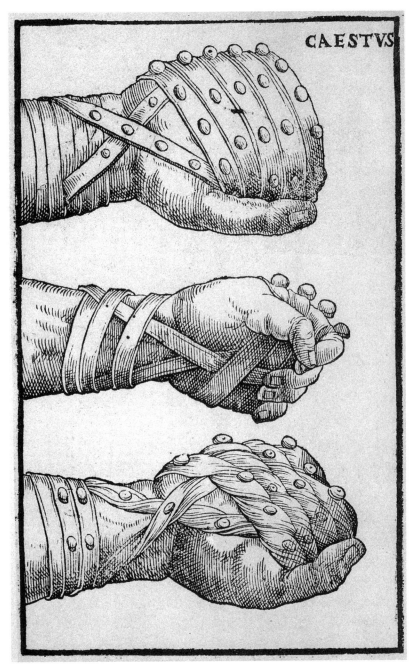

Contemporary illustrations of a Roman *cestus,* complete with spikes. (Mary Evans Picture Library/The Image Works)

toughest sports in Greece, if not most tough.

Rome outdid its Greek neighbors in making boxing even more potentially lethal by adding lead or iron to these leather bands. While in practice boxers probably used something less dangerous, in actual contests they wore these ancient forms of brass knuckles. Some idea of how frightful these matches might be can be gained from Book 5 of Virgil's national epic *The Aeneid,* in which a Trojan boxer, Dares, squares off against a much older but experienced Sicilian boxer, Entellus. Having received no answer to his challenge, the huge Dares was about to claim the prize for the fight when Entellus threw his *cesti* into the hazard. These old gloves were stained with gore and made the boastful Dares hesitate. In the end they fight, and Dares barely escapes with his life. The addition of metal to these gloves indicates that maiming and death must have been common aspects of Roman boxing contests.

SIGNIFICANCE

What the *cestus* and his spiked boxing glove indicate more than anything is the normalcy of blood sports in the Roman world. Rome is famous (or infamous) for its gladiators, arenas, and use of animals in executing criminals. These were popular spectacles, but in origin they were, like chariot racing, associated with funeral rites. The Romans believed that the tradition of gladiatorial combat began in the third century BCE, but it is possible that they adopted the practice from other peoples in Italy. The Etruscans, judging from artwork in their tombs, may have been the source for Rome's

games. In any event, by the third century when Rome's victories against Carthage and later Greek forces made the city master of much of the Mediterranean, gladiatorial contests were becoming a standard feature among certain celebrations of the Roman nobility. The first such match, in which three sets of gladiators vied against one another, was held in 264 BCE for the funeral of D. Junius Brutus Pera. Ostensibly all such contests were held to honor the dead. The word typically used was *munera* ("duties"), in the sense that the living owed the dead this tribute. Over the course of the third through first centuries BCE the idea that fights to the death should be held in honor of the departed persisted, but at the same time it was apparent that they were just as much if not more about entertainment.

One argument in favor of this view is that spectacles took a greater role in attempting to secure popular support in election season. Julius Caesar, to name only one example, held games for his father and daughter in 46 BCE. His example is not exceptional. Despite a law passed in 63 BCE by the Senate that sought to restrict the practice of holding games by aspiring magistrates, those with the power to do so, such as Caesar and Pompey the Great, did. The popularity of the games was such that even after the fall of the republic, emperors continued to hold public spectacles, often at great expense to the treasury and in lives. Some emperors, such as Commodus, even participated in gladiatorial combats, though his fights were no doubt arranged to some degree. While the Roman people looked upon their leader favorably for holding games, all the more so if they seemed engaged, they deplored as completely unacceptable any freeborn person, let alone an emperor, taking to the sand to fight in the arena.

Most combatants were either slaves bought and trained or prisoners of war. On occasion, a desperate freeborn man might take up the trade—prize money could be considerable for a long-standing victor—but this was never considered proper. Gladiators could win their freedom, but even when they did some decided to keep fighting. Successful fighters were some of the popular celebrities of their day. Though actors, gladiators, and other entertainers were considered to be engaged in disreputable activities, they nonetheless could win considerable fame. Surviving graffiti attests to this well, from the list of victories a favorite achieved to praises of another gladiator's good looks. Women too, referred to as *Amazones* ("Amazons") after the legendary female warriors in Greek myth, sometimes fought in the games.

There were several typical types of gladiator. The *retiarius* was armed with a net and trident. Normally these men were particularly nimble, and they had to be, as they wore almost no armor. Those with substantial armor, such as the *murmillo* and the Samnite, were equipped with helmets, shields, greaves, and a sword. In the case of the latter, like a few other types of fighter such as the Thracian, there was a connection with particular people and presumably their equipment and fighting style. The *secutor* ("pursuer")

also wore armor. Some pairings were traditional, such as *retiarii* against either *secutores* or *murmilliones,* but some of those who fought may have come from other traditions as well. Pitting those of different styles together, especially heavily armored against those lightly armored, while it may have been traditional, also allowed the strengths and weaknesses of each type of fighter to be displayed. Fans knew well the advantages of each sort of gladiator, and with betting being popular, such knowledge, always allowing for how well or poorly a gladiator had mastered his particular skills, was indispensable for maximizing the chance of winning such bets.

Gladiators were trained in a *ludus* ("school") and normally by a *lanista.* Many instructors had been gladiators themselves. It was hard training and was also financially costly. Professionally trained fighters were expensive not only to train but also to house, feed, and, when occasion called for it, to replace. Though many men died in the arena, *lanistae* did not throw the lives of their gladiators away lightly. Recent excavations have found gladiator graves with remains that show a diet that would have put a few extra pounds on the fighters. This indicates that as highly trained athletes they enjoyed some decent fare, but more than that, it is also likely that a bit of padding in the midsection may have helped prevent more serious injury in the arena. In the off chance that a gladiator received a cut across the abdomen, the chances of serious muscle damage were slightly decreased.

Not all who fought in the arena were so lucky. The condemned, for example, might be armed with a gladiator's tools, but against seasoned experts they stood little chance. Likewise, the *venatores* and *bestiarii,* those who fought against wild beasts in the arena, were less well armored than their more famous gladiatorial counterparts. The least fortunate, usually the condemned, were placed in the arena to be victims of underfed animals. However, there were also exhibitions of hunting, often with elaborate tricks such as avoiding a lunging lion or punching it before striking. Even sets, complete with bushes and trees, might be placed in the arena to heighten the experience. Arenas actually could hold a variety of spectacles. One of the more sophisticated was the *naumachia* (Greek for "ship battle"), a naval battle complete with ships, sailors, and marines.

Arenas were not used in the earliest days of gladiatorial contests. Many were held in the open air, often in temporary structures within the forum, but in time the size, frequency, and popularity of the games were such that the Romans built more permanent buildings. The Circus Maximus, where chariot races were held, was too large and spread out, so when specially constructed buildings for gladiatorial fights were built, they were made smaller in circumference so that all spectators could see. These arenas, called amphitheaters or a theater with two sides, were designed not only so that the public could see well but also with a certain eye for comfort. Many had awnings to shield the people from rain or sun. Vendors set up outside

the arena with refreshments, cushions, and other amenities on spectacle days. The most famous of these structures and one of the best preserved is the Flavian Amphitheater, better known as the Colosseum in Rome. With games first held there in 80 CE, the Flavian Amphitheater was a marvel of engineering. In addition to trapdoors, which could make an actor or gladiator appear seemingly out of nowhere, there were quarters, pens, and corridors beneath the floor. The Colosseum sat about 50,000 people and in its prime was decorated with statues and columns and faced with marble.

The games lasted until the early Christian era, when Emperor Constantine the Great first outlawed them (325 CE). Up to that time, they were popular entertainments but also a means by which the emperor might project his image, his magnanimity, and his benevolence. How the emperor behaved at games and how many he sponsored sent a message that was carefully monitored by the populace. In time, the chariot course and the arena became places for political performance and were among the rare places where the people and their ruler met.

FURTHER INFORMATION

Bomgardner, David L. *The Story of the Roman Amphitheatre.* London and New York: Routledge, 2000.

Edmondson, J. C. "Dynamic Arenas: Gladiatorial Presentations in the City of Rome and the Construction of Roman Society during the Early Empire." In *Roman Theater and Society,* edited by William J. Slater, 69–112. Ann Arbor: University of Michigan Press, 1996.

Futrell, Alison. *Blood in the Arena: The Spectacle of Roman Power.* Austin: University of Texas Press, 1997.

Homer. *The Iliad.* Translated by Richmond Lattimore. Chicago: University of Chicago Press, 1961.

Hopkins, Keith. *Death and Renewal.* Cambridge: Cambridge University Press, 1983.

Köhne, Eckart, and Cornelia Ewigleben, eds. *Gladiators and Caesars: The Power of Spectacle in Ancient Rome.* English version edited by Ralph Jackson. Berkeley: University of California Press, 2000.

Kyle, Donald G. *Spectacles of Death in Ancient Rome.* London and New York: Routledge, 1998.

Plass, Paul. *The Game of Death in Ancient Rome: Arena Sport and Political Suicide.* Madison: University of Wisconsin Press, 1995.

Poliakoff, M. *Combat Sports in the Ancient World.* New Haven, CT: Yale University Press, 1987.

Potter, David S., and David J. Mattingley, eds. *Life, Death, and Entertainment in the Roman Empire.* Ann Arbor: University of Michigan Press, 1998.

Theocritus. *Idylls: A New Translation by Anthony Verity.* Oxford: Oxford University Press, 2007.

Virgil. *The Aeneid.* Translated by Bernard Knox and Robert Fagles. London: Penguin, 2010.

Welch, Katherine E. *The Roman Amphitheatre: From Its Origins to the Colosseum.* Cambridge: Cambridge University Press, 2007.

Wiedemann, Thomas E. J. *Emperors and Gladiators.* London and New York: Routledge, 1992.

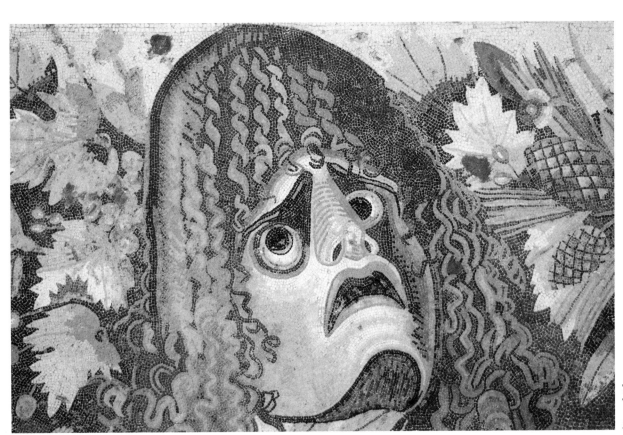

Theatrical Mask

Pompeii, Italy, House of the Faun
First Century CE

INTRODUCTION

The theatrical mask, today usually viewed as a pair with one representing comedy and the other representing tragedy, is a universal symbol for actors and drama. Theatrical masks are known in many cultures, but those of the Greek stage and later the Roman stage highlight the great debt that the modern world owes to classical drama. These plays are a mine of information about contemporary manners, humor, social interaction, language, and values. However, they are also important for the fact that dramatic performances were normally part of religious observance, from the *ludi* ("games") to ceremonies honoring the dead to celebrations of the gods. Plays were also popular entertainment. Theaters were built all over the Roman world. Some, such as the theater in Orange, France, are still in use as music venues.

DESCRIPTION

This mosaic of a theater mask, one of a pair, was discovered in the House of the Faun in Pompeii and dates to the second century BCE. It is now in the Museo Archeologico Nazionale in Naples, Italy. This set of mosaics divided the atrium of the house from the *fauces,* the entranceway to the atrium. Theatrical masks, like most aspects of early Roman drama and theater, were probably borrowed from the Greeks.

The origins of the theatrical mask are somewhat obscure, but it may be that their use derived from the cult of Dionysius, one of many so-called mystery cults (see the entry **Sistrum**) that became popular all over the Greco-Roman world. Masks were a part of Dionysiac ritual. In fact, there is much evidence to suggest that drama has its origins in religious observation—certain festivals included dressing up and acting out scenes from key myths or emulating aspects of the cult. For example, in the case of Dionysius, men dressed in goatskins and masks and performed a dance. Many theatrical masks were made of linen, though much of what we know about them comes from terra-cotta models, particularly the fine set found on the island of Lipari, the second of the Aeolian Islands north of Sicily. The Latin word

89

for mask, *persona,* is derived from Etruscan and was an important element in the funerals of the nobility. In funeral processions, the family donned the masks of their ancestors, in a sense reuniting the family, living and dead, as another member joined the ranks of the latter.

The use of masks in drama, however, was probably learned from the Greeks of Magna Graecia, the various colonial settlements in the south of Italy. Some of these cities already had theaters of stone. Like their Hellenic neighbors, the Romans used the sides of hills to install their theaters, though the first were temporary structures made of wood. Rome did not have stone theaters until 55 BCE, when Pompey erected one near the Campus Martius. There had been an earlier attempt in 155 BCE, but conservative elements within the Senate succeeded in halting construction before it was completed, all in an effort to preserve the morality of the people. While not all actors performed in lewd comedies, generally they were, like gladiators and other entertainers, low in status, considered *infamis* (masc.) or *infama* (fem.), that is, disreputable. Since some of these less than proper comedies dealt with earthy subjects they were suspect, and there was a fear among men such as Publius Cornelius Scipio Nasica Corculum (fl. 150 BCE), one such critic, that it was not good for people to see these sorts of things. His view did not prevail. Additional permanent theaters were built from the time of Pompey onward and in all parts of the empire.

Built along Greek lines, the Roman theater included many of the same elements of construction, albeit with a Roman eye for design. Roman theaters had a semicircular auditorium, or *cavea,* for spectators and a similar but smaller one for the orchestra. The stage ran along the diameter of the orchestral semicircle. Behind the stage, and forming the back wall of the enclosure from the spectator's perspective, was the *scaenae fons,* the backdrop in front of which all the action on the stage took place. Theaters varied in size. The Theater of Marcellus, which Emperor Augustus built in honor of his nephew, could seat 14,000. An excellent example, one of the best preserved, is in Orange (Roman Arausio), France, and could seat somewhere between 5,500 and 7,000. Most Roman theaters were essentially complete buildings, though they did not have roofs. As with the arenas (see the entry **Mosaic of a Boxer**), an awning could be pulled across the *cavea* to block out the sun or some of the rain.

SIGNIFICANCE

While theaters, and the equipment such as masks so often used in them, are important in their own right, both as examples of Roman building and stagecraft, what they point to most directly is the notable place of Roman drama. Entertaining and influential in their own day, the plays of Plautus, Terence, and Seneca have never lost their charm. While the topics may be particular to Roman life and culture, the Lar in *Aulularia* (often called *The Pot of Gold*

Definitions

Ludi

Literally "games" (sing. *ludus*), this term covers a wide range of Roman games. There were *ludi* that were part of religious festivals, such as the *ludi circenses,* or chariot races. A second form of *ludi* were the *ludi scaenici,* which involved dance and music. Still a third form was gladiatorial combats. Gladitorial schools were also called *ludi.* However, the word had other uses as well. *Ludi* could refer to most any game or sport, such as board games or activities such as wrestling. In some contexts *ludi* could also refer to elementary education.

now) and the miserly Euclio and his good daughter are all familiar stock characters.

What dramatic performances predate the third century BCE remains obscure. Some of the earliest plays hail from the third century BCE. Lucius Livius Andronicus, a freedman, wrote a comedy and tragedy performed at the Ludi Romani in 240. Livius even acted in some of his plays. Another famous early playwright was Quintus Ennius (d. 169 BCE). A well-to-do immigrant and one granted citizenship, Ennius hobnobbed with the great families in Rome, instructing their sons in both Latin and Greek. He wrote a variety of works, not just plays, and enjoyed considerable success. Romans were still reading him 600 years later. Much of the earliest work, such as that of Lucius Accius (d. ca. 86 BCE), a tragedian, are lost except for fragments preserved in the works of other authors.

Most plays—the general term for them was *fabulae* (sing. *fabula*)—were part of the various competitions that formed part of the *ludi* at religious festivals. Chariot racing, to name another example, was one such competition. Though a chance for artists to vie for success, the plays they put on were still considered part of the religious program of the *ludi.* The *fabulae* were sponsored by aristocrats who helped finance the plays and in so doing took some share in the glory. The type of play performed depended on the occasion. Those staged in honor of the departed, for example, may have been tragedies. There were a variety of types, some native to Italy and others influenced by Greek exemplars, and even the genres of comedy and tragedy could be subdivided.

Greek dramas, however, were highly influential. The Roman comedies that survive, such as the six by Terence and several of those by Plautus, indicate not only the debt that Rome owned to the playwrights of Greece but also the deft skill with which Roman authors put a Roman spin on Greek tales. Of the two, Terence's comedies tended to preserve more of the feel of the Greek

pieces; they were comical but dignified, staid, and respectable. Plautus, on the other hand, may have drawn upon comic geniuses such as Menander but added what was probably native Italic humor as well. Plautus's plays were extremely popular but were far less stately or refined than those of Terence.

The Romans enjoyed other types of dramatic performance as well. Pantomime grew in popularity and by the first century was perhaps more popular than the old Greek-based dramas. In these types of plays, the actors wore different masks but did not have speaking parts; the masks and the actors' expressions and movement communicated the story instead. There were several characters, but one of the more important was the *pantominus,* the Latin term for the Greek *pantomimos,* "imitator of all." This actor wore masks and used both dance and gestures to relate the story. There was musical accompaniment as well. Most plots revolved around well-known myths, so between general knowledge of traditional stories and the movement on stage, the audience easily followed the action and the story. There was a second type of performance called mime, but it was much different. These popular plays were performed by actors without masks, normally centered upon comedic situations, and more often than not included a lot of violence and bawdy humor. It was this type of drama that no doubt lent most actors the poor reputations they normally had.

While a wonderful window into Roman culture, values, humor, and everyday language, Roman drama has also been influential with later writers. To read Plautus, for example, reveals a lot about the challenges of romantic love, attitudes toward finances, military figures, relationships between slaves and masters, and the ways in which Roman writers selected their material from Greek and Italic sources. The skill with which they applied these influences and with which they depicted their characters makes both the plots and stock figures universal. William Shakespeare, the greatest English playwright, looked to Plautus's *Menaechmi* in writing *The Comedy of Errors.* Adaptations of Roman comedy have been popular even more recently. *A Funny Thing Happened on the Way to the Forum,* a Broadway musical from 1962, for example, drew upon several plays of Plautus. This same story enjoyed success as a movie in 1966 and is often still performed on smaller stages throughout the country.

FURTHER INFORMATION

Anderson, William S. *Barbarian Play: Plautus' Roman Comedy.* Toronto: University of Toronto Press, 1993.

Arnott, W. Geoffrey. *Menander, Plautus, Terence: Greece and Rome.* New Surveys in the Classics No. 9. Oxford, UK: Clarendon, 1975.

Coleman, Kathleen. "Fatal Charades: Roman Executions Staged as Mythological Enactments." *Journal of Roman Studies* 80 (1990): 44–73.

Easterling, P. E., and Edith Hall, eds. *Greek and Roman Actors: Aspects of an Ancient Profession.* Cambridge: Cambridge University Press, 2002.

Fantham, Elaine. "Mime: The Missing Link in Roman Literary History." *Classical World* 82 (1989): 153–163.

Marshall, C. W. *The Stagecraft and Performance of Roman Comedy.* Cambridge: Cambridge University Press, 2006.

McCarthy, Kathleen. *Slaves, Masters, and the Art of Authority in Plautine Comedy.* Princeton, NJ: Princeton University Press, 2000.

Moore, Timothy J. *The Theater of Plautus: Playing to the Audience.* Austin: University of Texas Press, 1998.

Panayotakis, Costas. "Women in the Greco-Roman Mime of the Roman Republic and the Early Empire." *Ordia Prima: Revista de Estudios Clásicos* 5 (2006): 121–138.

Plautus. *Four Comedies: The Braggart Soldier, The Brothers Menaechmus, The Haunted House, The Pot of Gold.* Translated by Erich Segal. Oxford World's Classics. New York: Oxford University Press, 1996.

Segal, Erich, ed. *Oxford Readings in Menander, Plautus, and Terence.* Oxford: Oxford University Press, 2001.

Slater, Niall W. *Plautus in Performance: The Theatre of the Mind.* 2nd ed. London and New York: Routledge, 2000.

Terence. *The Comedies.* Translated by Betty Radice. London: Penguin, 1976.

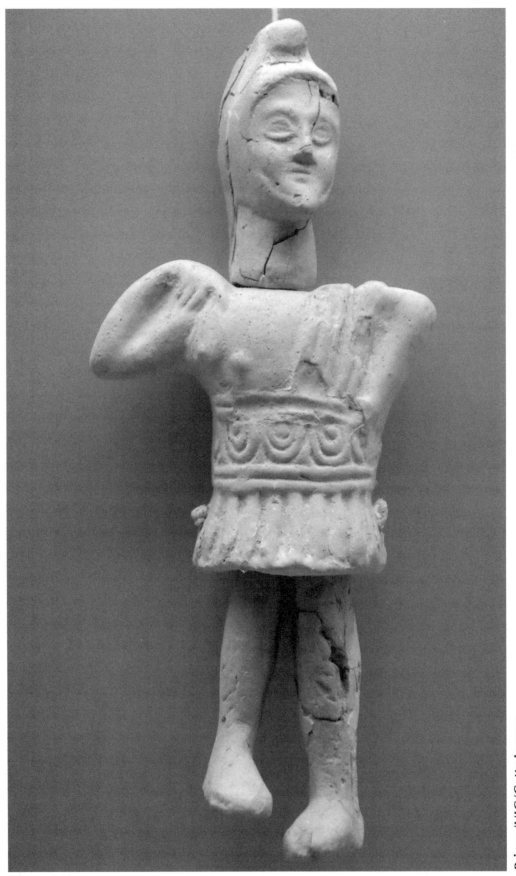

Toys

Olympia, Greece
Circa First through Third Centuries CE

INTRODUCTION

One of the most recognizably familiar objects of history, any history, is a child's toy. These artifacts stand out because they so often resemble toys that children have played with ever since. Roman children, for example, were fond of ball games, leapfrog, tops, yo-yos and wheeled animals that they might take for a walk just as many young children did a few hundred years ago and still do today. The fact that many such toys have survived is significant. Many have been uncovered in the graves of children, so many of whom did not live to see adulthood, and suggest that contrary to popular conceptions of all-powerful and strict homes, Roman parents loved their children every bit as much as parents anywhere and at any time have.

DESCRIPTION

The clay puppet here is one of several discovered in the Fragonisi Miraka Cemetery just east of Olympia, Greece. It dates to sometime in the first three centuries CE and now resides in the Archaeological Museum of Olympia. Much of what we know of ancient toys comes from similar contexts where children were buried with toys. There are also artistic representations on pottery and occasional glimpses from literature. The infant Dionysus, for example, was distracted by toys as enemies approached in one of his myths.

Many of the toys that children played with in Rome would be familiar today. For infants, *crepitacula* (sing. *crepitaculum*), or rattles, were popular. These were made from a variety of materials, often wood that produced a sort of clapping sound. Others were of metal and might employ bells or rings that jingled when shook. There is some evidence that rattles might have served as one of the many apotropaic devices so commonly used by the Romans. Like the bullae worn by children, bells could be worn and could also form part of a toy, and it is possible that the sound, while pleasing to the child, was also meant to frighten away evil spirits (see also the entry **Bulla**).

Puppets and other forms of doll were also popular. Many were made of clay, like the puppet here, but others were made of bone, rags, or wood; bone seems to have been a popular medium for making dolls. Dolls were a common toy, especially for young girls, and many had articulated limbs. Some, such as those of terra-cotta, were made with a chiton, or woman's tunic, but others were plain so that the child could dress them in toy versions of women's costume and jewelry. Much as they are used today, dolls allowed for role-playing, a notion confirmed by the fact that upon marriage young Roman women dedicated their dolls to Diana or Venus. Like dolls, animal figures were another typical plaything and might be made of similar materials. Many extant examples have wheels instead of legs so that children might tow them. Toy carts, chariots, and boats have likewise been found. The spinning top, hoop, and yo-yo were also known. Many toys were designed to encourage dexterity and movement. Some pushcarts, for example, may have helped toddlers learn to walk.

Games (*ludi,* sing. *ludus*) of all sorts instilled ideas of teamwork, competition, and perseverance as well as coordination, balance, and strength. For example, ball games and other games such as leapfrog (*saltus*) and hide-and-seek were popular. In addition to physical games such as these, there were those that developed hand-eye coordination and balance. For example, one popular game was simply balancing a stick on one's finger for as long as one could, a game depicted on many Greek ceramics with images of Paidia, a personification of play.

Board games, such as *duodecim scripta* and *ludus latrunculorum,* improved one's ability to recognize patterns, strategize, and outthink one's opponent (see the entry **Dice and Tavern Game Board**). There were many games one might play with *tali* ("knucklebones"), *aleae* ("dice"), or *nuces* ("walnuts"), the last of which were often used in games similar to modern-day marbles whereby one tries to throw the object into a small hole or container. Dice games in general were favorites of young and old alike.

SIGNIFICANCE

On the surface, toys, whenever they may have been made or used, are significant for what they tell us about childhood. It is perhaps little surprising that infants, toddlers, and children today often gravitate toward similar toys. Babies like rattles, toddlers enjoy movement and manipulating blocks or pulling toys on wheels, and older children love to role-play and use their imaginations. In this Roman children were no different from children of today. However, even with individual toys we learn something of the period. Animal toys, for example, might depict creatures from outside of Italy that were common in the public games. A doll set might include the objects associated with marriage ceremonies. One of the richest sources for toys and other pastimes actually come from adult sarcophagi. While this tells us

Primary Source

QUINTILIAN, *INSTITUTIO ORATORIA*, BOOK 1, CHAPTER 3, SECTION 8

Still, our pupils will require some relaxation, not merely because there is nothing in this world that can stand continued strain and even unthinking and inanimate objects are unable to maintain their strength, unless given intervals of rest, but because study depends on the good will of the student, a quality that cannot be secured by compulsion. Consequently if restored and refreshed by a holiday they will bring greater energy to their learning and approach their work with greater spirit of a kind that will not submit to be driven. I approve of play in the young; it is a sign of a lively disposition; nor will you ever lead me to believe that a boy who is gloomy and in a continual state of depression is ever likely to show alertness of mind in his work, lacking as he does the impulse most natural to boys of his age. Such relaxation must not however be unlimited: otherwise the refusal to give a holiday will make boys hate their work, while excessive indulgence will accustom them to idleness. There are moreover certain games which have an educational value for boys, as for instance when they compete in posing each other with all kinds of questions which they ask turn and turn about. Games too reveal character in the most natural way, at least that is so if the teacher will bear in mind that there is no child so young as to be unable to learn to distinguish between right and wrong, and that the character is best moulded, when it is still guiltless of deceit and most susceptible to instruction: for once a bad habit has become engrained, it is easier to break than bend. There must be no delay, then, in warning a boy that his actions must be unselfish, honest, self-controlled, and we must never forget the words of Virgil, "So strong is custom formed in early years (Georg. ii. 272)."

[Quintilian, *Institutio Oratoria*, Book 1, translated by Harold Edgeworth Butler (Cambridge, MA: Harvard University Press, 1920), http://www.perseus.tufts.edu/hopper/text?doc=Quint.+Inst.+1+.3&fromdoc=Perseus%3Atext%3A2007.01.0060.]

something of ancient toys and games, it also suggests something about the value that the Romans placed on both children and play.

Another source, this one archaeological, tends to bring the importance of children for the Romans into high relief. Many of the toys found come from the graves of children. In many works on ancient Rome one reads of the exposure of unwanted infants; of the ability of head of the family, the paterfamilias, to put to death anyone in his family, including children; and of the plight of children sold into slavery. That these things happened or were possible is hard to refute, but to focus on these aspects of life without attention to the great value that Romans placed on both childhood and their children is to miss something vital and beautiful about Roman culture. Unwanted children, to put it plainly, are not buried with their favorite toys and talismans to protect them in the next life. Infant mortality and the loss of young children to illness and injury were all too common. One example of this is the naming ceremonies for newborns. Once picked up by the paterfamilias,

the baby was officially accepted into the family. Next, if the baby was a boy, he would undergo the *lustratio,* a rite of purification, and receive his name on the ninth day of life. Baby girls went through the *lustratio* as well but after eight days. Many mothers died giving birth to their children, their babies often with them, so one sees that in waiting a week to name newborns the Romans were all too aware of the dangers of childbirth. Given the precariousness of life, it is small wonder that the Romans should value and cherish their children and, by extension, the period of childhood as preparation for adult life.

Children, understandably, were viewed as particularly vulnerable. Recognition of their immaturity, that they were prone to be selfish, fearful or overly cautious, silly, or weak led the Romans to focus attention on effective child rearing. Childhood, while a time for play, was also viewed as a critical period of development and thus was a topic to which many Romans gave considerable thought. Quintilian, for example, in his *Institutio Oratoria* (*Instruction in Oratory*), discusses how important play is in the development of young boys. Play built character, imparted skills in reasoning and cooperation, and could improve intelligence. Quintilian was not alone in discussing the value of games. In a work that unfortunately only survives in later glosses, the biographer Suetonius (d. after 122 CE) penned *Peri ton par' Hellesi Paidion* (*On the Games of Greek Children*). Not surprisingly, the philosopher, writer, and dramatist Seneca (d. 65 CE) also discussed child rearing. He even discussed his own childhood. For example, in his *Moral Letters* he relates returning to an old home and meeting a slave and former playmate from his youth. It was common for a citizen's children to play with the young slaves in the house. How those relationships changed could, if Seneca is any guide, work out better for the master's children than the slaves. Seneca's old friend was not in better circumstances when they met as adults, and the philosopher seems in his account of it less than concerned.

As children turned into young adults, their toys took on symbolic significance in their rites of passage. Young women, as mentioned above, gave their dolls to either the chaste goddess of the hunt, Diana, or to the goddess of love, Venus. Young men, in addition to offering their childhood tunic and bulla to the Lares, the household gods, often dedicated their toys as offerings to the gods that had protected them. These rites demonstrated, in obvious and public ways, the young person's break with childhood.

FURTHER INFORMATION

Bradley, Keith R. *Discovering the Roman Family: Studies in Roman Social History.* New York: Oxford University Press, 1993.

British Museum. *A Guide to the Exhibition Illustrating Greek and Roman Life.* London: Printed by order of the Trustees of the British Museum, 1908.

Klein, A. E. *Child Life in Greek Art.* New York: Columbia University Press, 1932.

Neils, Jenifer, and John H. Oakley. *Coming of Age in Ancient Greece: Images of Childhood from the Classical Past.* New Haven, CT: Yale University Press, 2003.

Rawson, Beryl. *Children and Childhood in Roman Italy.* New York: Oxford University Press, 2003.

Uzzi, Jeannine Diddle. *Children in the Visual Arts of Imperial Rome.* New York: Cambridge University Press, 2005.

Wiedemann, Thomas. *Adults and Children in the Roman Empire.* New Haven, CT: Yale University Press, 1989.

Grooming, Clothing, and Accessories

Fibula

Perfume Bottle

Phalera

Portrait Bust

Razor

Sandals

Strigil

Toga Praetexta

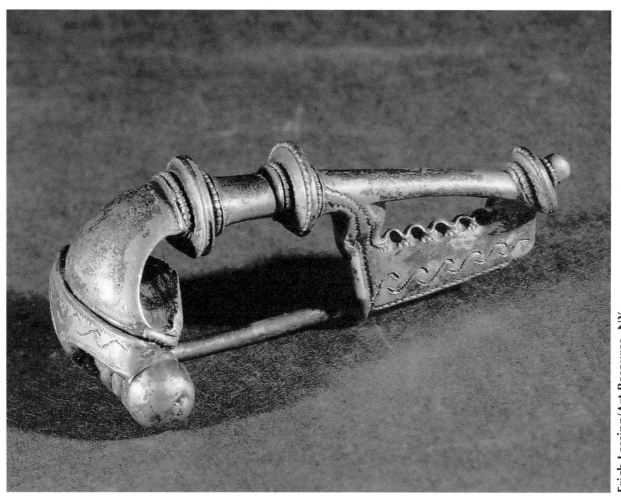

Fibula

Austria
First through Third Centuries CE

INTRODUCTION

Much of Roman clothing was voluminous and required either unique ways to drape and fold it or special pins or both to keep clothing on the body. One of the most popular methods, for both sexes, was the fibula, a functional pin and piece of jewelry that for many was a part of their everyday dress. These brooches clasped the large folds of traditional costume such as togas and *palla.* Much like the modern safety pin, fibulae allowed the wearer to clasp sections of clothing with minimal fear of being injured. Historically conservative in matters of wardrobe, Roman men but especially women turned to jewelry and hairstyles to distinguish themselves and express personal style.

DESCRIPTION

The silver fibula pictured here, discovered in Poechlarn and now in the Kunsthistorisches Museum in Vienna, Austria, dates to sometime between the first and third centuries CE. It is about 3.35 inches long (8.5 centimeters). Fibulae had been around since the Bronze Age and survived as brooches into the Middle Ages among some peoples, particularly in Celtic and Germanic areas. Ultimately these pins look back to a Minoan brooch that was bent at one end in order to prevent it from slipping out of one's clothing. This style was bent further into the bow shape common to many fibulae, and in time the bent end became an actual catch. Greek examples from the late Geometric Period (900–700 BCE) already displayed incised catch plates. Fibulae appear to have gone out of style in Greece sometime after the sixth century, but in Italy their use persisted, and new forms appear with the Romans.

There were a variety of forms and decoration, but most worked in much the same way. An *acus,* or pin, would be inserted through the clothing and then clipped behind a hook. Refinements over time made the fibulae not only safer but also more capable of embellishment. From simple bows to fasteners that sported large disks, quatrefoils, or rings, fibulae became

another way to make a fashion statement. Since Roman clothing fell into a few universal categories and since most people could not afford the expensive dyed cloth that would allow for much color variation, jewelry was often an easier substitute—even a well-made iron or bronze fibula might set off an outfit well. Many fibulae indeed were made of gold or bronze, though like most jewelry there were inexpensive versions as well. The delicate lines and ribbons on this piece are a fine example of how expertly and beautifully Roman jewelers could do filigree. Many fibulae were also decorated with precious stones or enameled, a process whereby various colored glasses are fused to indentations in the metal through heating. The latter process was especially popular from the second century CE on not only among Romans; Germanic peoples carried the tradition with them to the north.

Men wore a fibula with the *amictus,* a word that denotes an outer garment, such as a *pallium* ("cloak"), and generally pinned it together on the right shoulder. Women, however, wore fibulae with their *indutus,* or inner clothing, more often and unlike men were more likely to wear one on each shoulder. Women too fastened their outerwear with fibulae. Originally women had worn togas, but other influences, particularly Greek styles, did much to change the types of clothing women wore. These were, however, as conservative as the toga, and so to set apart oneself women turned to jewelry, hairstyles, and, for those who could afford it, different colored dress.

The *tunica,* or tunic, was the primary item of dress. Men wore them too, but theirs were shorter; women's tunics could reach the ankle or feet. There were two basic styles. The Greek *peplos* consisted of two rectangles of cloth sewn along the seams on the side but open at the top. The remaining material at the top was folded down and then pinned with fibulae or similar pins on the shoulders. A belt might be worn as well and could be used to change the shape of the *peplos*—it could hold down the folds or help prop them up to add volume. The second form of tunic was much like the Greek *chiton,* a gown sewn nearly to the shoulders, which left room only for the arms along the side. The shoulders were then either pinned or buttoned to keep the dress on. Depending on the size of the *chiton* it might have sleeves, both of which might also be pinned or buttoned.

Upon marriage, a woman was entitled to wear a *stola,* a long sleeveless tunic and one that could cover her head. It was often suspended by straps over the shoulder and tended to be a less fancy and more functional, hardy piece of clothing made of something simple, such as undyed wool. Most Roman clothes were made of wool, though women of means could afford linen, cotton, and in time silk. To this most women added a *palla,* or cloak. This last item was especially important for bad weather, but it was also considered proper for a woman to be covered when in public, something that the large *palla* did well.

Primary Source

LIVY, *HISTORY OF ROME,* BOOK 34, CHAPTER 1

1. Amid the anxieties of great wars, either scarce [1] finished or soon to come, an incident occurred, trivial to relate, but which, by reason of the passions it aroused, developed into a violent contention. [2] Marcus Fundanius and Lucius Valerius, tribunes of the people, proposed to the assembly the abrogation of the Oppian law. [3] The tribune Gaius Oppius had carried this law in the heat of the Punic War, in the consulship of Quintus Fabius and Tiberius Sempronius, that no woman should possess more than half an ounce of gold or wear a parti-coloured garment or ride in a carriage in the City or in a town within a mile thereof, except on the occasion of a religious festival. [4] The tribunes Marcus and Publius Iunius Brutus were supporting the Oppian law, and averred that they would not permit its repeal; many distinguished men came forward to speak for and against it; the Capitoline was filled with crowds of supporters and opponents of the bill. [5] The matrons could not be kept at home by advice or modesty or their husbands' orders, but blocked all the streets and approaches to the Forum, begging the men as they came down to the Forum that, in the prosperous condition of the state, when the private fortunes of all men were daily increasing, they should allow the women too to have their former distinctions restored. [6] The crowd of women grew larger day by day; for they were now coming in from the towns and rural districts. [7] Soon they dared even to approach and appeal to the consuls, the praetors, and the other officials, but one consul, at least, they found adamant, Marcus Porcius Cato, who spoke thus in favour of the law whose repeal was being urged.

[Livy, *The History of Rome,* Books 31–34, translated by Evan T. Sage (Cambridge, MA: Harvard University Press, 1935), http://www.perseus.tufts.edu/hopper/text?doc=Perseus%3Atext%3A1999.02.0164%3Abook%3D34%3Achapter%3D1.]

SIGNIFICANCE

Fibulae highlight several key aspects of the culture of Roman dress. Fibulae, as some of the most prominent ornaments a person wore, emphasize the marriage of form and function that one sees in so much of Roman life. Fibulae were functional and necessary to keep clothing fastened, but they were also prominent pieces of jewelry, usually worn on the shoulder but sometimes on the breast or arms as well. There were many varieties, from boat-shaped to leech-shaped to disk, spatulate, or violin-shaped, and any might have filigree, precious stones, or zoomorphic decoration as well. It was an everyday item that was easy to embellish and personalize.

This idea of jewelry expressing an individual's sense of style was not new and indeed is still a current feature of dress today, but for the Romans, for whom dress tended to be uniform and traditional, jewelry was perhaps one of the only ways to set a person apart. Most clothing was made of wool, and it was often undyed. Women tended to wear color more than men did,

but it could be expensive. Purple, for example, which covered not only tints of purple but many reds, came from a sea snail, and normally its use was confined to limited decoration, such as the borders of togas. Embroidery was another option, but since most clothes were made by loom, often what decoration went into a garment was created at the same time as the garment itself.

Generally the Romans were not known for ostentation, and there were times in their history when it was made illegal. For example, in 215 BCE after the terrific defeat at Cannae by Hannibal, the Romans passed the Lex Oppia, a sumptuary law intended to restrict how much jewelry a woman might wear. The idea was that they might wear half an ounce but give the rest over to the state to fund the war against Hannibal. The law was repealed in 195 BCE, in large part because of protests by Roman women. While the law may have helped increase revenue, it was unpopular, and despite support from such conservatives as Cato the Elder, it was struck down. One argument that women and their male supporters used was that jewelry was one of the few things that women might wear to distinguish themselves from others. Rich women in particular wanted to display their position. Indeed, it was only through lavish displays of wealth that women, who ordinarily kept to the domestic sphere, might indicate their rank, wealth, and style.

One of the more fascinating results of wearing such simple clothing was that in addition to jewelry, women who could afford it took to sporting elaborate hairstyles. This was such an important aspect of deportment that some portrait busts were made in such a way that the hairstyles could be updated (see the entry **Portrait Bust**). Some hairstyles were so elaborate that satirists such as Juvenal mocked them. For example, Juvenal poked fun at one popular hairstyle of the Flavian period (69–138 CE) in which a woman's hair was raised in an arch at the front but placed in a bun in the back, a style that lent one a sense of height until the back came into view. That these styles were well known and imitated is clear not only from portraiture but also from toys. Some dolls of the same period boast the same hairdo. The work that went into these elegant coifs was considerable, often requiring a team of slaves, cosmetics, numerous pins, and wigs or extensions. Roman portraiture has preserved what many of these elaborate coiffures looked like, though paintings also provide some insights into how such fashions changed.

Fibulae, via Rome, became a common adornment among peoples new to the empire too, particularly among the Germanic peoples. Their cloaks, so Tacitus claimed, were often held together with a similar brooch or thorn, much as fibulae fastened Roman clothing. Some of the finest examples that have been found hail from Germanic contexts and underscore the impact of Rome on its neighbors not only politically but stylistically and fashionably as well.

FURTHER INFORMATION

Calinescu, Adriana, ed. *Ancient Jewelry and Archaeology.* Bloomington: Indiana University Press, 1996.

Cleland, Liza, Glenys Davies, and Lloyd Llewellen-Jones, eds. *Greek and Roman Dress from A to Z.* New York: Routledge, 2007.

Cleland, Liza, Mary Harlow, and Lloyd Llewellen-Jones, eds. *The Clothed Body in the Ancient World.* Oxford, UK: Oxbow, 2005.

Croom, Alexandra. *Roman Clothing and Fashion.* Charleston, SC: Tempus, 2002.

Hattatt, R. *Ancient Brooches and Other Artefacts.* Oxford, UK: Oxbow, 1989.

Higgins, Reynold A. *Greek and Roman Jewellery.* 2nd ed. Berkeley: University of California Press, 1980.

Ogden, Jack. *Ancient Jewellery.* Berkeley: University of California Press, 1992.

Sebesta, Judith L., and Larissa Bonfante, eds. *The World of Roman Costume.* Madison: University of Wisconsin Press, 1994.

Stephens, Janet. "Ancient Roman Hairdressing: On (Hair)pins and Needles." *Journal of Roman Archaeology* 21 (2008): 110–132, http://www.journalofromanarch.com/samples/v21.110_adj.pdf.

Wilson, L. M. *The Clothing of the Ancient Romans.* Baltimore: Johns Hopkins University Press, 1938.

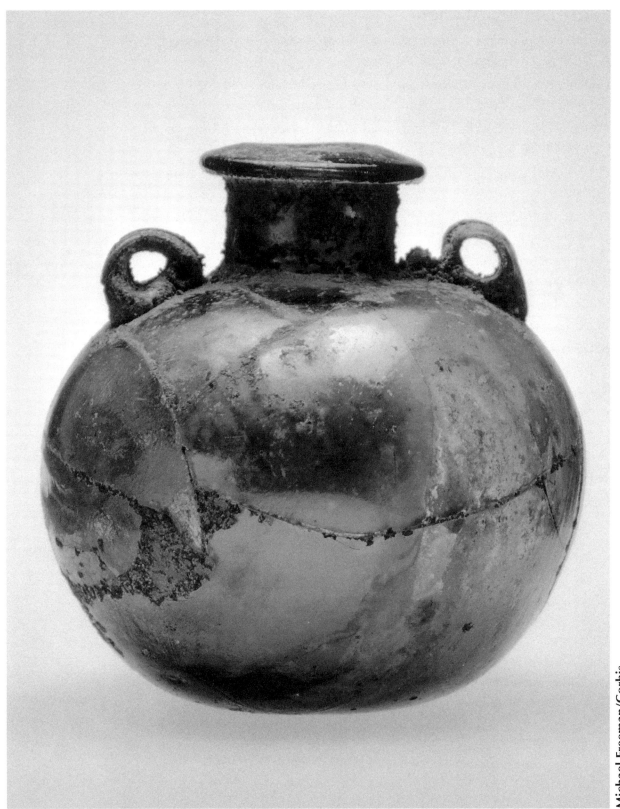

Perfume Bottle

Roman
First Century CE

INTRODUCTION

The use of makeup, perfume, and fancy bottles or canisters to house them was an import to the Roman world. Incense may have had a role to play, especially in religious contexts, but the Romans, unlike the peoples of the Levant and even Greece, did not by and large take to cosmetics or glass-making until the first century BCE.

DESCRIPTION

The small bottle shown here dates to the first century BCE and is typical of the small vessels used to contain either oil for after bathing or perfumes. The small eyelets at the top allowed the owner to suspend the bottle by a string or a chain around the neck. This made the bottle easily accessible, and when the bottle was attractively made it was also an item of jewelry. Generally small, these bottles, known by various names—*alabastra, unguentaria, ampulla,* and *aryballos*—were mainstays in personal care and one's toilette.

Glass manufacture, cosmetics, and perfume were ancient by the time Rome came to prominence. The Egyptians and Persians and through them the Greeks had long used cosmetics and stored them in attractive glass containers. In Italy, Greek communities to the south in Magna Graeca and the Etruscans farther north all used a variety of glass vessels, including those for cosmetics. In Rome and central Italy, however, little evidence of glass use has so far surfaced. Since makeup too seems to have been less common among the Romans until comparatively late—it was not popular until the late republic—it is possible that they had no real need for such containers or that they used ceramics. When glass did appear in Rome, around the middle of the first century BCE, it took off—within a century the Romans were producing glass on par with the best made anywhere else. The opening of the east in the wake of Rome's conquests in the Mediterranean gave the Romans more exposure to glassmaking but also gave glassmakers an entirely new and untapped market, and many probably made their way to Rome.

Glassmaking was highly developed in the Hellenistic world. When Roman consumers entered the picture, the style of glass was often suited to Roman tastes, but the techniques used to make it had yet to change. From 50 BCE to about 100 CE, much of glassware was cast. Beginning in roughly the same period (ca. 40 BCE to 650 CE), a new technique arrived and soon became the primary way to make glass—free glassblowing. Molten globules of glass were picked up with a hollow tube through which the artisan blew. Probably by experimentation, glassmakers invented a number of ways to improve upon this new technology, from reheating the blown glass to using tools to shape it. Mastery of these techniques enabled the craftsman to create nearly any shape in glass. As a result, glassware became widespread and was in use daily.

The next innovation was mold-blown glass (ca. 25–650 CE). Similar to free-blown glass, mold-blown glass was blown into a reusable mold. The advantage to this method was that it was a way in which to create and decorate a single piece all at once. Moreover, while one might have to replace the mold or sections of it from time to time, one could produce identical pieces. This technique has been used ever since.

There is evidence too that glass was used architecturally in the Roman world, though it was rare and expensive. It was in use by the first century CE and was reserved for buildings of importance.

Glassmaking continued unabated until increasing trouble, both internal and external, disrupted the western half of the empire. With the capital in Constantinople from the fourth century on and with fewer political and social disruptions, the eastern empire carried on the traditions of Roman glassmaking. Alexandria was one such site. In the western empire, glass was still made but increasingly on a smaller scale and in time with less sophistication.

SIGNIFICANCE

Exposure to eastern luxuries, one result of Rome's conquests in the eastern Mediterranean, introduced the practice of wearing cosmetics, and by the first century BCE the Romans too, particularly women, were wearing makeup. Attractive packaging then as now was important, and appealing glass bottles and cases no doubt did much to help sales. Sellers of perfumes (*unguentarii* or *unguentariae*), though in a low-status trade, often made a lot of money. Many perfumers were women too. Taken together, we see that even low-status work could be lucrative but also that women were not debarred from business. In the city of Capua, for example, one street was devoted solely to purveyors of perfumes and cosmetics. There were even perfumers in the forum, there to supply temples, funerary clubs, the public baths, and general customers.

Perfumes in some manner had been around for a long time. For example, the censors in 189–188 BCE attempted to ban the sale of *unguenta exotica,*

PLINY, *NATURAL HISTORY*, BOOK 13, CHAPTER 4

The excesses to which luxury has run in unguents

These perfumes form the objects of a luxury which may be looked upon as being the most superfluous of any, for pearls and jewels, after all, do pass to a man's representative, and garments have some durability; but unguents lose their odour in an instant, and die away the very hour they are used. The very highest recommendation of them is, that when a female passes by, the odour which proceeds from her may possibly attract the attention of those even who till then are intent upon something else. In price they exceed so large a sum even as four hundred denarii per pound: so vast is the amount that is paid for a luxury made not for our own enjoyment, but for that of others; for the person who carries the perfume about him is not the one, after all, that smells it. . . .

But the most wonderful thing of all is, that this kind of luxurious gratification should have made its way into the camp even: at all events, the eagles and the standards, dusty as they are, and bristling with their sharpened points, are anointed on festive days. I only wish it could, by any possibility, be stated who it was that first taught us this practice. It was, no doubt, under the corrupting influence of such temptations as these, that our eagles achieved the conquest of the world: thus do we seek to obtain their patronage and sanction for our vices, and make them our precedent for using unguents even beneath the casque.

[Pliny, *Natural History*, http://perseus.uchicago.edu/perseus-cgi/citequery3.pl?dbname=PerseusLatinTexts&getid=1&query=Plin.%20Nat.%2013.4.]

foreign or exotic perfumes, but the measure had little success. To pass such a decree suggests that use of perfume was already widespread even as the east was opening up. This makes sense, as temples used incense for ritual purposes; it is also likely, however, that they used it to mask the smells of the city.

The ancient world, particularly in urban settings, was a smelly place. Bathing, while a normal part of Roman life, was nonetheless performed without soap, and deodorants were unknown. Scented oils, especially applied after bathing, were popular. Waste from sewers, butcher shops, and tanneries as well as the odor from public toilets, fullers, shops, and refuse piles and the sweat of hardworking people all made the necessity for incense or perfumes urgent. In sacred precincts, for example, no one wanted the gods to suffer the city's stench, so incense was a must. Naturally the citizens, though used to certain unpleasant realities, desired to smell good themselves and fend off offending odors.

Perfumes were available to all, but quality varied. Some ingredients, such as those from India, Arabia, and Persia, were expensive and only affordable

for those of means. However, many native Italian ingredients or those found elsewhere in Europe made perfectly workable perfumes. Olive oil was probably one of the chief substances for a perfume's base—poor-quality oil would smell and taste less like olives and may have been preferred, since it would allow the other scents to work to best effect. There were many ingredients available, and several sources, including Pliny the Elder's *Natural History* and Theophrastus's (d. ca. 287 BCE) *On Odors,* detail recipes for both perfumes and cosmetics. Some of the more popular were rose petals (Campania was a major producer), anise, marjoram, tree resins such as styrax, and roots such as calamus (also known as sweet rush). Cinnamon, myrrh, frankincense, and cardamom were imported from various parts of Asia, some from as far away as India.

As with perfume, the Romans were relative latecomers to wearing makeup, though in both cases many authors railed against what they saw as degenerate, foreign practices. Greek men might wear makeup on occasion, as Demetrius Phalereus (d. 280 BCE), an Athenian orator, did most famously, but more conservative Romans believed that men should not don makeup. There were a variety of applications, including rouge, mascara, face powder, and hair coloring. The Romans referred to makeup as *fucus,* originally a moss used for blush or rouge but in time a collective noun for all manner of face paint. Some ingredients might raise an eyebrow today, such as dried crocodile dung for whitening the skin, but others are not so dissimilar to those in beauty products today. Lanolin, the oil from sheep's wool, is still used in many cosmetics and lotions today. The poet Ovid (d. 17 CE), in Book 3 of his *Ars Amatoria* (*The Art of Love*), devotes space to the use of cosmetics and their importance. He recommends that women use them if they need to but that they should not be seen using them and that they ought not apply unguents too thickly or in any way call attention to the artifice of beauty. As the author of a work on makeup, the *Medicamina Faciei,* often translated as *The Art of Beauty,* Ovid spoke with some authority on the subject.

Many of the ingredients used in the manufacture of cosmetics were also used as spices or in medicines in the Roman world. Some were also known poisons. Mercury and lead, for example, were common ingredients used to improve one's skin. Too much use of them, however, damages the skin, and so Roman ladies in attempting to improve damaged skin often did further damage with certain cosmetics. Good skin was a requisite for beauty in the Roman world, and women worked hard to make it look as smooth and light as possible. Some impetus for this may have come from class consciousness, that is to say, women with untanned skin clearly spent little time out of doors or working. Pale skin thus might have signified someone highborn.

Cosmetics retained their role in the eastern half of the empire. In the western empire, however, the culture changed as Germanic influence came

to dominate. Outside the church, where scented oils were necessary for various rites, the wearing of makeup and perfume became increasingly rare.

FURTHER INFORMATION

Ambrosio, A. *Women and Beauty in Pompeii.* Los Angeles: J. Paul Getty Museum, 2001.

Brun, Jean-Pierre. "The Production of Perfumes in Antiquity: The Cases of Delos and Paestum." *American Journal of Archaeology* 104(2) (April 2000): 277–308.

Dayagi-Mendels, M. *Perfumes and Cosmetics in the Ancient World.* Jerusalem: Israel Museum, 1989.

Fleming, Stuart J. *Roman Glass: Reflections on Cultural Change.* Philadelphia: University of Pennsylvania Museum of Archaeology and Anthropology, 1999.

Fleming, Stuart J. *Roman Glass: Reflections of Everyday Life.* Philadelphia: University of Pennsylvania Museum of Archaeology and Anthropology, 1997.

Jackson, Ralph. *Cosmetic Sets of Late Iron Age and Roman Britain.* London: British Museum Press, 2010.

Lightfoot, C. S. "The Pendant Possibilities of Core-Formed Glass Bottles." *Metropolitan Museum Journal* 36 (2001): 10, 59–66.

Olson, Kelly. "Cosmetics in Roman Antiquity: Substance, Remedy, Poison." *Classical World* 102(3) (Spring 2009): 291–310.

Stern, E. Marianne. "Roman Glassblowing in a Cultural Context." *American Journal of Archaeology* 103(3) (July 1999): 441–484.

Stewart, Susan. *Cosmetics & Perfumes in the Roman World.* Stroud, UK: Tempus, 2007.

Whitehouse, David. *Glass of the Roman Empire.* Corning, NY: Corning Museum of Glass, 1988.

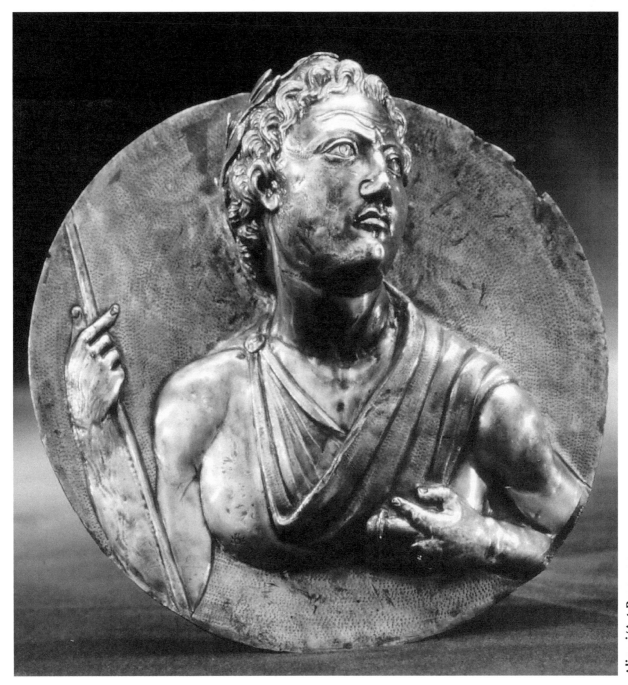

Phalera

Marengo, Italy
Second Century CE

INTRODUCTION

Armies have long called out and celebrated the bravest and most selfless among their ranks. In this the Romans were no exception, and during the Roman Republic they devised several different methods to mark soldiers who had especially distinguished themselves. To boast the highest military honors one could earn was not something taken lightly. Many veterans made sure that their funerary portraiture included their *dona militaria,* the ancient equivalent of service medals. The practice began in the republic, when additional rations, pay, or equipment served to reward the brave, but proliferated in the first two centuries of the Roman Empire. Roman military awards such as the *phalerae* (sing. *phalera*) show what the military held to be most important, but since those achievements also carried over into the civilian world, military awards also reveal the military's integral role in Roman society.

DESCRIPTION

The first image is of a Roman *phalera* of embossed silver, one found in the early 20th century in Italy. It dates to sometime in the second century CE, but *phalerae* had been military decorations since at least the time of the historian Polybius (d. 122 BCE), our earliest source for their use. The second image, a cenotaph, is now in the Rheinisches Landesmuseum in Bonn, Germany. It was found in Xanten, Holland, where nearby in the first century there had been a frontier fort, Vetera. Marcus Caelius, a centurion, stands out from two of his freedmen, wearing all his military decorations. He carries a baton and a symbol of his office, a *vitis,* made of twisted vines. He is clad in armor and atop that wears six *phalerae* (two hidden partially by his arms), disks awarded to him for service and valor. Caelius's military awards also include torques (open metal hoops), *armillae* ("bracelets"), and a rarely won honor, the *corona civica,* a crown of oak leaves, for having saved the life of a fellow citizen. He was at the time of his death a highly decorated army veteran, one who had clearly spent far more than the usual 20-year stint serving Rome. Upon the cenotaph is an inscription that reads:

M[arcus] Caelius M[arci] l[ibertus] Privatus // M[arcus] Caelius M[arci] l[ibertus] Thiaminus

M[arco] Caelio T[iti] f[ilio] Lem[onia] Bon[onia] // [centurioni] leg[ionis] XIIX ann[orum] LIII s[emissis] / [ce]cidit bello Variano ossa / [i]nferre licebit P[ublius] Caelius T[iti] <oab>E = F<cab>[ilius] / Lem[onia] frater fecit

M[arcus] Caelius Privatus, Freedman of Caelius// M[arcus] Caelius Thiaminus, Freedman of Caelius

For Caelius, son of Titus, from the Lemonian voting tribe, from Bologna, a centurion in Legion XVIII, 53 and a half years old. He fell in the Varian war. [His] bones one may bring [here]. Publius Caelius, son of Titus, of the Lemonian voting tribe, [his] brother, made this.

Caelius was killed in action during one of Rome's worst military disasters, the destruction of three legions under Publius Quinctilius Varus in the Teutoburger Wald (9 CE). Varus and his men had been lured out of their camp into an ambush by a former Roman auxiliary, Arminius, and no one was spared. Six years later another army came to the site to bury the dead and attempt to recover the standards. The bodies were interred on the spot, which explains why Caelius's brother wrote that Caelius's bones, if found, might be brought to his monument for reburial. Caelius had achieved so much in his long years of military service, so it is small wonder that his brother should desire that the memorial attest Caelius's valor. The *corona civica,* one of the highest honors in the Roman world, entitled the bearer to special seating near the senators during the games and to be greeted by standing ovation. The torques, which by the time of Augustus had become awards granted only to men of centurial rank or below, were granted for a variety of reasons, few of which are well attested. The bust of Caelius also displays his *phalerae.*

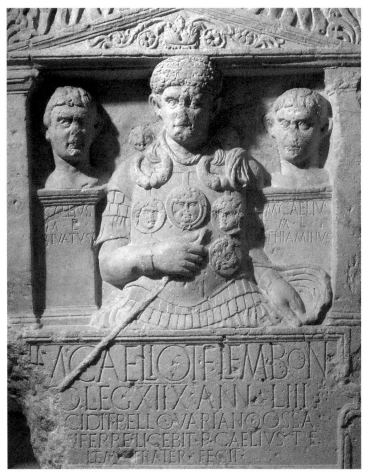

Cenotaph of Centurion Marcus Caelius, ca. 9 CE, from Xanten, Holland. (Alfredo Dagli Orti/The Art Archive/Corbis)

POLYBIUS, *HISTORIES*, BOOK 6, SECTION 39

Military Decorations

A very excellent plan also is adopted for inducing young soldiers to brave danger. When an engagement has taken place and any of them have showed conspicuous gallantry, the Consul summons an assembly of the legion, puts forward those whom he considers to have distinguished themselves in any way, and first compliments each of them individually on his gallantry, and mentions any other distinction he may have earned in the course of his life, and then presents them with gifts: to the man who has wounded an enemy, a spear; to the man who has killed one and stripped his armour, a cup, if he be in the infantry, horse-trappings if in the cavalry: though originally the only present made was a spear. . . . In the capture of a town those who are first to mount the walls are presented with a gold crown. So too those who have covered and saved any citizens or allies are distinguished by the Consul with certain presents; and those whom they have preserved present them voluntarily with a crown, or if not, they are compelled to do so by the Tribunes. The man thus preserved, too, reverences his preserver throughout his life as a father, and is bound to act towards him as a father in every respect. By such incentives those who stay at home are stirred up to a noble rivalry and emulation in confronting danger, no less than those who actually hear and see what takes place. For the recipients of such rewards not only enjoy great glory among their comrades in the army, and an immediate reputation at home, but after their return they are marked men in all solemn festivals; for they alone, who have been thus distinguished by the Consuls for bravery, are allowed to wear robes of honour on those occasions: and moreover they place the spoils they have taken in the most conspicuous places in their houses, as visible tokens and proofs of their valour. No wonder that a people, whose rewards and punishments are allotted with such care and received with such feelings, should be brilliantly successful in war.

[Polybius, *Histories*, translated by Evelyn S. Shuckburgh (1889; reprint, Bloomington: Indiana University Press, 1962), http://www.perseus.tufts.edu/hopper/text?doc=Perseus%3Atext%3A1999.01.0234%3Abook%3D6%3Achapter%3D39.]

Phalerae were small disks usually made of metal and typically decorated with images of deities or their symbols, mythological creatures, or animal-inspired motifs such as lion heads. Many were used to decorate horses, but they were also prominent military awards. Polybius recorded that a solider received a *patella*, another type of award, for having killed and despoiled an enemy but that cavalrymen received *phalerae*. This accords well with the *phalerae* as trappings for horses and with the notion that they likewise often stood as symbols of the equestrian order, which originally signified those who could afford to maintain and outfit horses for war. Over time *phalerae*

became another honor given to worthy soldiers, one that was generally rewarded to ranks at or below centurion by the time of the Principate. They were generally worn on the chest and thus visibly acted as both a testimony to the individual soldier's valor and an inspiration to his fellows to reach for similar distinction.

Many *phalerae* appear to have been awarded during the long wars with various Germanic peoples. Certainly Caelius is an example of this, but so too is the set of nine *phalerae* discovered at the site of Vetera, the same fort where Caelius's cenotaph was discovered. It is rare to find *phalerae,* let alone a complete set, as they were valuable. Some may have only had a wash of precious metal on them, but some likely contained considerable amounts. There are examples, for instance, of soldiers handing over their awards to usurping generals to finance their ambitions. Many *phalerae,* like most military equipment, were returned to the state when a soldier died and was reused. Some extant *phalerae,* for example, have more than one name etched into them.

SIGNIFICANCE

Phalerae indicate a number of key aspects of Roman culture, most particularly attitudes toward military duty, valor, and sacrifice. While we do not always know the exact stipulations required to earn individual awards, we do know from surviving sources that individual bravery was highly prized among the Romans. From Livy's legendary accounts of Horatio Cocles singlehandedly holding a bridge so his comrades could escape as well as from Julius Caesar's account of two rival centurions, Lucius Vorenus and Titus Pullo (now famous as characters in the fictional HBO series *Rome*), who attempted to outdo one another on the front lines, it is clear that Romans enjoyed tales of derring-do, perhaps all the more so when they had actually happened. Another indicator of this fascination is the fact that men who had won especially high honors were also accorded certain rights in the civilian world. In addition, for instance, to wearing their crowns and sitting next to senators at the games and other spectacles, those few men who earned the *corona civica* were also freed from all public duties, as were their fathers and grandfathers if still living. Moreover, the man who had been saved, whose testimony alone might earn his rescuer this honor, was expected to treat his savior like a father, paying him all the same honors he would his own parents. The public face of these military rewards no doubt added much to their appeal, for while such recognition might help with one's advancement through the ranks, the same attention in civilian life often had as many benefits.

The military awards that garnered the highest respect were those where the solider had risked his own life to perform a deed. The first man over an enemy's defenses, the first to board an enemy ship, and the man who stood his ground and successfully fended off an enemy from either a civilian or

fellow soldier all acquired great honor for facing dangers that in most cases probably meant the death of the man who attempted it. While important for the man in question and the one he might rescue, the impact on his fellow soldiers should not be underestimated. There are numerous accounts of soldiers wavering before action who went on to fight and win because of a brave comrade urging them on with either words of encouragement or friendly taunts. Livy, for example, relates one battle with the Istrians where the standard-bearer, Aulus Baeculonius, threw his standard across the enemy trench and then followed it, all in an effort to goad his comrades into action. Individual bravery on occasion could determine the outcome of the battle. In Baeculonius's case the men did follow him, routed the enemy, and retook the camp that the Istrians had captured.

Fashions change in military style just as they do in civilian contexts, and by the third century the centuries-old system of awarding soldiers with numerous metal decorations started to wane. Instead, fewer such awards were granted, and extra rations or pay were substituted. One still reads of a soldier being decorated with torques, but this mention is increasingly made in connection with his also being *duplarius,* a soldier who gets double rations. The third century was one of conflict, and it is possible that as precious metals were needed for other uses, their role in creating *dona militaria* dwindled. The practice, however, did not die out; it only changed. In the fourth century Emperor Julian awarded crowns for bravery, in the fifth century the *magister militum* Flavius Aetius was awarded several *dona,* and during the reign of Justinian in the sixth century his general Belisarius honored his men with *armillae* and torques. These later occasions stand out for the rarity of the practice, however, and while the institution of donatives such as extra pay or rations ousted the more glamorous *dona* such as *phalerae,* in many ways this change harkened back to the early republic, when similar rewards were popular.

FURTHER INFORMATION

Bishop, M. C., and J. C. N. Coulston. *Roman Military Equipment: From the Punic Wars to the Fall of Rome.* Oxford, UK: Oxbow, 2006.

Goldsworthy, Adrian. *The Complete Roman Army.* Reprint ed. London: Thames and Hudson, 2011.

Keppie, Lawrence. *The Making of the Roman Army: From Republic to Empire.* Totowa, NJ: Barnes and Noble Books, 1984.

Maxfield, Valerie A. *The Military Decorations of the Roman Army.* Berkeley: University of California Press, 1981.

Watson, G. R. *The Roman Soldier.* Ithaca, NY: Cornell University Press, 1985.

Webster, Graham. *The Roman Imperial Army of the First and Second Centuries A.D.* London: Adam and Charles Black, 1979.

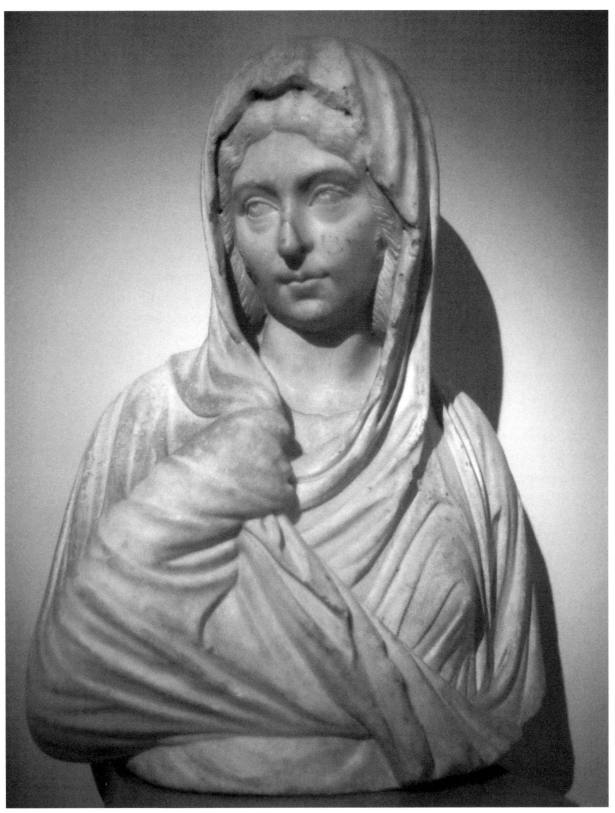

Portrait Bust

Possibly from Greek Islands
Circa Third Century CE

INTRODUCTION

Portraiture is a wonderful way to experience the past. The faces of people, famous and unknown, provide a look at the people who made a culture what it was. Portraiture, however, while it might depict an individual person, most often served other purposes as well. The death masks of Roman aristocrats lent their descendants continuity with their own past and advertised their aristocratic status to all at the same time. Imperial art took this aspect of public performance a step further in that art served as propaganda, demonstrating the values and goals of that regime. Portraiture is thus a look at not only the faces of the past but also the values, ideals, and sociopolitical outlook of those who commissioned them.

DESCRIPTION

The portrait bust displayed here, of a Severan lady, is made of marble and is about 26 inches (66 centimeters) tall. Its provenance is not certain, but it may have been discovered on one of the Greek islands; it is now on display at the Metropolitan Museum of Art in New York. This woman, whose name is unknown, wears the hairstyle made famous by Empress Julia Domna, second wife of Septimius Severus, one where the hair was divided along the ridge of the skull and arranged in neat rows. At one time this bust may have had a decoration for the hair, as there are small holes, one with the remains of an iron rod within it, just inside the veil.

Portraiture has a long history in Rome. Several ancient authorities cite the example of funeral processions where noble families wore the death masks of their ancestors. These were kept in order at home with records of their individual deeds. As death masks they naturally preserved the features of the deceased, but since they were likely made of wax or plaster they have not survived. It is possible that this tradition, where actual likenesses were taken, influenced the tradition of verism in Roman portraiture.

The earliest surviving busts and portraits are mostly from the last century BCE. In a time of intense political and social turmoil, when the traditional

competition for offices, position, and influence turned increasingly deadly, many of the top contenders, men such as Sulla, Pompey, Julius Caesar, and Octavian, made good use of portraits as propaganda. Caesar, for example, not only put his face on coins—a first—but also commissioned portraits that were carried by his supporters. The value of art as political tool is not new. After the assassination of Caesar in 44 BCE, for instance, Brutus made sure to depict not only his own portrait but also a *pileus,* or freedman's cap, and two daggers on the reverse (see the entry **Coin Mold**). Brutus's side lost to Octavian, whose skill at the uses of propaganda far exceeded that of the conspirators.

Octavian, better known by his imperial appellation Augustus, had a conscious program of recasting his own role in the civil wars that followed in the wake of his adopted uncle's murder and also promoting a more traditional Rome. Art played a key role in this. Augustus's portraits, for example, follow much of the Greek tradition in terms of their idealism—the emperor appears fit, young, and godlike—but with due attention to Roman constraint and conservatism. In his portraits as a general or pontifex maximus, the high priest, he is at once timeless and unabashedly Roman, an emblem of old-fashioned Roman values. Other Augustan works likewise demonstrate this program, such as the Ara Pacis, a sacrificial altar and monument replete with iconic images—Aeneas sacrificing to the Penates, Augustus with his family, the Senate in procession, Romulus and Remus, the goddess Roma in armor—all of which conjure tradition and Augustus as the restorer of that tradition.

Later imperial portraiture was likewise concerned with a political message. Augustus's successors, the Julio-Claudians (14–68 CE), maintained his portrait style in part to emphasize their continuation of his rule. Portraits of women in this period are famous for the elaborate hairstyles they so often depict (for more on women's clothing and adornment, see the entry **Fibula**). Under the Flavians (69–96 CE), especially under Vespasian who emerged as emperor after Nero, there was a return to the verism of the later republic. Vespasian and his sons, for example, appear less idealized than their Julio-Claudian predecessors. Still, even verism had conventions—the wrinkles, baldness, and other signs of age may have reflected the physiognomy of a 60-year old man but also played into ideas of the wise elder, the paterfamilias, and of a capable old-fashioned but solid man ruling the state.

The next great change happened with Emperor Hadrian (r. 117–138 CE). An admirer of Greek culture and of the first emperor, Augustus, Hadrian returned to the classicism of early imperial portraiture. He, like Augustus, was keenly aware of the role that art might play in his regime. Many of these portraits depict Hadrian bearded; this reflected both the new style of wearing facial hair that he ushered in but also recalled classical portraits of philosophers. One new and lasting technique employed by artists at this time was to drill the pupil and iris of the eye in sculpture—this lent the eyes more depth and interest. The Antonine emperors (138–192 CE) continued

Primary Source

POLYBIUS, *THE HISTORIES*, BOOK 6, SECTION 53

53 1 Whenever any illustrious man dies, he is carried at his funeral into the forum to the so-called rostra, sometimes conspicuous in an upright posture and more rarely reclined. 2 Here with all the people standing round, a grown-up son, if he has left one who happens to be present, or if not some other relative mounts the rostra and discourses on the virtues and successful achievements of the dead. 3 As a consequence the multitude and not only those who had a part in these achievements, but those also who had none, when the facts are recalled to their minds and brought before their eyes, are moved to such sympathy that the loss seems to be not confined to the mourners, but a public one affecting the whole people. 4 Next after the interment and the performance of the usual ceremonies, they place the image of the departed in the most conspicuous position in the house, enclosed in a wooden shrine. 5 This image is a mask reproducing with remarkable fidelity both the features and complexion of the deceased. 6 On the occasion of public sacrifices they display these images, and decorate them with much care, and when any distinguished member of the family dies they take them to the funeral, putting them on men who seem to them to bear the closest resemblance to the original in stature and carriage. 7 These representatives wear togas, with a purple border if the deceased was a consul or praetor, whole purple if he was a censor, and embroidered with gold if he had celebrated a triumph or achieved anything similar. 8 They all ride in chariots preceded by the fasces, axes, and other insignia by which the different magistrates are wont to be accompanied according to the respective dignity of the offices of state held by each during his life; 9 and when they arrive at the rostra they all seat themselves in a row on ivory chairs. There could not easily be a more ennobling spectacle for a young man who aspires to fame and virtue. 10 For who would not be inspired by the sight of the images of men renowned for their excellence, all together and as if alive and breathing? What spectacle could be more glorious than this?

[Polybius, *The Histories*, Vol. 3, translated by W. R. Paton (1923), http://penelope.uchicago.edu/Thayer/E/Roman/Texts/Polybius/6*.html.]

many of the conventions that Hadrian had established. They too appear with curly hair and nicely trimmed beards.

The Severan dynasty, which began with Septimius Severus (r. 193 CE) and ended with the death of Alexander Severus (d. 235 CE), was a remarkable period in Roman portraiture. In the Severan period, artists looked to previous Roman artistic styles but took them in new direction. Septimius Severus, a North African, was a devotee of the Egyptian god Serapis and was depicted with the same double corkscrew beard so often depicted on the deity. Severan artists also added the shoulders and later the torso to their portrait busts. Like so much of Roman portraiture, there was a certain degree of verism to their renderings; that is, they included less idealized, more

personal attributes. Since the Severans liked the style of portraiture favored by the Antonines, there is some continuity with the more idealized depictions they employed, but as with the figure here one sees that this is not a generic portrait but instead is one of an individual. With Caracalla, eldest son of Septimius and his coruler for the last 13 years of the latter's life, there is a return to a more severe depiction. In some portraits Caracalla, his hair short, his beard either just visible or short, seems to scowl menacingly. Accounts of his reign describe a man who was obsessed with Alexander the Great and was also superstitious and given to violence. On several occasions Caracalla was responsible for massacres, so it is possible that he wished to reinforce the idea of a tough, dangerous ruler.

In the period of war that followed the death of Alexander Severus (d. 235 CE), even those who wore the purple only a short time often managed to have their portraits made. These busts tend to display the same level of quiet ferocity that portraits of Caracalla often do. Like him, some of these emperors, such as Philip the Arab (d. 249), appear with short-cropped hair and stubbly beards. The veristic portrayal in this period gave way by the late third century to a more abstract style. The portraits of the Tetrarchs, for example, show them embracing—a sign of cooperation and solidarity—but they are almost caricatures. Not all portraits fell into this category. Some still employed the Hellenistic style that had characterized much of Roman portraiture since the first century BCE.

SIGNIFICANCE

Portraiture is a gold mine for historians. At the most basic level, one gets a sense of what people looked like; we can put names to faces and more easily imagine these remote figures as people. However, these same statues and busts also provide rich details about clothing, jewelry, hairstyles, and even footwear. This is important in its own right, but in the larger picture we can also learn a lot about a culture's values. Comparing, for example, a portrait of Augustus as general and one of Caracalla shows us two very different worlds. Both rulers sought to use their portraiture to say something of themselves and their reign, but they sent very different messages. With Augustus there is a sense of command, confidence, and quiet strength, just the sort of meaning he wanted to convey after the bloody civil wars that led to his success. Caracalla, on the other hand, appears strong but dangerous, not someone to trifle with, and for an emperor who spent much of his time at war, either with foreign enemies or his own family (he murdered his brother Geta, for example), this makes some sense. Art played a key role in power politics, in promoting ideas, in dynasties, and in cementing in the mind of the populace that they owed their ruler obedience.

Another important aspect of imperial portraiture, however, was its effect on how citizens, specifically nonelite citizens, approached art. In the time of

Augustus, for instance, many private citizens emulated imperial styles. Women, for example, had themselves depicted with the hairstyle of the empress, Livia. While nobles had long employed portraiture, many below them in rank began to do so too. The many tombs of freedmen in this period, perhaps not surprisingly, looked to late republican models of portraiture, with their realism, for inspiration. Having been successful in business, they proudly displayed their change of fortune and took pride in their trades, many of which are likewise depicted on their monuments. In emulating earlier, more traditional aristocratic portraiture, these freedmen also meant to demonstrate their own *romanitas,* their membership in society, and perhaps too a sense that they had arrived socially, at least within their own social division.

FURTHER INFORMATION

Brigstocke, Hugh, ed. *The Oxford Companion to Western Art.* New York: Oxford University Press, 2001.

Dunbabin, Katherine M. D. *The Mosaics of the Greek and Roman World.* New York: Cambridge University Press, 1999.

Goldscheider, Ludwig. *Roman Portraits.* New York: Oxford University Press, 2004.

Hanfmann, George M. A. *Roman Art: A Modern Survey of the Art of Imperial Rome.* Greenwich: New York Graphic Society, 1975.

Kampen, Natalie B. "On Writing Histories of Roman Art." *Art Bulletin* 85(2) (2003): 371–386.

Kleiner, Diana E. E. *Roman Sculpture.* New Haven, CT: Yale University Press, 1992.

Ling, Roger. *Roman Painting.* New York: Cambridge University Press, 1991.

Ramage, Nancy H., and Andrew Ramage. *Roman Art: Romulus to Constantine.* New York: Abrams, 1991.

Vanderpool, Catherine de Grazia. "Roman Portraiture: The Many Faces of Corinth." In *Corinth: The Centenary, 1896–1996,* Vol. 20, edited by Charles K. Williams II and Nancy Bookidis, 369–384. Princeton, NJ: American School of Classical Studies at Athens, 2003.

Vermeule, Cornelius, III. "Roman Art." In *Art Institute of Chicago Museum Studies: Ancient Art at the Art Institute of Chicago* 20(1) (1994): 62–77.

Wood, Susan. "Subject and Artist: Studies in Roman Portraiture of the Third Century." *American Journal of Archaeology* 85(1) (January 1981): 59–68.

Zanker, Paul. *The Power of Images in the Age of Augustus.* Ann Arbor: University of Michigan Press, 1988.

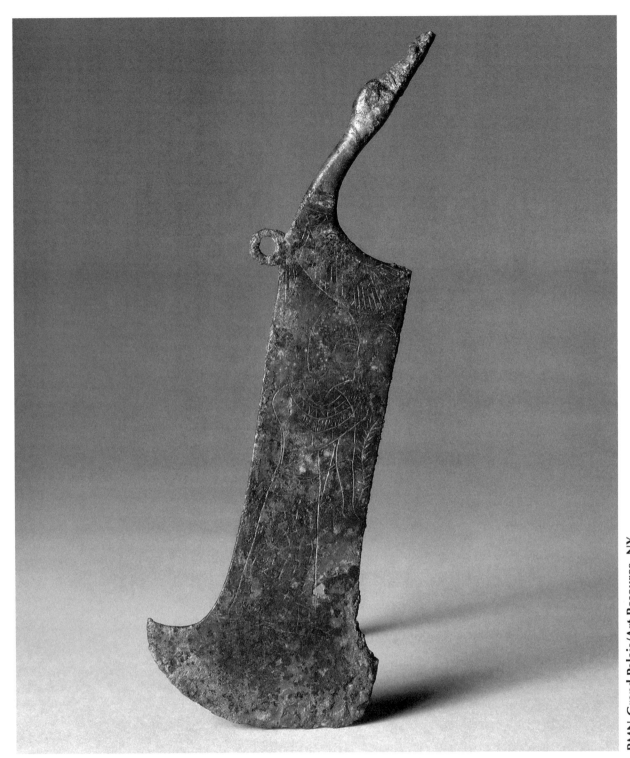

Razor

North Africa
Date Unknown

INTRODUCTION

Changes in fashion, appearance, and hairstyles can tell us much about a culture. The ancient world is no exception. The early Romans, down to the fourth century CE, wore beards and tended to have longer hairstyles. This changed ca. 300 BCE when the first barber arrived in Rome. From that time until the reign of Emperor Hadrian (d. 138), some four and half centuries later, most Roman men cut their hair short and shaved their beards. Shaving, which for most Romans was something a barber did for them, took on a number of meanings, from a rite of passage to a way to socialize and share news, and reveals a lot about Roman vanity, grooming, and even humor.

DESCRIPTION

This bronze razor was discovered in North Africa. It is one of several styles of *novaculae* ("razors" sing. *novacula*) used by the Romans. Most razors, while they might take a variety of shapes, were sharp and difficult to use on one's own. They were used much as straight razors were used until around 1903, when King Camp Gillette introduced the safety razor. Roman razors, and most of their descendants until recently, required sharpening, stropping, and a deft hand to cut the whiskers effectively without cutting the face. Most Romans appear to have trusted other more skilled hands for such grooming. Satirists, of course, were not averse to telling jokes about the dangers of being cut by poor barbers. Most men, despite the potential for injury, visited a *tonsor* ("barber"), often daily, to have their beards shaved, their hair cut, and their nails clipped.

The Romans had not always shaved. In fact, until about 300 BCE the Romans by and large wore beards. The Etruscans had razors, so it is possible that some Romans did too, but few examples have been found for the period before shaving became fashionable (ca. late fourth century BCE). Some might keep their beards relatively short or trimmed, but from portraiture and the history they told of themselves there is little reason to doubt

that in their earliest period the Romans did not shave. The sources for this are few but are instructive. For example, Livy relates the story of Marcus Papirius, an old magistrate, who with other aged men sat in their finery awaiting the Gallic invasion in 380 BCE. Many of the Gauls were curious about the venerable men sitting in their curule chairs, and one pulled the beard of Papirius, an act that cost the Gaul his life and so angered the other Gauls that they unleashed their fury on the city. The fact that the Roman men were bearded at the beginning of the fourth century BCE accords well with the tale of how shaving was introduced to Rome some 80 years later.

Several writers, such as Varro (d. 27 BCE) and Pliny the Elder (d. 79 CE), claim that Publius Ticinius Maenas (ca. 300 BCE) was the first to introduce barbers to Rome. He brought them from Sicily, and the practice of shaving spread. How quickly the practice spread is difficult to say, but certainly after the well-known general Scipio Africanus began to shave daily in the early second century BCE, shaving became fashionable. Fond of Greek culture, Scipio may have been influenced by current Greek practice. Alexander the Great did not wear a beard, and many Greeks followed suit. There is some indication that shaving, at least initially, may have been something only well-to-do people could afford. In time barbershops proliferated, as did open-air establishments that offered such services at markets, crossroads, or other busy locations. Initially the average Roman probably could not afford a barber. Even during the first century CE, the poet Martial poked fun at those who had no choice but to retain their beards. There were times, however, when beards were expected, such as when one was in mourning. Otherwise, beards during those centuries when most Romans were clean-shaven were considered uncouth.

The Roman barber became a mainstay of daily life. The *tonstrina* ("barbershop") could be found in most sections of the city. For those without slaves to groom them, visiting the barber might be one of the first activities of the day. Unlike today's shops, Roman barber shops did more than cut one's hair; it was normally the barber who shaved one's face and pared one's nails. Some also removed warts and corns. Certain aspects of the process would be familiar now, such as the cloth with which customers were draped to collect the trimmed hair or shavings and the exchange of news and gossip.

Scissors, though known and used, were less often used for haircutting than were simple shears and knives of varying shapes and sharpness. Since a good haircut was important then as now, barbers used tweezers (*volsellae*) to remove any missed hairs or those that made the coif uneven. Following the haircut, a man would be shaved. Barbers kept their razors in cases and prepared the blade using a whetstone. The only ointment or cream used for shaving was apparently water. Like one's hair, any missed hairs were plucked with tweezers. Given the dangers of shaving and the varying

Primary Sources

PLINY, *Natural History*, BOOK 7, CHAPTER 59

When barbers were first employed.

The next point upon which all nations appear to have agreed, was the employment of barbers. The Romans, however, were more tardy in the adoption of their services. According to Varro, they were introduced into Italy from Sicily, in the year of Rome 454, having been brought over by P. Titinius Mena: before which time the Romans did not cut the hair. The younger Africanus was the first who adopted the custom of shaving every day. The late Emperor Augustus always made use of razors.

[Pliny the Elder, *The Natural History*, translated by John Bostock and H. T. Riley (London: Henry G. Bohn, 1855), http://www.perseus.tufts.edu/hopper/text?doc=Plin.+Nat.+7.59&fromdoc=Perseus%3Atext%3A1999.02.0137.]

PETRONIUS, *SATYRICON*, CHAPTER 7, VERSE 46

"And there's a future pupil growing up for you, my little lad at home. He can repeat four pieces already; if he lives, you will have a little servant at your beck and call. If he has a spare moment, he never lifts his head from his slate. He's a bright lad with good stuff in him. . . . So I've just bought the lad some lawbooks, for I want him to have a smack of law for home use. There's bread and butter in that. For as to Literature, he has been tarred enough already with that brush. If he kicks, I've made up my mind to teach him a trade,—a barber, or an auctioneer, or best of all a lawyer,—which nothing but Hell can rob him of. So I impress on him every day. 'Believe me, my first-born, whatever you learn, you learn for your good. Look at Phileros the advocate; if he hadn't studied, he would be starving today. The other day, just the other day, he was carting things round on his shoulders, now he is a match for Norbanus himself. Learning's a treasure, and a trade never starves.'"

[Petronius, *The Satyricon*, translated by Alfred R. Allinson (New York: Panurge, 1930), http://www.sacred-texts.com/cla/petro/satyr/sat08.htm.]

qualities of barbers, many men turned to depilatories. Several were known, including *psilothron* and *acida Creta*. Pliny even included a recipe for a poultice for shaving nicks, made of cobwebs and olive oil. Another popular service was nail paring. Barbers used knives for this too. A busy shop might have a dedicated individual to handle this aspect of business. In one of Plautus's comedies, *Aulularia*, the miserly father Euclio retains his barber, a sign of how vital such services were.

Women, if they could afford it, had slaves to attend their toilet. Women also shaved and plucked unwanted hair. As with the average Roman man, if women could not afford slaves, they might attend to these duties themselves or perhaps visit a barber. There were no beauty shops per se but there were

female barbers, so it is conceivable that some of their clientele may have been women. Martial alludes unkindly to one such female barber.

Fashions change, and when Emperor Hadrian chose to wear a beard it became fashionable once again for Roman men to emulate him. One biographer, Plutarch, claimed that he grew a beard to hide a scar on his face, but whatever the reason, from the time of Hadrian until that of Constantine, most Roman men kept their beards. Barbers continued to help maintain and shape beards, but their role in providing shaving services probably diminished. This no doubt hurt the trade too. There were cases where some barbers, obviously skilled and popular, made significant fortunes, enough so that they could join the equestrian order. Some shops boasted mirrors and other amenities and were favored hangouts of Rome's fashionable set. A successful barber could make a comfortable living, and at least for one Roman emperor, so the historian Ammianus tells us, too comfortable a living. Emperor Julian (d. 363) was astounded by the riches a barber he visited had amassed, so much so that the emperor expelled barbers from the empire.

SIGNIFICANCE

Shaving and the culture associated with it tell us much about Roman life. One of the more well-documented and key rites of passage, for example, concerned the first time a young man shaved his beard (see also the entries **Toga Praetexta** and **Bulla**). This event heralded a young man's entry into adulthood and included his donning of the *toga virilis*. The age at which this rite was conducted varied—Augustus, for example, was 24 years old—but it was an occasion attended by festivities and an offering of one's cut hair to the gods.

Another key aspect of shaving and of the culture around it was social. Since most Romans made their way to a *tonstrina,* it became an ideal place to exchange stories, gossip, and socialize. Barbers in fact took on a reputation for chattiness; at least they were often stock figures in plays and satires. For instance, Plautus suggests that barbershops were places likely for idlers. In his play *Epidicus,* for example, Epidicus seeks high and low for Periphanes at all the locations where conversation and distraction were likely: at barbershops, the forum, the gymnasium, and perfumers' shops. Satirists such as Horace also referred to the talkative nature of many *tonsores.* Even in a sober history like that of Polybius, one sees analogies about talkative barbers and gossip. In Book 3, Chapter 20, of his *Histories,* Polybius refers to other writers who discussed the role of Saguntum during the Punic Wars as being as reliable as the "common gossip of a barber's shop."

The importance of this news sharing is easy to underestimate. All news traveled by word of mouth, and barbershops were instrumental not only in indulging local gossip but also in disseminating information, much as

newspapers and news programs do today. Moreover, barbershops were gathering places in much the way that cafés are today, a place to socialize, keep in touch, and people-watch.

FURTHER INFORMATION

Boon, George C. "'Tonsor Humanus': Razor and Toilet-Knife in Antiquity." *Britannia* 22 (1991): 21–32.

Carcopino, Jerome. *Daily Life in Ancient Rome.* New Haven, CT: Yale University Press, 1968.

Cowell, F. R. *Life in Ancient Rome.* New York: Putnam, 1980.

Gagarin, Michael, ed. *The Oxford Encyclopedia of Ancient Greece and Rome.* New York: Oxford University Press, 2010.

Kaufman, David B. "Roman Barbers." *The Classical Weekly* 25(19) (March 21, 1932): 145–148.

Nicolson, Frank W. "Greek and Roman Barbers." *Harvard Studies in Classical Philology* 2 (1891): 41–56.

Sandals

England
Date Unknown

INTRODUCTION

Footwear was an essential part of Roman dress. There were shoes for different occasions, shoes that helped distinguish one group of people from another, and shoes for different seasons. The Romans were extremely conscious of changes in style and updated their footwear accordingly. One shoe that certain Romans wore for centuries, however, was the legionary boot. Perhaps no other shoe tells us as much about Roman culture as the hardy, nail-shod *caligae,* or military boots.

DESCRIPTION

The two shoes depicted here represent not only two of the many types of Roman footwear but also the degree of sophistication that went into shoe making. Discoveries of ancient shoes at sites such as Vindolanda, the site of successive Roman forts just south of Hadrian's Wall in the north of England, have greatly altered many of the conceptions previously held about Roman footwear. This evidence has added greatly to knowledge of how Roman shoes, sandals, and boots were made; who wore them; and to what degree fashion trends in the empire determined the choice of footwear.

The Roman *sutor,* or shoemaker, was a skilled craftsman. Surviving relief sculpture, such as that on sarcophagi, depicts them hard at work. The *sutor* is typically seated on or astride a narrow bench, a shoe last or mold resting on a stand attached to the bench, and with hammer in hand the shoemaker forms the leather around the last. On another funerary monument, this one belonging to Caius Julius Helius, one sees a portrait of the deceased but also two forms or lasts above him, one with a *caliga* on it. Since this tomb was not only for Helius but also for his family and freedmen, his business must have been successful. For a maker of military equipment this is perhaps less surprising, being that he was a supplier to the army. However, other shoemakers seem to have done equally well for themselves. It is not always clear whether these craftsmen specialized in one form or more than one form of footwear, as the terms could refer to more than one artisan who worked with

133

shoes. *Sutor,* for example, might mean a shoemaker or be short for *sutor veteramentarii,* those who repaired old shoes. There were also more specific designations, such as *solearii,* or slipper makers; *sandalarii,* or sandal makers; and *caligarii,* those who made footwear for the military. However, it is likely that a good shoemaker could make a variety of shoes as well. It was an old profession. Numa Pompilius (r. 715–673), the legendary second king of Rome, for example, was credited with dividing Romans into colleges of artisans, the fifth of which was shoemakers. This guild may have met in the Atrium Sutorium, a building vital in the Tubilustrium, a festival in honor of Minerva held each year on March 23.

If surviving samples are any indication, the Romans liked their shoes and were quick to adopt the latest fashions. Many of those found at Vindolanda, for example, must have been expensive, given the level of craftsmanship, and yet they were replaced. When one considers that the predominating types of shoes only represent a fraction of what was available at the time, the importance of keeping up to date with fashion emerges clearly. The pattern for style adoption is consistent and indicates that people in the provinces were as keen to stay fashionable as those closer to Rome.

Shoes, in addition to their role in personal style and fashion, also played a role in class differentiation. Likewise, shoe type could sometimes reveal much about one's trade. *Sandalia* or *soleae* ("sandals") were popular and generally worn inside, though since many have been found with hobnails they were sometimes worn outside as well. An enclosed shoe or *calceus* (pl. *calcei*) was the proper shoe to wear with a toga, while *crepida* ("slippers") and sandals, for example, were considered unsuitable for use with a toga or palla. Women's shoes, apart from sandals, were not all that different from those of men, only smaller and often more decorated. Some sandals were so constructed that the second toe might project elegantly from the front, a stylistic feature amply displayed on statuary as well. There were also special shoes, ones that were meant to distinguish the wearer and highlight his importance. Patricians, for example, originally wore red shoes; senators wore the *calceus senatorius,* black shoes similar in style to that of the old patricians but with a crescent moon ornament. Slaves, so some sources claim, did not wear shoes but had their feet marked with chalk. The poet Juvenal in his seventh satire refers to slaves without shoes, but in that context they were recently taken from their homeland, not working in the many jobs that slaves did once sold. Certainly slaves must have worn shoes with some kinds of work and in poor weather. There were also a variety of boots, some wrapping higher up the leg than others, but probably one of the most common was the *caligae.*

SIGNIFICANCE

One of the most recognizable pieces of footwear is the legionary's boot, the *caliga.* It was a tough shoe, studded with hobnails and open-worked. These

Primary Source

JUVENAL, *SATIRES*, NO. 16

Let us first consider the benefits common to all soldiers, of which not the least is this, that no civilian will dare to thrash you; if thrashed himself, he must hold his tongue, and not venture to exhibit to the Praetor the teeth that have been knocked out, or the black and blue lumps upon his face, or the one eye left which the doctor holds out no hope of saving. If he seek redress, he has appointed for him as judge a hob-nailed [e.g., *caligae*] centurion with a row of jurors with brawny calves sitting before a big bench. For the old camp law and the rule of Camillus still holds good which forbids a soldier to attend court outside the camp, and at a distance from the standards. "Most right and proper it is," you say, "that a centurion should pass sentence on a soldier; nor shall I fail of satisfaction if I make good my case." But then the whole cohort will be your enemies; all the maniples will agree as one man in applying a cure to the redress you have received by giving you a thrashing which shall be worse than the first. So, as you possess a pair of legs, you must have a mulish brain worthy of the eloquent Vagellius to provoke so many jack-boots, and all those thousands of hobnails. And besides who would venture so far from the city? Who would be such a Pylades as to go inside the rampart? Better dry your eyes at once, and not importune friends who will but make excuses. When the judge has called for witnesses, let the man, whoever he be, who saw the assault dare to say, "I saw it," and I will deem him worthy of the beard and long hair of our forefathers. Sooner will you find a false witness against a civilian than one who will tell the truth against the interest and the honour of a soldier.

[Juvenal, *Satires,* translated by G. G. Ramsey (1918), http://www.tertullian.org/fathers/juvenal_satires_16.htm.]

boots were more like sandals than boots as we think of them. Being open, they breathed well in the warmer climates, allowed water to escape in wetter climates, and could be made warmer with leggings in colder weather. Some legionaries wore socks or stuffed their shoes with wool. Officers wore *calcei* rather than *caligae.* This was yet another way of distinguishing between the ranks and the officer corps.

Like all army equipment, *caligae* had to last, especially as the legion traveled by foot and often for hundreds of miles. Good as Roman roads were, marching is hard work and is tough on the feet, especially if one is burdened by a lot of equipment. While the legionary's kit changed over time, there were certain parts to his gear that remained constant. All legionaries carried their weapons, including the *pugio* (dagger), *gladius* (sword), two *pila* (sing. *pilum*), and javelins. Likewise, he carried his defensive gear, his *galea* (helmet), *scutum* (shield), and *lorica (cuirass).* The latter underwent significant evolution. Mail armor, *lorica hamata,* was in use

throughout much of the Roman period and well beyond it. *Lorica segmentata,* a modern designation, consisted of banded ribbons of iron; it was strong but apparently had a short window of use, from the first through third centuries CE. Another style, *lorica squamata,* or scale armor, was made of overlapping scales of iron. Legionaries also wore a scarf to protect their necks from cuirass and helmet, a belt called the *cingulum militare* that often had a *balteus,* a sort of apron of leather straps with metal decorations. In colder climes the legionary also wore short pants, usually down to the knee, one of the only times that Romans typically did, as they viewed pants as the clothes that barbarians preferred.

In addition to these items, the legionary very often carried tools and materials for camp making, something the legion very often did while on the march. The *dolabra,* a pickax, helped dig trenches. Two *sudes* (sing. *sudis*), or stakes, pointed on both sides, probably served a variety of defensive purposes, from providing a cheval-de-frise to placement in and on an embankment. Other equipment included a basket for moving earth or hauling other goods, cooking gear, and both a waterskin and a *sarcina,* or backpack, with 14 days' worth of food. All in all, assuming a soldier was carrying all of this, he might be hauling around 70–100 pounds of gear.

This was a lot of trouble, but it was worth the effort. A fortnight's amount of food meant that the legion did not have to forage, at least not at first. Moreover, the legionaries often made camp en route. A fortified camp did more than provide a line of defense in enemy territory; it was also psychological warfare. To march into a hostile area and set up and organize defense, all under threatening conditions, did much to say that the Romans were organized, disciplined, and unafraid, but it also meant that most troops got a good night's sleep. Well rested and secure behind entrenchments, the legion could then approach the enemy with more confidence. The effect of this on less well-organized armies, and especially on those who slept less securely or at all on the way to a battle, could be decisive.

It is here too that good footwear can make a difference. The legions traveled to diverse locations, experienced extremes of hot and cold, and had to have equipment that was flexible enough to handle any eventuality. The sturdy hobnailed *caliga* was an ideal choice, as it was light but tough, provided good support for the sole and ankle, and could be fitted out for service in cold or warm climates.

FURTHER INFORMATION

Bishop, M. C., and J. C. N. Coulston. *Roman Military Equipment: From the Punic Wars to the Fall of Rome.* Oxford, UK: Oxbow, 2006.

Cleland, Liza, Glenys Davies, and Lloyd Llewellen-Jones, eds. *Greek and Roman Dress from A to Z.* New York: Routledge, 2007.

Cleland, Liza, Mary Harlow, and Lloyd Llewellen-Jones, eds. *The Clothed Body in the Ancient World.* Oxford, UK: Oxbow, 2005.

Croom, Alexandra. *Roman Clothing and Fashion.* Charleston, SC: Tempus, 2002.

Edmondson, Jonathan. "Public Dress and Social Control in Late Republican and Early Imperial Rome." In *Roman Dress and the Fabrics of Roman Culture,* edited by Jonathan Edmondson and Alison Keith, 22–46. Toronto: University of Toronto Press, 2008.

Goldman, Norma. "Roman Footwear." In *The World of Roman Costume,* edited by Judith L. Sebesta and Larissa Bonfante, 101–129. Madison: University of Wisconsin Press, 1994.

Goubitz, Olaf. *Stepping through Time: Archaeological Footwear from Prehistoric Times until 1800.* Zwolle: Stichting Promotie Archeologie, 2001.

Olson, Kelly. *Dress and the Roman Woman: Self-Presentation and Society.* New York: Routledge, 2008.

Simkins, Michael, and Ron Embleton. *The Roman Army from Caesar to Trajan.* London: Osprey, 2000.

Sumner, Graham. *Roman Military Clothing,* Vol. 1, *100 BC–AD 200.* London: Osprey, 2002.

Van Duriel-Murray, Carol. "Vindolanda and the Dating of Roman Footwear." *Britannia* 32 (2001): 185–197.

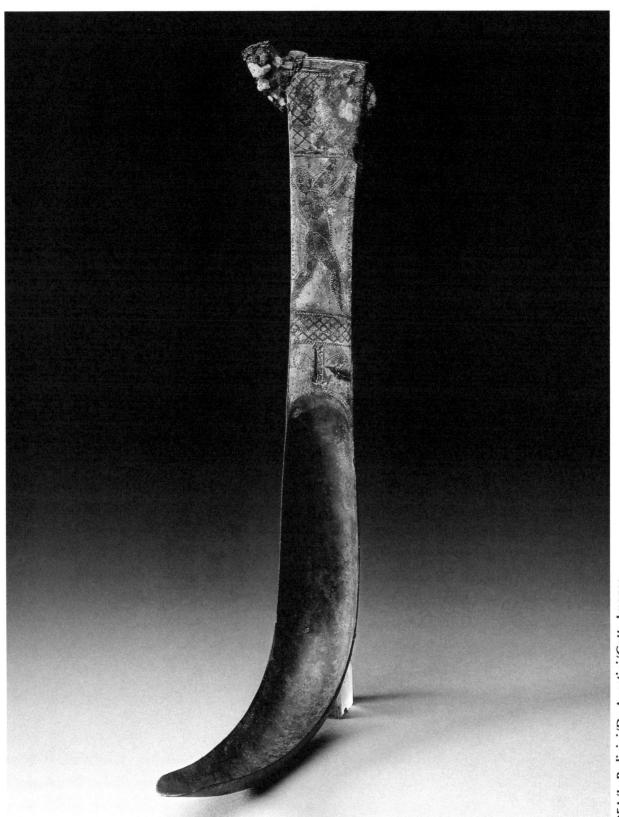

Strigil

Pompeii, Italy
First Century CE

INTRODUCTION

Strigils (Lating *strigilis,* from *stringere,* "to touch lightly, graze") formed a key part of personal toiletries and were common tools used in athletics and bathing. Personal hygiene was as important to the Romans and other ancient peoples as it is among people today. Normally used after an application of light olive oil, strigils scrapped the oil, sweat, and dirt from one's body after bathing or exercising. Strigils highlight not only the universal human concern with cleanliness but also the social importance of bathing and exercise among the Romans.

DESCRIPTION

The strigil pictured here is made of bronze and decorated with a dancing Satyr. It is from Pompeii, ca. first century CE, and is a little fancier than many other extant versions. Some, like this one, boast decorations, often athletic or mythological in theme, but others are simple bends of metal and are utilitarian in the extreme.

Strigils vary in size and shape but could be upward of 10 inches and were generally slightly hook-shaped. Often made of bronze, these scrapers consisted of a handle, sometimes curved for hanging, and a dull blade. Because of their durability, many have survived. There are also a number of murals and statues that depict athletes using strigils, such as the statue of an athlete now in the Ephesus Museum in Austria. Athletes commonly applied olive oil to the body in order to lubricate the muscles and protect the skin from dirt; olive oil was perhaps also used as a primitive sunblock. Postexercise, athletes used strigils much like their counterparts use a towel today, to wipe off the accumulated grime of oil and dirt.

Strigils, as they had been in Greece, were often used in conjunction with small oil flasks, or *aryballos.* These were portable and could be transported with the athlete wherever he went. The large public baths, however, had strigils too, though it appears that the cost of hiring an attendant with a strigil prevented many Romans from using this amenity. While one could

Tepidarium or warm bathing room in the Suburban Baths of Herculaneum, ca. first century CE. (De Agostini/Getty Images)

use a strigil oneself, it was evidently common at the baths to have an attendant or slave take care of areas that are difficult to reach, such as the back.

Though strigils might be used at any time to remove grime, they were a normal step in bathing. While individual practice and preference no doubt varied, we have, thanks to the ubiquitous nature and popularity of the baths, a number of references to the stages of Roman bathing, even if only briefly. Martial's often bitter epigrams are one such source, but so too is the advice about bathing from Pliny the Elder, Lucian's discussion of bath design, and the letters of Seneca. From these we have a good idea not only about the construction of baths but also about how the Romans used them.

After exercise, the bather would return to the *apodyteria,* or changing room, and then sometimes enter a type of sauna, or *sudatoria,* before the hot bath, or *caldarium.* There was a heated pool, but the *caldarium* often had a smaller tub or basin, the *labrum,* from which the bather could draw water for pouring over himself if he did not wish to take a dip. Originally the hot water had to be heated and poured in, but the Roman invention of the hypocaust, a series of underground channels to move hot air from wood-coal fires, improved upon this and made large-scale bathing more feasible. Hot water opened pores, relieved muscle fatigue, and cleansed the body of sweat, oil applied before exercise, and dirt. While soap was known to the

Primary Source

LUCIAN, "HIPPIAS, OR THE BATH"

. . . On entering, one is received into a public hall of good size, with ample accommodations for servants and attendants. On the left are the lounging rooms, also of just the right sort for a bath, attractive, brightly lighted retreats. Then, beside them, a hall, larger than need be for the purposes of a bath, but necessary for the reception of the rich. Next, capacious locker-rooms to undress in, on each side, with a very high and brilliantly lighted hall between them, in which are three swimming-pools of cold water. . . .

On leaving this hall, you come into another which is slightly warmed instead of meeting you at once with fierce heat; it is oblong, and has a recess at each side. Next it, on the right, is a very bright hall, nicely fitted up for massage, which has on each side an entrance decorated with Phrygian marble, and receives those who come in from the exercising-floor. Then near this is another hall, the most beautiful in the world, in which one can sit or stand with comfort, linger without danger and stroll about with profit. It also is refulgent with Phrygian marble clear to the roof. Next comes the hot corridor, faced with Numidian marble. The hall beyond it is very beautiful, full of abundant light and aglow with colour like that of purple hangings. It contains three hot tubs.

When you have bathed, you need not go back through the same rooms, but can go directly to the cold room through a slightly warmed apartment. Everywhere there is copious illumination and full indoor daylight. Furthermore, the height of each room is just, and the breadth proportionate to the length; and everywhere great beauty and loveliness prevail. . . .

. . . It has all the good points of a bath—usefulness, convenience, light, good proportions, fitness to its site, and the fact that it can be used without risk. Moreover, it is beautified with all other marks of thoughtfulness—with two toilets, many exits, and two devices for telling time, a water-clock that bellows like a bull, and a sundial. . . .

[*Lucian,* with an English translation by A. M. Harmon (Cambridge, MA: Harvard University Press, 1961), http://www.archive.org/stream/lucianha01luciuoft/lucianha01luciuoft_djvu.txt.]

Romans, a strigil was the normal tool for removing this grime after bathing rather than using soap. The bather would then enter the *tepidarium,* a warm but not too warm bath, to relax. Finally, the bather would plunge into the *frigidarium,* or cold pool.

The first Roman public baths, similar to Greek gymnasia, appeared in the second century BCE. The traditional division of the baths into *caldarium, tepidarium,* and *frigidarium* is a feature of these earliest public baths. One of the first monumental baths was sponsored by Emperor Augustus's close

and wealthy friend Marcus Vipsanius Agrippa (d. 12 BCE). Constructed near the Campus Martius and supplied by aqueduct, these baths were the main ones until Nero's baths were built. Later *thermae* were even more impressive. Emperors Titus and Trajan built extensive baths in 80 and 104 CE, respectively, and great as these were—Trajan's were the largest at the time—none compared to the immense baths of Caracalla, built between 212 and 216 CE.

There were downsides to the baths as well. Like the amphitheaters, arenas, and other crowded spots, the baths were an ideal locale for criminals. Even without criminal activity, at least some who lived nearby found aspects of the baths worthy of complaint. In one letter, for example, Seneca discusses the noise one must endure living in an apartment above a public bath. His description paints a wonderful image of life and activity at the baths—we read of bathers splashing, shopkeepers shouting, masseuses slapping the backs of clients, and athletes grunting. For those lucky enough to own private baths, little of this clamor was a problem.

Private baths were, in fact, not all that rare. Some of the more well-to-do people in Roman society had private baths. The usual term for a private bath was *balneae,* though in time this word came to refer to public baths, also known as *thermae.* Some private baths, such as those of Cicero's brother Quintus, had multiple chambers and could be elaborately decorated.

SIGNIFICANCE

Though a simple tool, the strigil highlights the emphasis that the Romans placed on good health and personal hygiene as well as on bathing as a social activity. Exercise, from throwing a ball to wrestling, was a popular aspect not only of childhood games but also of activities at the baths. The importance of exercise, even for nonathletes and nonmilitary personal, was recognized by ancient writers such as Pliny the Elder, and given the popularity of athletic games and training at public baths, one can conclude that many people must have held similar views. Exercise was also social, a pastime and a way to spend time with friends.

The value that Romans placed on their baths is evidenced not only by references to them in a number of authors but also in the many sites where one can still view what remains of baths today. Of note, baths were not restricted to Italy; they could be found all over the empire, as far as eastern Greece and the British Isles. Bath, England, for example, still boasts some of the most beautiful examples of *thermae* architecture; at the time, Britain was the considered to be the edge of the world. By the fourth century CE there were an estimated 1,000 baths of various types in Rome alone.

Public baths were busy places. While obviously vital to maintaining cleanliness, the public baths were also key meeting places. They were, first and foremost, a place to bathe, but they were also the athletic clubs and

malls of their day. Some had libraries, most had shops in or nearby, and all of these features worked together to make the baths an ideal place to meet. Romans, no matter their station, used the baths. While the classes might mingle in one pool, mixed bathing was unusual, though it did happen. At some baths there were portions restricted to women; at others, special hours were allocated to them. Everyone, however, used the various facilities, and we know this not only from literature but also from the artwork that decorated many baths. Some baths had restaurants and small theatrical stages as well. Archaeologists investigating the drains of ancient baths have discovered a wide variety of items, from jewelry to teeth (suggesting dentists too may have worked there), from tweezers to crockery, all of which suggests a lively and busy social center. The baths were places to be seen and to people-watch, though perhaps wearing jewelry while in the pool was as much about safeguarding one's belongings as showing off.

In addition to the leisure and health aspects, however, the baths also served as offices and meeting rooms. Business might be conducted there, but so too might politics, and very often the two went hand in hand. The baths themselves could be political symbols. They were popular physical reminders of the emperor's beneficence but also a clear example of his power, influence, and wealth. In this sense, the baths served well as state propaganda.

The baths remained popular with the Romans into the sixth century. Political and social upheaval, less and infrequent income to support city infrastructure, and war did much to undermine the large bath complexes, and in time they fell to ruin or were cannibalized for their stone. While not all emperors were as keen or saw the merit of the baths—Marcus Aurelius saw them as wasteful luxury—most later emperors, such as Constantine, continued to patronize the baths. Decoration changed once the empire became Christian, but the baths remained despite some who saw them as potential places of vice and idleness.

FURTHER INFORMATION

Anderson, James C. *Roman Architecture and Society.* Baltimore: Johns Hopkins University Press, 1997.

Balsdon, J. P. V. D. *Life and Leisure in Ancient Rome.* London: Phoenix Press, 2004.

Casson, Lionel. *Everyday Life in Ancient Rome.* Baltimore: Johns Hopkins University Press, 1998.

Fagan, Garrett G. "Bathing for Health with Celsus and Pliny the Elder." *Classical Quarterly* 56(1) (May 2006): 190–207.

Pappas, Stephanie. "Down the Drain: Lost Items Reveal Roman Bath Activities." LiveScience, January 11, 2013, http://www.livescience.com/26202-drain-lost-items-roman-baths.html.

Rodgers, Nigel. *Life in Ancient Rome.* London: Southwater, 2007.

Seneca. *Seneca: Epistles 66–92.* Translated by Richard M. Gummere. Cambridge: University Press, 1920.

Shelton, Jo-Ann. *As the Romans Did.* New York: Oxford University Press, 1988.

Toner, J. P. *Leisure and Ancient Rome.* Cambridge, UK: Polity, 1995.

Vitruvius. *Ten Books on Architecture.* Translated by Ingrid D. Rowland. Commentary and Illustrations by Thomas N. Howe. Cambridge: Cambridge University Press, 1999.

Yegul, Fikret. *Baths and Bathing in Classical Antiquity.* Cambridge, MA: MIT Press, 1992.

Websites

Kunst Historiches Museum Wien, http://www.khm.at/en/visit/collections/ephesos-museum/selected-masterpieces/.

"Roman Baths and Bathing." VROMA: A Virtual Community for Teaching and Learning Classics, http://www.vroma.org/~bmcmanus/baths.html.

Toga Praetexta

Tunis
Early Third Century CE

INTRODUCTION

Perhaps no other symbol is as immediately recognizable as Roman as is the toga. This large blanket-like costume was equally symbolic to the Romans. To be *togati*—that is, to be one who wears a toga—was to be Roman. The history of the toga stretches from the earliest history of the city to the late empire (ca. late fourth century CE) and provides a look not only into Roman fashion, particularly for men, but also into the ways that clothes were used to differentiate the social hierarchy.

DESCRIPTION

The scene from a mosaic depicted here, from the third century CE, is of the poet Virgil wearing a *toga praetexta*. The toga had long been the distinctive garment of the Roman people. Virgil, who penned the epic story of Rome's earliest if legendary ancestors in *The Aeneid,* referred to his people as the *gens togata,* the "toga-wearing people." Originally an Etruscan garment called a *tebenna,* in Rome's early history only citizens in Rome itself might wear the toga. Non-Romans and exiles, for example, were not allowed to don it. This changed as Rome's territorial expansion increased, not only because Romans took their unique garments with them but also because people new to Roman control often adopted it.

The *toga praetexta* in particular was a legacy of the Etrucsans, according to both Livy and Pliny the Elder. Legend recalls that Tullus Hostilius, the third king of Rome, first adopted it along with a broad purple stripe down the center, the *latus clavus,* as a symbol of royal authority. When the kings were expelled ca. 509 BCE, their distinguishing garb was carried over to the magistrates. Hostilius seems also to have been behind the *toga picta* or *toga pupurea,* a purple toga without further decoration and one that was later readopted by Rome's emperors. A similar toga was worn by generals during triumphs. Young children who were freeborn wore the *toga praetexta* in addition to their bullae in order to fend off evil spirits and bad luck (see the entry **Bulla**). Use of the *latus clavus* became general in the early

147

republic and did not reflect social hierarchy. In time, however, it did, and only the senatorial order might wear it. A similar set of stripes, the *angustus clavus,* which ran parallel one another from each shoulder down a man's tunic, became a marker for the equestrian order. The equestrian order, originally the mounted section of the Roman citizen army, eventually became the second rank after the senatorial order. While they might not field the cavalry, members of this order possessed enough wealth to qualify to serve as officers in the military. If elected to a magistracy, however, an equestrian entered the senatorial ranks. The *pratexta* had broad purple stripes along the edges. Use of the *toga praetexta* was limited to a special collection of offices in addition to young Romans. For example, dictators, consuls, and praetors were among those who might wear it, though praetors were to wear something else if condemning a criminal to death.

There were several forms of togas, and like most Roman clothing each was symbolic. At first, men and women both wore togas and nothing else. Eventually they added the *tunica* ("tunic") to their wardrobe as well as undergarments and wore the toga over them. The toga, traditionally, was made of wool and undyed. This did not make the toga white per se, though the addition of chalk to it did help color the toga when the occasion called for it, such as when men ran for office—this toga, the *toga candida,* looked cleaner and also helped the candidate stand out from most everyone else in their off-white homespun. Most people made sure that their togas were clean for festivals as well. Women, apart from young unmarried girls, switched from the toga to the *tunica* and *palla* or *stola* once married (for more on women's clothing, see the entry **Fibula**).

Color, while rare with togas, revealed a lot. For example, a toga made from black wool, the *toga pulla,* was one often worn by craftsmen, but it was also the appropriate color to wear when mourning. The *trabea* was another type of toga. There were actually several versions of this style. Generally they had horizontal stripes of purple. There was one with purple only, another with purple and white, and the last, worn by augurs, with purple and saffron. The *trabea* seems to have been, apart from the augurs who wore it as part of their office, a toga for unique occasions. Consuls might wear it when opening the temple of Janus. It seems, however, to have also been worn by equestrians as well during their annual Transvectio Equitum (Review of the Knights) procession.

There continues to be debate about the exact shape of the toga. Arguments for semicircular and something a bit more voluminous have been made. Dionysius is one ancient authority who describes the toga as semicircular, but there is some thought that the toga may have increased in size as the number and complexity of folds changed with fashion trends. It was certainly round in part, which can be observed in surviving sculpture. Much discussion has centered on how the toga was put on as well. While there

Definitions

Transvectio Equitum

This event, a parade, was held on the Ides of July (July 15) by the equites (knights) in honor of Castor and Pollux, gods believed to have aided the Romans at the Battle of Lake Regillus (496 BCE). The Transvectio Equitum began in 304 and then fell out of favor before Augustus reinstituted the practice. The parade started at the Temple of Mars, traveled the Appian Way, and proceeded toward the Capitol. Riders were clad in the *toga trabeae,* were crowned with olive leaves, and wore any military awards they had earned.

Tullus Hostilius

Rome's third king according to legend. Much of what Livy and others record of Tullus Hostilius (r. 671–642 BCE) echoes traditions associated with Romulus, Rome's first king, including his doubling of the population and his mysterious departure from the world during storms. Hostilius is said to have taken Alba Longa and incorporated it into Rome's sphere, adding its prominent men to the Senate. He is also credited with building the Curia Hostilia, the first Senate building, and the Comitium, the voting site just before the Curia. Archaeologically, the earliest phase of the Comitium dates to the seventh century BCE, and there is evidence as well of a major building having been close by. This does not prove the existence of Hostilius or that he commissioned these buildings, but it does put their erection at about the time the histories say they first appeared.

were probably a variety of ways to don the toga, one method appears to have been to fold one side a few times, drape it against the left leg, pass the remaining cloth over the left shoulder, next over the back, and then under the right arm. The folded section against the leg was then thrown across the chest, and the rest was thrown over the left shoulder. Often in Roman art one sees a man holding his left arm up in order to keep the toga in place.

SIGNIFICANCE

As one might imagine, the toga was not an easy garment to wear or in which much activity might be conducted. Supposedly the toga was worn in wartime in the early days of Rome, but this outfit was replaced at an unknown time by the far more fetching *sagum,* a woolen cloak, thick and hardy, that was fastened around the neck. The toga, however, was the civilian dress par excellence and indeed over time became the clothing for formal occasions. Some Romans, particularly among the upper classes, wore the toga daily, but this was as much to show that they did not need to move about freely in order to work, that they were not in trade, and thus it set them apart. That the toga was not an ideal day-to-day costume one sees from both legend and satire. For example, Cinncinatus asked his wife to bring his toga to him

when the embassy to make him dictator was approaching. He had been plowing and was not wearing his toga. This is important for two reasons. First, it made sense to the Romans that a man would not farm while wearing a toga; it was too cumbersome. Second, the toga was the appropriate dress to wear when a formal government delegation came to ask him for help. It was the right way to greet one's fellows.

Poets and satirists, such as Juvenal and Martial, were quick to point out the toga's shortcomings. Juvenal, for example, prefers the country because only the dead, who were buried in togas, wore them. Fashionable young Roman dandies were another easy target. The size of their togas could be large, either trailing behind them or so wide that they incurred the mirth of wits. Excesses like these were looked down upon except by those who wore them. Ovid advises his readers in the *Art of Love* to avoid wearing togas in such bad taste. These examples show that the toga had long been a way to express one's sense of style. Much attention was paid especially to the *sinus* and *umbo,* the folds on the chest that hung low and the bundle of cloth that hung over that, respectively. In fact, the first emperor, Augustus, when he entered the forum and saw so few men in togas enacted legislation that any man entering the forum or the Circus Maximus must be wearing a toga. Dress at such public spaces did much to indicate rank. At the circus, for example, not only did men wear togas after Augustus's law went into effect, but they sat according to station, their types of toga further emphasizing these class distinctions.

Despite these misgivings, however, the toga was clearly a much-admired and honored form of dress. One of the key events in a man's life, for instance, was when he took off the *toga praetexta* of boyhood for the *toga virilis* of the adult Roman. It was not only the occasion for a party with friends and family but was also a public declaration that a young man was ready for public life and old enough for military service. Most men underwent this ceremony between 14 and 17 years of age; once clad in the *toga virilis,* such young men were the *iuvenes,* the "youths." Those who planned to follow careers in either the senatorial or equestrian ranks would soon start their military training if they had not already. They might, for example, serve in the *tirocinium,* a preparatory step for actual service.

Togas, at least since the time of Augustus, became the normal formal attire in the Roman world. For those who could wear them, they made sure to do so when standing for a portrait, when depicted on their memorials, and when they were buried. As it had been during the republic, the toga was the quintessential mark of *romanitas,* that is, of Romanness, of participating and honoring that culture. The toga's history was long as well. It was not until the time of Theodosius the Great (d. 395 CE) that the toga finally gave way to a new style of Roman costume, the *paenula,* another form of cloak or cowl.

FURTHER INFORMATION

Cleland, Liza, Glenys Davies, and Lloyd Llewellen-Jones, eds. *Greek and Roman Dress from A to Z.* New York: Routledge, 2007.

Cleland, Liza, Mary Harlow, and Lloyd Llewellen-Jones, eds. *The Clothed Body in the Ancient World.* Oxford, UK: Oxbow, 2005.

Croom, Alexandra. *Roman Clothing and Fashion.* Stroud, UK: Tempus, 2002.

Edmondson, Jonathan. "Public Dress and Social Control in Late Republican and Early Imperial Rome." In *Roman Dress and the Fabrics of Roman Culture,* edited by Jonathan Edmondson and Alison Keith, 22–46. Toronto: University of Toronto Press, 2008.

Sebesta, Judith L., and Larissa Bonfante, eds. *The World of Roman Costume.* Madison: University of Wisconsin Press, 1994.

Wilson, L. M. *The Clothing of the Ancient Romans.* Baltimore: Johns Hopkins University Press, 1938.

Household Items

Cave Canem Mosaic

Drainpipes

Oil Lamp

Public Toilets

Sundial

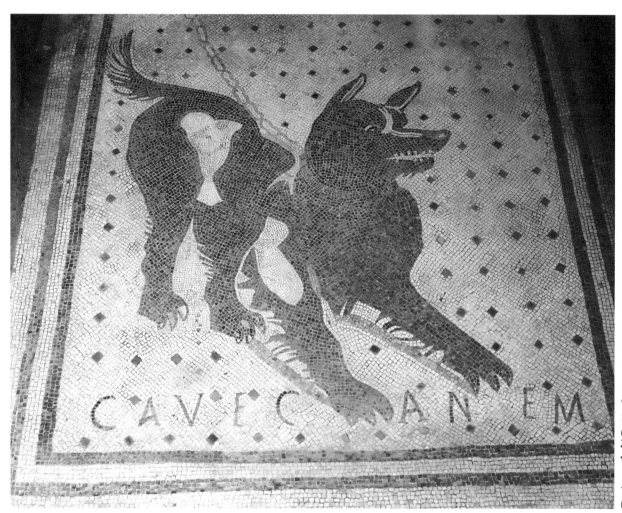

Cave Canem Mosaic

Pompeii, Italy, House of the Tragic Poets
First Century CE

INTRODUCTION

Cities in the ancient world, like cities today, were a mix of excitement and danger. For much of its history, Rome lacked any organized, state-sponsored organization that would rival the police forces of the modern era. Those few patrols that existed were small, had little authority, and could not cover as much territory as they needed. With the civil wars of the late republic, however, the need for some manner of official body of watchmen was felt more urgently than ever, and Augustus, the first emperor, instituted Rome's first quasi police force and fire brigade, the *cohortes urbanae*. Even with these measures and the increasing use of the military as guardians against crime, many Romans were forced to deal with crime on their own.

DESCRIPTION

This mosaic of a guard dog is inlaid into the floor of the entrance of a Roman villa in Pompeii, the House of the Tragic Poet. It is perhaps one of the best-known artistic pieces from Pompeii. Like the rest of the city, this house and its cautionary sign (the phrase "cave canem" means "beware the dog") was buried in volcanic ash in 79 CE. This is not the only house to greet the visitor, or potential intruder, with a warning in Pompeii. The House of Paquius Proculus (also referred to as the House of Cuspius Pansa for another set of graffiti on the house) and the House of L. Caecilius Jucundus likewise have mosaics of a guard dog; another, the Caupona (i.e., "tavern") of Sotericus, has a painting of a guard dog near the entrance. Other examples exist as well. Dogs were clearly employed by many households as watchdogs, a wise strategy in an age when police were rare.

These depictions, usually near the entrance to a home, warn not only visitors that a dog might be within but also anyone with less savory intentions who might try the door after dark. The paintings in the House of the Tragic Poet, named for a mosaic of a theater master, date to the first century CE, and though it is difficult to date the mosaic with the same certainty, this style of mosaic, wherein black and white tesserae were used, was popular in the

last centuries BCE and the first centuries CE. Mosaic decoration had a long history by this time and had undergone a variety of evolutions.

Mosaic was a popular style of decoration in the Roman world. Forerunners of mosaic have been discovered in the Near East, but the earliest recognizable work of mosaic hails from a Greek site of the eighth century BCE in Gordium, Phrygia, a kingdom in what today is west-central Turkey. This example used pebbles of black, red, and white to form geometric designs, all of which are similar to patterns used in textiles of the time. Mosaics spread to Greece and eventually to Italy. Hellenistic styles of mosaic and those created by Italic peoples coalesced into a few popular styles by the late republic and the early empire. One such style was the *opus signinum,* whereby a mix of crushed pottery or tile was mixed into the pavement and tiles of white were used to create geometric figures. The style of mosaic seen here was widely popular and spread from Italy into the provinces. Animals, mythological scenes, and various depictions of the natural world were all popular themes in these black and white mosaics.

SIGNIFICANCE

While Roman mosaics deserve their place in the history of art and even today inspire many imitators, the subjects of these mosaics and other styles tell us much about Roman life. Scenes of hunting, feasting, and even of people walking their dogs all reveal aspects of daily life, at least for those who could afford expensive mosaics. From the many images of guard dogs in mosaics and paintings, it is hard to escape the conclusion that the Roman world could be a dangerous place. In all likelihood, once night arrived most Romans stayed indoors, closing their windows and securing their doors. With Julius Caesar's edict that is often referred to as the Law of Caesar on Municipalities (44 BCE), no cart or wagon was allowed in the city's streets until nighttime, which meant that at least some people were out at night. Juvenal complained about the noise at night and wondered how any Roman avoided insomnia. There were exceptions to the traffic rule, but by and large the delivery men were the only ones, apart from the night watch, who were out at night except for criminals.

For much of its early history, Rome did not have any organized police force as we would think of it today. During the republic, minor officials, the *tresviri capitales,* were responsible for some policing, but with minor support, usually slave labor, they were not up to maintaining order over much of the city. With so little viable state protection at night, criminal activity was a constant problem, and the only real solution for the populace was to avoid as much as possible being in harm's way. For those wealthy Romans who attended dinner parties late into the night, the solution was to return home under guard. The night watch, the *sebaciarii* (named for the candle makers who supplied the few lights at night), could not be counted on and were never large in number.

Primary Source

JUVENAL, *SATIRES*, No. 3

And now regard the different and diverse perils of the night. See what a height it is to that towering roof from which a potsherd comes crack upon my head every time that some broken or leaky vessel is pitched out of the window. . . . There's death in every open window as you pass along at night; you may well be deemed a fool, improvident of sudden accident, if you go out to dinner without having made your will. You can but hope, and put up a piteous prayer in your heart, that they may be content to pour down on you the contents of their slop-pails!

Your drunken bully who has by chance not slain his man passes a night of torture like that of Achilles when he bemoaned his friend, lying now upon his face, and now upon his back; he will get no rest in any other way, since some men can only sleep after a brawl. Yet however reckless the fellow may be, however hot with wine and young blood, he gives a wide berth to one whose scarlet cloak and long-retinue of attendants, with torches and brass lamps in their hands, bid him keep his distance. But to me, who am wont to be escorted home by the moon, or by the scant light of a candle whose wick I husband with due care, he pays no respect. Hear how the wretched fray begins—if fray it can be called when you do all the thrashing and I get all the blows! The fellow stands up against me, and bids me halt; obey I must. What else can you do when attacked by a madman stronger than yourself? . . . Such is the liberty of the poor man: having been pounded and cuffed into a jelly, he begs and prays to be allowed to return home with a few teeth in his head!

Nor are these your only terrors. When your house is shut, when bar and chain have made fast your shop, and all is silent, you will be robbed by a burglar; or perhaps a cut-throat will do for you quickly with cold steel. For whenever the Pontine marshes and the Gallinarian forest are secured by an armed guard, all that tribe flocks into Rome as into a fish-preserve. What furnaces, what anvils, are not groaning with the forging of chains? That is how our iron is mostly used; and you may well fear that ere long none will be left for plough-shares, none for hoes and mattocks. Happy were the forbears of our great-grandfathers, happy the days of old which under Kings and Tribunes beheld Rome satisfied with a single gaol!

[Juvenal, *Satires,* translated by G. G. Ramsey (1918), http://www.tertullian.org/fathers/juvenal_satires_03.htm.]

The first real body assigned to policing, and it was as much a fire brigade as anything else, was organized by Augustus. This organization, the *cohortes urbanae,* answered to the prefect of the city, or the *praefectus urbi.* They started out with three cohorts of 500 men but in time added a fourth cohort and increased the size of each to about 1,000 men. Each was led by

a tribune and six centurions, somewhat along the same lines as the emperor's guard, the Praetorians. Most of those serving were from outside the city and signed on for 20 years, as with other military units. The need for such a force, while probably felt earlier, became especially obvious during the civil wars that brought Augustus to power. Not surprisingly, the *cohortes urbanae* provided extra protection for the emperor and also helped maintain order. By the third century CE there were close to 7,000 *vigiles,* another term for those who patrolled at night and fought fires.

A number of sources indicate that much of the Roman response to crime was local. We see this in the New Testament, where Paul recommends handling problems among other Christians, not the law courts, but we also see it in Apuleius, who complains in his *Metamorphoses* that judges can be bought. In the same story, when thieves attack a house they are repelled by the occupants. Vigilante justice such as this was often the only recourse, but even this assumed that a culprit could be identified and found. Citizens faced many of the usual threats common to most societies, including theft, assault, rape, and murder. Some crime was organized, and when it became enough of a danger it was often taken down forcibly by the state. Emperor Domitian, for example, eradicated an organization of professional assassins. On the other hand, some criminal outfits could be closely allied with the populace, as the Bacaudae were to citizens in Auxerre, Gaul, in the fifth century CE.

Despite the numerous examples in literature of private citizens taking the law into their own hands, Roman government did not stand by helplessly. Laws were meant to protect one and all, whatever the reality might be in local courts, and from early on in Rome's history citizens had recourse to legal courts for many issues. The Roman legal system was a highly developed one, and access to it depended, for most people, on the network of patronage to which they belonged. One also had to be a citizen of Rome. In addition to the court system, the government also, especially over the course of the first three centuries CE, increasingly turned to the military to help with policing. This was true not only in Rome but also in the provinces. Brigands were a constant threat along Rome's roads, and often it was local garrisons of the legion that dealt with the problem.

In late antiquity many of these tried-and-true methods remained, from military protection to the court system, but as the western half of the empire became fragmented and imperial administration became less reliable, brigandage and other evils returned. Many people, unable to defend themselves, turned to powerful landowners and offered their services in exchange for protection. This arrangement, known as *patrocinium,* was ironically as much to defend the rural population from the authorities and their tax collection as it was to protect the population against thieves and other criminals.

FURTHER INFORMATION

Africa, Thomas W. "Urban Violence in Imperial Rome." *Journal of Interdisciplinary History* 2(1) (Summer 1971): 3–21.

Carcopino, Jerome. *Daily Life in Ancient Rome.* New Haven, CT: Yale University Press, 1968.

Echols, Edward. "The Roman City Police: Origin and Development." *Classical Journal* 53(8) (May 1958): 377–385.

Fuhrmann, Christopher. *Policing the Roman Empire: Soldiers, Administration, and Public Order.* Oxford: Oxford University Press, 2011.

Harries, Jill. *Law and Crime in the Roman World.* New York: Cambridge University Press, 2007.

Knapp, Robert. *Invisible Romans.* Cambridge, MA: Harvard University Press, 2011.

Lintott, A. W. *Violence in Republican Rome: Civil Strife and Revolution in the Classical City.* Oxford: Oxford University Press, 1982.

MacMullen, Ramsay. *Enemies of the Roman Order.* Cambridge, MA: Harvard University Press, 1967.

Reynolds, P. K. Baillie. *The Vigiles of Imperial Rome.* London: Oxford University Press, 1926.

Robinson, O. *Ancient Rome: City-Planning and Administration.* New York: Routledge, 1992.

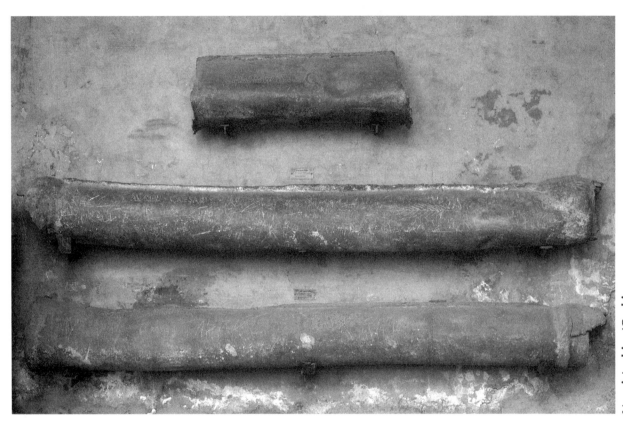

Drainpipes

Roman
Late Second Century CE

INTRODUCTION

Few monuments survive the Roman period that are as large or majestic as the aqueducts. One can find them from Spain to Turkey. Connected to these giant waterways on the city level were much less imposing pipes, usually of lead and usually underground. These pipes, however, were just as important, for it is through them that the Romans obtained water from the aqueducts in most cases.

DESCRIPTION

These sections of pipe, or *fistulae* (sing. *fistula*), made of lead, are representative of those used in channeling water in many aspects of Roman life, from fountains to aqueducts. The two longer pieces are about 12 feet in length. The words "AURELI CAESARIS" are inscribed on one section of the pipe and help us date it to the late second century CE. Lead was the most common material for water pipes. Terra-cotta pipes, or *tubulis fictilibus,* were also used but not as often.

 Pliny, Vitruvius, and Palladius all remark that terra-cotta, on the whole, was healthier, though it was clearly a second choice for most water pipes. It remains a mystery why knowledge that lead was dangerous, a fact amply attested at the time, had so little effect on the choice of materials. It may be that since water was running through them rather than sitting in them stagnantly, Roman engineers perceived lead water pipes to be less of a problem. Moreover, the water that flowed through Roman aqueducts and pipes was unfiltered, meaning it had a higher mineral content than most places do today. These minerals formed deposits within the pipes that served as a barrier between the water and the lead pipe itself. Though evidence has come to light of lead poisoning in some remains, by and large, despite popular theories to the contrary, lead was not a major factor in the decline or fall of Rome. Considering that the Romans used these pipes for centuries as the empire grew, this is a further argument against the notion about lead poisoning.

The pipes were made of sheets or plates and bent into a semicylindrical shape. On the examples here one can see at the top of the pipes a narrow ribbon where the metal was folded. Thickness was an all-important concern in pipe making. Our two chief sources for pipe fabrication are Vitruvius (fl. first century BCE), author of *On Architecture,* and Frontinus (d. ca. 103 CE), author of *Concerning Aqueducts.* They describe different methods. The former measured thickness according to the *lamina,* or sheet of lead, before folding, while the latter measured thickness based on the diameter of the pipe after it was made. Pipes were made at different lengths for use in diverse situations.

SIGNIFICANCE

Rome's famous lead pipes, facile theories of them as the source of Rome's doom aside, are most important for what they indicate about Roman waterworks more generally. The Romans obtained much of their water from natural sources such as springs and rivers, but what set Romans apart was the sophisticated apparatus with which they harnessed these resources: the aqueduct. Dionysius of Halicarnassus (fl. 20 BCE) listed the aqueducts as one of three of Rome's most impressive creations, with roads and sewers completing the triad. The aqueducts used Roman knowledge of the terrain, hydraulics, and gravity to bring water from the source to locations often more than 100 miles away. The longest aqueduct, by modern reckoning, is in Istanbul, Turkey, what was once the Roman capital of Constantinople; it ran about 155 miles (250 kilometers). The longest in Italy is the Aqua Augustus, also known as the Misenum or Serino Aqueduct, which runs about 65 miles (106 kilometers). The engineering skill to build these was considerable, and the fact that even today some aqueducts, usually altered or incorporated into modern water systems, still bring water to parts of the former Roman world is testimony to how well constructed these water channels were.

Water traveled from the source to its destination by flowing downhill at specified grades; gravity thus provided the energy for transport. Typically, the engineers used the topography to best advantage, only building up or digging down in order to keep the proper angle to maintain the water's flow. At the source, builders built a *specus,* or conduit, that took the water, usually underground, to a tank, or *castellum.* Often smaller tanks, known as *piscinae* ("fish ponds"), were built along the main line to help remove some of the larger impurities. One of the more impressive aspects of this system was the use of secondary lines that ran off of the main aqueduct. The *ramus,* as such lines were called, could add additional water to the supply, but they could also be used as branches off the aqueduct.

Pipes, like those depicted here, carried water from a *castellum* underground to those places where it was needed. Water from aqueducts supplied the baths, fountains, and some private homes. Usually, branch lines carried

Definitions

Frontinus

Julius Sextus Frontinus (d. ca. 104) enjoyed a long career and served in a variety of high positions, from consul to governor of Britain, and under several emperors, from Vespasian to Trajan. Frontinus wrote several works, but his *De Aquis Urbis Romae* (**Concerning the Water of the City of Rome**) is perhaps his most famous. It contains vital information on Rome's water supply, the administration of the city, and engineering.

Palladius

Little is known about Rutilius Taurus Aemilianus Palladius (ca. mid-fifth century CE). His *De Re Rustica* (**Concerning Rustic Matters**) is the only surviving source for agriculture from the late antiquity. From the text it is clear that he had practical experience in these matters, and since he was the owner of properties stretching from Sardinia to Rome, this is little surprising.

Vitruvius

Marcus Vitruvius Pollio (fl. first century BCE) is our chief source for Roman architecture. His *De Architectura* (**On Architecture**) explains much about architecture but is not a treatise in the sense that it was a guide to building. A military engineer and architect, Vitruvius may have been active under Julius Caesar but wrote his book late in life and dedicated it to Augustus. Much of Vitruvius's understanding is based on Greek precedents, but his own experience shines through as well. His book is typical of many Hellenistic works in that it tends toward the encyclopedic, covering anything the author thought might relate to architecture. For example, Vitruvius discusses philosophy, geometry, and astronomy.

water to other local *castella* for consumption as well. Topography played a key role in where *castella* where placed. The picture that arises from surviving aqueducts and the archaeological record in some respects reflects the divisions that Virtuvius lists in his text, namely that aqueducts supplied *lacus et salientes* ("reservoirs and fountains"), *balneae* ("public baths"), and *privatae domus* ("individual homes"). Frontinus relates that one-third of the water that was headed to Rome was diverted to places outside the city, much of it, perhaps as much as 60 percent of that third, to villas owned by Rome's elite. The fact that most of well-to-do Romans had villas near the oldest aqueducts in the *suburbium,* the region just outside the city, tends to confirm his numbers. Within the city, the situation is similar. Most water was channeled to public resources such as fountains and baths, but almost as much made its way to private homes. These lucky few either paid for the privilege or tapped into the system illegally. That this was a problem is readily

FRONTINUS, *DE AQUIS URBIS ROMAE,* **BOOK 2, SECTIONS 94–95**

94. We have further to indicate what is the law with regard to conducting and safeguarding the waters, the first of which treats of the limitation of private parties to the measure of their grants, and the second has reference to the upkeep of the conduits themselves. In this connection, in going back to ancient laws enacted with regard to individual aqueducts, I found certain points wherein the practice of our forefathers differed from ours. With them all water was delivered for the public use, and the law was as follows: "No private person shall conduct other water than that which flows from the basins to the ground" (for these are the words of the law); that is, water which overflows from the troughs; we call it "lapsed" water; and even this was not granted for any other use than for baths or fulling establishments; and it was subject to a tax, for a fee was fixed, to be paid into the public treasury. Some water also was conceded to the houses of the principal citizens, with the consent of the others.

95. To which authorities belonged the right to grant water or to sell it, is variously given even in the laws, for at times I find that the grant was made by the aediles, at other times by the censors; but it is apparent that as often as there were censors in the government these grants were sought chiefly from them. If there were none, then the aediles had the power referred to. It is plain from this how much more our forefathers cared for the general good than for private luxury, inasmuch as even the water which private parties conducted was made to subserve the public interest.

[Sextus Julius Frontinus, *The Aqueducts of Rome,* http://penelope.uchicago.edu/Thayer/E/Roman/Texts/Frontinus/De_Aquis/text*.html.]

apparent in Frontinus's *Concerning Aqueducts,* in which he laments that the old laws seem to have no effect in stopping abuses in his own day.

Aqueducts, in their early history, were built as needed. Until the first century BCE, when Augustus set about trying to improve the quality of life in Rome, the city relied on four aqueducts, the earliest of which was built in 312 BCE and the most recent in 126 BCE. From 33 BCE to 52 CE, when the Julio-Claudian dynasty was first established and then ruled, five more were aqueducts were added, one each in 33, 19, and 2 BCE and the last two in 52 CE. Later emperors augmented the supply as well, Trajan in 109 CE and then around 226 when Alexander Severus wished to supply his new bathing complex. By the fifth century, the combined output of Rome's 11 aqueducts supplied more than 1,000 fountains, 11 imperial baths, and an additional 926 public baths.

In the next century during the Gothic wars, Belisarius (d. 565), the famous general sent by Emperor Justinian (d. 565), fought against a Gothic king, Vitigis, who in the progress of the war cut off the water supply of the aqueducts in 537 CE. This damage was severe, enough so that on several occasions troops attempted to access Rome via the aqueducts, a fact that indicates that little to no water must have been flowing through some of them. After the war, Belisarius had many of them repaired. Further work was undertaken by Pope Gregory the Great (ca. 600 CE). Two centuries later Pope Hadrian I likewise restored several of the ailing aqueducts to use. During the Middle Ages, at least up to the 10th century CE, Rome relied on the diminishing returns of the ancient water system, but by the High Middle Ages, ca. 12th century, Rome's small population relied more on springs and wells. The first new aqueduct was built in the 17th century.

FURTHER INFORMATION

Aicher, Peter J. *Guide to the Aqueducts of Ancient Rome.* Wauconda, IL: Bolchazy-Carducci, 1995.

Bruun, Christer. *The Water Supply of Ancient Rome: A Study of Roman Imperial Administration.* Helsinki: Societas Scientiarum Fennica, 1991.

Evans, Harry B. *Water Distribution in Ancient Rome: The Evidence of Frontinus.* Ann Arbor: University of Michigan Press, 1994.

Hodge, A. Trevor. *Roman Aqueducts and Water Supply.* 2nd ed. London: Duckworth, 2002.

Humphrey, John W., John P. Oleson, and Andrew N. Sherwood. *Greek and Roman Technology.* New York: Routledge, 1998.

Jones, Rick, and Damian Robinson. "Water, Wealth, and Social Status at Pompeii: The House of the Vestals in the First Century." *American Journal of Archaeology* 109(4) (October 2005): 695–710.

Landels, John G. *Engineering in the Ancient World.* Revised ed. Berkeley: University of California Press, 2000.

Sextus Iulius Frontinus. "On the Water-Management of the City of Rome." Translated by R. H. Rodgers. University of Vermont, http://www.uvm .edu/~rrodgers/Frontinus.html.

Taylor, Rabun. *Public Needs and Private Pleasures: Water Distribution, the Tiber River, and the Urban Development of Ancient Rome.* Roma: "L'Erma" di Bretschneider, 2000.

Vitruvius. *Ten Books on Architecture.* Translated by Ingrid D. Rowland. Commentary and illustrations by Thomas N. Howe. Cambridge: Cambridge University Press, 1999.

White, K. D. *Greek and Roman Technology.* Ithaca, NY: Cornell University Press, 1984.

Wikander, Örjan, ed. *Handbook of Ancient Water Technology*. Leiden: Brill, 2000.

Wilson, Andrew I. "Hydraulic Engineering and Water Supply." In *The Oxford Handbook of Engineering and Technology in the Classical World,* edited by John P. Oleson, 285–318. New York: Oxford University Press, 2008.

Websites

Roman Aqueducts, http://www.romanaqueducts.info/index.html.

"Watering Ancient Rome." PBS, http://www.pbs.org/wgbh/nova/ancient /roman-aqueducts.html.

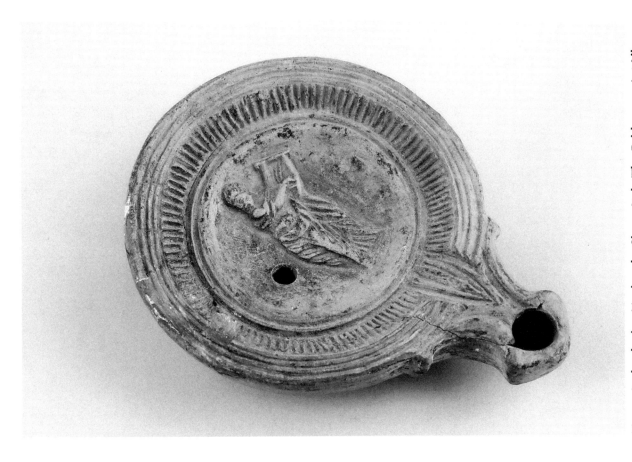

Oil Lamp

Possibly Italian
First Century BCE

INTRODUCTION

Before the advent of electricity, people the world over relied on sunlight and fire to light the world. The Romans, naturally, took advantage of daylight, and indeed most of life was conducted between dawn and dusk. Artificial lighting came from a variety of sources, but lamps were one of the chief methods used to light the night. Small, portable, and relatively safe if used away from flammable materials, lamps provided enough light to avoid injury when walking at night or when working in low-light conditions. Many lamps have been excavated (so many that they are still available to collectors today), and thus we know a fair amount about lamp production, especially for the last few centuries BCE and the first century CE when they were mass-produced.

DESCRIPTION

This terra-cotta lamp, now in the Museo Archeologico Nazionale in Siena, Italy, displays one of the iconic ceramic lamp shapes from antiquity. The round dish (from the Latin *discus*) was an ideal surface for decoration, and several different topics predominated, the most popular being religious, athletic, zoological, mythological, botanical, and pornographic. While shape and size could vary, most *lucernae* (sing. *lucerna*) or oil lamps consisted of several key parts. There was a shallow bowl for oil, which was the fuel of the lamp, and an attached cover pierced with two holes, one for the wick and one for filling. Many lamps had handles; these might be large enough for someone to carry the lamp by hand, or there may have been several smaller loops of clay from which one could suspend the lamp using hooks and either chain or rope. The normal fuel for lamps was olive oil. Wicks were made of a variety of materials, from cloth such as linen, papyrus, or rope. The fuel was drawn into the wick via capillary action—that is, from the surface tension between the liquid oil and the solid wick—and could keep lamps lit a long time, always depending on the quality of the wick and the amount of oil.

169

Many if not most of the terra-cotta lamps in this period, ca. first century BCE, were mass-produced in shops that produced other terra-cotta products, such as figurines, pottery, stamps, and other decorative pieces. The uniformity of many styles is one clue to this, but so too is the fact that many lamps bear the names of the factories that made them. Before the early third century BCE, lamps might be turned on a potter's wheel, a process that allowed for more individualization but was slow. A new process was developed that allowed for mass production during the third century BCE. Most shops began to use molds to create lamps, using one mold for the top and one for the base. Molds might be of clay or a mix of plaster with minerals such as gypsum. The clay was poured into the molds, and once the clay was hard enough to remove without falling apart, the sections were then put together with clay slip and fired. The baked clay coating, in addition to adding a little strength, also made the lamp less porous and thus less likely to lose oil.

Greece had been a major producer of oil lamps in the last two centuries BCE, but by the turn of the first century Italian workshops had begun to conquer the market. Many Roman lamps made in the late first century BCE and the first century CE, for example, have been excavated in Athens and Corinth. The lamp displayed here is typical of these turn-of-the-century lamps. It was in this period that many of the round volute lamps with short nozzles for the wick predominated. Other areas of the empire such as Britain, Gaul, and Germany also made lamps, but these shops suffered during the third century CE—a time of political and social chaos as various generals vied for the throne—and probably closed when the oil supply chain became unreliable.

Lamp production lasted longer in Italy and other Mediterranean areas, as these regions suffered less from the oil shortage. When Rome recovered from the third-century crisis, Greece reemerged as one of the leading lamp producers. Athens and Corinth, not surprisingly, led the way. In the fourth century, North African workshops produced red-gloss lamps, many with Christian symbols. Italian lamp production in late antiquity was poor by earlier standards of quality, and by the sixth century CE only Egypt and the Levant were making decent terra-cotta lamps.

This raises the question of what other methods the Romans used to light their homes. In addition to oil lamps, hearth fires offered some light, as did windows. Windows rarely boasted glass; not even most well-to-do families could afford large enough quantities to cover large windows. Few traces have been found for such extravagances in private residences, though the upper windows in the baths at Pompeii, for example, did have opaque glass panes that allowed some light into the large bathing halls. Windows during the day might admit light, and no doubt those who worked indoors took full advantage of this, but at night and during poor weather the windows had to be covered.

Lanterns or *laternae* (sing. *laterna*) were common as well. Usually made of open metal, horn, or even animal bladders, lanterns produced light via candles set inside them. By the imperial period the rich could afford lanterns with glass, which produced better light. *Candelae* (sing. *candela*), or candles, since they were made of tallow, could be a luxury—the poor, for example, could use tallow and olive oil for food. Beeswax was another common ingredient for candles—these were called *cereus,* from the Latin *cera,* meaning "wax." Candlelight is not particularly effective unless there are many candles, and only the rich could afford them in any number. Out of doors, open fires and torches were the usual methods for lighting, though few places had provisions for or the need for lighting at night. Antioch was one of the few cities, according to the historian Ammianus Marcellinus (d. 395 CE), that had streetlamps.

Petroleum products such as naphtha, though known to the Roman world, were little used for lighting. Only in the Levant was there a plentiful supply. Naphtha was known to be a dangerous product, however, and authors such as Strabo (d. after 21 CE) in his *Geography* related that when too close to flame it ignited and was extremely difficult to extinguish.

SIGNIFICANCE

With such relatively poor methods of lighting, it will probably come as no surprise that most activities were performed during daylight hours. By and large the Romans worked sunup to sundown, though naturally in winter, being darker longer, the days were shorter (see also the entry **Sundial**). Day and night were each divided into 12-hour periods, the end of the sixth hour marking the midpoint. Morning was thus ante meridiem, "before midday" or the sixth hour, and afternoon was post meridiem, or after the sixth hour, our a.m. and p.m., respectively. Most work and most entertainment took place during the day. Dinner parties, something only the wealthier members of society could afford to host, were one of the few after-hours events, and naturally these were usually small. Chariot races, gladiatorial games, theatrical performances, and most other entertainments all took place during the day. Because the night was so infrequently lit, it became, especially in urban settings, a notoriously dangerous time to be outdoors (see the entry **Cave Canem Mosaic**).

There were other downsides to lamps. Olive oil, though good as a fuel, produces an odor when burned. There are a number of references in the sources that discuss the problem of ill-smelling lamps. One remedy mentioned by both Petronius in his *Satyricon* and Martial in Epigram X was to perfume the oil. However, even with pleasant-smelling additives, the odor might permeate other things in the room. Quintilian (d. ca. 96 CE), a rhetorician who penned the *Institutio Oratoria* (*The Instruction of Oratory*), one of the classic works on Roman oratory, in discussing the evils of arrogance

recommends that one's work not "smell of the lamp." This idiom highlights not only the stench of an oil lamp but also the common practice of writers working into the night, a common literary motif if not a common authorial practice. Isidore of Seville, in his *Etymologies,* refers to a type of small lamp or candle called a *lucubrum,* from *lucere in umbra,* meaning "to light in the shadow," from whence the English term "lucubration" derives. In both cases the idea connotes working at night.

Students, who often began their lessons before dawn, carried oil lamps as well. Juvenal, whose biting wit could attack or defend, took up the cause of poor schoolteachers in his seventh satire. There, he decries both the odor of oil lamps and the damage their soot did to books. The soot from oil lamps seems to have been a common problem and not just for book lovers. The architect Vitruvius, for example, suggested that one not place lamps in rooms with expensive decor such as ornamental stucco or wall paintings. He also recommended that the surfaces in rooms with lamps be easy to clean.

Far more serious than the problem of odor or soot, however, was the danger of fire. Rome and other cities in the empire were always at the mercy of wayward flame. Many buildings were made of wood or included wood frames in their construction, and provisions for fighting fire were primitive. Augustus organized the first state-run body to deal with fire, but equipped with axes and buckets its members were only marginally effective if a fire got out of control. The Great Fire of 64 CE, for example, destroyed much of the city, despite efforts to fight it.

One other way in which lamps reveal much of ancient Roman life is in the mode of their production. Generally, mass-produced items are held to be a modern or at least early modern invention, something only possible after people were able to re-create pieces easily and accurately and fabricate them via an assembly line of workers. Roman oil lamps, however, were mass-produced in their heyday. The discovery of a lamp factory in Modena, Roman Mutina, in 2008 confirmed what previous researchers had already demonstrated about the output of such factories. The uniform nature of the round, stubby lamps produced by Roman firms such as Communis, Fortis, and Phoetaspi underscores not only the Roman ability to produce a product in quantity but also that certain brands may have had more appeal than others. From individual lamps, researchers have been able to determine that molds were reused even when worn by recarving the design in them. Such production is not perhaps on par with the advances invented in the 18th century CE or the modern era, but they still denote a sophisticated understanding of the market, excellent quality control, and effective distribution.

FURTHER INFORMATION

Bailey, D. M. *Greek, Hellenistic, and Early Roman Pottery Lamps.* London: British Museum Press, 1975.

Bailey, D. M. "Lamps Metal, Lamps Clay: A Decade of Publication." *Journal of Roman Archaeology* 4 (1991): 51–62.

Eckardt, Hella. *Illuminating Roman Britain.* Montagnac, FR: M. Mergoil, 2002.

Grandjouan, Clairève. *The Athenian Agora,* Vol. 6, *Terracottas and Plastic Lamps of the Roman Period.* Princeton, NJ: American School of Classical Studies at Athens, 1961.

Lapp, Eric C. "Clay Lamps Shed New Light on Daily Life in Antiquity." *Near Eastern Archaeology* 67(3) (September 2004): 174–175.

Perlzweig, Judith. *The Athenian Agora,* Vol. 7, *Lamps of the Roman Period, First to Seventh Century after Christ.* Princeton, NJ: American School of Classical Studies at Athens, 1961.

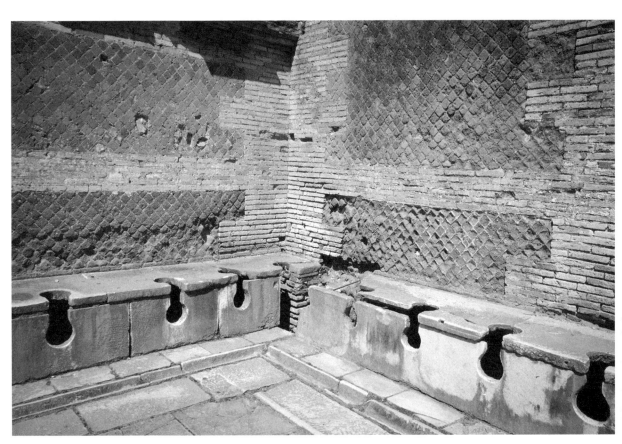

Public Toilets

Ostia, Italy
Second Century CE

INTRODUCTION

It is little surprise that a bustling city might have had public lavatories. Though Rome boasted impressive and well-respected sewers, there was little connection between these gutters and either the private homes of the wealthy or the crowded *insulae* of most everyone else. In addition to chamber pots and commodes, which most living spaces would have had in some number, most Romans made use of the amenities in various parts of the city.

DESCRIPTION

The row of toilets in this public latrine is the most recognizable feature of the remains of the privy near the forum baths in Ostia, Italy, once the port city of Rome. The forum baths were built ca. 150–175 CE under the direction of Marcus Gavius Maximus, then *praefectus praetorio,* or praetorian prefect, the highest equestrian rank and the right-hand man of Emperor Antoninus Pius (d. 161 CE). Marcus Gavius most likely financed the building of this impressive bath complex and its large 20-seat latrine.

Public toilets, or *foricae* (sing. *forica*), such as this were common in the cities of the Roman world. The most striking feature of them today is the lack of privacy; there were no stalls or curtains or any other such blinds. Modern commentators have puzzled over this fact, but either Roman clothing was so constructed as to give ample coverage or the Romans had fewer qualms about certain activities being public. Public latrines still exist in certain parts of Europe, so it may be that as an everyday, normal part of life, answering the call of nature did not require privacy. To date there is little evidence to suggest whether or not public latrines were coed or differentiated between the sexes.

Most latrines were large and either square or rectangular in shape. The seats might be made of stone, as they are here, or of wood. Toilets that had wooden seating have not survived but probably resembled those of stone. The waste was washed away by a running stream of water underneath the benches. The small trough in front of the toilets are thought to have served

175

as a place to wash either one's hands or the *tersorium,* a stick with a sponge at the end that served as toilet paper. Even with water running through these channels, it seems odd that such a place would be meant for hygiene. The theory is that the person would use a *tersorium* by inserting the implement through the hole on the lower section of the bench. The same device would rest in the trough or be washed there. It seems far more likely that the trough was simply a drain, a catch for any waste that might escape, and perhaps too a channel through which to pour water to wash the floors. A bucket might have served to hold the *tersoria,* though it would have needed some manner of cleaning agent such as vinegar or salt in it, something that the poet Seneca remarks upon in one of his letters. Moreover, the fourth wall of this particular public lavatory had a washbasin, something that suggests strongly that the channel in the floor must have served a purpose other than hand washing.

Waste from the public latrines was carried to a larger sewer. Not all cities had these, however, so some locations may have used small canals to remove waste. These were open and probably did little to improve air quality in crowded neighborhoods. Rome boasted an old sewer, one supposedly begun by Tarquinius Priscus, the fifth king of Rome, in the seventh century BCE. This drain, the Cloaca Maxima, or Great Sewer, had originally helped drain the land around the forum. It was repaired and added to over time. In the third century CE engineers enclosed major sections of the up to then open drain, and in 33 CE Agrippa, then an aedile, gave much of the system as it survives today its look. In the sixth century CE when Theodoric the Ostrogoth (d. 526) was king of Italy, Cassiodorus, who held various offices under the king, listed the impressive sewer system as one the wonders of the city. Even today part of the Roman sewer system uses the Cloaca Maxima, a testimony to its engineers. Despite the incredible skill that the Romans had in engineering and building, many cities still had open drains that served as sewers.

By one estimate, there were more than 100 public latrines in Rome, though few have been discovered and fewer still have been excavated. One reason for the high degree of public amenities is that most homes did not have their own toilets, not those that drained into the city's sewers. Most people used chamber pots, which could be taken out in the morning and emptied. Some houses did have toilets, but many of these were simply seats placed over a chamber pot. Many of Pompeii's homes have toilets, usually near a kitchen, but generally these were more like modern outhouses, using a cesspit that must have needed cleaning periodically. In fact, most houses did not have connections to the main sewers. The Romans used their public drains not only for waste but also for river and fountain runoff, and so far archaeologists have discovered few cases where private houses connected their drains to larger city drains.

MARTIAL, *EPIGRAMS*, BOOK 6:93

THAIS smells worse even than a grasping fuller's long-used crock, and that, too, just smashed in the middle of the street . . . than the breath of a lion; than a hide dragged from a dog beyond Tiber; than a chicken when it rots in an abortive egg; than a two-eared jar poisoned by putrid fish-sauce. In order craftily to substitute for such a reek another odour, whenever she strips and enters the bath she is green with depilatory, or is hidden behind a plaster of chalk and vinegar, or is covered with three or four layers of sticky bean-flour. When she imagines that by a thousand dodges she is quite safe, Thais, do what she will, smells of Thais.

[Martial, *Epigrams*, 2 vols., translated by D. R. Shackleton Baily, 1919–1920, http://archive.org/stream/ martialepigrams01martiala/martialepigrams01martiala_djvu.txt.]

PLINY, *NATURAL HISTORY*, BOOK 36, CHAPTER 24

But it was in those days, too, that old men still spoke in admiration of the vast proportions of the Agger, and of the enormous foundations of the Capitol; of the public sewers, too, a work more stupendous than any; as mountains had to be pierced for their construction, and, like the hanging city which we recently mentioned, navigation had to be carried on beneath Rome; an event which happened in the ædileship of M. Agrippa, after he had filled the office of consul.

For this purpose, there are seven rivers, made, by artificial channels, to flow beneath the city. Rushing onward, like so many impetuous torrents, they are compelled to carry off and sweep away all the sewerage; and swollen as they are by the vast accession of the pluvial waters, they reverberate against the sides and bottom of their channels. Occasionally, too, the Tiber, overflowing, is thrown backward in its course, and discharges itself by these outlets: obstinate is the contest that ensues within between the meeting tides, but so firm and solid is the masonry, that it is enabled to offer an effectual resistance. Enormous as are the accumulations that are carried along above, the work of the channels never gives way. Houses falling spontaneously to ruins, or levelled with the ground by conflagrations, are continually battering against them; the ground, too, is shaken by earthquakes every now and then; and yet, built as they were in the days of Tarquinius Priscus, seven hundred years ago, these constructions have survived, all but unharmed.

[Pliny the Elder, *The Natural History*, translated by John Bostock and H. T. Riley (London: Henry G. Bohn, 1855), http://www.perseus.tufts.edu/hopper/text?doc=Plin.+Nat.+36&fromdoc=Perseus%3Atext %3A1999.02.0137.]

Disposal of waste was essential for good health and clean air. Regardless of the various efforts used, there must have been times when the city was a particularly unpleasant place. While the poets Martial and Juvenal both complain of aspects of urban life, Juvenal informs us that one of the many downsides was the danger of waste being dumped from the upper stories of

insulae, the Roman equivalent of high-rise apartments. There were people, often convicts, who cleaned the sewers, and there is evidence of *conductores foricarum,* those who managed the public facilities, but most people probably dumped their own waste into the drain closest to them. Fullers, who collected urine for washing clothing, also collected some waste. Amphorae were placed in various parts of the city, usually outside the fuller's shop, for such collections and were often targets of pranksters who on occasion knocked them over (see the entry **Amphora**). Urine contains ammonia, which is even today a key ingredient in many soaps. Fullers cleaned clothing using two tanks, one for scrubbing that contained urine and another for rinsing. Finally, there were outfits one might hire to remove the contents of cesspits as well as collectors of night soil who removed waste by carts to use as fertilizer in the fields outside of cities.

SIGNIFICANCE

The public latrines of Roman cities were more than necessary adjuncts in the life of a populace who lacked indoor plumbing and connections to sewer lines. Public latrines were also yet another place where people met. Martial, in one of his more bitter epigrams, makes fun of a man named Vacerra who, so the poet claims, spent all day at the latrine hoping to be asked for dinner. Similar remarks were made of those at the baths. What this satirical look also demonstrates is the Roman use of low humor, an aspect of Roman society reflected not only in works of literature but also in numerous graffiti at public lavatories. Scatological humor is not new.

The ways in which the Romans handled waste removal highlight their resourcefulness. The networks of sewers in many Roman cities were great feats of engineering. Dionysius of Halicarnassus (fl. 20 BCE), for example, numbered Rome's sewers among the three most wonderful works of the empire, the other two being the aqueducts and the roads. The collection of urine, both animal and human, for the fullers' shops might have been unpleasant, but it was the chief way in which the Romans washed their clothes, another important aspect of daily life that would have been difficult to complete in the crowded *insulae* of the city. Fullers had legal rights to water, were normally situated close to water sources, and provided an important service for their fellow citizens.

Likewise, the men who collected waste and night soil and carted it out of the city, either to a refuse pile or to the fields as fertilizer, not only helped rid the city of an unpleasant health hazard but also put that hazard to better use in helping ensure that the crops that fed a portion of the city were nurtured. This was all the more important, as Rome at least had no official office charged with cleaning up waste. There is ample evidence that in addition to those paid to remove waste, those who lived in and operated shops on a street were expected to keep them clean, a goal, however, less often achieved

than the authorities probably hoped. Surviving sources mention that dogs and birds often ate the waste in the street. The health risks not only from the refuse but also from animals running wild and eating it must have been considerable. There is one story, for example, of a dying beggar fighting off vultures as he listens to the dogs who hope to feast on him. In addition, among the more common ailments that the Romans suffered were various stomach illnesses, a hardly surprising fact given the inadequate waste removal and the close proximity between eating areas and sewage (see the entry **Votive Male Torso**).

FURTHER INFORMATION

Bradley, Mark, ed. *Rome, Pollution and Propriety: Dirt, Disease and Hygiene in the Eternal City from Antiquity to Modernity.* Cambridge: Cambridge University Press, 2012.

Hobson, Barry. *Latrinae et Foricae: Toilets in the Roman World.* London: Duckworth, 2009.

Hodge, A. Trevor. *Roman Aqueducts and Water Supply.* London: Duckworth, 2002.

Jansen, Gemma. "Toilets with a View: The Luxurious Toilets of the Emperor Hadrian at His Villa near Tivoli." *Babesch: Annual Papers on Mediterranean Archaeology* 82(1) (2007): 165–181.

Jansen, Gemma, Ann Olga Koloski-Ostrow, and Eric Moormann, eds. *Roman Toilets: Their Archaeology and Cultural History.* Leuven: Peeters, 2011.

Scobie, Alexander. "Slums, Sanitation, and Mortality in the Roman World." *Klio* 68(2) (1986): 399–433.

Wilson, Andrew. "Drainage and Sanitation." In *Handbook of Ancient Water Technology,* edited by Örjan Wikander, 151–179. Leiden: Brill, 2000.

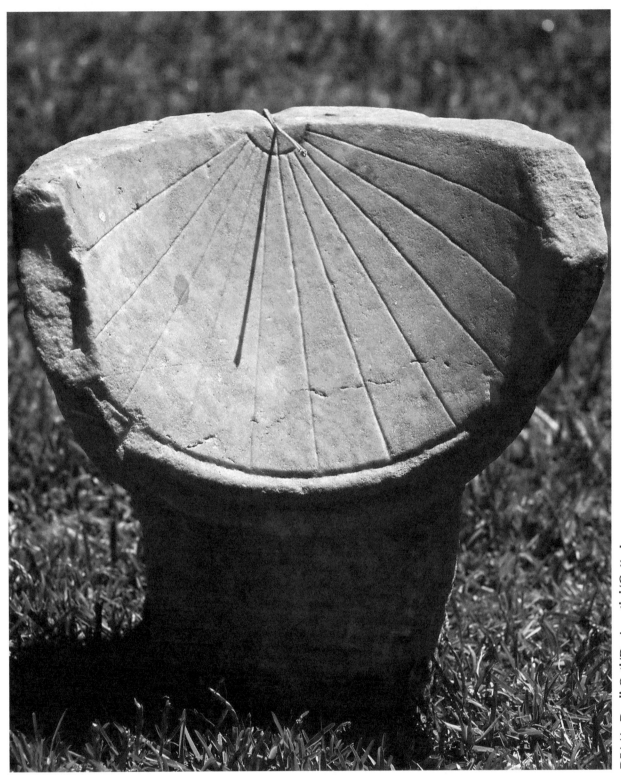

Sundial

Oulili, Morocco
First Century CE

INTRODUCTION

Though only novelties today, sundials were one of the chief methods by which ancient peoples marked the time. The oldest found to date are from Egypt and are of great antiquity, ca. 1500 BCE, but they were probably invented even earlier than that in the Near East. Rome was a relative late-comer to the use of devices for telling time. Roman life was regulated, even after the advent of clocks, by dividing the day into hours of sunlight and darkness, each about 12 hours long regardless of season. These were further subdivided into before and after midday and, later still, into morning and before midday, or ante meridiem. The advances in sundial technology and later clepsydra (water clock) technology, however, continued apace and ultimately produced accurate instruments with which to measure both daylight hours and those at night.

DESCRIPTION

This terra-cotta sundial from Volubilis (present-day Oubili), a site near Meknes, Morocco, dates from the first century CE. The most common device by which to reckon time, the sundial first appeared in Rome in 263 BCE as part of the booty from the First Punic War. The Greek historian Herodotus claimed in his history that sundials originated with the Babylonians, as did the division of the day into 12 units. Sundials may have arrived in Greece as early as the sixth century BCE, but they were not common until the third century BCE.

Sundials were known by several names in Rome. From the Greeks they borrowed the words *gnomon* (meaning "interpreter") and *horologium* (Greek *horologion,* meaning "an hour teller"), but sundials were also referred to as *solaria* (sing. *solarium,* meaning "sundial"). Time telling with these devices was imprecise but far less so than watching the path of the sun in the sky. Most sundials, like this one here, combined a rod or gnomon and a flat or convex surface that caught the shadow of the gnomon. These fields were often inscribed with marks to indicate, using the length or direction of

the shadow, the approximate time. One story relates how Marcus Valerius Messalla, one of the consuls in 264 BCE, brought as a prize of war with the Carthaginians a sundial from Catana, Sicily. However, no one noticed that the lines on the *polus,* another word for the rod of the sundial, were only accurate for Sicily, and it was nearly a century before this was corrected and the prized clock actually told the correct time. Improvements in sundials, however, and in understanding how they worked led to improved use and accuracy. Some models, for example, told not only the relative time of day but even the season by indicating where the shadow fell at midday.

One of the most famous sundials was one erected by Augustus in commemoration of his victory against enemies in Egypt. This sundial, the Horologium Augusti, consisted of bronze lines laid down in travertine marble. The gnomon was an Egyptian obelisk taken from Heliopolis, one of Egypt's oldest cities. Laid out at the north end of the Campus Martius in the shape of a double ax, and doubling as a calendar, this impressive sundial was inaccurate by the time of Pliny the Elder (d. 79 CE). It was refurbished during the reign of Emperor Domitian (d. 96 CE).

Even with more accurate sundials, however, they were only useful during the day and then only when it was sunny. Another form of clock, the clepsydra (literally "water thief"), provided another way to tell the time. Known in Athens by at least the fifth century BCE and used in the law courts, the use of water clocks in Roman courts dates to the consulship of Pompey in 52 BCE. These particular clocks did not so much count the hours as acted like a stopwatch. Speakers spoke until the water in the clock had run out. The letters of Pliny the Younger (d. ca. 112 CE), among other sources, relate that prosecutors received two-thirds of the time as the party of the accuser to speak. When documents were produced by either side, an attendant stopped the flow of water. For more general time telling, one of the first water clocks in Rome was set up by Publius Scipio Nasica, censor in 159 BCE, who intended it to keep time night and day.

There were several kinds of clepsydra. One of the more common types consisted of a vessel, often conical, that allowed water to drip out of the bottom at a constant rate. Others were made of glass and may have been clear enough for the viewer to see the water rise up to marks that signified the hours. Many, however, were probably made of terra-cotta and marked the time not via marks on the receiving container but instead by the emptying of the original reservoir, like those used in law courts. How much time the water clocks counted depended on the amount of water the reservoir held. There were limitations to this method of time reckoning, too. First, temperature affected the rate at which the water flowed from the vessel. Second, in wintertime the hours were shorter. One interesting solution recommended for the second problem came from a Greek military theorist of the fourth century BCE, Aeneas Tacticus, who in his *Poliorcetica* (Siegecraft)

Primary Source

PLINY, *NATURAL HISTORY,* BOOK 7, CHAPTER 60

Chap. 60.—When the First Time Pieces Were Made

The third point of universal agreement was the division of time, a subject which afterwards appealed to the reasoning faculties. We have already stated, in the Second Book, when and by whom this art was first invented in Greece; the same was also introduced at Rome, but at a later period. In the Twelve Tables, the rising and setting of the sun are the only things that are mentioned relative to time. Some years afterwards, the hour of midday was added, the summoner of the consuls proclaiming it aloud, as soon as, from the senate-house, he caught sight of the sun between the Rostra and the Græcostasis; he also proclaimed the last hour, when the sun had gone down from the Mænian column to the prison. This, however, could only be done in clear weather, but it was continued until the first Punic war. The first sun-dial is said to have been erected among the Romans twelve years before the war with Pyrrhus, by L. Papirius Cursor, at the temple of Quirinus, on which occasion he dedicated it in pursuance of a vow which had been made by his father. This is the account given by Fabius Vestalis; but he makes no mention of either the construction of the dial or the artist, nor does he inform us from what place it was brought, or in whose works he found this statement made.

M. Varro says that the first sun-dial, erected for the use of the public, was fixed upon a column near the Rostra, in the time of the first Punic war, by the consul M. Valerius Messala, and that it was brought from the capture of Catina, in Sicily: this being thirty years after the date assigned to the dial of Papirius, and the year of Rome 491 [262 BCE]. The lines in this dial did not exactly agree with the hours; it served, however, as the regulator of the Roman time 99 years, until Q. Marcius Philippus, who was censor with L. Paulus, placed one near it, which was more carefully arranged: an act which was most gratefully acknowledged, as one of the very best of his censorship. The hours, however, still remained a matter of uncertainty, whenever the weather happened to be cloudy, until the ensuing lustrum; at which time Scipio Nasica, the colleague of Lænas, by means of a clepsydra, was the first to divide the hours of the day and the night into equal parts: and this time-piece he placed under cover and dedicated, in the year of Rome 595 [158 BCE]; for so long a period had the Romans remained without any exact division of the day.

[Pliny the Elder, *The Natural History,* translated by John Bostock and H. T. Riley (London: Henry G. Bohn, 1855), http://www.perseus.tufts.edu/hopper/text?doc=Plin.+Nat.+7.60&fromdoc=Perseus%3Atext%3A1999.02.0137.]

suggested that sentries on night watch use wax on shorter nights of the year to decrease the amount of water within the clock. This wax could be removed gradually as the nights grew longer. The most significant improvements to the water clock, however, came in the third century BCE with the genius of Ctesibius (fl. 270 BCE), an Alexandrian who devised the first

accurate water clock. He introduced a way to make the flow of water more regular and reliable. In his design, which as Vitruvius describes it is rather complicated, Ctesibius posited a system wherein water falling into a basin raised a small inverted bowl connected to a series of gears. As the water falls in the basin, the bowl is raised and moves figures that point to a column with marks to indicate the hours. While a clepsydra this complicated was probably not in every home, the basic idea behind an in-flow water clock persisted and spread quickly.

SIGNIFICANCE

Though improvements to sundials and water clocks made the measuring of time easier, day or night, the Romans continued to reckon most everything by sun and moon. These more general divisions served most people well, as most activities were daytime events, while night for most was when one slept. This was true regardless of the advances in knowledge of astronomy too. Knowledge of the cycles of the lunar month and the solar year were already accurate; Greek astronomers as early as the fifth century BCE knew that the lunar month was about 29.5 days long and the year was about 365.25 days long. Calendars of the period reflect this awareness, but until the interest and popularity in astrology took off in the last century BCE and the first century CE, most people had little need or desire to know such precise movements and how they affected time reckoning (see the entry **Calendar**).

A number of sources not only highlight the traditional way of dividing up the day but also poke fun at the ways clocks changed society. For example, a character in the "Boeotia" of Plautus, preserved as a fragment by Aulus Gellius, remarks:

> May the gods curse that man who first discovered the hour and who much more first set up this sundial, who broke up the pieces of the day for wretched me! For the stomach was a sundial for me as a boy, one better and truer than all of these. It used to warn me to eat, unless there was nothing; now, even when there is, it is not eaten unless the sun allows it. And so much more now is the city filled with sundials: the greater part of the people crawl, shriveled with hunger.

This is good comedy, but it also points to the Roman penchant for practicality. In the lives of most people, more mundane concerns, such as meals, hours of available sunlight to work, and their usual duties and routines were probably a surer guide than any clock.

Other traditions likewise informed the Roman of the most important moments of the day. For example, the consuls had an attendant who watched the progress of the sun as it reached midday. When it did, this attendant made an announcement in the forum for all to hear. This was especially

important for those in law, as their cases had to be made before noon to be considered valid. One finds in various sources, such as in Petronius and Martial, that it was common for slaves to be assigned the task of announcing the time as well. These measures did not remove the necessity for more effective ways of telling the time but instead indicate that even with better clocks, most Romans were content to observe older methods.

FURTHER INFORMATION

Bickerman, E. J. *Chronology of the Ancient World.* Ithaca, NY: Cornell University Press, 1980.

Drachmann, A. G. *Ktesibios, Philon and Heron.* Copenhagen: Munksgaard, 1948.

Gibbs, Sharon L. *Greek and Roman Sundials.* New Haven, CT: Yale University Press, 1976.

Humphrey, John W., John P. Oleson, and Andrew N. Sherwood. *Greek and Roman Technology: A Sourcebook.* New York: Routledge, 1998.

Mosshammer, Alden E. *The Chronicle of Eusebius and Greek Chronographic Tradition.* Lewisburg, PA: Bucknell University Press, 1979.

Waugh, Albert. *Sundials: Their Theory and Construction.* New York: Dover, 1973.

Religion and Funerary Practices

Aedicule Memorial

Bulla

Catacombs

Curse Tablet

Lar

Sistrum

Votive Male Torso

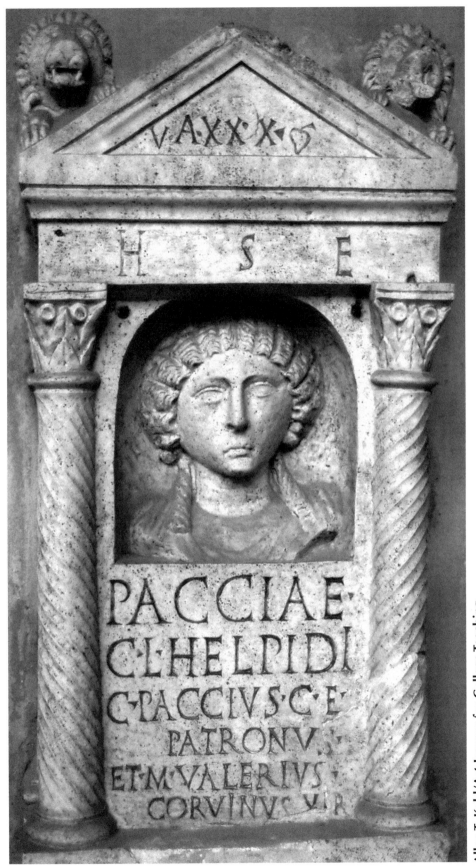

Aedicule Memorial

Classe, Italy
First Century CE

INTRODUCTION

Death is an everyday event in all cultures. Roman funeral practices, burial styles, and ways of commemorating the dead tell us much about family identity, theories of the afterlife, and public immortality.

DESCRIPTION

The gravestone here, made of marble, is an aedicule memorial from a first-century CE necropolis in Ravenna, Italy. It is one of many Roman styles of funerary art. "Aedicule" is a diminutive form of the Latin term for building, *aedificium,* so an aedicule is a "little building." They were common architectural motifs in funerary art and in certain types of shrines, such as *lararia.* This aedicule memorial depicts the deceased within the building, an epitaph below her, and architectural motifs such as columns, lions, and the pediment where her age is listed (V.A. XXX).

Funerary art and inscriptions can tell us a lot about a person. Inscriptions normally follow a similar pattern to this one, with the details varying according to the achievements, connections, wealth, and history of the deceased. The more money one had, the larger the monument might be; the more one had achieved in life, the more might be listed. Men who had held government and military positions, for example, normally included these accomplishments on their tombstones. Most stones provided at least the person's age, name, family, district, and occupation. The inscription here reads:

V(ixit) a[nnos] XXX / h[ic] s[ita] e[st] / Pacciae / C[ai] l[ibertae] Helpidi / C[aius] Paccius C[ai] f[ilius] / patronus / et M[arcus] Valerius / Corvinus vir.

She lived thirty years. Here she lies, Paccia Helpis, freedwoman. Caius Paccius son of Caius, her patron, and Marcus Valerius Corvinus, her husband [had this made].

From this we learn that Paccia was a freedwoman, a former slave, and that her former master remained her patron even after she married Marcus Valerius Corvinus, a common practice for freedmen and freedwomen. Often the abbreviations HFC (*heres faciendum curavit/curaverunt,* "the heirs had [this] made") and HP (*heredes posuerunt,* "the heirs placed [this]") accompany the names of either the heirs or those who erected the monument. Here that information is implied.

Not all burials used aedicule memorials or provided so much information. In their earliest history down to about 100 BCE, the Romans favored simple graves. Both inhumation and cremation were practiced in Italy, but influences from the Greek colonies in the south and the fabulous chamber tombs of the Etruscans led some Romans to gradually adopt the more elaborate memorial practices of their neighbors. Inhumation seems to have predominated, and even when bodies were cremated it was customary to take part of the body, such as a finger, and place it in the ground.

Initially most people probably could not afford formal cremation, and the more traditional families, especially among the wealthy, tended to be more conservative and thus buried their dead. In time, however, and certainly by the time of Emperor Augustus (late first century BCE), cremation had become the predominant method of funeral practice. Roman law, at least from the Twelve Tables (ca. 451–450 BCE) on, forbade burials within the city, so the dead were taken outside of the city. Cremations too were performed outside city limits. In part this was probably a question of concern for health and cleanliness but also because of traditions about the dead. It was important not to pollute the sacred precincts, but the general fear of ghosts also meant that it was deemed wise to take care of the dead quickly and to remove their earthly remains to a safe distance.

Because the dead were not to be interred within the city, many roads leading out of cities such as Rome were lined with elaborate tombs and sarcophagi. The Appian Way, Rome's oldest road, boasted tombs of the older and noble families, but few roads lacked avenues of such memorials. There were also burial spots for the less wealthy, and in some cases there were mass graves. The *puticuli,* as these are called, were plain unlined holes, typically about 12 feet square. These were usually intended for those without any connections, such as the extremely poor, criminals, and those who had died in the arena. Because other refuse was often added to these graves, they were uncovered—the combined stench of refuse and the remains was horrific. Originally in the republican period, these pits were on the eastern side of the Esquiline Hill. Augustus's friend and advisor, Maecenas (d. 8 BCE), buried this area under 25 feet of soil and made it a park, the Horti Maecenatis (Gardens of Maecenas).

There were a variety of tomb styles. Many graves if not most were humble. Family tombs, particularly for noble families, were common. Since

they were larger, generations might be buried there or their ashes placed within. In some cases family servants, even freedmen, might be interred along with the main family. Many of the tombs lining the roads fall into this category. While tombs might contain an individual, more often memorials to one individual, particularly a well-known or politically important person, were memorials rather than graves. Though the least fortunate ended their days in the *puticuli,* most people found more suitable grave sites. Freedmen might be able to afford their own tombs, but it was common for them to find resting places in the family plots of those they had once served.

Communal tombs were common as well. One such burial style was the *columbarium.* Literally this term means "dovecote" but refers to the niches, or *loculi,* in

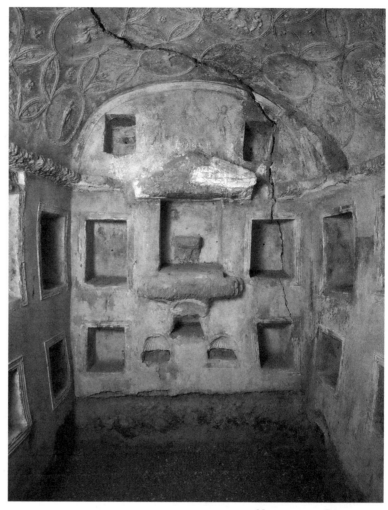

Hypogeum, Rome, Italy, with excellent examples of columbaria. (Araldo de Luca/Corbis)

these often huge memorial buildings. The photograph of a hypogeum shows the interior of Roman columbarium in Rome, Italy. There are many of these near the city, but some of the most significant are those of the freedmen who were patronized by Livia (d. 29 CE), the wife of Augustus, a giant complex with some 3,000 tombs; the columbaria of Pomponius Hylas at the Porta Latina and those at the Villa Doria-Pamphili, both famous for their exceptional murals; and the tombs for freedmen at the Vigna Codini. All of these are first-century CE grave sites.

Often underground, long, and rectangular in shape, columbaria contained hundreds of small recesses that could hold urns. These varied from simple holes to architectural renderings. A typical columbarium was arranged more or less along both horizontal and vertical axes, the *gradus* and *ordines,* respectively. Some of the niches were larger than others and could accommodate more than one urn, or *olla.* A placard, often of marble, sat either above or below the niche and provided the name of the deceased. When a family had a number of niches close together, they often separated their portion out using decorative columns, again much like an aedicule. In fact, these related

sections were called *aediculae*. Apparently, the most expensive niches were those closer to the floor, perhaps because they were easier to find and thus easier for observing memorial rites. In general columbaria were more affordable, and it is perhaps unsurprising that they appeared during the reign of Augustus when land prices were particularly high. What remains of those in Rome today were used to hold the ashes of many of the slaves and freedmen and freedwomen who had worked for the Julio-Claudian emperors. These, such as that of Empress Livia, were large enough to contain thousands of loculi. By the mid-second century customs had changed, and new inhumation graves were cut into some columbaria. These new tombs, or *arcosolium,* were recessed as well but were large enough to hold a burial or more. Cremation fell out of favor around 200 CE, and use of *arcosolia* continued, though often in rows one above the other.

Since burial could be expensive, many people formed funeral clubs. Members pooled money together in order to ensure that each would have a proper funeral when the time came. Originally such organizations began within particular occupations, but as an effective way to guarantee proper burial, the idea caught on. These *collegia funeraticia* ("funeral clubs") sometimes fell prey to government suspicion of small groups but were normally spared. One senatorial order, for example, allowed such clubs to meet so long as they agreed only to meet once a month. When the members met they often shared a meal, so in addition to providing for funerals, these organizations also functioned as social clubs. When one of their members passed, the funeral club paid the expenses, made sure the proper rites were observed, and likewise conducted the rituals and provided the offerings on the days to remember the dead.

SIGNIFICANCE

The ways in which a people handle death and burial reveals much about their views on life, death, the afterlife, and society. It is difficult to generalize the usual procedures followed when a person died, because much depended on what an individual or his or her family could afford to spend. There were certain proprieties, however, that were common and that all Romans attempted to observe. Most of what we know of funerals pertains only to elite households.

When a person died, the family placed cypress branches outside the house to announce to all that a death had occurred. The attention paid to a person at death depended on his or her status and position. When a father died, for example, the eldest son had certain duties. First, he performed the *conclamatio* in which he called his father by name and then finished this quick rite by announcing that this had been tried. The next step was to prepare the body, which meant washing it and applying oil; in the case of a man who had held a curule magistracy, a wax death mask was made of his face.

Likewise, he was decked out in a toga that spoke to his rank and was sometimes crowned with a laurel wreath. These masks were important not only as reminders to the family of its past service to the state, of their *nobilitas,* but also up until the imperial period were worn during the funeral procession. The body lay in state for several days so that family, friends, and clients might pay their respects.

Taking the body out of the city for burial was the next step, one normally conducted via a procession that preceded and followed the body on its litter. Here too, status determined the amount of pomp. Those who could afford it added professional mourners to the entourage. The more important the deceased, the larger and more ostentatious the procession. It might include not only musicians to lead the way but also singers, clowns, and then the more formal group of family wearing the death masks of their ancestors. The family was followed by friends, freedmen, and slaves. If suitable, a speech was made in the forum to celebrate the man's life and accomplishments.

At the grave site, the rites continued. The deceased, if burned, was lowered into a pit with wood for that purpose; if he was to be buried, then he might be lowered on the litter or in a coffin, one often made of clay or stone. Gifts, spices, or perfume might be thrown upon the funeral pyre or into the grave, and then dirt was ceremoniously added. If the person was cremated, a bone was symbolically buried. The ashes were doused with wine and then collected into an urn for deposit in a tomb or burial. Once these rites were over, the family stayed behind to undergo purification by water before returning home.

The central role of family, living and dead, emerges clearly from these funeral rituals. Even after the funeral, the family maintained the graves and commemorated the dead. In fact, in some sense the Roman dead did not necessarily go to the underworld at time of death. The Romans believed that so long as one was buried appropriately, that one remained among the *di manes,* the spirits that lived outside the city. In a way, these spirits were treated as a collective, that is, as a community of the dead living next to that of the living, complete with priests to ensure their goodwill and festivals to honor them, such as the Parentalia held during February 13–21. Those spirits that were unburied were considered hostile and unhappy, and they too had to be appeased. The festival of Lemuria, held in May, was intended to propitiate these potentially malevolent spirits.

In addition to festivals and rites, much of Roman immortality, such as it was, consisted of leaving behind impressive memorials. Only those with means could do this, but those memorials that survive today impress one by their size and the different forms they took, from the simple aedicule memorials like this one here to the large tower tombs, common in the eastern half of the empire; to the small pyramid of Gaius Cestius (ca. 15 BCE); and the tomb of Eurysaces (ca. 30 BCE), a prominent baker.

FURTHER INFORMATION

Adkins, Lesley, and Roy A. Adkins. *Dictionary of Roman Religion.* New York: Facts on File, 1996.

Carroll, Maureen, and Jane Rempel, eds. *Living through the Dead: Burial and Commemoration in the Classical World.* Oxford, UK: Oxbow, 2011.

Fedak, Janos. *Monumental Tombs of the Hellenistic Age.* Toronto: University of Toronto Press, 1990.

Hope, Valerie. *Death in Ancient Rome: A Sourcebook.* New York: Routledge, 2007.

Johnston, Harold Whetstone. *The Private Life of the Romans.* Revised by Mary Johnston Scott. Chicago: Scott, Foresman, 1932.

Morris, Ian. *Death-Ritual and Social Structure in Classical Antiquity.* New York: Cambridge University Press, 1992.

Toynbee, J. M. C. *Death and Burial in the Roman World.* Ithaca, NY: Cornell University Press, 1971.

Walker, S. *Memorials to the Roman Dead.* London: Published for the Trustees of the British Museum by the British Museum Press, 1985.

Website

"A Roman Funeral." University of Michigan, http://www.umich.edu/~kelseydb/Exhibits/Death_on_Display/Cremation_Group/funeral.html.

Bulla

Pompeii, Italy, House of Menander
First Century CE

INTRODUCTION

In many images of Roman children one sees young boys wearing a necklace with a small, round globe attached to it. This pendant, a *bulla* (pl. *bullae*), symbolized the freeborn status of the child and informed others that his father and/or paternal ancestors had held curule magistracies, such as consul, praetor, or curule aedile, or early on could afford to serve in the cavalry. Bullae, however, were also amulets meant to protect the boy from malevolent spirits, the evil eye, and curses. They are thus a prime example of the Roman belief in and practice of magic.

DESCRIPTION

This image depicts a bulla made of gold. It was found within the House of Menander in Pompeii and dates to the first century CE. Bullae were special amulets worn by Roman boys to indicate their rank and to act as protective amulets. Bullae were normally round and bulbous like a bubble, hence the name (the Latin term *bulla* means "bubble"). Precious metals, especially gold or silver, were common, but bronze and leather were also used, especially by those who lacked the means for the more expensive models.

The Romans credited the Etruscans with the tradition of wearing a bulla. According to legend, an Etruscan king, Tarquinius Priscus, rewarded his young son with both a bulla and a *toga praetexta* for his heroism in battle (see the entry **Toga Praetexta**). Tarquinius Priscus is also credited with mandating that all freeborn boys wear this item so long as their fathers had money enough to own a horse (and thus had served in the cavalry) or had held one of the curule magistracies. From that time on, freeborn youths wore the bulla as a symbol of rank. In addition, however, the bulla also served as an amulet to protect the child from maleficent forces. Bullae often contained items meant to increase their effectiveness, from charms to perfumes. Young girls did not wear bullae, but many did wear a similar amulet, such as the *lunula,* and for much the same reason.

Children were believed to be more at the mercy of malignant spirits, the evil eye, and other ills. This may have been because of the high infant mortality rate, the fact that many children did not live to see adulthood, or that being young they were more prone to illness and less effective at fighting it, not having built up immunity. All of these factors probably colored the view that children were especially vulnerable and needed protection. The bulla and the purple stripe on the *toga praetexta* both served to provide boys with added layers of protection. Virgil, in his *Eclogues,* suggests that the young were especially prone to harm from the evil eye, a superstition often countered via amulets. Adults too wore charms, painted their houses with apotropaic devices, and feared curses and evil spirits. Pliny the Elder in his *Natural History* related that most Romans, whatever their rank or education, seemed to be enamored of charms and amulets.

When young men reached maturity, there were several rituals they underwent to leave behind childhood and enter the world of adults. A boy offered his *toga praetexta* and bulla to the Lares of his household (see the entry **Lar**), and he put on the *toga virilis,* a white toga that symbolized his having reached maturity. The young man also had his first shave, and his hair was cut short. Once these rites were observed, he accompanied his father, male relations, and family friends to the forum, where they would perform a rite at the Capitol. The young man's name would also be put down in the roll of citizens. Roman sculptures depicting children often show young boys wearing both the *toga praetexta* and a bulla.

SIGNIFICANCE

The bulla is important, for it shows the attitude and concern that the Romans had toward their children. Though not everyone could afford a golden bulla, even less fortunate children wore some manner of protective amulet. In addition to the insights that these charms give us into Roman ideas of childhood, bullae are also a prime example of the pervasive belief in magic, something officially condemned but widely practiced.

Pregnancy, childbirth, and childhood were all dangerous phases in life. Many women died in childbirth, and many children died young. Injury, illness, violence, and exposing unwanted children to the elements all took an unknown toll on the population. Since people married younger and had many children, not all of whom survived, birth rates appear to have remained stable, but those who lost children still suffered psychologically. Grave inscriptions indicate that many women married in their early teens, had multiple children, and might be grandmothers by the time they were 30. Children who survived their first few years were still believed to be vulnerable and thus in need of special protection. The Romans, like all peoples, loved their children and wanted them to thrive. With little effective medicine or knowledge of how to prevent and treat disease, it was natural for a

Primary Source

PLINY THE ELDER, *NATURAL HISTORY,* BOOK 28, CHAPTER 4

There is no one, too, who does not dread being spell-bound by means of evil imprecations; and hence the practice, after eating eggs or snails, of immediately breaking the shells, or piercing them with the spoon. Hence, too, those love-sick imitations of enchantments which we find described by Theocritus among the Greeks, and by Catullus, and more recently, Virgil, among our own writers. Many persons are fully persuaded that articles of pottery may be broken by a similar agency; and not a few are of opinion even that serpents can counteract incantations, and that this is the only kind of intelligence they possess—so much so, in fact, that by the agency of the magic spells of the Marsi [*an Italic people in the mountains of central Italy*], they may be attracted to one spot, even when asleep in the middle of the night. Some people go so far, too, as to write certain words on the walls of houses, deprecatory of accident by fire.

But it is not easy to say whether the outlandish and unpronounceable words that are thus employed, or the Latin expressions that are used at random, and which must appear ridiculous to our judgment, tend the most strongly to stagger our belief—seeing that the human imagination is always conceiving something of the infinite, something deserving of the notice of the divinity, or indeed, to speak more correctly, something that must command his intervention perforce. Homer tells us that Ulysses arrested the flow of blood from a wound in the thigh, by repeating a charm; and Theophrastus says that sciatica may be cured by similar means. Cato has preserved a formula for the cure of sprains, and M. Varro for that of gout. The Dictator Caesar, they say, having on one occasion accidentally had a fall in his chariot, was always in the habit, immediately upon taking his seat, of thrice repeating a certain formula, with the view of ensuring safety upon the journey; a thing that, to my own knowledge, is done by many persons at the present day.

[Pliny the Elder, *The Natural History,* translated by John Bostock and H. T. Riley (London: Henry G. Bohn, 1855), http://www.perseus.tufts.edu/hopper/text?doc=Perseus%3Atext%3A1999.02.0137%3Abook%3D28.]

religiously minded people to look to the supernatural for explanations of sudden mishap and for help.

Officially, magic was condemned in Roman society and law. The Twelve Tables, one of Rome's earliest collections of laws, forbade the use of magic, and yet the dividing line between magic and religion was often thin and permeable. There were magical elements to certain Roman religious rituals, but since these were employed in the best interests of the state and to propitiate the gods, the Romans either did not see this as magic or saw it as acceptable magic. There was overlap, and both the official world of ritual and the popular world of magic no doubt influenced one another. Some scholars maintain that one of the primary differences was in one's intentions. Magic,

by and large, was self-serving; religion, though it had a personal side, was the duty of the state and helped manage Rome's relationship with the gods for the good of all. The fact that magic was hidden, something secretive and connected to both antisocial characters and behavior, did little to recommend it to officials. Despite legal and social uncertainty, the use of magic was widespread and popular.

The idea behind magic was to use words, objects, gestures, or symbols or a combination of these to persuade the gods, spirits, or other forces to bring about the magician's objective. Roman magic, like most traditions, drew upon that of its neighbors, so Celtic, Greek, and especially Egyptian ideas of magic had great influence on Roman methods. Many magic names, or *voces magicae,* for example, were either foreign or nonsense words. Folk tradition and healing, elements of Roman religion, and a wide variety of other spiritual and magical traditions all helped shape theories and practices of Roman magic. A key part of the belief in magic, whatever its origin, was that through proper methods one could control more powerful, mysterious entities, to "bind" them so that they must help or do one's bidding. Such power might be used for good or ill, but even some seemingly less harmful uses, such as love magic, could be hard on the object of a spell. The object's feelings and existing relationships, for example, were not a primary concern. Some *magi* (from the Latin *magus,* meaning "magician, sorcerer") used their skills to foretell the future, consult with the dead or spirits, or make and sell spells and magical items.

Amulets, like a child's bulla, were one of the more common magical objects. Most anything might be rendered magical so long as it had been charmed and was used appropriately; some magical objects required incantations to work, while others had to be moved or used in a prescribed manner. Some materials were favored, however, and gold and precious gems, for example, might be thought of as more effective than lesser metals or regular stones. These objects, like most other means of manipulating the supernatural, relied on the idea of sympathies. For example, curse tablets (see the entry **Curse Tablet**) were often deposited with something that belonged to the intended victim, say a lock of hair or something the person had touched, the idea being that because it had belonged to or had come into contact with the person it was somehow imbued with more of that individual's essence. It was connected to the person, so if one harmed or cast a spell upon such objects, the more likely the magic was to work. In short, harm something connected to the victim, harm the victim. Amulets were also popular in folk medicine and were believed to work the same way. Pliny the Elder lists numerous medical uses of amulets, from teeth to plants, though he does not always believe them to work.

Roman bullae thus highlight not only the sacredness of children, how parents worried for their safety and survival, but also the reliance upon supernatural means to ensure a child's security.

FURTHER INFORMATION

Adkins, Lesley, and Roy A. Adkins. *Dictionary of Roman Religion.* New York: Facts on File, 1996.

Graf, Fritz. *Magic in the Ancient World.* Cambridge, MA: Harvard University Press, 1999.

Harlow, Mary, and Ray Laurence. *Growing Up and Growing Old in Ancient Rome.* New York: Routledge, 2002.

Luck, Georg. *Arcana Mundi: Magic and the Occult in the Greek and Roman Worlds.* Baltimore: Johns Hopkins University Press, 1985.

Ogden, Daniel. *Magic, Witchcraft and Ghosts in the Greek and Roman Worlds: A Sourcebook.* New York: Oxford University Press, 2009.

Rawson, Beryl. *Children and Childhood in Roman Italy.* New York: Oxford University Press, 2003.

Shelton, Jo Ann. *As the Romans Did: A Sourcebook in Roman Social History.* New York: Oxford University Press, 1988.

Websites

"Casa del Menandro." The Stoa Consortium, http://www.stoa.org/projects /ph/house?id=9.

"The House of Menander." Pompeii on Your Desktop, http://archaeology .uakron.edu/pompeii_site/Topics/menander/men_frameset.html.

Catacombs

Rome, Italy
In use, 3rd through 7th Centuries CE

INTRODUCTION

The famous catacombs have become emblematic of early Christianity. Though commonly featured in film and literature as the hiding place of wary Christians avoiding persecution, the catacombs were in fact well-known cemeteries just outside Rome. In time they also became places of commemorating the saints, as many interred within the winding chambers had died during persecutions. So important were such sites for early Christians that access to the catacombs was sometimes made easier. Pope Damasus (d. 384), for instance, installed stairs, repaired broken sections of the tombs, and even redecorated the rich murals painted within some catacombs.

DESCRIPTION

The image here shows the entrance into the catacombs of Saint Sebastian in Rome. These were the first catacombs and are so-called because they were near the church of Saint Sebastian, three miles south of Rome along the Via Appia. The term itself comes from Greek *kata kumbas,* and it is unclear whether or not this referred to the landscape near the church that contained depressions (*kumbas* means "cup" or "hollow") or to a road sign. The word was in use by the fourth century CE and designated first the cemetery at Saint Sebastian and later, by extension, any similar underground network of tombs. The catacombs, a predominantly Christian system of burial, were in use from the late third or early fourth centuries until the sixth or early seventh centuries CE.

The catacombs share much in common with both Roman and Jewish tombs. In some respects the catacombs resemble the *columbaria*, a popular style of Roman burial (see the entry **Aedicule Memorial**), but they were also similar to a particular Jewish practice of interment and one adopted by early Roman Christians. Rock-cut tombs were common in the Levant, and Jews took the practice to Rome with them. As Christianity grew out of Judaism and as many of the first converts were Jews, naturally Christians

203

continued the tradition. Some catacombs were patronized and maintained by churches, but others may have been donated by well-to-do families for their fellow parishioners.

Catacombs consist of a network of long, narrow passages with side rooms, alcoves, and branches. New passages were cut into volcanic tuff over the course of the fourth and fifth centuries. The various sets of catacombs, if their length were to be combined, would extend hundreds of miles. Normally used for inhumation graves, where the body was deposited rather than cremated, the catacombs are riddled with *loculi* (sing. *loculus*), horizontal, narrow niches cut into the volcanic rock where the deceased was deposited. These were usually sealed, though many today have lost their covering. Particularly important graves, such as those for martyrs and some of the early popes, were often constructed with special rooms called *cubicula* (sing. *cubiculum*) not only for burial but also for memorials. Some such rooms, for example, have small altars and rich murals. This indicates that the catacombs, while they were not used as hiding places, a common misconception, were used to commemorate early Christian heroes. Many of the *cubicula* also have *arcosolia,* a sort of table cut into one wall of the room. The deceased was buried under this table, though in some cases more than one body might be interred. A lunette, the semicircular spot at the back of the arch above the table was another surface upon which to add painting.

By Roman law, cemeteries had to be outside the city, so the catacombs were originally outside of Rome and the few other cities, such as Ostia, that had them. There are around 50 known sets of catacombs near Rome, most along what were once major roads, such as the Via Appia in the south and the Via Salaria to the north of the city. Some catacombs, such as those of Saint Domitilla, grew out of existing graveyards, in this case out of the Flavian Hypogeum. While there were martyrs, well-known bishops, and popes buried in some catacombs, they were largely used for the average Christian. In fact, around 200 CE Pope Zephyrinus organized a program to ensure that the unfortunate also found decent resting places. This was reportedly carried out by Saint Callixtus, whose name became synonymous with the earliest catacomb on the Appian Way.

In addition to their use as burial grounds, which continued until funerary customs changed, the catacombs also became key devotional sites. This practice continued well after the catacombs had ceased to be used to bury the dead. Not all who were interred within the catacombs were famous martyrs or saints, but a number of churches sprang up above those graves that either did belong to such Christian heroes or were believed to. Pilgrims came from all over the Roman world to worship there and seek the intercession of the saints. The practice grew first with the legalization of Christianity and then all the more when the Roman world became predominantly Christian. There are several sources that allude to these famous tombs. The

Primary Source

PRUDENTIUS, *PERISTEPHANON*, BOOK 11

Hard by the City Walls—amid the orchards—there is a Crypt. . . . Into its secret cells there is a steep path with winding stairs. . . . As you advance, the darkness as of night grows more dense. . . . At intervals, however, there are contrived openings cut in the roof above, which bring the bright rays of the sun into the crypt. Although the recesses twisting this way and that form narrow chambers, with galleries in deep gloom, yet some light finds its way through the pierced vaulting down into the hollow recesses. . . . And thus throughout the crypt it is possible still to revel in the brightness of the absent sun.

To such secret recesses was the body of Hippolytus borne, quite near to the spot where now stands the altar dedicated to God.

That same altar-slab provides the sacrament, and is the trusty guardian of its martyr's bones, which it guards there in the waiting for Eternal Life, while it feeds the dwellers by the River Tiber with holy food.

Marvellous is the sanctity of that place. The altar is close by for those who pray, and it assists the hopes of such by mercifully giving what they require. Here, too, have I when sick with ills of soul and body, often knelt in prayer and found help. . . . Early in the morning men come to salute [Hippolytus]; all the youth of the place worship here; they come—they go—until the setting of the sun. Love of religion gathers into one vast crowd both Latins and strangers.

[Henry Donald Maurice Spence-Jones, *The Early Christians in Rome* (New York: John Lane, 1911), 253–254.]

poems of Prudentius (d. after 405 CE), for example, celebrate both the art of the catacombs and well-known martyrs. Like Saint Jerome, who had visited the catacombs as a young man, Prudentius had visited these locations in order to celebrate, honor, and beseech the help of saints such as Hippolytus. Such sources give us a firsthand glimpse of devotional practices and the creation of the cult of the saints.

SIGNIFICANCE

The catacombs are significant for several reasons. First, they are a mine for early Christian art. Some of the earliest representations of well-known Christian themes are painted within the winding halls under the city. The catacomb in Via Latina, for example, is decorated on nearly every wall. Such decor was probably not affordable for most Christians, so these tombs may have belonged to several wealthy families, but regardless they tell us a

lot about early Christian imagery. Some of the images in the Via Latina catacombs, such as vines, vases, various animals and birds, and flowers and fruits, were common in paintings as well as in funerary art. However, even these might contain symbolic significance. Sheep, for example, suggested Christ as the Good Shepherd; birds eating grapes or sitting in trees, symbols also common in Jewish tombs, sometimes evoked ideas of immortality. Scenes from stories in the Bible, especially from the Old Testament, such as the temptation of Adam and Eve, the sufferings of Job, and Jonah and the whale, were popular. Likewise, one finds paintings of the miracles of Christ, of Jesus as the Good Shepherd, and of the faithful celebrating an agape, a Eucharistic feast, in catacombs. Important as art objects in their own right, these paintings also reveal what books from the Hebrew Bible and the New Testament were popular—that is, which were read and known—a key insight since the Bible as it is known today did not take its final form until the fifth century CE.

The fact too that so many different artistic motifs are present in the catacombs suggests that modern categories of "Christian" or "Jewish" or "pagan" were less fixed. This is not to suggest a widespread syncretism, but it is to say that not only is it sometimes difficult to tell a Jewish from a Christian grave within the catacombs but also that much of the decoration was common to all Romans, whatever their religious outlook. The depiction of sheep and a thyrsus together, for example, need not mean that the person interred was a devotee of Dionysus. More likely, this image, which may once have denoted a follower of Dionysus, had simply become part of funerary art, its original meaning either lost or modified. Even in cases where a particular grave is marked with symbols such as the menorah, fish, or Chi-Rho, one must be cautions; since so many early Christians were Jews, it makes sense that even some of this iconography might be misleading. Even in the fourth century, for instance, Saint John Chrysostom berated his Christian flock for observing Jewish rites and festivals. Thus, a Christian tomb might boast both a Chi-Rho or fish and symbols that today are unequivocally Jewish. In addition, many so-called pagan themes are present, perhaps most famously the scenes of some of Hercules's labors. Here too, however, iconography is not a sure guide—Christians valued the mythology of Roman culture too.

The catacombs are also significant for what they say about Roman religious toleration. No funerary complex the size of these catacombs, built just outside of Rome along major thoroughfares, was built in secret. This gives the lie to the idea that these tombs were hiding places, but it also means that they were constructed under the auspices of the authorities. Funeral clubs had a long history in the Roman world before the rise of Christianity, and it is likely that many catacombs, particularly for the more humble among Christian ranks, operated much like other funeral clubs. The evidence of Roman law suggests that use of the catacombs may have existed freely

without express sanction, but regardless, even when hostile emperors took away the right to burial, as Valerian did during the persecution of 257–260 CE, they were restored by successors, in this case by Valerian's son, Gallienus (d. 268). Persecution was sporadic though often horrific and was always a possibility until Constantine the Great legalized Christianity in 312. From the time of Constantine until today, Christians have visited the catacombs to wonder, learn, and commemorate the early Christians.

FURTHER INFORMATION

Adkins, Lesley, and Roy A. Adkins. *Dictionary of Roman Religion.* New York: Facts on File, 1996.

Bertonière, Gabriel. *The Cult Centre of the Martyr Hippolytus on the Via Tiburtina.* Oxford, UK: B.A.R., 1985.

Goodenough, Erwin R. "Catacomb Art." *Journal of Biblical Literature* 81(2) (June 1962): 113–142.

Goodenough, Erwin R. *Jewish Symbols in the Graeco-Roman Period.* Princeton, NJ: Princeton University Press, 1992.

Hertling, Ludwig, and Engelbert Kirschbaum, *The Roman Catacombs and Their Martyrs.* Milwaukee: Bruce Publishing, 1956.

Spera, Lucrezia. "The Christianization of Space along the Via Appia: Changing Landscape in the Suburbs of Rome." *American Journal of Archaeology* 107(1) (January 2003): 23–43.

Stevenson, James. *The Catacombs: Life and Death in Early Christianity.* London: Thames and Hudson, 1985.

Webb, Matilda. *The Churches and Catacombs of Early Christian Rome: A Comprehensive Guide.* Portland, OR: Sussex Academic, 2001.

Websites

"Maps of the Catacombs." International Catacomb Society, http://www.catacombsociety.org/maps.html.

White, Michael I. "In the Catacombs." PBS, http://www.pbs.org/wgbh/pages/frontline/shows/religion/first/catacombs.html.

Curse Tablet

Trier, Germany
Second through Third Centuries CE

INTRODUCTION

One of the more fascinating aspects of ancient Roman superstition was the use of curse tablets. Rooted in the belief that appropriate actions, words, and intentions might obtain divine assistance, curse tablets bridge the personal side of Roman religion with public religious rites and vows, many of which contained a promise that one be cursed should that person fail to uphold her or his vow. Curse tablets are a wonderful insight into the day-to-day concerns of Romans of all stations, in all regions of the empire, and into ideas of magic.

DESCRIPTION

The curse tablet shown here dates from the second or third century CE. Discovered in the amphitheater at Augusta Treverorum, (present-day Trier, Germany), this Gallo-Roman *tabella defixio,* or "curse tablet," is made of lead, like most, and reveals both of the attributes common to these artifacts, a spell inscribed upon it and piercings, the latter of which were likely intended to help cement or bind the curse. Most such tablets were small, measuring only about 3 × 4.75 inches (12 × 8 centimeters), about the size of a modern 3 × 5 file card. Thin lead sheets were perhaps the most popular writing surface, but curses could and were inscribed on other media as well, including wood, stone, papyrus, and wooden writing tablets (see the entry **Wax Tablet**). Some of the best examples come from the Attic region of Greece and from Britain, both areas with abundant lead resources, though in the case of Britain many of the tablets are actually pewter, an alloy of lead and tin.

Lead may have also been an ideal choice for cursing tablets because its attributes share much symbolically with the dark purpose to which they were put. Lead is cold, dark, and heavy and comes from the earth. Similarly, many of the gods and spirits invoked in curses are chthonic (underworld) deities. In the earliest curse tablets, which hail from the sixth century BCE, the curses are simple, but over the centuries they grew more elaborate and

usually fell within a few basic formulae, some more legal in language, others more religious or magical. There was crossover between the more public forms of cursing and the personal sphere. In ancient Athens, for example, ostracism was a way to rid the polis of potentially dangerous individuals. Their names were inscribed upon *ostraka* (sing. *ostrakon*), broken pieces of pottery, and then thrown into an urn. The person so selected was exiled from the city for 10 years. In Roman culture, those making vows called down curses upon themselves should they fail in their oath. Much of the language, intent, and ritual around these public rites were mirrored in curses cast by private citizens.

In general outline, curse tablets begin with the person making the curse invoking a god or spirit. Deities and forces of the underworld were popular, such as Hades, Mercury, Hecate, or the Furies, and might be offered either a prayer, a gift, or a percentage of the returned valuables in cases of theft. Next, the curser might list a complaint or request, often both, and ask the deity to act for the curser. On many tablets the name of the accursed is listed, but in some cases the person making the curse did not know the object's name, in which case there were formulaic ways to help ensure that the malefactor was found and punished. Much of the language tries to cover any possibility, requesting that the person—whether male or female, high or low, free or slave—be found. The actual curse varied but most commonly requested that the god confound the enemy, bring the person to justice, or destroy the person. Many curses go into great detail about the desired punishment—it is not unusual to ask that the person's organs, body, memory, life, or health be affected, damaged, or taken.

The premise behind cursing worked on the concept of sympathies. Inscribing the spell was one step, but details about the person to be cursed if available or catchall phrasing if such information was unavailable sought to bind the spell to that person. The tablet was then folded over, the ends closing the document, and in many cases the tablet was then pierced with nails or needles. This is thought to have sealed the document, but it is also possible that the act of piercing the tablet, even folding it, might have been believed to have harmed the object of the curse, much like voodoo dolls in more recent history. In fact, some curse tablets were deposited with images of the accursed, either inscribed upon the tablet itself or accompanying it in doll form.

The type of curse depended on the situation or harm, real or perceived, that the curser felt he or she had suffered. Hate, envy, greed, and vengeance were all popular motives. Not all called for bodily harm or death; in many cases the person making the curse called upon higher, less grim gods to bring a person to justice. Some *defixiones,* however, sought to use similar sympathetic magic to achieve more positive outcomes. Many, for example, deal with romance. Some lovers sought to make the object of their affection more inclined toward them, while others sought to block rivals and still others

sought to discover a love unknown. The principle was the same—one invoked the help of the supernatural to bind another person in some manner.

Once the tablet was inscribed and folded, the final step was to place it in an appropriate place, and this depended on several factors. In Bath, England, where hundreds of these tablets have been discovered, most were deposited in a pool connected to the sacred spring at the temple of Sulis Minerva. Water was a common site for tablet deposition, and artifacts have been found not only in sacred pools but also in rivers and even in drainpipes. In keeping with the sympathetic nature of cursing, those tablets calling upon the darker powers are often found in ancient graveyards. It appears that the graves of those who died early or through violence were ideal sites. This may have been because as people wronged themselves their spirits might be more sympathetic or because the nature of their deaths made them excellent candidates to intercede with underworld spirits of violence. Given the importance of chariot racing and the heavy betting that the Romans engaged in, it is little wonder that sports fans often cursed their favorite's rival teams. The curse tablet depicted here is a prime example—it was discovered in an amphitheater. The exact location of such finds tells us a lot about the intentions of the curser—many are found, for example, at the most dangerous parts of the racecourse, such as turns, and the language of many of these racing-related tablets makes it clear that harm or death was the desired result.

SIGNIFICANCE

Roman *defixiones* reveal much about Roman culture. On the one hand they are a wonderful reminder that people have always been concerned about many of the same things and are subject to the same frustrations and weaknesses. On the other hand, the particular expression tells us a lot about the Roman understanding of the world, the gods, and how everything was connected. Invoking a god's aid, making a vow to repay the assistance, and expecting the gods to act in the here and now indicates the high degree to which Romans of all stations believed the world to be one where humanity and the divine interacted constantly. As impressive as Roman law could be, justice was not always available or quick; the many curse tablets that deal with thieves show that for many Romans, their only real hope was divine intervention.

Curse tablets also indicate that the line between magic, normally proscribed in Roman culture, and religion could be thin. Since great quantities of *defixiones* have been found at sacred sites and inscribed in language close to that of sacrifice and ritual, it is clear that these do not easily fall into the category of magic. Those tablets found at grave sites, however—areas believed to be haunted by the dead and by witches and that more often call down the powers of darkness—more readily qualify as magic, and yet the

basic structure of the texts, the intent, and the way in which the curses worked was the same. This goes for those tablets written with legal language as well. The overlap tells us that the hard categories we see were perhaps more fluid for the Romans.

For the archaeologist, historian, and linguist, curse tablets are a mine of information about the languages of the Roman world, the changes in Latin and its dialects, the ways in which writing varied, and to some degree the demography of Rome. Latin predominates as the tongue for curse tablets, but other languages, among them Greek, Egyptian, and varieties of Celtic, also appear in the surviving corpus. As objects of everyday life, these tablets use colloquial speech, often with variations in syntax as well as misspellings, alternate spellings, and foreign words and names. All, however, follow much the same formula, which is significant. One reason for this is that some curse tablets drew from established manuals of cursing. Within the Greek and Egyptian magical papyri, for example, one could find boilerplate spells. There were also purveyors of all manner of magical products, from spells to amulets, and while some magicians were socially questionable, others were often from respected backgrounds. In Roman Egypt, for example, there is evidence that some monks produced and sold spells. What this indicates for the larger Roman community is that despite linguistic barriers, different people within the Roman world all shared a belief in the power of the spirits to effect change in their lives. Their writing ranged in quality, but the fact that so many people could read and write is important too. Finally, and with key caveats, curse tablets can give us an idea of the movement of peoples within Roman territory. Names are not a sure guide to origin, as foreign names might be given to children, but in broad strokes curse tablets demonstrate that in regions as far away as Britain many ethnic groups might be found, not just Romans from Rome or Celts.

Curse tablets often have an immediacy about them; that is, the anger, fear, hatred, disappointment, or hope expressed upon them all resonate strongly today. The use of curse tablets lasted a long time, into the eighth century CE, before they were finally abandoned. The church had long railed against their use. Eusebius of Caesarea, for example, complained about their use in his speech to dedicate the Church of the Holy Sepulcher (335 CE); most of his audience was Christian, so the use of curse tablets was not confined only to non-Christians. Popular superstitions, however, persisted, and while the use of curse tablets fell out of use, people in the late Roman and early medieval worlds continued to look to charms, amulets, and other features of sympathetic magic for a long time to come.

FURTHER INFORMATION

Adkins, Lesley, and Roy A. Adkins. *Dictionary of Roman Religion.* New York: Facts on File, 1996.

Cunliffe, B. W., ed. *The Temple of Sulis Minerva at Bath,* Vol. 2, *The Finds from the Sacred Spring.* Oxford: Oxford University Committee for Archaeology, 1988.

Cunliffe, B. W., and P. Davenport. *The Temple of Sulis Minerva at Bath,* Vol. 1, *The Site.* Oxford: Oxford University Committee for Archaeology, 1985.

Faraone, Christopher A. *Ancient Greek Love Magic.* Cambridge, MA: Harvard University Press, 1999.

Frankfurther, David. "The Perils of Love: Magic and Countermagic in Coptic Egypt." *Sexuality in Late Antiquity,* Special issue of *Journal of the History of Sexuality* 10(3–4) (July–October 2001): 480–500.

Gager, J. G. *Curse Tablets and Binding Spells from the Ancient World.* Oxford: Oxford University Press, 1992.

Nock, A. D. "Greek Magical Papyri." *Journal of Egyptian Archaeology* 15(3–4) (November 1929): 219–235.

Versnel, H. S. "Some Reflections on the Relationship Magic-Religion." *Numen* 38(2) (December 1991): 177–197.

Websites

"A Corpus of Writing-Tablets from Roman Britain." Center for the Study of Ancient Documents, http://www.csad.ox.ac.uk/rib/ribiv/jp4.htm.

Curse Tablets from Roman Britain, http://curses.csad.ox.ac.uk/.

Lar

Susegana, Italy
Second Century BCE

INTRODUCTION

The Roman world was one where spirits and gods inhabited most places in the living world. Rivers, forests, hills, and streams all had their presiding spirit. Domestic spheres such as houses, farms, and even cities had them as well. One of the most important and enduring were the Lares, household gods that looked after a family and its home. So deep did this cult run that even today there are languages, such as Portuguese, where one of the words for God is "Lar."

DESCRIPTION

The Lar pictured here, made of bronze, dates from the second century BCE. In one hand he holds a cornucopia (horn of plenty) and in the other a rhyton, a form of drinking horn. As deities found in most every Roman household, the specific appearance of *Lares* (pl. of *Lar*) as either statuettes or paintings could be individualized. In general, however, many if not most boast similar iconography. Lares are most often portrayed as young men, sometimes dancing. The cornucopia and the drinking horn feature largely in depictions of Lares and make sense, as these deities were responsible for the well-being of the home. The cornucopia suggests abundance, while the drinking horn suggests fellowship and cooperativeness. Youth signifies youth but perhaps health and fecundity too. In some painted versions, such as in the House of the Vettii in Pompeii, Italy, one sees in addition to two young Lares dancing a figure between them, the genius or spirit of the paterfamilias, and a snake slinking along below them, a symbol of luck and protection.

The Lares served as guardians whose special concern was the home and family. Each home had a small shrine, or *lararium,* where depictions of these deities resided, usually by the hearth or sometimes within the atrium, which was the main hall or entrance to the Roman house. For example, in the play *Aulularia* (The Pot of Gold) by Plautus, a Lar introduces the audience to the plot—in his prologue he reveals not only his location, by the

hearth, but also that he has been there for generations and is currently helping the man of the house, Euclio, hide a pot of gold. The head of the household, the paterfamilias, was responsible for making sure that offerings were given to the Lares at mealtimes.

The origin of the Lares is unknown. Virgil has his hero Aeneas bringing the household gods with him from Troy, but the chief theories do not posit a foreign source. One theory holds that the Lares were originally ghosts or ancestral spirits. A close association with crossroads, sites believed to have been favored by ghosts, links the Lares to such shades, but other evidence suggests that the Lares may have originated as farm deities. These particular Lares, the *lares familiares,* are believed to have been introduced to private homes by slaves working on farms. Over time, the domain believed to be under the care of the Lares expanded out of individual homes and into communities. The connection to crossroads, for example, which may have started with the boundaries between farms, extended out of the country and into cities. In time, not only cities and roads but also travelers fell under the auspices of the Lares. There was even a college of officials, the *collegia compitalicia,* whose duty was to attend the shrines and manage the festivals associated with these public guardians. The chief festival associated with the Lares was the Compitalia, named appropriately from *compita,* or "crossroads" (sing. *compitum*). Like the college that looked after the Lares, this festival had disappeared during the civil strife of the Roman Republic, but Augustus revived both as part of his program of reinvigorating traditional customs and mores. The day of the festival was announced each year by the praetor in January. The date of the festival, however, shifted, as it depended on what date officials decided marked the end of the agricultural year.

The Lares were one set of domestic deities worshipped within Roman homes. A central place was also devoted to Vesta, goddess of the hearth, though in time the state took over the maintenance of her cult, and it became less common for individual homes to celebrate her rites. In addition to the Lares and Vesta, the Romans also honored the *di penates,* the "gods of the cupboard." Significantly, the *di penates* who looked after Rome, the *di Penates Publici,* were worshiped with Vesta, both at her temple in Rome and on the Velia, a hill between the Palatine and Oppian Hills. In individual homes, their shrine was located in the interior of the house. The *di penates* were especially associated, according to Cicero, with either the *penus,* or cupboard for provisions, or with specific recesses in the house *peniti* (sing. *penitus*). Where the Lares protected the family, the *di Penates* ensured that the family's stores were well looked after. Together, the Lares and *di Penates,* and originally Vesta, were the most important cults in the Roman home.

The Lares that looked after the state, the *Lares Praestites,* were the Lares of the home writ large. Their temple was at the head of the Via Sacra (Sacred

Primary Sources

OVID, *FASTI*, KALENDS, MAY 1

The Calends of May witnessed the foundation of an altar to the Guardian Lares, together with small images of the gods. Curius indeed had vowed them, but length of time destroys many things, and age prolonged wears out a stone. The reason for the epithet applied to them is that they guard all things by their eyes. They also stand for us, and preside over the city walls, and they are present and bring us aid. But a dog, carved out of the same stone, used to stand before their feet. What was the reason for its standing with the Lar? Both guard the house: both are faithful to their master: cross-roads are dear to the god, cross-roads are dear to dogs: the Lar and Diana's pack give chase to thieves; and wakeful are the Lares, and wakeful too are dogs. I sought for the images of the twin gods, but by the force of yearlong time they had decayed. In the city there are a thousand Lares, and the Genius of the chief, who handed them over to the public; the parishes worship the three divinities.

> [Ovid, *Fasti*, translated by James G. Frazer (1931), http://archive.org/stream/ovidsfasti00oviduoft /ovidsfasti00oviduoft_djvu.txt.]

T. MACCIUS PLAUTUS, "PROLOGUE" FROM *AULULARIA*

Lest any one should wonder who I am, I will tell you in a few words. I am the household God of this family, from whose house you have seen me coming forth. It is now many years that I have been occupying this houses and I inhabited it for the father and the grandfather of this person who now dwells here. But beseeching me, his grandfather entrusted to me a treasure of gold, unknown to all. He deposited it in the midst of the hearth, praying me that I would watch it for him. He, when he died, was of such an avaricious disposition, that he would never disclose it to his own son, and preferred rather to leave him in want than to show that treasure to that son. He left him no large quantity of land, on which to live with great laboriousness and in wretchedness. When he died who had entrusted that gold to me, I began to take notice whether his son would any how pay greater honor to me than his father had paid me. But he was in the habit of venerating me still less and less by very much, and gave me a still less share of devotion. So in return was it done by me; and he likewise ended his life. He left this person who now dwells here, his son, of the same disposition as his father and grandfather were. He has an only daughter; she is always every day making offerings to me, either with incense, or wine, or something or other; she presents me, too, with chaplets. Out of regard for her, I have caused this Euclio to find this treasure, in order that he might more readily give her in marriage if he should wish. . . .

> [*The Comedies of Plautus*, translated by Henry Thomas Riley (1912), http://www.perseus.tufts.edu /hopper/text?doc=Perseus%3Atext%3A1999.02.0094%3Aact%3Dprologue.]

(Continued on next page)

(Continued from previous page)

PLUTARCH, *ROMAN QUESTIONS*

51 1: *Why is a dog placed beside the Lares that men call by the special name of praestites, and why are the Lares themselves clad in dog-skins?*

Is it because "those that stand before" are termed *praestites,* and, also because it is fitting that those who stand before a house should be its guardians, terrifying to strangers, but gentle and mild to the inmates, even as a dog is? Or is the truth rather, as some Romans affirm, that, just as the philosophic school of Chrysippus think that evil spirits stalk about whom the gods use as executioners and avengers upon unholy and unjust men, even so the Lares are spirits of punishment like the Furies and supervisors of men's lives and houses? Wherefore they are clothed in the skins of dogs and have a dog as their attendant, in the belief that they are skilful in tracking down and following up evil-doers.

["Roman Questions," in Plutarch, *Moralia,* Vol. 4, translated by Frank Cole Babbitt (1936), http://penelope.uchicago.edu/Thayer/E/Roman/Texts/Plutarch/Moralia/Roman_Questions*/C.html#51.]

Way) that led from the forum to the Veila. Their cult center thus was situated at a key junction in the city, one commensurate not only with their supervision of crossroads but also with their role as guardians of Rome and by extension those territories that the city controlled. It was perhaps fitting that a dog, a common symbol of loyalty and protection (see the entry **Cave Canem Mosaic**) sat between the two Lares in the temple. Plutarch remarked that as *praestites,* that is, as those who "stand before," the Lares clearly took on the same protective role that domestic Lares did.

SIGNIFICANCE

Plutarch's discussion of the Lares in his *Roman Questions* highlights the important junction between private and public religion. Often in discussions of Roman religion the artificial distinction between these spheres appears far more solid than in fact it was. Just as the ancient state was instituted to maintain the *pax deorum,* the "peace of the gods," so too each family had to do what it could to appease those deities and spirits more directly in control of their lives and homes. The Lares are an excellent example of the ways in which so-called private and public religionwere interconnected. The Romans thought of the state as a large family, so whereas priests oversaw the state cults, the father oversaw those of the home.

The Lares likewise reveal the importance of a key Roman social institution, the paterfamilias, the male head of the household. It was his duty to care for the Lares, and we see this clearly in Plautus's play *Aulularia.* The particular Lar in this play is keen to help the daughter because she has paid the god honors and made offerings to him, a job that ought to be the province first and foremost of the man of the house. The paterfamilias in Roman

tradition and law had absolute power, *patria potestas,* over everyone in the family. Under these powers, the head of the house also arranged marriages, represented the family in most matters, and could, if he so wished, do everything from force a child to divorce (regardless of the child's feelings) to killing a child who had crossed him. In elite families, the paterfamilias possessed a particular spirit, a genius (from the Latin term *gignere,* meaning "to beget"), which he inherited from previous heads of house and passed on to the next. In some depictions of family Lares, one sees a figure of the genius such as in the House of the Vettii, so the connection between the Lares and the leading male in a family was close. In time, a similar female spirit, the *juno,* became common, but this spirit did not, so far as we can tell, enjoy a cult of its own.

FURTHER INFORMATION

Adkins, Lesley, and Roy A. Adkins. *Dictionary of Roman Religion.* New York: Facts on File, 1996.

Ando, Clifford, ed. *Roman Religion.* Edinburgh, UK: Edinburgh University Press, 2003.

Clarke, John R. *The Houses of Roman Italy, 100 BC–AD 250: Ritual, Space and Decoration.* Berkeley: University of California Press, 1992.

North, J. A. *Roman Religion.* Oxford: Oxford University Press for the Classical Association, 2006.

Rives, James P. *Religion in the Roman Empire.* Malden, MA: Blackwell, 2006.

Schneid, John. *An Introduction to Roman Religion.* Translated by Janet Lloyd. Bloomington: Indiana University Press, 2003.

Waites, Margaret C. "The Nature of the Lares and Their Representation in Roman Art." *American Journal of Archaeology* 24(3) (July–September 1920): 241–261.

Warrior, Valerie M. *Roman Religion.* New York: Cambridge University Press, 2006.

Website

Connor, Peter. "Lararium: Household Religion." University of Arizona, http://www.u.arizona.edu/~afutrell/404b/web%20rdgs/tour%20pomp/larartour.htm.

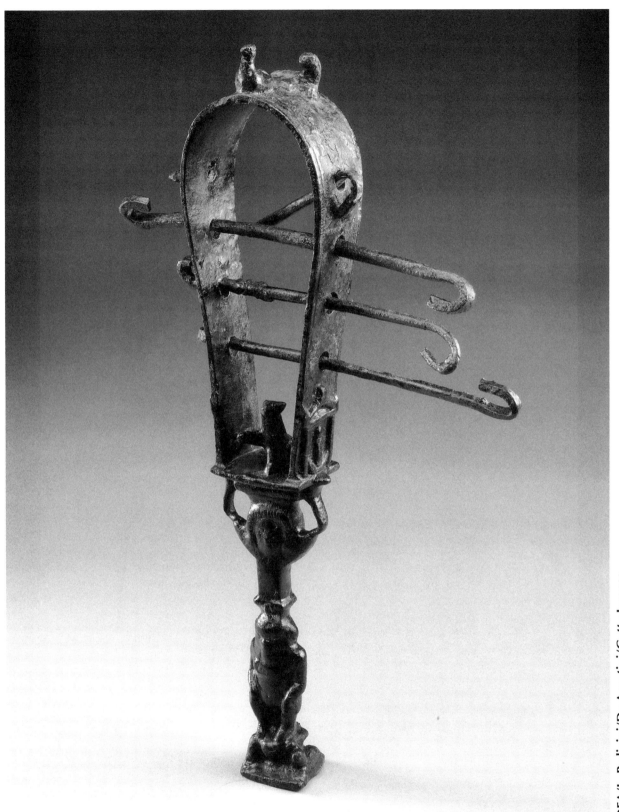

Sistrum

Pompeii, Italy
First Century CE

INTRODUCTION

Some of the more well-known varieties of religious expression in the Greco-Roman world are the so-called mystery cults, secretive foreign sects with rites of initiation and promises of salvation. The oldest, that of Eleusis, was influential, and many Romans joined, but others, such as the cults of Mithras, the Great Mother, and Isis, were also popular. Most came from the east, from the Levant, Egypt, and Persia, but most underwent some degree of Hellenization before reaching Rome. The idea that mystery religions provided a spiritually starved populace, bored with traditional cults, something new has given way to the notion that these cults operated alongside traditional religion and that they were actually more marginal than some scholars have treated them in the past. However, these cults had a deep and significant impact on Roman society. In fact, they grew alongside another foreign cult, one that shared certain basic similarities with the others and that in time became the religion of the empire, Christianity.

DESCRIPTION

The *sistrum* pictured here, which was found at Pompeii, is made of bronze and dates to the first century CE. The decorative handle is of Bes, an Egyptian deity, supporting a woman's face and a small cat. A god associated with pleasure and the joys of life, Bes was associated with Qetesh, a goddess of love and one often connected to Isis. *Sistra* were rattles that served as both symbols of Isis and as instruments in the rites of her cult. This particular style of metal rattle developed in Egypt and when shaken made a sort of tinkling sound. Most were less than 10 inches in height. They probably served several purposes in addition to providing some percussion for religious music, including scaring away evil spirits.

The cult of Isis, which came to Rome sometime in the first century CE, was one of the more popular mystery cults among the Romans. Isis was a mother-goddess and the savior of her husband, Osiris, better known to the

Romans as Serapis (sometimes Sarapis), whom she brought back to life. She is often depicted with her son, Horus, who was referred to as Harpocrates among the Romans. These three were normally worshipped in conjunction, though other deities, such as Bes, were often included in some contexts. The goddess's name, Isis, is the Greek version of the Egyptian name Aset or Eset and means "throne." She was referred to by a variety of titles, all of which reveal aspects of her worship, such as "mistress of the house of life" and "invoked by innumerable names," fitting designations for a deity concerned with fertility, creation, and rebirth. She is often depicted with a *sistrum* and a *situla,* a small bucket containing holy water from the Nile, both of which featured largely in rituals. Her iconography also often includes a headdress consisting of a solar disk supported by a crescent moon (or cow horns) and the ankh, a symbol of life.

Before coming to Rome, Isis was closely associated with the pharaoh, a connection further strengthened by her marriage to her brother Osiris, known as the king of Egypt. In one of the main myths about her, one promoted by the priests at Heliopolis, Isis appears as a supportive consort of her royal husband. She was also a sort of culture figure, particularly for Egyptian women, to whom she taught brewing, baking, and weaving. Osiris's brother, Seth, was jealous, murdered Osiris, and then became king. Isis, however, missed her beloved husband and searched all over the country to find him. She brought his coffin back to Egypt, but Seth discovered this and then dismembered Osiris, scattering his body in all directions. Resourceful, Isis called upon her sister, Nephthys, for help and transformed herself into a bird in order to scour Egypt to locate all his missing parts. They found all but one, reassembled him, and reanimated him. A son, Horus, followed soon after the resurrection of Osiris. The old king was, however, between life and death and unable to live as before, so Osiris became the king and judge of the dead. In order to avoid Seth's wrath, Isis hid Horus until he was of an age to avenge his father, protecting him all the while. In the end Horus and Seth fought, and Horus emerged the victor.

This myth highlights several key themes celebrated by the later Romans who became initiates in her cult. Isis is a loyal wife, a powerful protector, a caring mother, and a magical healer. Egyptian religion was complicated, and Isis was often associated with other deities, especially once her cult grew and her connection to the pharaoh was well established. Among the Greeks and Romans, much of this complex series of affiliations boiled down to three key roles. Isis became a patron and protector of women, marriage, and childbirth. She also looked after newborns. Finally, and in part due to her close associations with marriage and fertility, she had oversight of fertile fields and rich harvests, a typical sideline for mother goddesses.

Primary Source

APULEIUS, *METAMORPHOSES,* BOOK 11

When I had ended this oration, discovering my plaints to the goddess, I fortuned to fall again asleep upon that same bed; and by and by (for mine eyes were but newly closed) appeared to me from the midst of the sea a divine and venerable face, worshipped even of the gods themselves. Then, by little and little, I seemed to see the whole figure of her body, bright and mounting out of the sea and standing before me: wherefore I purpose to describe her divine semblance, if the poverty of my human speech will suffer me, or her divine power give me a power of eloquence rich enough to express it. First she had a great abundance of hair, flowing and curling, dispersed and scattered about her divine neck; on the crown of her head she bare many garlands interlaced with flowers, and in the middle of her forehead was a plain circlet in fashion of a mirror, or rather resembling the moon by the light that it gave forth; and this was borne up on either side by serpents that seemed to rise from the furrows of the earth, and above it were blades of corn set out. Her vestment was of finest linen yielding divers colours, somewhere white and shining, somewhere yellow like the crocus flower, somewhere rosy red, somewhere flaming; and (which troubled my sight and spirit sore) her cloak was utterly dark and obscure covered with shining black, and being wrapped round her from under her left arm to her right shoulder in manner of a shield, part of it fell down, pleated in most subtle fashion, to the skirts of her garment so that the welts appeared comely. Here and there upon the edge thereof and throughout its surface the stars glimpsed, and in the middle of them was placed the moon in mid-month, which shone like a flame of fire; and round about the whole length of the border of that goodly robe was a crown or garland wreathing unbroken, made with all flowers and all fruits. Things quite diverse did she bear: for in her right hand she had a timbrel of brass [i.e., a *sistrum*], a flat piece of metal curved in manner of a girdle, wherein passed not many rods through the periphery of it; and when with her arm she moved these triple chords, they gave forth a shrill and clear sound. In her left hand she bare a cup of gold like unto a boat, upon the handle whereof, in the upper part which is best seen, an asp lifted up his head with a wide-swelling throat. Her odoriferous feet were covered with shoes interlaced and wrought with victorious palm.

[Lucius Apuleius, *The Golden Ass: Being the Metamorphoses of Lucius Apuleius,* translated by W. Aldington, revised by S. Gaslee (1928), http://archive.org/stream/goldenassbeingme00apuliala /goldenassbeingme00apuliala_djvu.txt.]

SIGNIFICANCE

Perhaps the most significant aspect of Isis's cult was the salvation her initiates believed she might bestow upon them. In this the cult of Isis was similar to those of the Great Mother (Cybele), Mithras, and the Eleusinian Mysteries of Demeter and Persephone. It is difficult to generalize these mystery religions, as they varied considerably and were always somewhat marginal to the more established traditional cults. What they offered in

broad terms was a more individual experience of deity. Most included secret rites of initiation whereby the candidate sought communion with the deity or deities, often through some sort of mystic experience or ecstasy.

Most of the secret knowledge was well guarded, as we have few sources or insights into the exact nature of most cults. In the case of Isis, however, the Roman writer Apuleius, in Book 11 of his *Metamorphoses,* provides a unique glimpse at some of the initiatory ceremonies in the cult of Isis (see the sidebar for a sample). In his story, one of the first novels in history, he recounts the literal and spiritual salvation by the goddess of Lucius who, having been turned into a donkey, is magically made human again. Apuleius describes her majesty, compassion, and willingness to help even a wretch like Lucius. Apuleius also reveals several steps of the initiation process, including baptism, sacrifices, prayer, and ritual clothing. The actual mysteries of the rite, however, he dutifully conceals. The reader knows that Lucius experiences a journey through the darkness, an imitation of death, and that he emerges into the light, into life. Much of this echoes Egyptian ideas about the sun, a god in his own right, who traveled the underworld at night only to emerge again in the morning.

Cults such as that of Isis provided believers with a sense of special community, with hope for a happy afterlife, and sometimes even with ecstatic joy during rituals and festivals. Often devotees to these deities entailed some service to the deity as well. Most cults also had a public state-sponsored presence. Isis, for example, had a temple in the Campus Martius of Rome. This particular Iseum, as her temples were called, had a long history. Though destroyed at least once, the Temple of Isis in Rome was rebuilt, repaired, and added to at least as late as the reign of Alexander Severus (d. 235). Each was attended by a priesthood who managed the cult and protected its secrets. The Iseum in Pompeii, for example, had high walls surrounding it, in all probability to ensure that no curious onlookers were able to discover the secret rites or their meanings.

Christianity has often been compared to mystery religions or included among them, and indeed the similarities can be striking. Most offered salvation and included initiation rituals and a sense of community, but the differences are important too. Whereas one could honor the state gods and Isis, one could not in Christianity, to name only one example. The importance of these ideas, however, of individual spiritual salvation took on new life as the religious world of the Romans slowly transformed into a Christian world. There were influences from other cults during this period of change, and not all of them were hostile. For example, the popularity of Isis, especially as tender mother, also influenced Christian art. While there is no direct link between images of Isis nursing Horus and of the Virgin Mary nursing Jesus, the relation that each has to the moon and the common depiction of them enthroned share much in common artistically if not thematically.

FURTHER INFORMATION

Adkins, Lesley, and Roy A. Adkins. *Dictionary of Roman Religion.* New York: Facts on File, 1996.

Bowden, Hugh. *Mystery Cults of the Ancient World.* Princeton, NJ: Princeton University Press, 2010.

Burkert, Walter. *Ancient Mystery Cults.* Cambridge, MA: Harvard University Press, 1987.

Cosmopoulos, Michael B. *Greek Mysteries: The Archaeology of Ancient Greek Secret Cults.* New York: Routledge, 2002.

Heyob, Sharon Kelly. *The Cult of Isis among Women in the Graeco-Roman World.* Leiden: Brill, 1975.

Johnson, Luke Timothy. *Among the Gentiles: Greco-Roman Religion and Christianity.* New Haven, CT: Yale University Press, 2009.

Meyer, Marvin W. *The Ancient Mysteries: A Sourcebook.* San Francisco: Harper and Row, 1987.

Orlin, Eric. *Foreign Cults in Rome: Creating a Roman Empire.* New York: Oxford University Press, 2010.

Turcan, Robert. *The Cults of the Roman Empire.* Cambridge, UK: Blackwell, 1997.

Wild, Robert A. *Water in the Cultic Worship of Isis and Sarapis.* Leiden: Brill, 1981.

Witt, R. E. *Isis in the Ancient World.* Baltimore: Johns Hopkins University Press, 1997.

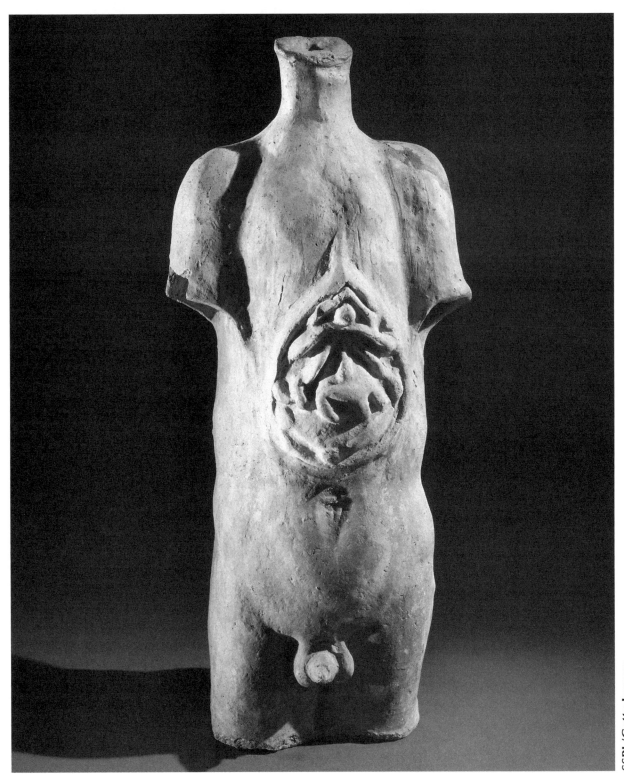

Votive Male Torso

Isola Farnese, Italy
Circa 200 BCE through 200 CE

INTRODUCTION

Votive offerings, in supplication and in thanks, are common finds in many ancient sacred sites around the Mediterranean. They are striking artifacts in and of themselves. Some are as simple as a terra-cotta foot, while others are graphic representations of various ailments, injuries, and medical concerns. Either way, they capture one's attention immediately. They also tell us a great deal about daily life and the challenges that people of all stations faced. They are not only vivid reminders that people have long been preoccupied with health and well-being but also that they have looked to religion as well as medical professionals for assistance when ill, wounded, or facing natural processes such as childbirth. Not all votives were given for reasons of health, but many, such as the torso depicted here, were. The practice was widespread and already old by the time the Romans came to it. While certainly some Greek influence, especially from analogous cults such as that of Asclepius, influenced votive practices in Rome, much if not most of the tradition, cult, and expectations around votive offerings had existed in Italy from the proto-Villanovan period (ca. 1200–900 BCE), at least 400 years before Rome began to dominate the peninsula.

DESCRIPTION

The terra-cotta male torso shown here was made ca. 200 BCE to 200 CE. The open cavity on the front displays key organs—the heart, stomach, lungs, and intestines—and probably reflects one man's health concerns, though what specifically these were is impossible to tell from a generalized votive such as this. The open cavity displays stylized organs, but they are generally where they should be in relation to one another and appear healthy. Other votives are often far more specific; it is not uncommon to find a hand, a foot, a head, or other body parts about which the supplicant was worried. Many concern childbirth and the health of young children. Depictions of diseased organs are relatively rare, which points to anatomical votives as offerings of

thanksgiving for recovery rather than as gifts given first to enlist a god's aid against a specific ailment.

The practice of dedicating an object to a deity is an old one and is not confined to Italy. Votives might take a variety of shapes too, from the bones of a sacrificial animal to statuary, from vases to war spoils. The second example here, of a small metal *tabella* (see the entry **Wax Tablet**), was offered by two men, Euporis and Pharnaces, for the new year in hopes of *faustum* ("prosperity") and *felicem* "happiness." People gave according to their means. In one entry of the *Palatine Anthology,* a late collection of Greek works, mostly verse ranging from the seventh century to 1000 CE, a man saved from shipwreck gave locks of his hair, as he had nothing else to offer. Even temples themselves might be dedicated as votive offerings—Appius Claudius Caecus offered one in 296 BCE to Bellona Victrix after invoking her aid in battle.

Many votive offerings have not survived. Looting was an ever-present danger, as temples were known repositories of precious items, but sometimes temple officials would melt down works of gold or silver into bullion—they had expenses to pay too—and while some votives, especially high-profile ones, might be kept, others could be converted to more easily tradable currency. In some temples, however, all votives became sacrosanct once used, and it is less likely that these would have been melted down. There is some evidence to suggest that at some sanctuaries, previous votives, some probably centuries old, were broken underfoot as new suppliants brought in their own offerings. For votives made of fragile materials, such as terra-cotta or wood, this would hardly be surprising.

Terra-cottas, of which many anatomical votives consist, burgeoned in Italy with the rise of cities and more industrial methods of manufacture. Those producing them, which probably included some temples, enjoyed a lucrative business. Specific types could be sold ready-made, though no doubt some terra-cottas were commissioned for specific concerns or ailments as well. Ceramic offerings were popular among the Greeks too, and with Greek colonies in the south of Italy there was probably some crossover between artistic styles. For the most part, Greek terra-cottas tended to display a greater concern for anatomical accuracy, but in terms of function they were used much the same as those elsewhere in Italy.

With 200 sanctuaries known to have votive deposits in Italy alone, it is clear that the practice of contracting with a god via a gift was both widespread and of some antiquity. The donation of an offering was only one aspect of a much larger public procedure. One also made a *votum* ("vow") publically promising to donate something in exchange for divine aid. The language of these oaths was formulaic and when combined with the public nature of the vow lent the act a legal quality; perhaps also it helped ensure that those one making a vow would fulfill their side of the bargain,

LIVY, *THE HISTORY OF ROME,* BOOK 10, CHAPTER 19:17–22

[17] It is said that when the conflict was at its hottest, Appius was seen to lift up his hands in the very forefront of the standards and utter this petition: "Bellona, if today thou grant us the victory, then do I vow thee a temple." Having pronounced this prayer, as though the goddess were inspiring him, he kept pace with the courage of his colleague and the army kept pace with his. [18] And now the generals were quitting themselves like true commanders, and the soldiers were striving that victory might not come first on the other wing. [19] They therefore routed and put to flight the enemy, who found it no easy task to withstand a greater force than they had been wont to engage with. [20] Pressing hard upon them when they faltered and pursuing where they fled, the Romans drove them to their camp. There, on the appearance of Gellius and the Sabellian cohorts, the battle was renewed for a little while; [21] but presently, when these too had been dispersed, the conquering troops assailed the camp, and while Volumnius himself led a charge against the gate, and Appius, calling from time to time on Bellona, goddess of victory, inspirited his soldiers, they burst through the trenches and the rampart. [22] The camp was taken and pillaged, and the vast booty found there was given over to the soldiers. Seven thousand eight hundred of the enemy were slain, two thousand one hundred and twenty taken prisoners.

[Livy, *The History of Rome,* Books 8–10, translated by Benjamin Oliver Foster (Cambridge, MA: Harvard University Press, 1926).]

as others would remember it too. The vow was contractual and dependent upon the successful conclusion of the request. The idea was *do ut des,* "I give so that you will give," and required that the vow maker give a gift to that deity.

Modern religious emphasis, which often focuses on behavior or proselytizing, is very different. Roman religion placed great emphasis on the communal aspects of maintaining relations with the gods. Proper practice (orthopraxy) rather than proper belief (orthodoxy) was what mattered. In making an offering to effect a specific outcome, one had to observe the correct procedure and the public ritual and make sure not to approach the gods empty-handed. They expected something for their help. The specific vow might be written and attached to a statue or inscribed upon the artifact itself. Some votives had inscriptions incised in them before the clay was fired, which suggests that the process by which one supplicated the gods could be lengthy. There is no way to determine how long it might have taken between ordering a votive, its manufacture, and its dedication, but no doubt wait time depended on the busyness of a particular sanctuary or potter, the distance one might have to travel to dedicate the votive, and whether or not there were specific times one had to make the vow. Some state vows, such

as the *vota* for the welfare of the state before the Senate's first regular meeting, had specific dates, in this case the first of January.

The general pattern for votive contracts was first a public announcement of the vow. While an offering might be made then, it was far more common to dedicate the votive to the temple or sanctuary upon completion of the god's help. The wording of many formulae support the idea that most gifts were handed over only after the prayer was answered. For example, many individual offerings had the phrase *v[otum] s[oluit] l[ibens] m[erito],* meaning "X has paid his vow with pleasure and deservedly." Abbreviations such as this were common on both private and public inscriptions. The language here refers to something already accomplished and thus to an offering given in thanks. When spoken, vows had to be re-said if one made mistakes, especially in public dedications. Assuming that one's prayer was heard, one would then make a public proclamation to the effect and hand over the votive. The public nature of this process was important—sharing hopes for a positive outcome, promising to do one's part in exchange publicly—and having witnesses cemented the act and helped give it gravity.

There were also private vows, often arising from some exigency such as survival in battle or childbirth. Some surviving examples include recovery from illness, a good harvest, the birth of a healthy child, and safe landing after a sea voyage.

SIGNIFICANCE

Votives such as this terra-cotta torso are important for a variety of reasons. First, they are prime examples of the religious side to ancient methods of health care. The Romans were famous for eschewing the help of doctors—Pliny the Elder in his *Natural History* reports that good old-fashioned Romans used home remedies more readily than the dubious medical procedures of doctors, so many of whom were either quacks or poorly trained hacks. Good doctors, however, could and did make a lot of money in the Roman world, so Pliny's protests aside, it is clear that many people were willing to visit a *medicus.* Not everyone, however, could afford a doctor, and in a world where the gods were believed to intervene in human affairs, it made sense to strike a deal with a deity for help. Good as a doctor or home remedy might be, the gods were more powerful and might, with the proper motivation, provide help. Votive offerings demonstrate this idea and thus the spiritual side of the Roman approach to health care.

Second, the sanctuaries, types of votive offerings, and rituals around them highlight the great debt that the Romans owed to their political and cultural predecessors, most especially the Etruscans. The continuity of practice from at least the proto-Villanovan period, if not earlier, to the heyday of the empire demonstrates the thoroughness with which early Italy, despite

differences in language and politics, embraced a common religious outlook. While the use of anatomical votives was perhaps learned from Greek colonists in southern Italy ca. fourth century BCE, it took off in Italy more so than anywhere else. The names of gods on some of these, such as Menerva and Vei, rather than Asclepius, is significant in this regard. The Greek god of healing had two known centers, one in Rome on Tiber Island and the other at Fregellae, but otherwise appears to have been less popular to approach than were native gods. Taken with the earlier evidence of votive practices, of votive offerings of all types, and the language used in public vows, we can point to votive dedications as one of many legacies bequeathed to Rome by preceding Italic cultures.

Finally, like augury, which the Romans also learned from the Etruscans, anatomical votives indicate a deep and early knowledge of anatomy. It was not until the Hellenistic period, when researchers such as Erasistratus of Ceos and Herophilus (third century BCE) conducted autopsies on corpses, that understanding of anatomy, particularly human anatomy, grew in depth. While the rendering of organs on this terra-cotta is more symbolic, which makes sense given the purpose of the votive, other more specific votives, such as representations of livers, can be extremely detailed and betray a sophisticated knowledge of the human body.

Votive practices followed the Romans wherever they went and influenced and were influenced by other traditions. The impact of votive offerings was a deep and lasting one. The Christian cult of the saints, for example, shares a certain degree of affinity with aspects of Roman votive practice. Even today, one can find items such as crutches, icons, candles, and holy cards (small cards with a picture of Christ, the Virgin, or saints on one side and a prayer on the other side) left at saints' shrines in thanks for having been healed. The public vow is not there, but the same idea that one might approach the divine and that one show some manner of public thanks is alive and well.

FURTHER INFORMATION

Bispham, Edward, and Christopher Smith, eds. *Religion in Archaic and Republican Rome and Italy: Evidence and Experience.* Edinburgh, UK: Edinburgh University Press, 2000.

Gagarin, Michael, ed. *The Oxford Encyclopedia of Ancient Greece and Rome.* Oxford: Oxford University Press, 2010.

Gleba, Margarita, and Hilary Becker, eds. *Votives, Places and Rituals in Etruscan Religion: Studies in Honor of Kean MacIntosh Turfa.* Leiden: Brill, 2008.

Hornblower, Simon, et al., eds. *The Oxford Classical Dictionary.* 4th ed. Oxford: Oxford University Press, 2012.

Linders, T., and G. Nordquist, eds. *Gifts to the Gods: Proceedings of the Uppsala Symposium, 1985.* Uppsala: Academia Ubsaliensis, 1987.

Turfa, Jean MacIntosh. "Votive Offerings in Etruscan Religion." In *The Religion of the Etruscans,* edited by Nancy Thomson de Grummond and Erika Simon, 90–115. Austin: University of Texas Press, 2006.

Tools and Weapons

Ballista

Coin Mold

Fasces

Gladius

Scales and Steelyard

Scalpels and Bronze Scissors

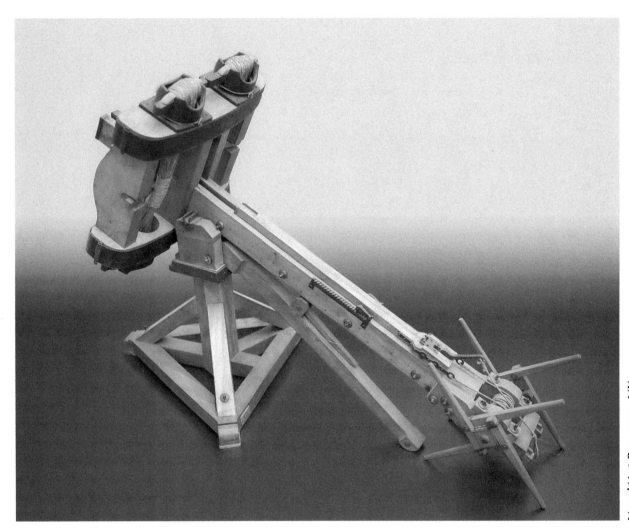

Ballista

Rome, Italy, Museo della Civilta
Twentieth Century

INTRODUCTION

The Romans were consummate military engineers, not only devising their own weapons and systems of fortification but also improving upon the ideas of their neighbors. While the Greeks designed the first ballistae and made good use of them, we have come to identify them more with Roman armies than any other. From large weapons that could take down walls to smaller versions used for infantry suppression, Roman ballistae helped catapult the empire's expansion, struck fear into enemies lacking such technology, and provided a model for future siege engine designers in the Middle Ages.

DESCRIPTION

The image here is of a model in the Museo della Civilta Romana in Rome, Italy, and depicts one form of Roman ballistae. Known by several names, chiefly *ballista* ("throwing machine" from the Greek *ballein,* meaning "to throw") or *scorpio* ("scorpion"), these artillery pieces were built in several sizes to assist the army in different facets of fighting. Though somewhat interchangeable terms, *scorpiones* were smaller fieldpieces, while ballistae were larger fieldpieces intended primarily for siege. Ballistae could fire iron-tipped missiles or stones, some up to 100 pounds, and were effective not only in attacking enemy fortifications but also as antipersonnel weapons. Ballistae worked much like crossbows. Using a wench, legionaries would wind cords of leather, tendon, horsehair, or rope to create sufficient tension to launch the missile. Ballistae were even used aboard ship.

The earliest known artillery weapons in the Mediterranean world were built by men working for Dionysius, the tyrant (nonconstitutional ruler) of Syracuse (ca. 399 BCE). One was a handheld weapon that a single man could set. The machine employed tension via a composite bow fixed to a stock; a sliding rod helped fit the arrow and set the bow, while a trigger device on the other end of the slider provided a lock to keep the tension. Since the archer using it set the tension by placing the front of the weapon on a solid surface while pushing against the back of the stock with his

235

Primary Sources

AMMIANUS MARCELLINUS, *THE HISTORIES*, BOOK 19: 22, "THE SIEGE OF AMIDA"

Beholding such innumerable peoples, long sought for to set fire to the Roman world and bent upon our destruction, we despaired of any hope of safety and henceforth strove to end our lives gloriously, which was now our sole desire. And so from sunrise until the day's end the battle lines stood fast, as though rooted in the same spot; no sound was heard, no neighing of horses; and they withdrew in the same order in which they had come, and then refreshed with food and sleep, when only a small part of the night remained, led by the trumpeters' blast they surrounded the city with the came awful ring, as if it were soon to fall. . . .

Then heads were shattered, as masses of stone, hurled from the scorpions, crushed many of the enemy; others were pierced by arrows, some were struck down by spears and the ground strewn with their bodies, while others that were only wounded retreated in headlong flight to their companions. No less was the grief and no fewer the deaths in the city, since a thick cloud of arrows in compact mass darkened the air, while the artillery which the Persians had acquired from the plunder of Singara inflicted still more wounds. For the defenders, recovering their strength and returning in relays to the contest they had abandoned, when wounded in their great ardour for defence fell with destructive results; or if only mangled, they overturned in their writhing those who stood next to them, or at any rate, so long as they remained alive kept calling for those who had the skill to pull out the arrows implanted in their bodies. Thus slaughter was piled upon slaughter and prolonged to the very end of the day, nor was it lessened even by the darkness of evening, with such great determination did both sides fight.

> [Ammianus Marcellinus. *Roman History*, 3 Vols. Trans. by J. C. Rolfe (Cambridge, MA: Harvard University Press, 1950.)]

JOSEPHUS, *THE WARS OF THE JEWS*, BOOK 33: 9, 18–19

9. Vespasian then set the engines for throwing stones and darts round about the city. The number of the engines was in all a hundred and sixty, and bid them fall to work, and dislodge those that were upon the wall. At the same time such engines as were intended for that purpose threw at once lances upon them with a great noise, and stones of the weight of a talent were thrown by the engines that were prepared for that purpose, together with fire, and a vast multitude of arrows, which made the wall so dangerous, that the Jews durst not only not come upon it, but durst not come to those parts within the walls which were reached by the engines; for the multitude of the Arabian archers, as well also as all those that threw darts and slung stones, fell to work at the same time with the engines. . . .

18. Upon this, Vespasian, when he saw the Romans distressed by these sallies . . . ordered his armed men to avoid their onset, and not fight it out with men under desperation, while nothing is more courageous than despair; but that their violence would be quenched when

(Continued on next page)

(Continued from previous page)

they saw they failed of their purposes, as fire is quenched when it wants fuel; and that it was proper for the Romans to gain their victories as cheap as they could, since they are not forced to fight, but only to enlarge their own dominions. So he repelled the Jews in great measure by the Arabian archers, and the Syrian slingers, and by those that threw stones at them, nor was there any intermission of the great number of their offensive engines. Now the Jews suffered greatly by these engines, without being able to escape from them; and when these engines threw their stones or javelins a great way, and the Jews were within their reach, they pressed hard upon the Romans, and fought desperately, without sparing either soul or body, one part succoring another by turns, when it was tired down.

19. When, therefore, Vespasian looked upon himself as in a manner besieged by these sallies of the Jews, and when his banks were now not far from the walls, he determined to make use of his battering ram. . . . This was the experiment which the Roman general betook himself to, when he was eagerly bent upon taking the city; but found lying in the field so long to be to his disadvantage, because the Jews would never let him be quiet. So these Romans brought the several engines for galling an enemy nearer to the walls, that they might reach such as were upon the wall, and endeavored to frustrate their attempts; these threw stones and javelins at them; in the like manner did the archers and slingers come both together closer to the wall. This brought matters to such a pass that none of the Jews durst mount the walls. . . . Now, at the very first stroke of this engine, the wall was shaken, and a terrible clamor was raised by the people within the city, as if they were already taken.

["The Wars of the Jews: Or The Destruction of Jerusalem, Book III," Christian Classics Ethereal Library, http://www.ccel.org/j/josephus/works/war-3.htm. For a slightly more recent translation, see Josephus, *The Jewish War*, Books 3–4, translated by H. St. J. Thackeray (London: W. Heinemann, 1927).]

stomach, it was termed a "belly-bow," or *gastrophetes*. The obvious utility of a projectile weapon that one man could use not surprisingly led to further refinements. The Roman version, the *manuballista* ("hand throwing machine"), or *cheiroballista* in Greek, was still large but apparently still operable by a single soldier. Larger versions were also made, complete with winch and stands for stability—these, unlike the handheld version, could throw stones. Some 50 years later, engineers working for Philip II devised missile weapons with torsion devices. These also included a winch but had two springs made of rope that increased the drawing power. Such ballistae usually had reinforcing metal plates on the frame to prevent the stock or bow from breaking. One such plate, known as the Cremona Battleshield, dating from 69 CE, was found in a grave pit outside the city of Cremona. Good as these machines were, the Romans improved upon Greek design throughout their history. Many of these changes increased the effectiveness of the machines, but some changes also helped protect them from the enemy. The Cremona Battleshield, for example, is representative of the metal plating that covered much of the ballistae—it not

only kept the wood a bit drier in bad weather but also acted as armor against enemy barrages. The Romans also increased the power of the torsion springs by creating more efficient tightening mechanisms and using curved arms for those ballistae that shot arrows. For stone-throwing engines, they changed the circular spring holes to oval ones; this gave the arm more room to tighten and thus more power. New washers also helped protect the spring holes from damage. Another sign of Roman improvement is the variety of uses to which the Romans put their ballistae.

Some ballistae were clearly intended as siege artillery. Firing either large bolts or stones, these machines were intended to weaken or break through an enemy's defenses. A siege by the Roman emperor Vespasian is described vividly by the Jewish historian Flavius Josephus in *The Wars of the Jews*. In addition to the damage wrought upon defenses and defenders alike, there was also the psychological side of artillery fire. It arrived fast, often unseen (especially at night), and did unspeakable harm. To face an enemy on the field in pitched battle is terrifying, but when that same enemy can reach over walls, this adds a significant advantage to the attacker.

Many ballistae were also part of Roman fortifications. How early the Romans mounted artillery on their walls is difficult to determine, but certainly by the high imperial period they had already done so. The evidence from an inscription, ca. 220 CE, along Hadrian's Wall reveals that ballistae were an integral part of the wall's tactical function. The inscription details the erection of a catapult platform at the site by the First Cohort of Vardulli, a detachment that served at several forts along the wall in the third century. A more dramatic instance is recorded in the *Histories* of Ammianus Marcellinus, a retired soldier and one of the last great Roman historians who recounted what he saw at the siege of Amida in 359 CE. While his patron was blamed for the loss of that town to the Persians and Ammianus perhaps was at pains to provide Ursicinus with some good press, his details about the role of ballistae during the siege are probably representative of what he saw and what these machines could do. Both sides used ballistae and with telling effect.

By this time the Roman Army had devised the *onager,* or "wild donkey," a single-armed ballista that threw rocks, the very idea of a catapult in the standard sense. That such machines became key components of the legion is affirmed, at least for the later empire, by accounts such as that of Vegetius, a military theorist of the late fourth or early fifth century. Questions remain about some of his assertions, but much of what he describes about the use of ballistae has been corroborated by other evidence. He wrote that each legion had 55 cart-mounted ballistae (*carroballistae*) and 10 *onagri*. Evidence from Trajan's column, celebrating the emperor's wars with the Dacians (101–102 CE and 105–106 CE), shows the army and the enemy using these machines in various ways, from hauling them by cart to defending a bastion to assault.

SIGNIFICANCE

The impact of these missiles could be devastating. Sufficient barrages could bring down walls, but the damage to enemy warriors could be just as horrific. One well-known and chilling example is the head of a ballista bolt discovered in the spine of a defender of Maiden Castle in Dorset, England. For Rome's adversaries, without such weapons the feeling of inferiority, of being at the mercy of one's enemy, could be devastating to morale. Even when an enemy might have similar weapons—the Dacians depicted on Trajan's column are shown with a ballista, for example—the efficiency, skill, and sheer number of Roman artillery could be overwhelming. Likewise, the ability of Roman armies to lay prolonged siege to enemy cities and fortifications gave them a great advantage. It was not simply the ability to use siege engines and artillery to best effect but also that Rome's disciplined, well-supported, and organized military planned ahead and well. Few of Rome's enemies could field both the forces and the resources to supply themselves as effectively.

What ballistae and similar war machines highlight too is the incredible effectiveness of Rome's military, one of many reasons for Rome's dominance of the Mediterranean world and Europe for so long. Rome applied the same genius for engineering to these catapults that it did to architecture, road building, and other forms of construction. This ability to improve upon existing ideas, to improvise, and to rethink even the most effective weapons gave Rome an edge in its conflicts with others. So effective were these innovations that Roman design went on to influence siege engine builders in the Middle Ages.

FURTHER INFORMATION

Bishop, M. C., and J. C. N. Coulston. *Roman Military Equipment from the Punic Wars to the Fall of Rome.* Oxford, UK: Oxbow, 2006.

Corfis, Ivy A., and Michael Wolfe, eds. *The Medieval City under Siege.* Woodbridge, UK: Boydell, 1999.

Hornblower, Simon, et al., eds. *The Oxford Classical Dictionary.* 4th ed. Oxford: Oxford University Press, 2012.

Keppie, Lawrence. *The Making of the Roman Army: The Making of the Roman Army.* Totowa, NJ: Barnes and Nobles Books, 1984.

Landels, J. G. *Engineering in the Ancient World.* Berkeley: University of California Press, 1978.

Marsden, E. W. *Greek and Roman Artillery: Historical Development.* Oxford, UK: Clarendon, 1969.

Marsden, E. W. *Greek and Roman Artillery: Technical Treatises.* Oxford, UK: Clarendon, 1971.

Rihill, Tracy. *The Catapult: A History.* Yardley, PA: Westholme, 2007.

Webster, Graham. *The Roman Imperial Army.* London: Adam and Charles Black, 1979.

Wilkins, Alan. *Roman Artillery.* Princes Risborough, UK: Shire, 2003.

Coin Mold

Jerusalem
Hellenistic/Roman Period

INTRODUCTION

Much can be learned from a society's methods of exchange, be it barter or coinage. Roman coins, though they appear later than in other contemporary societies, give snapshots of Roman history from the Roman Republic down to the successor states and the Byzantine Empire. Coins are a mine of information about political ideals, propaganda, religious beliefs, technology, and provincial administration.

DESCRIPTION

This mold for casting coins was found near Jerusalem at Khirbet Rafi. It is made of stone and is representative of many used during the Hellenistic and Roman periods. While casting coins was not unheard of, that is where coins and the designs upon them were created in a single process; the usual method both in the Greek and Roman worlds was to strike a metal sheet between two dies. Each had a design incised, in reverse, upon it. Some native Italic mints did cast their coins, as did some in Thrace, but these were the exception. The technology involved in coin production was relatively simple. While there were innovations, the methods involved from the earliest use of coins in the Mediterranean through the Early Middle Ages remained very much the same.

The coin maker only needed a few raw materials and some simple tools. The first step was to create a mold from which to produce the raw material for the coins. Metal was poured into the molds to cast flans, the blanks for striking coins. Some flans were cut from bars of raw metal and beaten into shape. For those cast, most flans were connected either by intervening strips of metal or along the edge of the coins themselves. The artifact depicted here illustrates the use of connecting channels. Though most coins were probably made from scratch using this process, there were times when old coins were recycled and restamped. During the Second Jewish Revolt (132–135 CE), for example, many old Roman and Hasmonaean coins were filed down and restruck by the rebels. For those cast, once cool these blanks

would be trimmed and shaped before being heated and struck with whatever design was to go on them.

The next step was a bath in a weak acid, perhaps old wine or vinegar, to brighten the metal and remove the fire scale. This was one area in which the Romans improved existing technology. Some coins, for example, when placed in an acid solution removed surface copper from the silver. This meant that coins with little actual silver content would appear to have much more than they did. Hammering the blank flat only intensified this effect. Many of the coins minted under Emperor Valerian I used this technique, which is one reason for the debasement of coins such as the *antoniniani.* The government's economy in saving precious metal, while perhaps cutting down immediate costs, produced a coinage actually worth less than it should have been, which led to inflation. Another key process was the introduction in 45 BCE of *orichalcum,* a type of brass, which was used for several different coins, first the *dupondii* and later during the reign of Augustus for *sestertii* as well.

Once the flans were ready, the minter used tongs, a hammer, a punch, dies, and engraving tools to complete the coin. Most dies were made of hardened bronze or iron in order to impress the coin metal. Bronze wore out faster but was easier to carve. The dies themselves had to be carved in reverse, which required considerable skill. The minter may have performed this delicate task, but jewelers may also have worked on the dies as well. Some of these incuse designs display a high degree of artistic and technical sophistication, so it is not surprising that some coin designs in the ancient world even boast the names of those who carved them. For large batches of coins, minters would need many copies of the same die; how these copies were made remains obscure. They may have been cast, apprentices may have worked on designs around the central portrait carved by a master engraver, or dies may have been mass-produced by a process called hubbing whereby designs are impressed into a soft metal.

A single person might strike coins, but it is likely that minters worked in teams. One man would hold the flan with tongs atop the obverse die, while another held the reverse die above the flan. The first might have struck the reverse die, or perhaps a third man did. The impact of the hammer drove the design into the flan, making the coin. The tongs kept fingers out of danger, but the flans were heated as well to make the metal a bit softer for taking the design. Modern experiments have demonstrated that even small teams might strike thousands of coins from a single die. Roman improvements in die design, such as hinged die sets that reduced irregular strikes, did much to speed up the process. From offset strikes, double strikes, and other imperfections, coin production was clearly a laborious task and one that could be inconsistent in quality.

Much about the workshops that produced coins remains a mystery. During the Roman Republic, most coins were minted in Rome at the temple

of Juno Moneta. By the first century BCE, mints appeared in other parts of the growing empire. Though local mints were often a feature of Roman minting, Rome itself once again became the center of production by the turn of the second century CE. In fact, until 240 CE when the city of Antioch coined money to help pay the army, Rome was the only legitimate source of coin. From the third century on, however, provincial mints also helped supply coinage. By the fourth century there were 15 official mints in the empire. Most mints were probably rather small; in fact, there is evidence from first-century BCE Judea to suggest that even a shop with only a few workstations might produce enough coins for its ruler, in this case Herod I. Evidence from Roman Britain and the Levant, where coin molds have been found outside key civic centers, suggests a number of possibilities. It may be that some officially sanctioned minting was carried out in villages where the necessary craftsmen dwelled. Some evidence has suggested that these particular molds may have been those used by counterfeiters. Without further information it is impossible to conclude anything, but it is likely that minting was outsourced. Even when the frequency of minting was high, local shops may have assisted government mints in key administrative cities.

SIGNIFICANCE

Unlike the Greeks and Etruscans, the latter of which borrowed the idea from Greeks in the south of Italy, Rome did not use money until the late fourth century BCE. Instead, Rome used a form of payment called *aes rude,* a plain bronze bar. The Samnite Wars brought the Romans into greater contact with the Greeks in southern Italy and their money economy. Over the course of the fourth century, the Romans and cities conquered by them began to produce silver coins, though in limited amounts. Further conquests, however, flooded Roman coffers with precious metal and by the mid-third century BCE Rome struck Greek-inspired *didrachms.* In addition to these coins, bronze money of various values was used, such as the *aes* or *as* (pl. *asses*), which was equal to a Roman pound, or libra. The chief coin, however, was the silver denarius, first minted in 211 BCE. At first worth 10 *asses,* the denarius by the mid-second century was worth 16 *asses* when bronze coins lost much of their value. As Roman rule spread throughout the Mediterranean, naturally Roman coins spread too. As before, conquest helped fuel the output of coinage. The lucrative wars that Caesar waged in Gaul, for example, brought substantial amounts of gold into the Roman world. A new coin, the *aureus* (pl. *aurei*), worth 25 denarii, was one result. Caesar was also the first Roman to have his portrait on a coin; thereafter every ruler, even those who reigned a very short time, had their portraits minted on coins.

With the ascension of Augustus, several changes took place in minting. Coins made of *orichalcum,* for example, like the *as, dupondius,* and

sestertius, were made in greater numbers and became much more popular. Still, the key coinage was the aureus and the denarius. Under the Severans, when increasingly more of the precious metal content in coins was reduced, several coins lost their value. Starting around 238 CE, silver coinage lost its value, and some coins, such as the denarius, were no longer minted. By 270 CE the *astoninianus,* first minted by Caracalla, likewise contained barely any silver at all. This had dire effects—taxes were paid in poor coin, and good coin was either saved or melted down. Diocletian, who did much to solve the problems of the third century, improved coinage by introducing more silver and standardizing gold coinage at 60 aurei with the new name, solidus. This coin, though it too lost some of its precious metal content under Constantine, remained in circulation for several centuries.

The growth of a money economy never replaced the reality of Rome's dependence of surplus agriculture, but it did much to foster commerce, enable easier assessment of taxes, and through the images and words on their coins spread Roman ideas and values. Even though Rome allowed some coins to be made in provincial style, they still worked with and as Roman coinage. It is perhaps their value as insights into Roman political tools that coins help us most. Certainly money was something vital in running a large empire, but Roman coins also tell us a lot about Roman society and the ideas that the government wished to foster.

Thus, the study of coins, numismatics, provides insights into not only technology, metallurgy, and design but also values. The mottos, iconography, and portraits often add to or corroborate information gained from other sources. For example, coins issued by Brutus, one of the key conspirators in the assassination of Julius Caesar (44 BCE), had a liberty cap, two daggers, and the abbreviation *EID MAR* ("Ides of March"), the day they killed Caesar (March 15). Brutus was a direct descendant of Brutus the Liberator, the man credited with driving out the last king, Tarquin the Proud, in 509 BCE. This coin was a propaganda move, an attempt to link what Brutus had done with the famous and favorably viewed actions of his namesake. Caesar was popular and the gambit did not work, but coins such as that of Brutus, often issued soon after an event or change of power, give us great insight into the mind-set of those involved. From coins too we see changes in religious outlook, from images of temples and gods to the cult of the ruler and eventually to coins such as the later *nummus,* a bronze coin of Constantine where traditional symbols such as Victory were side by side with the Christogram.

FURTHER INFORMATION

Ariel, Donald T. "Identifying the Mints, Minters and Meanings of the First Jewish Revolt Coins." In *The Jewish Revolt against Rome: Interdisciplinary Perspectives,* edited by Mladen Popovic, 373–418. Leiden: Brill, 2011.

Burnett, Andrew M., et al. *Roman Provincial Coinage.* 2 vols. London: British Museum Press, 1992, 1999.

Duncan-Jones, Richard. *Money and Government in the Roman Empire.* New York: Cambridge University Press, 1994.

Harl, Kenneth W. *Coinage in the Roman Economy, 300 B.C. to A.D. 700.* Baltimore: Johns Hopkins University Press, 1996.

Howgego, Christopher. *Ancient History from Coins.* New York: Routledge, 1995.

Howgego, Christopher, et al. *Coinage and Identity in the Roman Provinces.* Oxford: Oxford University Press, 2005.

Mattingly, Harold, et al. *The Roman Imperial Coinage.* 10 vols. London: Spink, 1926–2007.

Meshorer, Ya'akov. *A Treasury of Jewish Coins from the Persian Period to Bar Kokhba.* New York: Amphora, 2001.

Vermeule, Cornelius. "Minting Greek and Roman Coins." *Archaeology* 10(2) (June 1957): 100–107.

Websites

"How Ancient Coins Were Made." Classical Coins, http://www.classical-coins.com/page103.html.

"Numiswiki: The Collaborative Numismatics Project." Forum Ancient Coins, http://www.forumancientcoins.com/numiswiki/view.asp.

Roman Provincial Coinage Online, http://rpc.ashmus.ox.ac.uk/.

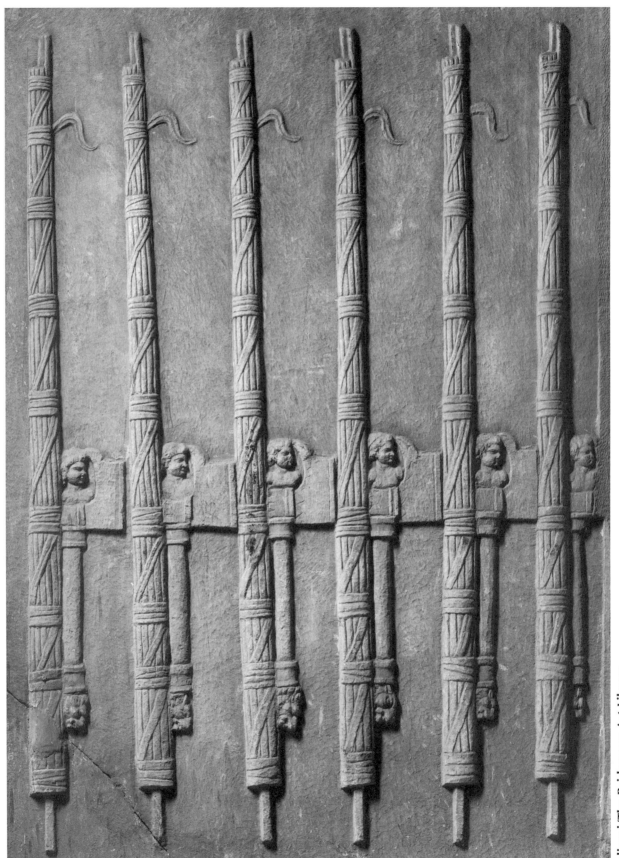

Fasces

Rome, Italy
Roman Republic

INTRODUCTION

Best known today as symbols either of early 20th-century Italian fascism or as the motif on the reverse side of the Mercury dime (ca. 1916–1945), the fasces were originally an ancient Roman symbol of authority. Special attendants, first for kings and later for Roman magistrates, carried these bundles of rods and axes whenever their charge was out in public. The rods signified the power to command, prosecute justice, and protect the state. Throughout Rome's history, from monarchy to republic and from republic to empire, the fasces and the men who carried them were there to lead and announce Rome's leaders.

DESCRIPTION

This relief sculpture from S. Paolo fuori le Mura (popularly known as St. Paul outside the Walls) in Rome, Italy, provides a good glimpse at the fasces, both the rods and axes, that symbolized Roman imperium. Generally about five feet long (1.5 meters), the rods that made up the fasces, or bundle of rods, were bound by red thongs and carried on the left shoulders of the lictors. The fasces were a symbol of power and authority, and the number of lictors and accompanying fasces varied by the amount of power, or *potestas,* an official held.

Most likely Etruscan in origin, the lictors and their fasces originally symbolized the power of the king and his power to scourge and execute. Though many early Latin states were run by aristocracies, Rome appears to have had a series of kings, many of them non-Roman—the last, Tarquin the Proud, for example, was Etruscan. Much of the nature of this monarchy remains obscure, but in our sources these kings held a collection of powers, among them leadership in war, the exercise of justice (including execution), and certain religious powers, the last of which were shared with various priests. The term for this set of powers is *imperium*. When the monarchy was deposed, traditionally sometime in the sixth century BCE when Tarquin was ousted, the king's authority was abstracted and given to succeeding

magistrates. Since this authority now existed outside of an individual and since it was conceptual, it could be more easily compartmentalized and divided up among various officials.

When the Roman Republic began in 509 BCE, royal authority was invested in new leaders. Initially these new officials may have been dictators or praetors—both offices that survived, much changed, into the late republican and imperial periods—but sometime in the fifth century or early fourth century BCE these had coalesced into the college of consuls, two of whom were elected annually. However, there were other magistrates who might hold imperium as well. Dictators, who were elected for limited periods (six months), usually in time of crisis, were accompanied by 24 lictors. Consuls were entitled to 12 lictors, and praetors were entitled to 6 lictors. The designation of 12 lictors to a consul may derive from the Etruscan League, the idea being that each city in the league would hand over an ax to the man appointed to lead them in a combined military enterprise. Whenever any of these officials left the city, the ax was added to the fasces; within the city, lictors only carried the rods. Each of these magistrates had lictors with them at all times, normally leading the way in single file and announcing the arrival of their charge. Most everyone had to make way for them except married women and the Vestal priestesses. To help set them apart, lictors sometimes adopted special dress: within the city they wore togas, but outside the city or in the train of a triumph they donned a red cloak. Organized into decuries, each governed by 10 men, the lictors carried out their duties for various officials and, in the later republic, even for nonmagistrates if they were responsible for the games. Among the other figures whom lictors might serve were proconsuls and propraetors, both magistrates who worked outside Rome in the usual yearly elected positions. With expansion came a need to extend imperium not only to more areas but also with greater duration so that government business, law, and war might be continued. Lictors also preceded a general celebrating a triumph.

SIGNIFICANCE

The abstraction of authority and power into a transferable privilege that might be invested in different magistrates lent Roman government a flexibility and effectiveness that goes a long way in explaining their political and military success. Imperium, at its simplest the right to carry out duties, bypassed many of the obstacles that might have impeded success in battle, might have made justice more variable and uneven, and might have delayed actions or decisions requiring official sanction. Technically both consuls needed to agree, but since imperium could be distributed to other magistrates, even physical separation could be less of an obstacle. Military tribunes (*tribuni militum*), for example, could hold imperium as well. This gave them the ability to make key decisions in the field without having to submit

Definitions

Dictator

The office of dictator was an emergency position that lasted six months. Dictators had absolute power over the state and the army while in office. The danger of abusing the position was mitigated by its temporary nature and by the relative rareness with which dictators were appointed.

Pro Consule, Pro Praetore

These terms refer to the imperium granted to someone in place of a consul or praetor. This became especially important as the empire grew and the consuls thus could not be in all corners at once. Decrees of the Senate, rather than of the people, were sufficient to invent these extra magistrates.

Res Gestae

The Res Gestae, perhaps best translated as "Deeds Achieved," was a sophisticated propaganda campaign put forth by the first emperor, Augustus (d. 14 CE), around the time of his death if not before. While much of what it conveys did in fact happen, the coloring given to many statements listed in these inscriptions was nonetheless designed to place the deeds of the emperor in the best light. He emerges, for example, from the Res Gestae as a benevolent ruler universally acclaimed, not as a ruthless and active participant in the proscriptions that murdered unknown numbers of his opponents. Still, much can be learned from propaganda, at the very least how Augustus wished to recast the civil wars and his own success.

Tarquin the Proud

Traditionally the seventh and last king of Rome (r. 534–510 BCE), Tarquin murdered his brother for the throne. His despotic rule made him unpopular, and when his son wronged Lucretia, the wife of Lucius Tarquinius Collatinus, Tarquin was ousted. He attempted to retake Rome three times but was repulsed, and a republic was founded.

Triumph

In many ways to be voted a triumph was one of the highest achievements that a Roman man might win. Successful generals who had won major battles would proceed through the city of Rome to the temple of Jupiter Capitoline. These processions were public and grew in pomp and grandeur over time. Following the *triumphator* in his four-horse chariot would be wagons with the spoils of war, prisoners (especially any high-ranking enemy commanders), and animals to sacrifice to Jupiter. Those who won a triumph were entitled to be escorted by lictors during the procession; these lictors walked before the chariot.

plans or options to their superiors when far away from the city. Significantly, imperium *militare* was absolved when the consuls or military tribunes reentered the city. This is another way in which the abstraction of the power to command benefited Rome. Though later ignored—by Marius, Sulla, and Caesar, to name only three examples—this stipulation that military command, and thus an army, not be allowed within the city helped keep Rome safe from military coups for an extremely long time. Provincial officials too generally held imperium only within their defined sphere of influence. In most cases this power was tied to office, was limited in duration, and was circumscribed by scope, all of which helped prevent any one man from taking over the state.

Because power was abstract—it did not reside in any one person as it would with a monarch—the Romans could separate the individual aspects of imperium. For example, in the exercise of justice, whereas originally magistrates might sentence and execute those found guilty of wrong, various pieces of legislation from the fourth to the second centuries BCE, such as the Lex Valeria (300 BCE), introduced the right of the accused in capital cases to appeal to the people; despite imperium, it was illegal for a magistrate to ignore such an appeal and summarily execute the accused. This same right of appeal was later granted to those outside the city. What this demonstrates is not only that the power to coerce or mete out justice could be improved upon, changed, or defined in new ways but also that no one official might abuse the authority granted to him.

Imperium might come with a particular office, like consul, but it was still something conferred. Normally, for anyone to be invested with such authority he needed first to be granted imperium by a *lex curiata,* that is, by the curiate assembly, itself represented by 30 lictors. By the late republic (first century BCE) the *lex curiata* had become a formality, but the idea of imperium itself, that one needed it for legitimacy, carried over through the dark years of civil war and into the imperial period.

One thing that imperium bestowed, apart from state-sanctioned power, was *auctoritas.* We normally translate this as "authority," which it was, but it also connoted influence, prestige, and dignity. For example, were a consul and a proconsul, both with imperium and 12 fasces each, to disagree, the consul's more elevated office, one that embodied more *auctoritas,* would supersede that of the proconsul. It is a difficult concept, as it has no real modern equivalent. With the creation of the principate under Augustus, the idea of *auctoritas* became an imperial attribute and one that could have profound effects in political practice. For instance, in 27 BCE Augustus made his beau geste, a calculated move wherein he played to the Senate's ideas of its own importance. He officially laid down his powers, and the senators, mostly his own men who were all too aware that a man in control of the legions was not really without power at all, begged him to stay in

office. The *Res Gestae,* his official autobiographical record inscribed and set up around the empire, states that after this time he exceeded no one in *potestas* ("power"), only in *auctoritas* ("influence" or "dignity"). Likewise, Augustus held imperium in several ways. Significantly, imperium continued to be voted to him, thus preserving the republican idea of imperium deriving in part from the will of the people. Emperors could have imperium extended to others too, either to represent them on the front or to indicate a successor, as Augustus did with Tiberius.

The appeal of the fasces as a symbol has persisted into the modern era. In the United States it adorns a variety of military badges, government buildings, and national shrines (the seat upon which Abraham Lincoln sits in the Lincoln Memorial in Washington, D.C., has two on the armrests) and once upon a time was even on its 10-cent coin, the dime. However, the fasces has also been put to darker purpose, most notoriously by the Italian fascists under Benito Mussolini.

FURTHER INFORMATION

Beard, Mary. *The Roman Triumph.* Cambridge, MA: Harvard University Press, 2009.

Giovannini, Adalberto. *Consulare Imperium.* Basel: F. Reinhardt, 1983.

Grant, Michael. *From Imperium to Auctoritas.* Cambridge: Cambridge University Press, 1970.

Hornblower, Simon, et al., eds. *The Oxford Classical Dictionary.* 4th ed. Oxford: Oxford University Press, 2012.

Lintott, Andrew W. *Imperium Romanum: Politics and Administration.* New York: Routledge, 1993.

Rawson, E. *Roman Culture and Society.* New York: Oxford University Press, 1991.

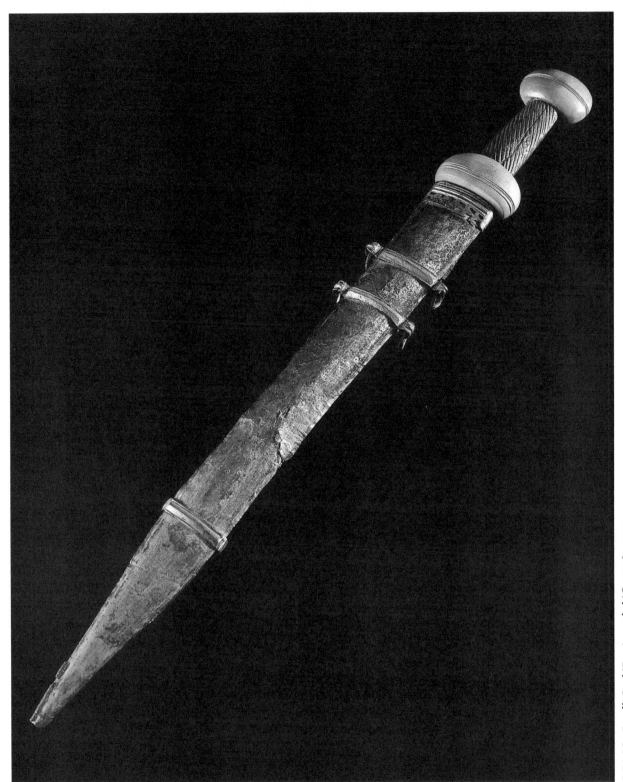

Gladius

Pannerden, Netherlands
Roman Republic

INTRODUCTION

To say that Roman armies carved out an empire is almost literally true. It was in large part thanks to the discipline, training, and effectiveness of the legionaries that their conquests were successful. Early Italy had been a proving ground for military innovation—so many different peoples, often with distinctive ways of fighting, mixed together, some winning, some losing—and some, such as the Romans, learned from them all. In a time when forests of densely packed spears were the standard defense and offense of most armies, the Romans found new and unique approaches to warfare that spelled the doom of the tried-and-true phalanx. Part of their answer was the *gladius*.

DESCRIPTION

The sword pictured here is a typical *gladius*. Sealed by rust within a sheath of bronze, wood, and bone, this 27-inch sword is representative of the weapon that made the legionary famous. Generally measuring about two feet in length, the *gladius* was primarily a close-quarters stabbing weapon. Its broad blade was capable of creating large puncture wounds, but it had enough heft to sever a limb as well. Used from behind the large infantry shield, or *scutum*, the solider could wield the weapon from cover and from the cover of his neighboring legionary. This gave each man not only better protection in the thick of battle but also greater confidence, a real advantage in hand-to-hand combat. Some *gladii* recovered by archaeologists list the names of several soldiers on their scabbards, suggesting that they were reissued more than once.

A variety of swords were in use in ancient Italy. Greek colonists in the south of Italy had introduced the phalanx, rows of warriors with shields and long spears as well as their short swords. In addition to the straight-bladed short sword of the hoplite, the Greeks used the *kopis,* a recurved blade that made devastating cuts. These were popular weapons in Italy and may even have originated there. The Etruscans, who came to dominate much of Italy

in the seventh century BCE, employed the phalanx and a variety of swords and daggers. The various Latin tribes, many of whom were under the control of Etruria, varied considerably in both tactics and weapons. A key change arrived at the end of the fifth century BCE when invading Celts introduced new swords and new methods of fighting. So effective were their tactics that they drove the Etruscans out of the Po Valley and took northern Italy. In 390 BCE the Celts sacked Rome.

The response from the Latin tribes, especially the Romans, was gradual, but it accomplished two feats that set Rome on the path to glory. First, it did much to forestall the Celtic advance into the Italian peninsula. Second, the new strategy of the Romans was to make them masters of most of the Mediterranean in the second and first centuries BCE. Celtic ironwork was superior to that of Rome; the Celts' long swords cut through shields without problem. The impact of a Celtic charge armed with longer and more effective weapons was such that the first rank of Romans would break, effectively rendering defense useless. To counteract this advantage, the Romans created a unique pairing of *gladius* and *pilum,* a type of javelin that had a long metal head. To these two weapons they added a new reinforced shield that covered almost the entire body. The assault of so many Roman *pila* disrupted the enemy's advance and gave the advantage to the Romans. Defended by their large shields, each overlapping the legionary and his fellow, the Romans were free to strike with their swords from better cover.

Under the general Marius, most soldiers were armed along the lines of the *principes,* men who were in the prime of life, were well armored, and comprised the heavy infantry. These units all used a short sword, but it was not the typical *gladius.* That change occurred during the Second Punic War (218–201 BCE), when Rome fought against Carthage and the use of the maniple reached its full development. Scipio Africanus is credited by some with adopting the *gladius Hispaniensis,* or Spanish sword.

Little is known about the origins of the *gladius* itself or its possible connections to Spain. Polybius refers to it as "Spanish," but archaeologically no *gladius* has been discovered earlier than the first century BCE, and most have been found in what is now Germany. Many of these are referred to as the Mainz pattern, which is typified by a slightly narrower central section of the blade. Similar blades have been found in Spain, but they are several hundred years older. However, their scabbard fittings are similar to those that the Romans used, so it is conceivable that the *gladius* did originate in the Iberian Peninsula.

The Mainz pattern *gladius* remained in use until the mid-first century CE. The new form of *gladius,* the Pompeian, boasted a shorter, less waisted blade, one that was narrower, straighter, and honed to a shorter point. One possible reason for the change in blade has to do with the

Primary Source

DIONYSIUS, BOOK 14

10 (17) Now the barbarians' manner of fighting, being in large measure that of wild beasts and frenzied, was an erratic procedure, quite lacking in military science. Thus, at one moment they would raise their swords aloft and smite after the manner of wild boars, throwing the whole weight of their bodies into the blow like hewers of wood or men digging with mattocks, and again they would deliver crosswise blows aimed at no target, as if they intended to cut to pieces the entire bodies of their adversaries, protective armour and all; then they would turn the edges of their swords away from the foe. 2 (18) On the other hand, the Romans' defence and counter-manoeuvring against the barbarians was steadfast and afforded great safety. For while their foes were still raising their swords aloft, they would duck under their arms, holding up their shields, and then, stooping and crouching low, they would render vain and useless the blows of the others, which were aimed too high, while for their own part, holding their swords straight out, they would strike their opponents in the groins, pierce their sides, and drive their blows through their breasts into their vitals. And if they saw any of them keeping these parts of their bodies protected, they would cut the tendons of their knees or ankles and topple them to the ground roaring and biting their shields and uttering cries resembling the howling of wild beasts. 3 (19) Not only did their strength desert many of the barbarians as their limbs failed them through weariness, but their weapons also were either blunted or broken or no longer serviceable. For besides the blood that flowed from their wounds, the sweat pouring out over their whole bodies would not let them either grasp their swords or hold their shields firmly, since their fingers slipped on the handles and no longer kept a firm hold. The Romans, however, being accustomed to many toils by reason of their unabating and continuous warfare, continued to meet every peril in noble fashion.

[Dionysius of Halicarnassus, *Roman Antiquities*, Vol. 7, Book 11, Fragments of Books 12–20, translated by Earnest Cary (Cambridge, MA: Harvard University Press, 1950), 275–277.]

enemies Rome faced at the time. Whereas in the last centuries BCE Rome squared off against well-armored foes such as the Carthaginians and Greeks, many of Rome's enemies in the last century BCE and the first century CE were from the north and were either unarmored or less well armored than Mediterranean foes. Celts and Germans, for example, by and large fought without the complicated armor that Rome was used to. A stabbing weapon such as the Mainz pattern, while it could cut, was primarily used to thrust. The Pompeian blade, named for examples from the famous city buried by Mt. Vesuvius in 79 CE, because it was stouter was probably just as effective with a cut as a thrust, and since legionaries had to worry less about piercing armor, a more versatile weapon made sense. Tactics were much the same—legionaries still acted in concert and

from the cover of their shields—but this style of sword perhaps worked better than its predecessor for cutting and thrusting. There is some thought that the Pompeian blade may have originated with the gladiatorial schools. Gladiators, as the name suggests, were primarily swordsmen, but more than that, they did not wear as much armor as the typical soldier and thus benefited from a style of weapon equally suited to slashing as stabbing.

During the second century CE, a tumultuous time in the empire, the military underwent many changes. The *gladius,* though still in use, was gradually replaced by a longer weapon long used by cavalry, the *spatha.* As one might expect, a change in sword also meant a change in shield; it was hard to wield a longer sword effectively with the large scutum. The baldric was slung across the shoulder, which increasingly became the preferred method of wearing the sword.

SIGNIFICANCE

The *gladius* is important for several reasons. One significant aspect of the Roman mind that it exemplifies is the ability of Rome to learn from its neighbors, even its enemies, and to adapt to new situations. Whereas other peoples in Italy stuck to the tried-and-true phalanx, Rome did not. Rome kept the defensive value of shields massed together in a line but replaced the forest of spears with javelins, which were more effective offensive weapons; there was also a new deadly reliance on the short sword. The legion with its smaller, more mobile units allowed the Romans to adapt to changing situations on the battlefield, where the phalanx only allowed for slow movement in a one-way circling motion. Against the phalanx, the scutum proved to be a solid defense, and once past the point of the long spears, the *gladius* could be put to best use. On the other hand, against largely unarmored foes such as the Celts, the barrage of javelins, the wall of shields, and the quickness of the *gladius* proved equally effective. As the needs of the army changed, so too did the *gladius,* further demonstrating the Roman willingness to adapt as necessary.

What the success of the *gladius* also demonstrates is the incredible discipline and training of the Roman Army. Both were vital for success in battle. Training took two forms: individual and collective. Individual technique was influenced by the gladiatorial schools, but collective training and effectiveness came from soldiers drilling together, learning to wield their weapons in unison while in close ranks.

The *gladius,* in conjunction with *pilum* and scutum, was one of the primary reasons that Rome prevailed over its enemies and came to dominate so much of the Mediterranean and Europe. The effectiveness of the *gladius* as a weapon and the discipline of those who wielded it were unparalleled elsewhere at the time.

FURTHER INFORMATION

Caesar. *The Gallic War,* Vol. 44. Translated by H. J. Edwards. Cambridge, MA: Harvard University Press, 1994.

Connolly, Peter. "Greece and Rome." In *Swords and Hilt Weapons,* edited by Michael D. Coe et al., 20–20. New York: Weidenfeld and Nicolson, 1993.

Dionysius of Halicarnassus. *Roman Antiquities.* Vol. 7, Book 11, Fragments of Books 12–20. Translated by Earnest Cary. Cambridge, MA: Harvard University Press, 1950.

Gellius, Aulus. *Attic Nights,* Vol. 2, Books 6–13. Translated by J. C. Rolfe. Cambridge, MA: Harvard University Press, 1927.

Gmirkin, Russell. "The War Scroll and Roman Weaponry Reconsidered." *Dead Sea Discoveries* 3(2) (July 1996): 89–129.

Griffiths, N. A. "A Gladius from Dorset, in the Ashmolean Museum." *Britannia* 10 (1979): 259–260.

Hazell, P. J. "The Pedite Gladius." *Antiquaries Journal* 61(1) (March 1981): 73–82.

Koch, John T. *Celtic Culture: A Historical Encyclopedia.* Santa Barbara, CA: ABC-CLIO, 2005.

Lang, Janet. "Study of the Metallography of Some Roman Swords." *Britannia* 19 (1988): 199–216.

Plutarch. *Lives II: Themistocles and Camillus, Aristides and Cato Major, Cimon and Lucullus.* Translated by Bernadotte Perrin. Cambridge, MA: Harvard University Press, 1914.

Polybius. *The Histories,* Vol. 1, Books 1–2. Translated by W. R. Paton. Cambridge, MA: Harvard University Press, 1922.

Tacitus. *Agricola, Germania, Dialogus,* Vol. 1. Translated by M. Hutton and W. Peterson. Cambridge, MA: Harvard University Press, 1914.

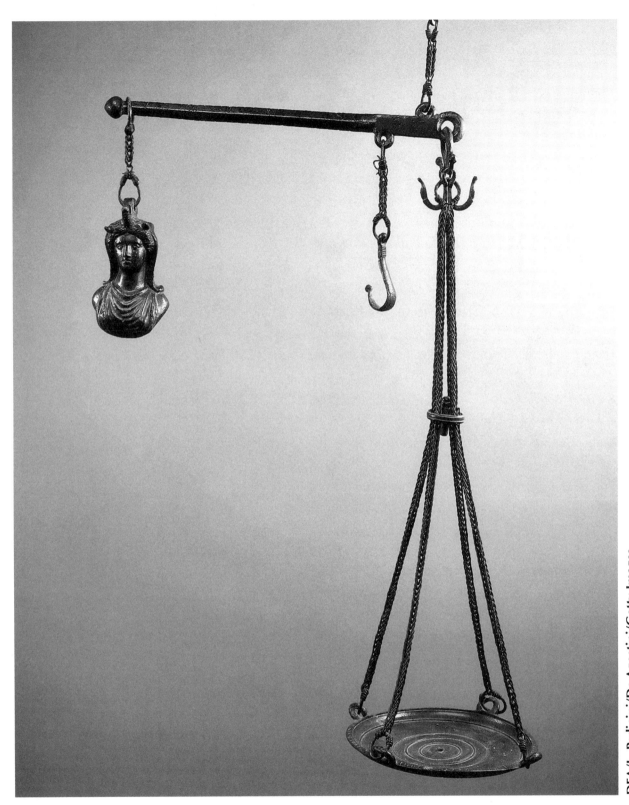

Scales and Steelyard

Pompeii, Italy
Circa First Century CE

INTRODUCTION

Commerce, though competitive, operates best when merchant and consumer share an understanding of standard measures. Without them, quantities, prices, and even quality can fluctuate greatly and undermine the process. The introduction of the Roman steelyard, a way of assessing the weight of a wide variety of commercial products, was an improvement on the more ancient balance scale. Simpler and less cumbersome to use in many respects than the balance, the steelyard grew in popularity and spread to all corners of the Roman world.

DESCRIPTION

The steelyard pictured here was made of bronze and dates from the first century CE. It was discovered in Pompeii, the famous Roman resort town buried under ash when Mt. Vesuvius erupted in 79 CE. According to Isidore of Seville (d. 636 CE), a late source, the steelyard was first invented in Campania, the region in southern Italy where Pompeii and Herculaneum were located. The steelyard was often referred to as the *statera campana,* and its use was certainly widespread in the region, but without further information all one can say is that it was a Roman invention. The *libra,* or balance, is of much greater antiquity, in use in the Indus Valley in the third millennium BCE, in Egypt by at least the second millennium, and in Mycenaean Greece ca. 1500–1200 BCE.

The Latin term for a steelyard is *statera,* but often the steelyard and related measuring devices, such as the *libra,* were referred to under the term *trutina.* In some contexts *trutina* refers to large steelyards, the smaller sort being known as *momentana* or *moneta.* Again, Isidore provides some insight in his *Etymologies.* According to him, the *trutina* is a larger instrument that uses two plates for heavy items, things weighing as much as a talent or what he calls 100-pound weights. A *momentana,* on the other hand, is small and is useful for things such as coins. For Isidore these are both different from a *statera,* which he refers to as a *campana,* because it uses only one plate and an uneven beam.

Steelyards measured objects using unequal beams. The balance, on the other hand, had arms equidistant from the fulcrum of the device. The way the steelyard worked was similar to the balance, only the object being weighed rested within a dish hung from a shorter arm and was weighed against a weight suspended from the longer arm. The steelyard's versatility made it popular, and it soon became the most popular form of scale. In general, the steelyard had several key parts. The plate, or *patera,* was used to hold the commodity and hung down from a short beam, or *scapus.* A longer beam, along which were marks to help determine the weight of the object, was counterbalanced against the short one using a weight, or *aequipondium,* that could be slid up and down in order to find the correct measure, much as the modern medical scale works. The weights might vary in size and weight depending on the size of the steelyard, but generally one could use one standard and let the beam do the work. This was far simpler than using a balance, which required a number of weights in order to find the correct balance.

A steelyard was only as accurate as the weight used with it, and based on archaeological finds, even standard measures could vary widely. From weights found in Herculaneum and Pompeii we have a good sense of what the average Roman pound was ca. first century CE. Similar discoveries elsewhere in the Roman world help round out this picture too. On average, the Roman pound, or libra, was a little over 11 ounces or 323 grams, or about 5 ounces less than our pound (16 ounces or 453.6 grams). In addition to the libra, the Romans also used *unciae,* or ounces, and on a set of weights from Charterhourse-on-Mendip, England, these were marked 1 to 4. Most likely an individual merchant used the most common set of weights he might need; in other archaeological contexts a much wider variety of *unciae* weights have been discovered, so the choice of what weight or weights and what size steelyard to use must have been largely determined by one's type of business.

The Romans used different measures for different types of products. Dry objects, such as grain, were measured by *modius,* about 2.3 gallons or 8.62 liters. The *modius* was much used in the military; surviving ration records, for example, are often in *modii.* For wet items such as wine and oil, measurements might be expressed in *modii* too, but the amphora itself also served as a standard of measure. Those amphora containing olive oil from Spain, for example, typically held about seven *modii*; those for wine held about three ounces. There were a number of standard measures for both wet and dry goods, much as there are today. For dry goods, for example,

1 *modius* = 16 *sextari* 2.3 gallons or 8.62 liters
1 *sextarius* = 2 *heminae* a half quart or 0.55 liters
1 *hemina* = 6 *cyathi* 1.2 cups or 0.28 liters

Definitions

Aediles Curules

One of many Roman magistrates, the aediles were originally officers working under the tribunes of the plebs, a connection that extended the sacrosanct nature of the tribunes to them. In 376 BCE the aediles curules were added and early on were drawn from the patricians. These were elected positions, chosen via the *comitia tributa,* and elections were held each year. The chief duties of all aediles were the *cura urbis,* or care for much of the infrastructure of the city; the *cura annonae,* or the public grain supply; and the *cura ludorum sollemnium,* or the public games. They also, however, had oversight over the market and had jurisdiction over many of the cases pertaining to commerce and sales.

Campania

A region in southern Italy settled first by the Etruscans and Greek colonists. Capua was the chief city of the region and in time became the capital of the Samnites who conquered the area in the late fifth century BCE. The region is perhaps most famous, however, for the buried cities of Pompeii and Herculaneum, both victims of the 79 CE eruption of Mt. Vesuvius.

Digest of Justinian

Emperor Justinian I (d. 565 CE) commissioned a reworking of Roman law that resulted in his *Corpus Juris Civilis* (Body of Civil Law), completed in 565. While there was a section for new laws, much of the *Corpus* drew upon or included entire editions of earlier laws. There were four chief sections, the "Codex Constitutionem" (Constitutional Code), the "Digest," the "Institutes," and the "Novels." The "Digest," for example, drew most of its contents from the work of Ulpian, a lawyer of the third century CE. It was intended to make civil cases more efficient but also to help teach new lawyers their trade.

Isidore of Seville

Isidore of Seville (d. 636 CE) was a bishop and an author and was one of the finest minds of the early Middle Ages. Isidore's *Etymologies,* an encyclopedic work that attempted to collect all knowledge of the time, remained a key source for centuries afterward.

Standard Roman weights were useful in many areas of life. In commerce they helped regulate quantities and prices for products, but they were also useful in evaluating precious goods. For example, on many finds of valuables, such as silver plate, mirrors, and other precious items, the weight was incised upon it in some detail. This might help with resale or in simply keeping an inventory of what one owned and what particularly fine housewares were worth. There is some thought that derivations from standard weights, particularly with coins or other valuable items, might reflect the

result of cleaning these items or from the corrosive effects of having been buried for so long.

SIGNIFICANCE

The steelyard was an improvement upon the *libra* and helped refine commercial weights and measures. This is important because it made it easier to set a standard. Setting standards for weights helps maintain a good economy—if the quantity of some product varies, then the price will, but if what constitutes a standard measure varies, then the price may not reflect the actual value. At its least complex, heavier weights favor the buyer, while lighter weights favor the seller. So, in the first case those on the business end will be hurt because it means that they may sell more stock for less. Conversely, if on the other hand the weights are lighter, then consumers will feel the pinch, as they will be paying more for less.

Not surprisingly, Rome had laws to help regulate the potential dangers to both parties. One of the earliest laws that dealt with this sort of crime was the Lex Silia de Ponderibus, probably from the third century BCE, which imposed penalties for any magistrate either forging or participating in the forging of weights and measures. How such cases were investigated or prosecuted is hard to say, but there were specific magistrates charged with oversight of weights and measures—the aediles curules were, by the time of Julius Caesar (mid-first century BCE), overseers for a number of tasks, including public games, but they were also responsible for key market concerns, including weights and measures. Another law, one that went on to influence many alter ones, was the Lex Cornelia de Falsis, which had first concerned falsifying wills and coins but came to include other cases concerning falsification or forgery, everything from assumed titles to manipulating weights used with scales. That concern over falsification of weights continued is evidenced by the later Roman law codes as well. In Justinian's *Digest,* a collection of laws from 533 CE meant to teach new lawyers and reduce court time in certain legal cases, there is a law that touches on an old one of Emperor Hadrian's (d. 138 CE) that stipulated penalties for those who used false weights and measures.

While there were laws that pertained to trade and while the government (especially the army) was the largest customer, for the most part the Roman economy was a privately run, localized affair. It was agrarian and subject to the perils and time constraints of long-distance travel as well as regional variation in supply, demand, and cost. Cities consumed more than did towns or rural areas, so trade was more focused there. Wherever one traded, however, one used coin. This was the most obvious way that the Roman government was involved in commerce; the government minted the coins upon which so much of trade depended (see the entry **Coin Mold**).

FURTHER INFORMATION

Bang, Peter Fibiger. *The Roman Bazaar: A Comparative Study of Trade and Markets in a Tributary Empire.* New York: Cambridge University Press, 2008.

Dean, James Elmer, ed. *Epiphanius' Treatise on Weights and Measures: The Syriac Version.* Chicago: University of Chicago Press, 1935.

Duncan-Jones, Richard. *The Economy of the Roman Empire: Quantitative Studies.* 2nd ed. Cambridge: Cambridge University Press, 1982.

Ligt, Luuk de. *Fairs and Markets in the Roman Empire: Economic and Social Aspects of Periodic Trade in a Pre-Industrial Society.* Amsterdam: J. C. Gieben, 1993.

Morley, Neville. *Metropolis and Hinterland: The City of Rome and the Italian Economy, 200 B.C.–A.D. 200.* Cambridge: Cambridge University Press, 1996.

Morley, Neville. *Trade in Classical Antiquity.* Cambridge: Cambridge University Press, 2007.

Peacock, D. P. S., and D. F. Williams. *Amphorae and the Roman Economy: An Introductory Guide.* New York: Longman, 1986.

Scheidel, Walter, Ian Morris, and Richard Saller, eds. *The Cambridge Economic History of the Greco-Roman World.* Cambridge: Cambridge University Press, 2007.

Ward-Perkins, J., and A. Claridge. *Pompeii AD 79.* London: Royal Academy, 1976.

Website

Büttner, Jochen. "Ancient Balances at the Nexus of Innovation and Knowledge." Max Planck Institute for the History of Science, http://www.mpiwg-berlin.mpg.de/en/news/features/feature32.

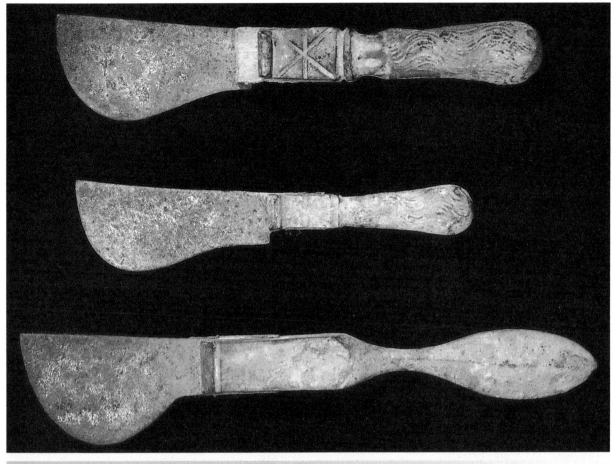

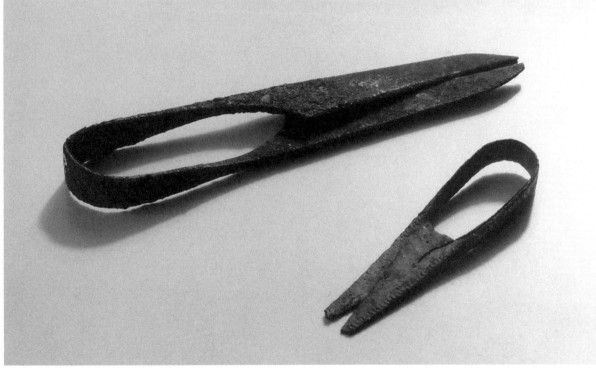

Scalpels and Bronze Scissors

Roman *Date Unknown*

Roman *Circa 201 through 500 CE*

INTRODUCTION

In a world where medical treatment was more often indifferent or deadly, where essentially anyone could call themselves a doctor, and where mortality rates were high, it is perhaps little wonder that the Romans were traditionally skeptical of doctors. It did not help that most doctors were foreign and most Romans were parochial in outlook. A number of sources decry the medical profession not only because it was considered a dubious, low trade taken up by shysters and charlatans but also because training and knowledge varied considerably. Despite the challenges with decent medical care, there were doctors who successfully treated patients. While recovery from illness or injury was chancy, surviving surgical tools and depictions of treatments indicate that the Romans performed sophisticated medical procedures and that, criticisms notwithstanding, many patients were treated successfully.

DESCRIPTION

The tools pictured here are typical surgical instruments. The scalpels, made of bronze, could be honed razor sharp and, like their counterparts today, were a stock tool in the surgeon's kit. The largest of the three, at the bottom, may have a spatulate probe on its other end. Likewise, these bronze scissors, made ca. 200–500 CE, though they might be used in a variety of trades, were common medical implements. Many of the medical instruments either excavated or depicted in mosaics, paintings, and relief sculptures would be familiar to doctors today—probes, various speculae, scalpels, scissors, tweezers, and expanders were all used by Roman doctors too.

In some cases we have a fair idea of how some tools were used. Those like scalpels and scissors, which are still used today, need little reconstruction to understand, but some, like trepanning drills, we understand by analogy, by the obvious ways in which a tool might have functioned, and if we are lucky because of artistic representations or descriptions found in surviving sources. The picture of medicine that emerges from both documentary

evidence and the archaeological record is of a diverse, often competing set of traditions and practices. From votive artifacts (see the entry **Votive Male Torso**) to surgical tools to the extant tracts on medicine, it is clear that not only did doctors vary in outlook and training but also that people availed themselves of many different health care avenues.

Roman medical practice derived from several sources. On the one hand, Etruscan influence seems to have been strong. The continued tradition of anatomical votive offerings, for example, demonstrates a religious dimension to health care, and surviving artifacts reveal a firm grounding in human anatomy. Moreover, some sources, such as Theophrastus (b. ca. 370 BCE), who penned a large work on botany, *Enquiry into Plants,* mentioned that the Etruscans were well respected for their expertise in recognizing and preparing medicinal herbs. The emphasis placed on herbal medicine and home remedies likewise reflects this do-it-yourself approach to health care that is so prominent in Roman works. For instance, Pliny the Elder, in discussing the history of medicine in Rome, mentions that the statesman Cato the Elder was quick to condemn doctors and swore by home remedies and that his long life (Cato lived to be 85) owed much to such preparations. Cato's dislike of doctors was such that he even forbade his son to see them. Pliny devotes a lot of verbiage to lambasting medical professionals. He seems to have particularly disliked the theoretical side of Greek medicine but could praise their knowledge of drugs and other practices that seemed more like those of his own people. Of doctors, however, he had little positive to say. He discusses their greed, lack of concern for the professional standing of their craft, and the fact that they appeared to be the only people who could get away with murder.

The prejudice against doctors reflects several concerns. There was neither a unified course of medical study nor a regulatory body that ensured proper training. Thus, anyone might call themselves a *medicus,* a doctor, and with predictable results. Training varied in length and in quality. Galen (d. 200 CE), one of the most famous ancient doctors, whose teaching defined medicine in the West for the next millennium, berated Thessalus of Talles, a popular physician during the reign of Nero (d. 68 CE), for promising to train doctors in only six months. Galen himself studied for 11 years before practicing. With no medical schools, aspiring physicians either learned from their fathers or joined a practicing doctor on his rounds. Many doctors were itinerant, but even those in one location such as Rome generally made house calls. The poet Martial provides some wonderful if acerbic insights into these visiting physicians. In one epigram he relates how a doctor, Symmachus, visited him with "one hundred" students in train, all of whom felt the poet's pulse with hands "chilled by the North Wind." Martial wrote, "I didn't have a fever, Symmachus; but I do now."

In addition to inconsistent and poor training, most doctors were either slaves or freemen and as members of the lower strata of society were not

Primary Source

PLINY THE ELDER, *THE NATURAL HISTORY*, CHAPTER 5

There can be no doubt whatever, that all these men, in the pursuit of celebrity by the introduction of some novelty or other, made purchase of it at the downright expense of human life. Hence those woeful discussions, those consultations at the bedside of the patient, where no one thinks fit to be of the same opinion as another, lest he may have the appearance of being subordinate to another; hence, too, that ominous inscription to be read upon a tomb, "It was the multitude of physicians that killed me."

The medical art, so often modified and renewed as it has been, is still on the change from day to day, and still are we impelled onwards by the puffs which emanate from the ingenuity of the Greeks. It is quite evident too, that everyone among them that finds himself skilled in the art of speech, may forthwith create himself the arbiter of our life and death: as though, forsooth, there were not thousands of nations who live without any physicians at all, though not, for all that, without the aid of medicine. Such, for instance, was the Roman people, for a period of more than six hundred years; a people, too, which has never shown itself slow to adopt all useful arts, and which even welcomed the medical art with avidity, until, after a fair experience of it, there was found good reason to condemn it.

[Pliny the Elder, *The Natural History*, translated by John Bostock and H. T. Riley (London: Henry G. Bohn, 1855), http://www.perseus.tufts.edu/hopper/text?doc=Perseus:text:1999.02.0137:book=29:chapter=5&highlight=multitude+of+physicians%2C.]

greatly trusted or admired. The latter, manumitted slaves, despite their freedom, were still generally held in low esteem. In addition, many doctors hailed from other countries, especially Greece. Pliny reports that the first physicians came from Greece, and certainly Greeks dominated the medical field in Rome. One, Archagathus, arrived in 535 BCE from the Peloponnese and was even granted citizenship. His shop, situated on a busy street, was paid for at public expense and was popular when he first set up practice. He was even called "Vulnerarius" (Wound Curer). However, Pliny states that Archagathus did not enjoy this popularity long; he gained a reputation for slicing and burning his patients and earned a new nickname, "Carnifex" (Butcher). The term *carnifex* also meant "executioner," so it was a doubly unpleasant appellation. In another of his famous epigrams, Martial discusses one doctor's career change to undertaker, noting that nothing changed in his workday. All of this speaks to the pain of certain procedures (there were few if any anesthetics) and low survival rates for many patients.

Greek influence came via Magna Graeca, the Greek colony in the south of Italy, and from Greeks arriving in Rome from their homeland. They

brought with them several medical traditions. One of the most important of these was the Hippocratic school. Hippocrates, about whom little is known for certain, came to be regarded as the author and inventor of a variety of medical works and methods, collectively the *Hippocratic Corpus*. Even in antiquity there was debate about which treatises he himself may have written. In general, the approach of doctors ascribing to this methodology meant careful observation of the patient, the view that health and medicine can be understood like other natural phenomena, and attention to what we might term a holistic approach, that is, a concern for diet, lifestyle, and conditioning. Galen of Pergamum (d. ca. 199 CE) wrote voluminously about his own theories and practice, but he was also the one who helped define how people have looked at Hippocrates, thanks to Galen's opinions of the medical pioneer. For Galen, demonstrative knowledge is the foundation of all medicine, not only in diagnosis and treatment but also in learning. There were competing schools of thought, and a good physician would use logic and knowledge to know what to take, if anything, from the various medical sects.

Despite the prejudice against doctors, many patients clearly benefited from their treatments, something perhaps not entirely owing to their physicians but nonetheless instructive. Archagathus, for example, would not have been invited to Rome and granted citizenship if his reputation had always been so poor. In addition, the criticism of his cutting and searing may, in fact, reflect well on his actual practice. Pliny preferred herbal cures, but cutting and searing could and did work. Cutting, while dangerous in a time when knowledge of infection was poor, was often successful. We know of people who survived amputations. Gladiators, not to mention soldiers, were often wounded, and many went on to keep fighting. Searing, or cauterizing, was up to relatively recently a fair guard against infection. A wound might be cauterized both to close it and kill germs, though clearly in the latter instance this was not well understood until the modern era. The fact that so many scalpels, scissors, and other medical artifacts have been found attests not just to widespread use but also, to a certain degree, to some success in their use.

SIGNIFICANCE

Extant medical instruments like those pictured here give us keen insights into Roman ideas of health and healing. First, we see that as in so many other areas of science, the Romans took a practical approach to medicine. In popular imagination of the time, a certain natural, unsophisticated rural toughness was one of the defining aspects of the Roman character. In stories they told of themselves, Roman would rather suffer without complaint and fix things themselves with good old-fashioned tried-and-true home remedies than seek out help, especially from foreigners. The reality, however, was often very different. Clearly many Romans valued the *medicus* in their

neighborhood; otherwise, the complaints by writers such as Pliny of doctors getting rich many times over would make little sense. A certain xenophobia also plays into this idealized simple Roman characterization, but here too it would seem that not everyone had a problem seeing a foreign physician. While most doctors may have been Greek or of Greek extraction, they nonetheless had Roman patients, and clearly these patients often sought out medical expertise, whatever its actual quality. Second, irrespective of critics such as Cato, Pliny, and even Galen, Greek medicine itself was popular and must have often been effective. Inscriptions tell us of particular specializations much like we have today; this suggests that the medical field was large and successful enough to accommodate specialists. We know too from inscriptions that women practiced medicine. That female doctors could and did practice suggests not only a wider field than most others in Roman society but also that the populace must have sought them out and thus have been accepting of women in medical roles. Arguments from silence are precarious on their own, but taking the sources and artifacts together with what such inscriptions say, from what it was that Pliny objected to, and from the implications of so many stories of successful doctors, one gains an appreciation for the variety and perhaps too the efficacy of Roman medical practices.

It is easy to see the limitations in ancient medicine. However, the roots of modern medicine began there and owe much to the theories of men such as Hippocrates and Galen. To this day, for example, doctors continue to take the Hippocratic Oath, but more than that, the ideas of careful observation, examining evidence, and taking into account a patient's lifestyle and diet are all current in modern medicine too. On a more material level, many of the tools, such as the scalpel, have remained essentially unchanged in more than 2,000 years; they are still on the operating tables in hospitals the world over and are likely to be there for a long time to come.

FURTHER INFORMATION

Flemming, Rebecca. *Medicine and the Making of Roman Women: Gender, Nature, and Authority from Celsus to Galen.* Oxford: Oxford University Press, 2000.

Gagarin, Michael, ed. *The Oxford Encyclopedia of Ancient Greece and Rome.* Oxford: Oxford University Press, 2010.

Hornblower, Simon, et al., eds. *The Oxford Classical Dictionary.* 4th ed. Oxford: Oxford University Press, 2012.

Jackson, Ralph. *Doctors and Diseases in the Roman Empire.* Norman: University of Oklahoma Press, 1988.

King, Helen. *Greek and Roman Medicine.* London: Bristol Classical Press, 2002.

McGeough, Kevin M., and William E. Mierse, eds. *World History Encyclopedia, Era 3: Classical Traditions, 1000 BCE–300 CE.* Santa Barbara, CA: ABC-CLIO, 2010.

Nutton, Vivian. *Ancient Medicine.* New York: Routledge, 2004.

Scarborough, John. *Roman Medicine.* Ithaca, NY: Cornell University Press, 1969.

Transportation

Farm Cart

Horse Bit

Milestone

Rostrum

Farm Cart

Ostia, Italy
First Century CE

INTRODUCTION

Travel in the ancient world, while often difficult, was not uncommon. Merchant ships hugged the coasts of the Mediterranean to bring wares from one corner of the Roman world to another, mule teams and wagons did the same by road, and individual travelers might take boat, cart, or horse to visit friends and family, conduct business, or visit famous sites. There were a variety of wheeled vehicles available, from the farm cart to speedy chariots, and what one chose depended largely on the purpose for which one traveled.

DESCRIPTION

This mosaic of a cart dates to the first century CE and is one of many mosaics in the Square of the Guilds in Ostia Antica, once the port city of Rome. The mosaics were laid down in the time of Augustus (d. 14 CE) and Hadrian (d. 138 CE), but there were renovations as well in the third century CE. Though this depiction shows a cart with only two wheels, it is likely that this cart was a four-wheeler. Significantly, the cart is pulled by a mule, one of the most common draft animals in the Roman world.

Mules, donkeys, oxen, and people supplied the Roman world's call for a draft animal or porter. Horses, while sometimes used to pull carts, were more commonly used to bear a rider or pull a light chariot. The Roman *carrus,* which can refer to a cart, chariot, or wagon depending on context, was—excluding chariots—either large for heavy loads and pulled by oxen or lighter for less heavy loads and drawn by mules or horses. Chariots were more commonly referred to by type. A *bigae* was a chariot paired with two horses, a *triga* was paired with three horses, and a *quadrigae* was paired with four horses. Most animals were attached to wagons by yoke; this was attached to the pole on the vehicle. In the case of oxen, because they have a slight bump at the withers, the typical yoke worked well. Instead of choking the animal, it helped the ox thrust forward to move the wagon. Mules, though better suited to this work than horses, lack a bump at the withers and could conceivably have been choked by the yoke. However, since mules no

doubt pulled smaller and less heavily laden carts, this was probably not as serious a hindrance as has sometimes been suggested.

Mules and donkeys, in addition to acting as draft animals, could also carry *clitellae,* or panniers. The *muliones,* or muleteers, provided good local transport. In a poem attributed to Virgil, for example, he discusses a muleteer who boasted of his speed. Virgil's piece is a satirical version of a poem by Catullus and pokes fun at a consul, Ventidius Bassus, who began his career as a muleteer. Humor aside, the poet mentions that while quick with deliveries in town, the same "Sabinus" claimed to be just as quick with longer trips, such as the run from Rome to Brixia (present-day Brescia), a distance of almost 350 miles (559 kilometers) along a modern road. Even allowing for poetic exaggeration, the places and distances that Sabinus claims to have visited and traveled suggest that it was common for mule teams to perform long-distance hauling. For shorter trips, say in loading and unloading ships, barges, or wagons, and especially when entering most buildings, the usual transport was the *saccarius,* the sack man or porter. Humans, however, can only carry so much for so long, so heavier loads were better tackled by draft animals.

In fact, most long-distance travel was easier by sea, and it is no accident that cities such as Ostia thrived. Rome, being an inland city, lacked a harbor, so Ostia served as the capital's main port. Roads, however, were integral to the Roman world, and by the fourth century BCE there were eight chief highways that connected Rome with the principal cities in Italy (see the entry **Milestone**). Roads varied in quality and degree of upkeep, and this naturally affected those who traveled on them.

Our knowledge of Roman roads exceeds what we know of the vehicles that traveled them. Comparatively speaking, there are fewer archaeological finds that inform our picture of ancient vehicles to the degree than there are of bathing complexes or amphorae. Descriptions in surviving sources and artwork supply most of our information. Both sources are sometimes fraught with difficulties. In the example on view here, we see two wheels on one the side of cart but nothing on the other side, despite the fact that the artist attempted to render both driver and mule in three-quarter perspective. Given the relative proportions, however, the two wheels are probably meant to suggest that both sides have the same number of wheels.

The Romans employed a variety of wheeled transport. Chariots, wagons, and different sizes of carts helped people journey around town, between cities, and from farm to market and back. Unwheeled vehicles, such as litters, were likewise popular with those who could afford the slaves to carry them. By and large, however, most people walked. Crowded cities such as Rome, especially after laws were passed to ban traffic during the day, meant that with few exceptions people had to walk unless they had a litter. Horses were also popular (see the entry **Horse Bit**). Not everyone owned a horse,

however, and even those who did were less likely to travel great distances on land. It was far easier to take a ship to Greece, for example, than to take the roads that led north out of Rome, through Norica, Pannonia, Dalmatia, Macedonia, and Epirus into the province of Acheae. One could take a *carpentum,* a carriage, but travel was slow and often uncomfortable and was always at the mercy of weather and brigands.

SIGNIFICANCE

Not so long ago, the scholarly consensus was that travel by sea was less expensive than travel by land. In more recent years, and thanks in large part to examinations of Egyptian papyri, the model has changed to one that posits that most long-distance travelers used both. To name just one example, goods arriving in Ostia by boat would then be loaded onto carts and taken by road to Rome and other destinations. Even travelers by river would eventually connect with a town linked to others by roads. This does not mean that sea travel, since it largely followed the coasts, was not easier and in many cases safer (not to mention faster) than journeying by land, rather that the picture of the Romans as less inclined to take their magnificent roads is inaccurate.

Inns and taverns, for example, were often on roadways, which suggests that traffic must have been ample enough to make hostelry a viable business venture. That these same places could be dangerous for unwary travelers is suggested by Apuleius in his *Metamorphoses*—Lucius, for example, stays at an inn that is set upon by brigands (see the entry **Cave Canem Mosaic**). As the legions were more often stationed in the provinces to act as police, however, this danger, while it did not disappear, no doubt diminished. That this was the case is supported by our knowledge that people engaged in tourism.

Not everyone could afford to see most of the territories under Roman control, but from some notable exceptions one can deduce that other tourists, who perhaps ventured slightly more close to home, were likewise plying the rivers and taking the roads to attractions near them. One of the most famous tourists, Pausanias (d. 180 CE), traveled extensively and recorded his adventures as well as descriptions of buildings, artworks, and places in the *Periegesis Hellados,* or *Tour of Greece.* A wealthy man, Pausanias could afford to travel widely, and though he spent most of his time in the eastern half of the empire, he also visited Italy. The *Tour of Greece* is one of the most valuable guides to ancient art and architecture, but importantly Pausanias records little about the details of travel during the Pax Romana. Other writers, however, sometimes give us a glimpse of life on the road. Another Greek, Aelius Aristides (d. after 181 CE), discussed the speed of travel by cart; on good roads with no other hindrances, he claims to have gone about 35 miles (56 kilometers) in one day. Of note, he mentions that

VIRGIL, *CATALEPTON*, EPIGRAM 10

O strangers, that Sabinus whom you see
Doth say he was the fastest muleteer,
And didn't fail to go beyond the speed
Of any gig that flew, e'en were the task
To fly to Brixia or Mantua.
And this the emulating Tryphon's house
Or noble island of Caerulus don't,
He says, deny, nor th' situation rough
Where that Sabinus, as he afterwards
Became, aforetime says its bushy neck
He sheared for Quinctius with the double shears,
Lest 'neath the boxwood collar pressing, hair
So hard might cause a wound. Cremona cold,
To thee, and thee, O Gaul, that's filled with mud,
Sabinus says these things both were and are
Particularly known, and says that at
His earliest origin he stood amid
Thy depths, and in thy marshes dropped his packs,
And through so many rutty miles from there
He bore his yoke, and whether on the left
Or on the right the mule began to sink,
Or both together. . . .
Nor had he for himself to wayside gods
An offering made, except this final one,
His father's reins and newest curry-comb.
But these are what have been in former times:
Upon an ivory seat he now doth sit
And dedicates himself to thee, the twin
That's Castor, and to Castor's brother twin.

[Joseph J. Mooney, trans., *The Minor Poems of Vergil: Comprising the Culex, Dirae, Lydia, Moretum, Copa, Priapeia, and Catalepton* (Birmingham, UK: Cornish Brothers, 1916), http://virgil.org/appendix/catalepton.htm.]

he journeyed so far that day because he did not find an inn to his liking. We learn a lot more from Horace (d. 8 BCE), one of Rome's greatest poets, who provided more detail about his travels. In his first satire, for example, Horace relates, among other things, losing sleep because of frogs croaking at night, poor roads after rain, and poor fare at taverns.

The ability of people to travel in the Roman world, even with obstacles, was important for more than tourism. Ideas traveled with people wherever they went, as did religions. Some of the more important tourism in the later Roman world, especially after the legalization of Christianity in the early fourth century, was pilgrimage. Non-Christians too made journeys to notable religious sites, a tradition that continued when the ancient shrines were replaced by the catacombs and tombs of the martyrs, the locations Jesus visited, and the great churches.

FURTHER INFORMATION

Adams, Colin. *Land Transport in Roman Egypt: A Study of Economics and Administration in a Roman Province.* Oxford: Oxford University Press, 2007.

Casson, Lionel. *Travel in the Ancient World.* Baltimore: Johns Hopkins University Press, 1994.

Chevallier, Raymond. *Roman Roads.* Translated by N. H. Field. London: Batsford, 1976.

Elsner, Jaś, and Ian Rutherford, eds. *Pilgrimage in Graeco-Roman and Early Christian Antiquity: Seeing the Gods.* New York: Oxford University Press, 2005.

Habicht, Christian. *Pausanias' Guide to Ancient Greece.* Berkeley: University of California Press, 1985.

Hyland, Ann. *Equus: The Horse in the Roman World.* New Haven, CT: Yale University Press, 1990.

Landels, J. G. *Engineering in the Ancient World.* Berkeley: University of California Press, 1981.

Matthews, John F. *The Journey of Theophanes: Travel, Business, and Daily Life in the Roman East.* New Haven, CT: Yale University Press, 2006.

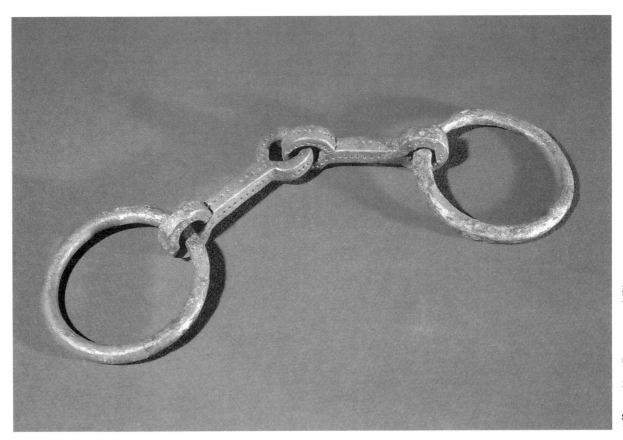

Horse Bit

France
First Century CE

INTRODUCTION

The horse was one of the chief methods of land travel in the Roman world. Elegant, swift, and reliable when well trained, the horse was a good companion on the road, an asset on the battlefield, an ally in hunting, and the speed behind a chariot. While the Romans were fond of spectacles, few commanded the devotion of the populace as deeply or for as long as did chariot racing. Romulus, the first king of Rome, was believed to have held races, particularly to occupy the Sabines so the Romans could seize their wives for themselves, but chariot racing probably owes its origins to funeral games. Whatever their beginning, the entertainment value was high, and with the speed, danger, accidents, and time spent with friends, the chariot race became a staple of Roman entertainment.

DESCRIPTION

The bronze horse bit on view here, which dates to the first century CE, is now in the Musee d'Archeologie Nationale, Saint-Germain-en-Laye, France. The horse bit is testimony not only to the skillful equitation of the Romans but also to their technology, given that this style of bit, sometimes called a smooth o-ring bit today, is still in use and looks much the same as this ancient predecessor. Research over the last century has indicated that many of the myths about the Romans and horses are unfounded. Experiments with replica Roman bits, for example, have proved that they were every ounce as effective in commanding horses as are modern versions.

While the Romans lacked the stirrup—this would not appear in the West until about the eighth century CE—they had much of the same tack that riders employ today, such as the *frenum* ("bridle") and *ephippium* ("saddle"). Initially, only the upper economic levels of Rome owned horses. Aristocrats and wealthy freeholders normally supplied the military's cavalry, but over time the Romans increasingly employed auxiliary cavalry as well. The cachet of the cavalry remained, but with the rise of Rome's infantry, horsemen became more an adjunct to unmounted troops. The horse, however,

remained an important means of transport, hunting, and racing. They were faster than other common working animals, such as oxen, mules, and donkeys, and were thus used for couriers and the postal system (see the entry **Seal Ring**). Some horses were put to work, but pulling plows or carts was generally relegated to oxen and mules.

SIGNIFICANCE

Chariot racing brought members of society from all walks of life, many cultures, and various class levels into close proximity. Fellow fans, whatever their background, left all that behind when cheering their favorite team. The Romans brought chariot racing to all parts of the empire; there are racetracks from North Africa to England. One of the more interesting developments within racing was the increasing political role that racing factions played in Roman politics. Such was this influence that factionalism sometimes led to violence. For example, in 532 CE the Nika Riots were sparked when members of the Blues and Greens, two of the four traditional colors, were arrested.

Many archaeologists, historians, and other researchers believe that the horse was likely domesticated in what today is eastern Turkey. The chariot may hail from the same general region. The evidence, both literary and physical, suggests that people in the Near East were some of the first to use chariots, probably ca. 2000–1000 BCE. It was at this time too that the chariot appeared in India and in Greece. With Greek colonies in the south of Italy, it is conceivable that the Latin cities received the chariot from Greek settlements, but since the Etruscans too employed chariots, they are another likely candidate. Etruscan tombs provide evidence, especially in their fifth-century tomb frescoes. The fact that these scenes were painted within tombs argues strongly that the Etruscans probably held chariot races as a part of their funeral rites as well. Additionally, there are many depictions of chariots and chariot racing on extant metalwork, ceramics, and stone. Given their close proximity to both the Greeks and Etruscans, it seems likely that the Romans adopted the tradition of funeral races from their neighbors. *Ludi circenses* ("circus games") appear in the official calendar in the fourth century BCE, which suggests that the Romans were already racing as early as the sixth century BCE.

The origins of the first chariot race remain a mystery. The chariot was probably long used for war before it was used for sport. As with the chariot itself, the tradition probably began in the Near East or in Egypt. So far, the best evidence for racing chariots comes from Mycenaean Greece. On an amphora from Tiryns (13th century BCE) there is a funeral scene with a chariot race. Many Indo-European–speaking peoples, such as the Celts, included chariots in funerals and burials. Many Celtic burials, for example, have been unearthed in England and on the European continent. Much the

same practice seems to have been at work in Greece of the Mycenaean and Archaic ages. Homer is probably the most famous example. In his epic poem *The Iliad,* there is a chariot race held in honor of the dead hero Patroclus, the dearest friend of the hero Achilles. As with so much in this poem, the scene of funeral games and a chariot race was probably not an invention of the poet but a reference to a well-known practice. Funeral culture changed, but the Greeks retained chariot racing. It was, in fact, a crowd pleaser in the Olympic Games as well.

Regardless of origin, chariot racing quickly became a mainstay of popular entertainment. Throughout the republic and the empire, no other sport defined the Romans like chariot racing. Even in the stories they told of themselves in popular legends, one might hear of this passion. For example, Rome's fifth king, Tarquinius Priscus, was credited with organizing races on the plains between the Aventine and Palatine Hills. Fans watched from the sides of the hills as the chariots raced along the track between them. Livy, our chief source for Rome's early history, says that this was the origin of [the] Circus Maximus, the premier racing arena, and one that already had gates by 329 BCE. In order to assist spectators, a series of markers were set up in 174 BCE to indicate the progress of the race. Seven wooden eggs, symbols of the gods Castor and Pollux (twins associated with horses), were later joined by dolphins, symbols of another god with equine connections, Poseidon. These symbols graced racing arenas all over the empire. Originally constructed of wood, the Circus Maximus was improved several times in stone. The Circus Maximus was the course par excellence in Rome, and races were held there down to the sixth century CE.

In layout the Circus Maximus is more ovoid than circular (the Latin term *circus,* meaning "circle," denotes the circular nature of the track), and though arenas might vary, most followed the same general pattern. In the middle was the *spina,* a long narrow strip at the ends of which stood *metae,* or turning posts. The racecourse was about 656 yards long and 164 yards wide, large enough to allow up to 12 teams at a time. Some races fielded only 4 teams, while others fielded 6 or 8 teams. It was not unusual for a team to field more than one chariot, as this increased the chance that the team might win. The Circus Maximus could hold 150,000 people, all of whom sat on three sides of the track. Starting gates at the north end prevented that section from housing spectators. This was also the location of the *carceres,* or stables, where up to 12 teams of horses might be housed. Races were generally seven laps long.

As exhilarating as the races were for the audience, the racers themselves must have enjoyed the stress, danger, and speed even more. Most drivers were slaves, at least at first, and good drivers became heroes for their factions. Many kept racing after they were manumitted, and there is evidence that some at least survived long enough to win a lot of money. Survival was,

however, chancy. The chariots were light, there was little to protect the *auriga* ("charioteer"), and much of the racing strategy involved putting the other teams in harm's way. This was part of the entertainment too—crowds referred to terrible wrecks as *naufragium* ("shipwrecks"). Outside the arena, drivers were held to be undesirable because they were entertainers, but when successful they were stars. One of the most famous examples was a Lusitanian *auriga,* Diocles, who lived to be 42 years old and had won hundreds of races and a substantial fortune. Naturally the team's owner pocketed much of the winnings, but the evidence suggests that the *aurigae* were rewarded too. As with most sporting events, betting was popular, and chariot racing was one of the few events not banned via legislation (see the entry **Dice and Tavern Game Board**).

In general, chariot racing involved only four teams or factions—the blues, greens, reds, and whites. Others appeared, such as Emperor Domitian's purple and gold factions, but they lacked the age and fan base of the traditional four. Racing fans could be fanatical, and competition was sometimes so fierce that racing enthusiasm on occasion turned into violence. One's team could determine much of one's public identity, especially among the young, and in fact younger fans often wore either distinctive clothing or hairstyles that marked them as belonging to specific teams. This tendency took on more political hues in the later empire.

While only the blue and green factions survived into late antiquity with any real backing, a lack of other competition and rivalry for imperial favor led each to become what were essentially political parties. They were volatile, however, and even when an emperor favored one team, that team could still cause problems. One reason for this was that the circus had become an important place for expressing both admiration and support for the emperor and was also a platform for complaint. This was valuable for the emperor too; it gave him a pulse on where the populace was and an idea of what concerned them and also allowed him a stage on which to demonstrate his care and benevolence. Racing teams were often the first to greet the emperor on his *adventus,* or grand entry, when he returned. They were also behind many of the popular acclamations expressed in the Circus Maximus and the Hippodrome (Constantinople's premiere race track). This support was powerful but could turn into a liability too. The Nika Riots in 532 began with the arrest of some racers, but behind this was the rivalry between fans of the Greens and Blues. Violence between them turned into a riot, and in addition to burning the racetrack the crowd even elected an usurper. The price, however, was steep, and the rioters were massacred by imperial troops in the Hippodrome.

Chariot racing brought all levels of Roman society together. It was popular for the skill of the drivers, the danger, the betting, and the joys of fandom. The Gothic king Totila was the last to patronize a race at the Circus

Maximus (547 CE). As other demands required the increasingly strained resources of the government, money for the races was diverted, and the last race in the western empire was held in 549 CE. Among the Byzantines, however, chariot racing survived into the Middle Ages and never ceased to draw a crowd.

FURTHER INFORMATION

Auguet, Roland. *Cruelty and Civilization: The Roman Games.* New York: Routledge, 1994.

Bergmann, Bettina A., and Christine Kondoleon, eds. *The Art of Ancient Spectacle.* Washington, DC: National Gallery of Art, 1999.

Cameron, Alan. *Circus Factions: Blues and Greens at Rome and Byzantium.* Oxford, UK: Clarendon, 1976.

Harris, H. A. *Sport in Greece and Rome.* Ithaca, NY: Cornell University Press, 1972.

Humphrey, John H. *Roman Circuses: Arenas for Chariot Racing.* Berkeley: University of California Press, 1986.

Hyland, Ann. *Equus: The Horse in the Roman World.* New Haven, CT: Yale University Press, 1990.

Lee, Robert Emmons. "Ancient Roman Curb Bits." *Harvard Studies in Classical Philology* 11 (1900): 150–157.

Potter, D. S., and D. J. Mattingly. *Life, Death, and Entertainment in the Roman Empire.* Ann Arbor: University of Michigan Press, 1999.

Romano, David Gilman. "A Roman Circus in Corinth." *Hesperia: The Journal of the American School of Classical Studies at Athens* 74(4) (October–December 2005): 585–611.

Wistrand, Magnus. *Entertainment and Violence in Ancient Rome: The Attitudes of Roman Writers of the First Century A.D.* Göteborg: Acta Universitatis Gothoburgensis, 1992.

Websites

"The Circus: Roman Chariot Racing." VROMA: A Virtual Community for Teaching and Learning Classics, http://www.vroma.org/~bmcmanus/circus.html.

International Museum of the Horse, http://www.imh.org/.

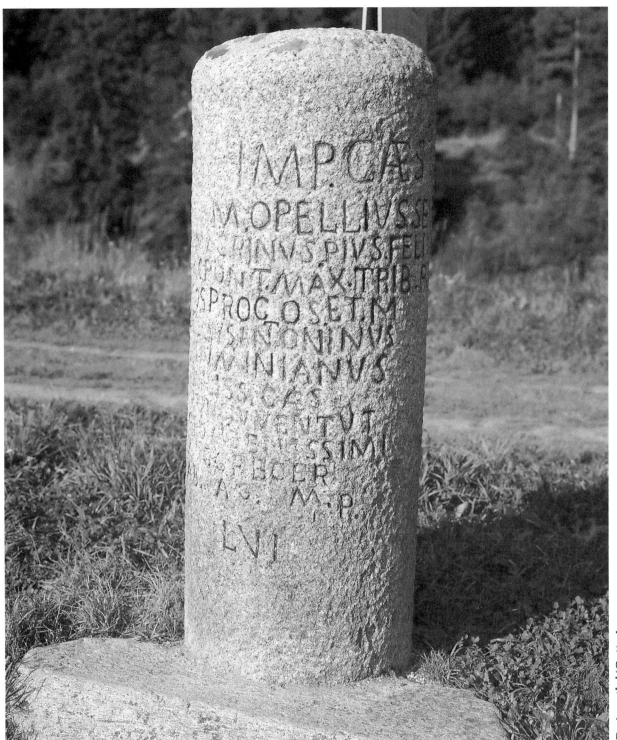

Milestone

Sebatum, Italy
Early Third Century CE

INTRODUCTION

Travel is so easy in the modern world that roads and road signs are taken for granted. Road signs, maps, and Global Positioning System (GPS) devices all notify travelers of the distances they have traveled and how far it is to reach a destination. Commonplace today, such information was not so readily available in the ancient world, which underscores just what an innovation the Romans provided with their highways and milestones. For the Romans, milestones—columns of rock inscribed with basic information such as the distance to the next town—were a great boon. Milestones helped organize daily travel, from knowing where the next available water for animals was to how far an enemy might be camped. Roman roads and the milestones that helped regulate them are prime examples of Rome's ingenuity, engineering, and knack for large-scale, empire-wide organization. Milestones were a key part of Roman highways. Some of the most ubiquitous examples of Roman might are the surviving roads laid down by the legions. Originally military highways throughout Italy (later extending into the provinces), roads quickly became key conduits of trade, travel, and cultural exchange. Roman roads are arguably the single greatest reason that Roman culture was able to spread throughout Europe so effectively.

DESCRIPTION

The milestone pictured here, a replica of an original now in the Museum Ferdinandeum in Innsbruck, Austria, was erected during the reign of the Severan emperor Marcus Opellius Severus Macrinus (r. 217–218). Carved from quartz phyllite, the milestone is nearly 8 feet high with a base of about 25 inches in diameter. It was erected near the Roman town of Sebatum in Noricum in what today is the town of San Lorenzo di Sebato, Italy. The inscription reads:

Emperor and Caesar Marcus Opellius Severus Macrinus Pius Felix Augustus, Pontifex Maximus, vested with tribunician power for the second

time, Father of the Fatherland, Consul, Proconsul and Marcus Opellius Antoninus Diadumenianus, most noble Caesar, First of the Youths, [our] most Provident Augusti [had this] made. From Agunto, 56 miles.

Macrinus ruled for 14 months, between Caracalla and Elagabulus, and is notable for being the first emperor not descended from a senatorial family. Little is known about Macrinus's early life, although he rose through the equestrian ranks under Emperor Caracalla and earned his ruler's trust but was also implicated as the mastermind behind Caracalla's assassination. Cassius Dio, a Roman historian, remarks that Macrinus early in his career was placed in charge of the Via Flaminia, so he clearly had experience with roads.

The earliest extant example of a milestone is from ca. 250 BCE. Road construction, like much of Roman engineering, was learned from the Etruscans, but the Romans appear to have been the first in the region to erect milestones. Most *miliarium* (plural *miliaria*) are cylindrical and about 6 feet in height (or about 1.8 meters). Generally, they were placed every Roman mile (about 9/10ths of a mile today) along main or trunk roads. Later in the time of Emperor Trajan, roads in the three parts of Gaul and in Germany were measured in *leugae,* about 1,500 paces or 900 yards (about 823 meters).

In Italy, each marker provided the distance from Rome; in the provinces, the distance listed was typically from the provincial capital. By the time of Emperor Augustus, who came to rule in 31 BCE, milestones were commonplace. The contribution he made to this system was a special *miliarium,* the *miliarium aureum* or "golden milestone," in the forum. Upon it in letters of gold were the names of the major cities of the empire. In a sense, this golden milestone was the center of the Roman world. During the republic, milestones bore the names of the consuls or state official concerned with their upkeep, while under the principate and later the empire the complete name and titles of the emperor might be listed, such as in our example here. Macrinus is listed with the usual appellations and titles given to emperors.

Some milestones list the feats of construction, such as tunneling or draining swamps, as well. One such stone states that a road repair commissioned by Trajan involved cutting through mountains and removing dips in the land. In the eastern half of the empire, milestones were erected along new or improved roads into the fifth century CE and were often in multiple languages. In this way, both those who knew the official Latin tongue and those who only knew provincial languages might benefit from milestones.

SIGNIFICANCE

Roman milestones reveal much about Roman government and culture. Like the roads they helped measure, milestones are a testament to the power, organization, and ingenuity of the Romans. Only a highly centralized,

Definitions

Imperial Titles

"Pius Felix Augustus," "Pater Patriae," *nobilissimus,* and *providentissimi* were all common imperial terms and titles associated with the emperor. Words such as *pius* ("holy" or "virtuous") and *felix* ("lucky" or "fortunate") underscore both the sacred nature of the office and perhaps also expressed a wish for the emperor's continued good fortune. The title "Augustus" suggests a venerable, majestic bearing. During the Roman Republic the term had been restricted to religious contexts, but Octavian was granted the title "Augustus" after his accession, and it is by this name that he became known. The title "Pater Patriae," meaning "Father of the Fatherland," reveals the value that the Romans placed on fatherhood. Just as the Roman father, the paterfamilias, is the head of the family with power of life and death over all members, the emperor is the "father" of the Roman people. *Nobilissimus* ("most noble") and *providentissimi* (sing. *providentissimus,* meaning "most provident" or "most full of forethought") highlight the aristocratic background of the emperor and how fortunate the state was to have a strong leader. Pontifex maximus, or high priest, denotes the emperor's sacred status. "First of Youths" is an old republican term, recast by Augustus and used to denote a probable successor. Here it means coruler and heir.

well-run administration could muster the manpower and resources to build roads and erect milestones over so many miles of territory. While Rome eventually boasted a navy, it was primarily a land empire, something to which its miles and miles of roads attest.

One of the primary reasons for good roads was to make it possible for the Roman Army to travel quickly and easily. Knowing the distance between cities was important in organizing a march. The ability to reach troubled corners of the empire in time to forestall a threat gave the army a great advantage over less organized foes. Once laid down, the roads might serve other purposes as well. For instance, in the time of Emperor Augustus, the *cursus publicus,* a mail system, made great use of the highways to get messages from one end of the empire to another. This ease of travel extended to civilians too. Knowing how far one was from an inn, from a meal, and from places to feed or exchange animals was a great benefit and helped regulate travel and trade. People, goods, and ideas traveled these roads, and towns sprung up along them, very often near milestones, to accommodate and facilitate travel. For example, in France there is a village on the road from Aix to Marseilles called Carts, a name derived from Latin *quartum* ("fourth"), a nod to the fourth stone from Marseilles. About three miles from Carts is the village of Septèmes, a derivation of Latin *septimum* ("seventh"), again referring to a milestone, in this case one seven miles out from Marseilles.

Primary Source

STATIUS, "THE VIA DOMITIANA," BOOK 4.3, LINES 40–55

The first labour was to mark out trenches,
Carve out the sides, and by deep excavation
Remove the earth inside. Then they filled
The empty trenches with other matter,
And prepared a base for the raised spine,
So the soil was firm, lest an unstable floor
Make a shifting bed for the paving stones;
Then laid the road with close-set blocks
All round, wedges densely interspersed.
O what a host of hands work together!
These fell trees and strip the mountains,
Those plane beams and smooth posts;
Some bind stones, consolidate the work,
With baked clay and tufa mixed with dirt;
Others toil to drain waterlogged ditches,
And divert the lesser streams elsewhere.

[Statius, *Silvae*, Book 4.3, Lines 40–55, translated by A. S. Kline, http://www.poetryintranslation.com/PITBR/Latin/StatiusSilvaeBkIV.htm#_Toc317239405. Used by permission.]

Milestones, and the roads they served, also testify to Roman engineering skill and the practical application of science. There were roads and empires before Rome, but it was the methodical and clever approach that the Romans took to their roads that helped make their city the seat of one of the largest empires in history. Engineers made careful studies of terrain before construction and adapted roads to the environment that those roads were to traverse. It is clear that the Romans took great pride in their road building as well. The standout example is a poem by Statius (d. ca. 96 CE), a poet during the time of Emperor Domitian (r. 81–96 CE). In a poem celebrating the Via Domitiana and its namesake, Statius provides the only extant description of Roman road building, step by step, as well as details about the major sites along the new road. While many sections are damaged today, the fact is that these roads are still here, and this means that they were exceptionally well made. Even with ruts worn into the paving stones, the evidence of so many years of cart wheels trundling along them, they have remained intact. Moreover, that a poet, and one so popular with the emperor, should expound at length upon road building highlights both the importance of roads and the pride that the Romans took in constructing them.

Perhaps the greatest achievement that milestones represent is the exchange of information, ideas, and populations. Exchange was a two-way street. Not only did Roman roads extend Roman culture as far as Scotland, North Africa, and the Near East, but these far-flung regions also imported new ideas, products, and peoples into the Roman world. Education, food, religious ideas, and technology were able to spread from one end of the empire to another thanks to the dedication with which Romans approached travel and the roads that made it possible.

FURTHER INFORMATION

Casson, Lionel. *Travel in the Ancient World.* Baltimore: Johns Hopkins University Press, 1994.

Chevallier, Raymond. *Roman Roads.* Los Angeles: University of California Press, 1976.

Crane, T. "Caveat Viator: Roman Country Inns." *Classical Bulletin* 46 (1969): 6–7.

Davies, Hugh E. H. "Designing Roman Roads." *Britannia* 29 (1998): 1–16.

Dio Cassius. *Roman History,* Vol. 9, Books 71–80. Loeb Classical Library No. 177. Cambridge, MA: Harvard University Press, 1927.

Herodian. *History of the Empire,* Vol. 1, Books 1–4. Translated by C. R. Whittaker. Cambridge, MA: Harvard University Press, 1969.

Herodian. *History of the Empire,* Vol. 2, Books 5–8. Translated by C. R. Whittaker. Cambridge, MA: Harvard University Press, 1970.

Historia Augusta, Vol. 1. Translated by David Magie. Cambridge, MA: Harvard University Press, 1921.

Historia Augusta, Vol. 2. Translated by David Magie. Cambridge, MA: Harvard University Press, 1924.

Nauta, Ruurd R., et al. *Flavian Poetry* (Mnemosyne Supplementa). Leiden: Brill, 2005.

Shelton, Jo-Ann. *As the Romans Did: A Sourcebook in Roman Social History.* New York: Oxford University Press, 1988.

Statius. *Silvae.* Translated by Betty Rose Nagle. Bloomington: Indiana University Press, 2004.

Websites

There are several websites available with information about milestones and Roman roads.

Birmingham Roman Roads Project, http://www.brrp.bham.ac.uk/.

This site has information about Roman roads in Britain, specifically near Birmingham.

Epigraphik-Datenbank Clauss/Slaby EDCS, http://db.edcs.eu/epigr/epi_en.php. This website allows one to search Roman inscriptions, such as those found on *miliaria.*

Roman Roads, http://penelope.uchicago.edu/Thayer/E/Gazetteer/Periods/Roman/Topics/Engineering/roads/.

Thompson, Logan. "Roman Roads." *History Today* 47(2) (1997), http://www.historytoday.com/logan-thompson/roman-roads.

Ubi Erat Lupa, http://www.ubi-erat-lupa.org/about.php. This website is a picture database for stone monuments and their inscriptions and artwork.

UNRV (United Nations of Roma Victrix) History, http://www.unrv.com/culture/roman-roads.php. UNRV is a collection of news, articles, and blogs about Roman history.

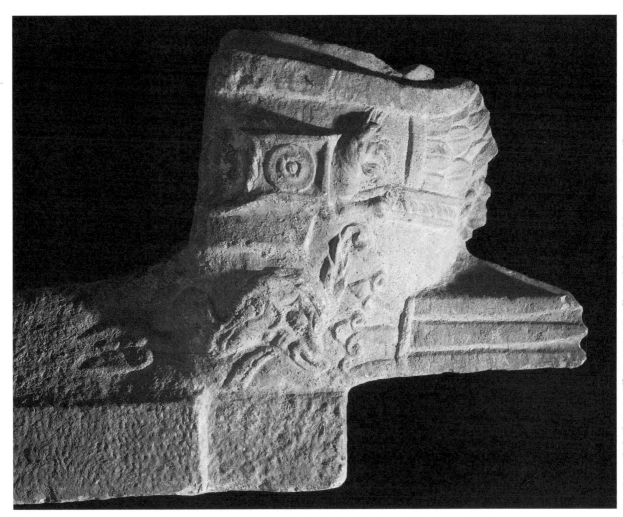

Rostrum

Italy
First Century CE

INTRODUCTION

The rostrum was what made the naval vessels of antiquity into warships. Reinforced with bronze, these rams were aimed at enemy ships and propelled toward them by the might of banks of oarsmen. Though ships armed in this way might also serve other purposes, from patrolling the coast to helping protect land forces from sea assault, they were primarily intended to disable or destroy enemy ships. The Greeks had sometimes taken the rostra of their foes as trophies, but it was the Romans who took this victory tradition to new heights. There are several well-known instances in which victorious Roman fleets provided the city with the beaks of enemy ships for use in monuments. The most famous is the Rostra, the speaker's platform in the forum and the place from which so much government business was conducted.

DESCRIPTION

The carving here, now in the Museum of Roman Civilization in Rome, depicts a ship's bow with a rostrum. Of carved stone, the piece hails from the first century CE and was discovered in the Natisone River in northern Italy. The rostrum ("beak" or "ship's prow") was an offensive weapon attached at the waterline of ancient ships. While missile weapons and marines were important, much of ship-to-ship warfare consisted of maneuvering a ship or fleet in such a way so as to ram the opposing side and sink its vessels. Warships were thus narrow and built for speed, powered by both sails and oars, and were primarily intended as torpedo-like weapons.

The Mediterranean had long been the highway of the people who lived around it. Though the sailing season was short, the waters of the Mediterranean were relatively calm in summer. With ample and excellent harbors, the sea was often a better and surer way to travel than were roads. The best sailing months were from March to October, but in some areas one could sail slightly longer provided that the weather held. Before the Romans came to dominate the sea, most peoples were at the mercy of pirates, yet another danger on the open water.

295

Primary Source

POLYBIUS, *HISTORIES*, BOOK 1:60–61

That the Romans should have a fleet afloat once more, and be again bidding for the mastery at sea, was a contingency wholly unexpected by the Carthaginians. . . . Hanno, who was appointed to command the fleet, put to sea and arrived at the island called Holy Isle. He was eager as soon as possible . . . to get across to Eryx; disembark his stores; and having thus lightened his ships, take on board as marines those of the mercenary troops who were suitable to the service, and Barcas with them; and not to engage the enemy until he had thus reinforced himself. But Lutatius was informed of the arrival of Hanno's squadron, and correctly interpreted their design. He at once took on board the best soldiers of his army, and crossed to the Island of Aegusa. . . . There he addressed his forces some words suitable to the occasion, and gave full instructions to the pilots, with the understanding that a battle was to be fought on the morrow.

At daybreak the next morning Lutatius found that a strong breeze had sprung up on the stern of the enemy, and that an advance towards them in the teeth of it would be difficult for his ships. The sea too was rough and boisterous: and for a while he could not make up his mind what he had better do in the circumstances. Finally, however, he was decided by the following considerations. If he boarded the enemy's fleet during the continuance of the storm, he would only have to contend with Hanno, and the levies of sailors which he had on board, before they could be reinforced by the troops, and with ships which were still heavily laden with stores: but if he waited for calm weather, and allowed the enemy to get across and unite with their land forces, he would then have to contend with ships lightened of their burden, and therefore in a more navigable condition, and against the picked men of the land forces; and what was more formidable than anything else, against the determined bravery of Hamilcar.

He made up his mind, therefore, not to let the present opportunity slip. . . . The rowers, from their excellent physical condition, found no difficulty in overcoming the heavy sea, and Lutatius soon got his fleet into single line with prows directed to the foe. When the Carthaginians saw that the Romans were intercepting their passage across, they lowered their masts, and after some words of mutual exhortation had been uttered in the several ships, closed with their opponents. . . . The Romans had reformed their mode of shipbuilding, and had eased their vessels of all freight, except the provisions necessary for the battle: while their rowers having been thoroughly trained and got well together, performed their office in an altogether superior manner, and were backed up by marines who, being picked men from the legions, were all but invincible. The case with the Carthaginians was exactly the reverse. Their ships were heavily laden and therefore unmanageable in the engagement; while their rowers were entirely untrained, and merely put on board for the emergency; and such marines as they had were raw recruits, who had never had any previous experience of any difficult or dangerous service.

(Continued on next page)

(Continued from previous page)

> **The fact is that the Carthaginian government never expected that the Romans would again attempt to dispute the supremacy at sea: they had, therefore, in contempt for them, neglected their navy. The result was that, as soon as they closed, their manifold disadvantages quickly decided the battle against them. They had fifty ships sunk, and seventy taken with their crews. The rest set their sails, and running before the wind, which luckily for them suddenly veered round at the nick of time to help them, got away again to Holy Isle.**
>
> [Polybius, *Histories,* translated by Evelyn S. Shuckburgh (London and New York: Macmillan, 1889; reprint, Bloomington: Indiana University Press, 1962), http://www.perseus.tufts.edu/hopper/text?doc= Perseus%3Atext%3A1999.01.0234%3Abook%3D1%3Achapter%3D60.]

Rome was a relative latecomer to the sea. Until the Punic Wars, Rome could not boast of a navy, certainly not one that could compare to that of its foes: the Carthaginians and the Greek states. The struggle with Carthage, however, not only spurred the Romans into creating a navy, but between the onset of the first conflict in 264 BCE and the conclusion of the last conflict in 146 BCE, this navy put Rome on the road to controlling the Mediterranean. Wars in Greece that followed the Punic Wars led to further refinements, and by the time of Emperor Augustus, Rome could truly call the Mediterranean Sea the *Mare Nostrum* ("Our Sea").

There were several types of warship, most derived from Greek exemplars. One was the trireme, one of the earliest ships, and these were generally about 120 feet long and about 20 feet wide. What made the trireme dangerous was the bronze-reinforced ram at the bow of the ship. Nimble, light, and fast, the trireme was propelled by three banks of oarsmen on each side. Debate continues as to how the rows of oars were organized. One theory is that the three banks were placed one above the other; a competing theory posits that three men sat to an oar. However organized, triremes were quick and effective warships. Modern estimates and experiments with replica vessels suggest that these warships could probably make between seven and nine knots.

Fast and dangerous as they were, there were a few drawbacks to triremes. Since they were narrow they were not the most seaworthy ship, one reason that naval warfare took place generally only when the weather was favorable. Moreover, as a weapon they tended to lack the amenities of other ships; triremes were uncomfortable, could not store much in the way of provisions, and frequently did not even have decks. The way in which they were used indicates that they were more oceangoing battering rams than ships in the sense that we usually think of them—in battle, both the mast and the sail were either left on land or stowed on deck. Without a sail, it was up to the rowers to maneuver the ship. Since triremes were, they made effective blockading vessels, a use to which they were often put. However, size was not all, for in many cases the blockades were simply rammed. Techniques

such as the Greek *diekplous,* whereby a mass of ships sailed through and out of enemy ranks, could undo a blockade. This maneuver was in essence a feint. The first line of ships approached as if to ram but then sailed past the enemy. Once through their ranks, they turned and attacked the enemy line. Without ample stores, triremes would either have to return to port or be supplied from other smaller boats. The logistics were complicated, especially if the fleet was under attack, and limited the effectiveness of blockades. Navies, generally, were great financial burdens.

Even with these challenges, however, the trireme was effective enough to see service into the fourth century CE. Only after Licinius, Emperor Constantine's opponent, was defeated in 324 CE was the trireme retired. In battle the trireme was primarily a ram, but the Romans put the trireme to other uses as well. Marines—that is, sailors who fought much like infantry only aboard ship—often boarded enemy ships. The advantage of boarding parties was that assuming victory, another ship was acquired. Archers and artillery might also fire ship to ship. One of the classic examples of Roman naval combat was the Battle of Actium in 31 BCE. In an earlier phase of the conflict, Mark Antony's fleet ended up under blockade in the Ambracian Gulf. The exact nature of Antony's strategy remains a topic of debate, but it is likely that at least part of his plan included escape. He burned some of his own ships, probably as an attempt to block Marcus Vipsanius Agrippa's fleet, sow confusion, and mask his intentions. Antony also had additional sails loaded on some of his ships. The events of the battle are also unclear. Archaeological evidence from Nicopolis, the city that Augustus built to commemorate the victory at Actium, suggests that the opposing navies were similarly equipped. Agrippa is said to have had more ships than Antony, one reason perhaps that Antony seems to have planned to escape, but by the next morning it was clear that Agrippa had won. Antony's fleet had continued to fight after its leader and Cleopatra made their getaway.

SIGNIFICANCE

Rome's quick rise to naval domination of the Mediterranean is only one way in which the rostrum, which was such a key part of war at sea, is significant. From the Punic Wars down to the Battle of Actium, rostra played a key part in Roman victory celebrations and propaganda. In 338 BCE, for example, the rostra retrieved from the Battle of Antium were used in the forum to decorate the speaking platform. Our modern rostrum takes its name from this tradition. Sometimes the rostra were attached to a column, as they were in the case of the monument to Marcus Aemilius Paullus in 255 BCE for another naval victory against the Carthaginians. At other times they were melted down and forged into a new column; this is what Augustus ordered for the rostra from the Battle of Actium. Virgil records that there was enough bronze from Antony and Cleopatra's fleet to create four columns.

The Rostra played a key role in Roman politics. Situated between the Comitium and the forum, it was an ideal location from which to make speeches. Julius Caesar (d. 44 BCE) designated a new spot in the forum for the Rostra, but the old one remained and was still referred to as the Rostra Vetera ("Old Rostra"). Augustus made further changes, but at both sites citizens would look upon images of Rome's great statesmen and heroes. The Rostra was supposedly the spot from which Mark Antony delivered his funeral oration for Caesar. A more grisly but less legendary event associated with Antony concerned the death of the orator Cicero. Proscribed for his attacks against Antony, Cicero was assassinated and his head and hands nailed to the Rostra as a warning to others.

Monuments such as the Rostra were more than simple trophies. They were visual representations of Roman might and power. An orator delivering a speech, whatever its topic, from atop a platform surrounded with pieces of enemy ships sent a powerful message. Rome had nearly been defeated by Carthage, and no one wished to forget it. In like manner, the columns that Augustus had set up in Nicopolis were physical reminders of his victory, a way to advertise his power and suitability to rule.

FURTHER INFORMATION

Ammerman, Albert J. "On the Origins of the Forum Romanum." *American Journal of Archaeology* 94(4) (1990): 627–645.

Casson, Lionel. *The Ancient Mariners.* 2nd ed. Princeton, NJ: Princeton University Press, 1991.

Casson, Lionel. *Ships and Seafaring in Ancient Times.* Austin: University of Texas Press, 1994.

Casson, Lionel. *Travel in the Ancient World.* Baltimore: Johns Hopkins University Press, 1994.

Houston, George W. "Ports in Perspective: Some Comparative Materials on Roman Merchant Ships and Ports." *American Journal of Archaeology* 92(4) (October 1988): 553–564.

Morrison, J. S., and R. T. Williams. *Greek Oared Ships, 900–322 B.C.* London: Cambridge University Press, 1968.

Parker, A. J. *Ancient Shipwrecks of the Mediterranean and the Roman Provinces.* Oxford, UK: Tempus Reparatum, 1992.

Richardson, Lawrence, Jr. *A New Topographical Dictionary of Ancient Rome.* Baltimore: Johns Hopkins University Press, 1992.

Rodgers, William Ledyard. *Greek and Roman Naval Warfare: A Study of Strategy, Tactics, and Ship Design from Salamis (480 B.C. to Actium).* Annapolis, MD: U.S. Naval Institute, 1964.

Rodgers, William Ledyard. *Naval Warfare under Oars, 4th to 16th Centuries: A Study of Strategy, Tactics and Ship Design.* Annapolis, MD: U.S. Naval Institute, 1967.

Starr, Chester G. *The Influence of Seapower on Ancient History.* Oxford: Oxford University Press, 1989.

SELECT
BIBLIOGRAPHY

Any examination of the ancient world owes a great debt to the multitude of historians and archaeologists who have opened up the past to us and who continue to add to what we know every year. An equal debt is owed to all those who have translated the works of the Greco-Roman world. We are lucky to live in an age when so many of these sources are now available in English and, more than that, are also available online. Lovers of print will find a great resource in the Loeb Classical Library from Harvard University Press, now in its 113th year, and to the many excellent editions put out by Penguin Books. Several volumes from each publisher are listed below. Between these two publishers, most works from ancient Rome are available. Both also provide solid introductions and notes. Loeb has the added benefit of providing the Latin or Greek on the facing page.

TRANSLATIONS OF ANCIENT AUTHORS

The following list includes more up-to-date editions of those works cited in the individual entries. These, having been pulled from works now out of copyright, are easily found online and are serviceable, but some of these editions preserve translations so old, such as John Dryden's translations of Plutarch's *Lives,* that they are classics in their own right! In addition, during the 20th century there was a lot of scholarship, and much of our knowledge and thinking about the Roman world has changed. For these reason, I list only the more recent editions of these ancient authors here. They also are more likely to include helpful notes, additional information about the author and his work, and more up-to-date bibliographies. A few additional works are listed as well because they are often texts that students first encounter, such as those of Cicero and Tacitus, and because they are especially good introductions to much of Roman history and culture.

MODERN SCHOLARSHIP

Bernard of Chartres (d. ca. 1130 CE), the noted French philosopher, re-marked once that he felt as if he were a dwarf standing on the shoulders of

giants. Perhaps nowhere is this as true as in scholarship. To the legion of books and monographs upon which the serious study of history depends must be added the thousands of articles, reports, and notes in academic journals. It is often here where the most recent and cutting-edge work is on view. Some familiarity with this literature is requisite, because in a topic so well covered as the ancient Mediterranean world, the chances are highly likely that someone has already investigated one's interests. It is not possible to list all such sources or indeed all those consulted in putting together this book, but I include a few in the "Further Information" sections of particular entries and a fair number in the section titled "Modern Scholarship" below.

EPIGRAPHIC AIDS

In terms of language and Latin in particular, there are a few how-to guides on the subject of inscriptions, but there is no substitute for learning to read paleography from a qualified instructor. Students of Latin and/or those interested in epigraphy, however, will benefit from two sites that provide details about specific inscriptions. The first is the *CIL* or *Corpus Inscriptionum Latinarum,* the "Body of Latin Inscriptions," first published in print but much of which is now available online at CIL Open Access (http://arachne.uni-koeln.de/drupal/?q=en/node/291). Volumes still other copyright are unavailable. A second site, the Epigraphik-Datenbank Clauss/Slaby (http://db.edcs.eu) allows one to search for terms from inscriptions using keywords and location. See also Alison E. Cooley's *The Cambridge Manual of Latin Epigraphy* (Cambridge University Press, 2012). A good Latin dictionary is useful as well. Lewis and Short's *A Latin Dictionary* (Clarendon, 1969) is excellent, but so too is Glare's *Oxford Latin Dictionary* (Clarendon, 1982). Online, the University of Notre Dame's "Latin Dictionary and Grammar Aid" (http://archives.nd.edu/latgramm.htm) is a wonderful resource as well.

ONLINE RESOURCES

There are several credible websites where one can find historical information on the ancient Mediterranean and good translations, even if those translations are somewhat dated. Very often the original language can be found with it on the same web page. One such site is the Perseus Project (http://www.perseus.tufts.edu/hopper/) from Tufts University, which is a gold mine for the student of the Greco-Roman world. The many offerings at both the Tertullian Project (http://www.tertullian.org/) and the Internet Classics Archive (http://classics.mit.edu/) at MIT are likewise wonderful to explore. James Grout's *Encyclopedia Romana* (http://penelope.uchicago.edu/~grout/encyclopaedia_romana/index.html) is especially good for buildings, basic information about government, and culture. For students of the later Roman

world, early Christianity, and late antiquity, the CCEL: Christian Classics Ethereal Library (http://www.ccel.org/) provides both reference works, such as Philip Schaff's *Nicene and Post-Nicene Fathers, Series II,* and translations of many sources relating to the early Christian world.

To these online sources, mention should be made of Bill Thayer's "LaucusCurtius: Into the Roman World" (http://penelope.uchicago.edu/Thayer/E/Roman/home.html). He has translated a few works there but has also uploaded some out-of-print translations as well as reference works, such as William Smith's *Dictionary of Greek and Roman Antiquities* (1875), the likes of which, with its attention to detail, the copious references to ancient sources, and devotion to day-to-day artifacts, is not often published today. Other valuable websites for students include the Internet Ancient History Sourcebook (http://www.fordham.edu/Halsall/ancient/asbook.asp), at Fordham University, and VROMA (http://www.vroma.org/), a site for both teachers and students that covers a wide range of topics on Rome and the Latin language.

TRANSLATIONS AND EDITIONS OF ANCIENT AUTHORS

Apuleius. *The Apologia and Florida of Apuleius of Madaura.* Translated by Harold Edgeworth Butler. Oxford, UK: Clarendon, 1909. http://classics.mit.edu/Apuleius/apol.4.4.html.

Apuleius. *The Golden Ass.* Translated by P. G. Walsh. New York: Oxford University Press, 2008.

Caesar. *The Gallic War.* Translated by H. J. Edwards. Cambridge, MA: Harvard University Press, 1994.

Catullus. *The Poems of Catullus: A Bilingual Edition.* Translated by Peter Green. Berkeley: University of California Press, 2007.

Cicero, Marcus Tullius. *Selected Works.* Translated by Michael Grant. London: Penguin, 1960.

Cicero, Marcus Tullius, and Titus Pomponius Atticus. *Cicero's Letters to Atticus.* Translated by D. R. Shackleton Bailey. London: Penguin, 1978.

Dean, James Elmer, ed. *Epiphanius' Treatise on Weights and Measures: The Syriac Version.* Chicago: University of Chicago Press, 1935.

Dio Cassius. *Roman History,* Vol. 9, Books 71–80. Loeb Classical Library No. 177. Cambridge, MA: Harvard University Press, 1927.

Dionysius of Halicarnassus. *Roman Antiquities,* Vol. 7, Book 11, Fragments of Books 12–20. Translated by Earnest Cary. Cambridge, MA: Harvard University Press, 1950.

Eusebius. *Life of Constantine.* Translated by Averil Cameron and Stuart Hall. Oxford: Oxford University Press, 1999.

Frontinus. "On the Water-Management of the City of Rome." Translated by R. H. Rodgers. University of Vermont, http://www.uvm.edu/~rrodgers/Frontinus.html.

Frontinus. *Stratagems: Aqueducts of Rome.* Translated by C. E. Bennett and Mary B. McElwain. New York: Putnam, 1925. http://penelope.uchicago.edu/Thayer/E/Roman/Texts/Frontinus/De_Aquis/text*.html.

Gellius, Aulus. *Attic Nights,* Vol. 2, Books 6–13. Translated by J. C. Rolfe. New York: Putnam, 1927.

Isidore of Seville. *The Etymologies of Isidore of Seville.* Translated by Stephen A. Barney, et al. Cambridge: Cambridge University Press, 2006.

Josephus. *The Jewish War.* Revised ed. Translated by Betty Radice. London: Penguin, 1984.

Juvenal. *Satires.* Translated by Niall Rudd and William Barr. Oxford, UK: Oxford World's Classics, 2008.

Livy. *The Early History of Rome,* Books O–V. Translated by Aubey De Selincourt and Stephen Oakley. London: Penguin Classics, 2002.

Livy. *The History of Rome,* Books 31–34. Translated by Evan T. Sage. New York: Putnam, 1935. http://www.perseus.tufts.edu/hopper/text?doc=Perseus%3Atext%3A1999.02.0164%3Abook%3D34%3Achapter%3D1.

Lucian. *Hippias or The Baths,* Vol. I. Translated by A. M. Harmon. Cambridge, MA: Harvard University Press, 1913. http://www.archive.org/stream/lucianha01luciuoft/lucianha01luciuoft_djvu.txt.

Marcellinus, Ammianus. *The Later Roman Empire, AD 354–378.* Translated by Andrew Wallace-Hadrill and Walter Hamilton. London: Penguin Classics, 1986.

Marcellinus, Ammianus. *Roman History.* 3 vols. Translated by J. C. Rolfe. Cambridge, MA: Harvard University Press, 1935–1939.

Martial. *Epigrams.* 2 vols. Translated by D. R. Shackleton Bailey. New York: Putnam, 1919–1920. http://archive.org/stream/martialepigrams-01martiala/martialepigrams01martiala_djvu.txt.

Martial. *The Epigrams: Dual Language Edition.* Translated by James Mitchie. London: Penguin Classics, 1988.

Ovid. *Fasti.* Translated by Anne Wiseman and Peter Wiseman. Oxford, UK: Oxford World's Classics, 2013.

Ovid. *Metamorphoses.* Translated by David Raeburn and Denis Feeney. London: Penguin Classics, 2004.

Petronius. *The Satyricon and the Apocolocyntosis of the Divine Claudius.* Translated by J. P. Sullivan. London: Penguin Classics, 1986.

Plautus. *Four Comedies: The Braggart Solider, The Brothers Menaechmus, The Haunted House, The Pot of Gold.* Translated by Erich Segal. Oxford, UK: Oxford World's Classics, 2008.

Pliny the Elder. *The Natural History.* Translated by John Bostock and H. T. Riley. London: Henry G. Bohn, 1855. http://www.perseus.tufts.edu/ hopper/text?doc=Plin.+Nat.+7.59&fromdoc=Perseus%3Atext %3A1999.02.0137.

Pliny the Elder. *Natural History: A Selection.* Translated by John F. Healey. London: Penguin Classics, 1991.

Pliny the Younger. *The Letters of the Younger Pliny.* Translated by Betty Radice. London: Penguin, 1963.

Plutarch. *Lives II: Themistocles and Camillus, Aristides and Cato Major, Cimon and Lucullus.* Translated by Bernadotte Perrin. Cambridge, MA: Harvard University Press, 1914.

Plutarch. *Roman Questions.* In Plutarch, *Moralia,* Vol. 4. Translated by Frank Cole Babbitt. Cambridge, MA: Harvard University Press, 1936. http://penelope.uchicago.edu/Thayer/E/Roman/Texts/Plutarch/Moralia/ Roman_Questions*/C.html#51.

Polybius. *The Histories.* Translated by Robin Waterfield and Brian McGing. Oxford, UK: Oxford World's Classics, 2010.

Roberts, Michael. *Poetry and the Cult of the Martyrs: The Liber Peristephanon of Prudentius.* Ann Arbor: University of Michigan Press, 1994.

Statius. *Silvae.* Translated by Betty Rose Nagle. Bloomington: Indiana University Press, 2004.

Suetonius. *The Twelve Caesars.* London: Penguin, 1989.

Tacitus. *Agricola and Germania.* Translated by James Rives and Harold Mattingly. London: Penguin Classics, 2010.

Tacitus. *Annals.* Translated by Cynthia Damon. London: Penguin, 2013.

Virgil. *The Aeneid.* Translated by Bernard Knox and Robert Fagles. London: Penguin, 2010.

Vitruvius. *Ten Books on Architecture.* Translated by Ingrid D. Rowland. Commentary and illustrations by Thomas N. Howe. Cambridge: Cambridge University Press, 1999.

REFERENCE WORKS

There are a number of good reference works available in most school libraries. *The Oxford Classical Dictionary,* now in its fourth edition, is indispensable. Likewise, the Cambridge Ancient History series is an ideal place to stop for narrative accounts of the periods in Roman history as

well as the major figures and events. Another good general reference for history, literature, and artifacts is *Harper's Dictionary of Classical Literature and Antiquities.* Ray Laurence's *Roman Archaeology for Historians* (Routledge, 2012), *Ancient Rome: The Archaeology of the Eternal City* (Oxford University School of Archaeology, 2000) by J. C. Coulston and Hazel Dodge, and *Rome: An Oxford Archaeological Guide* (Oxford, 2010) by Amanda Claridge, which is especially good for the city of Rome itself, are excellent starting places to begin studying Roman archaeology.

Adkins, Lesley, and Roy A. Adkins. *Dictionary of Roman Religion.* Oxford: University Press, 1996.

Brigstocke, Hugh, ed. *The Oxford Companion to Western Art.* New York: Oxford University Press, 2001.

Cleland, Liza, Glenys Davies, and Lloyd Llewellen-Jones, eds. *Greek and Roman Dress from A to Z.* New York: Routledge, 2007.

Cooley, Alison E. *The Cambridge Manual of Latin Epigraphy.* Cambridge: Cambridge University Press, 2012.

Gagarin, Michael, ed. *The Oxford Encyclopedia of Ancient Greece and Rome.* Oxford: Oxford University Press, 2010.

Hornblower, Simon, et al., eds. *The Oxford Classical Dictionary.* 4th edition. Oxford: Oxford University Press, 2012.

Humphrey, John W., John P. Oleson, and Andrew N. Sherwood. *Greek and Roman Technology: A Sourcebook.* New York: Routledge, 1998.

Koch, John T. *Celtic Culture: A Historical Encyclopedia.* Santa Barbara, CA: ABC-CLIO, 2005.

Mattingly, Harold, et al. *The Roman Imperial Coinage.* 10 vols. London: Spink, 1926–2007.

McGeough, Kevin M., and William E. Mierse, eds. *World History Encyclopedia, Era 3: Classical Traditions, 1000 BCE–300 CE.* Santa Barbara, CA: ABC-CLIO, 2010.

Sebesta, Judith L., and Larissa Bonfante, eds. *The World of Roman Costume.* Madison: University of Wisconsin Press, 1994.

Shelton, Jo-Ann. *As the Romans Did: A Sourcebook in Roman Social History.* New York: Oxford University Press, 1988.

MODERN SCHOLARSHIP

Africa, Thomas W. "Urban Violence in Imperial Rome." *Journal of Interdisciplinary History* 2(1) (Summer 1971): 3–21.

Aicher, Peter J. *Guide to the Aqueducts of Ancient Rome.* Wauconda, IL: Bolchazy-Carducci, 1995.

Ambrosio, A. *Women and Beauty in Pompeii.* Los Angeles: J. Paul Getty Museum, 2001.

Anderson, James C. *Roman Architecture and Society.* Baltimore: Johns Hopkins University Press, 1997.

Ando, Clifford. *The Matter of the Gods: Religion and the Roman Empire.* Berkeley: University of California Press, 2008.

Auguet, Roland. *Cruelty and Civilization: The Roman Games.* New York: Routledge, 1994.

Austin, R. G. "Roman Board Games I." *Greece & Rome* 4(10) (October 1934): 24–34.

Bagnall, Roger S. *Everyday Writing in the Graeco-Roman East.* Berkeley: University of California Press, 2011.

Bailey, D. M. *Catalogue of Lamps in the British Museum: Greek, Hellenistic, and Early Roman Pottery Lamps.* London: British Museum Press, 1975.

Baird, Jennifer, and Claire Taylor, eds. *Ancient Graffiti in Context.* New York: Routledge, 2012.

Balsdon, J. P. V. D. *Life and Leisure in Ancient Rome.* London: Phoenix Press, 2004.

Bang, Peter Fibiger. *The Roman Bazaar: A Comparative Study of Trade and Markets in a Tributary Empire.* Cambridge: Cambridge University Press, 2008.

Beard, Mary. *The Roman Triumph.* Cambridge: Harvard University Press, 2009.

Bishop, M. C., and J. C. N. Coulston. *Roman Military Equipment: From the Punic Wars to the Fall of Rome.* Oxford, UK: Oxbow, 2006.

Bispham, Edward, and Christopher Smith, eds. *Religion in Archaic and Republican Rome and Italy: Evidence and Experience.* Edinburgh, UK: Edinburgh University Press, 2000.

Bodel, John, ed. *Epigraphic Evidence: Ancient History from Inscriptions.* London: Routledge, 2001.

Bonner, S. F. *Education in Ancient Rome.* Berkeley: University of California Press, 1977.

Boon, George C. "'Tonsor Humanus': Razor and Toilet-Knife in Antiquity." *Britannia* 22 (1991): 21–32.

Bowden, Hugh. *Mystery Cults of the Ancient World.* Princeton, NJ: Princeton University Press, 2010.

Bradley, Mark, ed. *Rome, Pollution and Propriety: Dirt, Disease and Hygiene in the Eternal City from Antiquity to Modernity.* Cambridge: Cambridge University Press, 2012.

Brothwell, Don, and Patricia Brothwell. *Food in Antiquity.* Baltimore: Johns Hopkins University Press, 1997.

Brown, Peter. *Power and Persuasion in Late Antiquity: Towards a Christian Empire.* Madison: University of Wisconsin Press, 1992.

Bülow-Jacobsen, Adam. "Writing Material in the Ancient World." In *The Oxford Handbook of Papyrology,* edited by Roger S. Bagnall, 3–29. Oxford: Oxford University Press, 2009.

Burkert, Walter. *Ancient Mystery Cults.* Cambridge, MA: Harvard University Press, 1987.

Burnett, Andrew M., et al. *Roman Provincial Coinage.* 2 vols. London: British Museum Press, 1992–1999.

Calinescu, Adriana, ed. *Ancient Jewelry and Archaeology.* Bloomington: Indiana University Press, 1996.

Callender, M. H. *Roman Amphorae.* New York: Oxford University Press, 1965.

Cameron, Alan. *Circus Factions: Blues and Greens at Rome and Byzantium.* Oxford, UK: Clarendon, 1976.

Carcopino, Jerome. *Daily Life in Ancient Rome.* New Haven, CT: Yale University Press, 1968.

Carroll, Maureen, and Jane Rempel, eds. *Living through the Dead: Burial and Commemoration in the Classical World.* Oxford, UK: Oxbow, 2011.

Casson, Lionel. *Travel in the Ancient World.* Baltimore: Johns Hopkins University Press, 1994.

Chadwick, Henry. *The Early Church.* Revised ed. New York: Penguin, 1993.

Chevallier, Raymond. *Roman Roads.* Berkeley: University of California Press, 1976.

Clarke, M. L. *Higher Education in the Ancient World.* Albuquerque: University of New Mexico Press, 1971.

Comotti, Giovanni. *Music in Greek and Roman Culture.* Baltimore: Johns Hopkins University Press, 1989.

Cowell, F. R. *Life in Ancient Rome.* New York: Putnam, 1980.

Croom, Alexandra. *Roman Clothing and Fashion.* Charleston, SC: Tempus, 2002.

Dayagi-Mendels, M. *Perfumes and Cosmetics in the Ancient World.* Jerusalem: Israel Museum, 1989.

Drake, H. A. *Constantine and the Bishops: The Politics of Intolerance.* Baltimore: Johns Hopkins University Press, 2000.

Dunbabin, Katherine M. D. *The Mosaics of the Greek and Roman World.* New York: Cambridge University Press, 1999.

Duncan-Jones, Richard. *Money and Government in the Roman Empire.* New York: Cambridge University Press, 1994.

Easterling, P. E., and Edith Hall, eds. *Greek and Roman Actors: Aspects of an Ancient Profession.* Cambridge: Cambridge University Press, 2002.

Faas, Patrick. *Around the Roman Table: Food and Feasting in Ancient Rome.* New York: Palgrave MacMillan, 2003.

Fagan, Garrett G. "Bathing for Health with Celsus and Pliny the Elder." *Classical Quarterly* 56(1) (May 2006): 190–207.

Faraone, Christopher A. *Ancient Greek Love Magic.* Cambridge, MA: Harvard University Press, 1999.

Flemming, Rebecca. *Medicine and the Making of Roman Women: Gender, Nature, and Authority from Celsus to Galen.* Oxford: Oxford University Press, 2000.

Fowler, William Warde. *The Roman Festivals of the Period of the Republic: An Introduction to the Study of the Religion of the Romans.* Port Washington, NY: Kennikat, 1969.

Fox, Robin Lane. *Pagans and Christians.* London: Penguin, 2006.

Fuhrmann, Christopher. *Policing the Roman Empire: Soldiers, Administration, and Public Order.* Oxford: Oxford University Press, 2011.

Gager, J. G. *Curse Tablets and Binding Spells from the Ancient World.* New York: Oxford University Press, 1992.

Gamble, Harry. *Books and Readers in the Early Church: A History of Early Christian Texts.* New Haven, CT: Yale University Press, 1995.

Gibbs, Sharon L. *Greek and Roman Sundials.* New Haven, CT: Yale University Press, 1976.

Gleba, Margarita, and Hilary Becker, eds. *Votives, Places and Rituals in Etruscan Religion: Studies in Honor of Kean MacIntosh Turfa.* Leiden: Brill, 2008.

Goldscheider, Ludwig. *Roman Portraits.* Reprint ed. New York: Phaidon, 2004.

Graf, Fritz. *Magic in the Ancient World.* Cambridge, MA: Harvard University Press, 1999.

Habinek, Thomas. *The World of Roman Song: From Ritualized Speech to Social Order.* Baltimore: Johns Hopkins University Press, 2005.

Harlow, Mary, and Ray Laurence. *Growing Up and Growing Old in Ancient Rome.* London: Routledge, 2002.

Harries, Jill. *Law and Crime in the Roman World.* New York: Cambridge University Press, 2007.

Harris, H. A. *Sport in Greece and Rome.* Ithaca, NY: Cornell University Press, 1972.

Harris, W. V. *Ancient Literacy.* Cambridge, MA: Harvard University Press, 1989.

Hobson, Barry. *Latrinae et Foricae: Toilets in the Roman World.* London: Duckworth, 2009.

Hodge, A. Trevor. *Roman Aqueducts and Water Supply.* London: Duckworth, 2002.

Howgego, Christopher. *Ancient History from Coins.* London: Routledge, 1995.

Humphrey, John H. *Roman Circuses: Arenas for Chariot Racing.* Berkeley: University of California Press, 1986.

Hyland, Ann. *Equus: The Horse in the Roman World.* New Haven, CT: Yale University Press, 1990.

Jackson, Ralph. *Doctors and Diseases in the Roman Empire.* Norman: University of Oklahoma Press, 1988.

Jaeger, Werner. *Early Christianity and Greek Paideia.* Cambridge, MA: Belknap Press of Harvard University Press, 1985.

Jansen, Gemma, Ann Olga Koloski-Ostrow, and Eric Moormann, eds. *Roman Toilets: Their Archaeology and Cultural History.* Leuven: Peeters, 2011.

Johnson, Luke Timothy. *Among the Gentiles: Greco-Roman Religion and Christianity.* New Haven, CT: Yale University Press, 2009.

Kastor, Robert A. *Guardians of Language: The Grammarian and Society in Late Antiquity.* Berkeley: University of California Press, 1988.

Kaufman, David B. "Roman Barbers." *Classical Weekly* 25(19) (March 21, 1932): 145–148.

Keppie, Lawrence. *The Making of the Roman Army: From Republic to Empire.* Totowa, NJ: Barnes and Noble Books, 1984.

King, Helen. *Greek and Roman Medicine.* London: Bristol Classical Press, 2002.

Kleiner, Diana E. E. *Roman Sculpture.* New Haven, CT: Yale University Press, 1992.

Knapp, Robert. *Invisible Romans.* Cambridge, MA: Harvard University Press, 2011.

Köhne, Eckart, and Cornelia Ewigleben, eds. *Gladiators and Caesars: The Power of Spectacle in Ancient Rome.* English version edited by Ralph Jackson. Berkeley: University of California Press, 2000.

Landels, J. G. *Engineering in the Ancient World.* Revised ed. London: Constable and Robinson, 2000.

Ling, Roger. *Roman Painting.* New York: Cambridge University Press, 1991.

Lintott, A. W. *Violence in Republican Rome: Civil Strife and Revolution in the Classical City.* Oxford: Oxford University Press, 1982.

Lintott, Andrew W. *Imperium Romanum: Politics and Administration.* New York: Routledge, 1993.

Lynch, Joseph H. *Early Christianity.* New York: Oxford University Press, 2010.

MacMullen, Ramsay. *Christianizing the Roman Empire, AD 100–400.* New Haven, CT: Yale University Press, 1984.

MacMullen, Ramsay. *Enemies of the Roman Order.* Cambridge, MA: Harvard University Press, 1967.

Marrou, H. I. *History of Education in Antiquity.* Translated by George Lamb. Madison: University of Wisconsin Press, 1982.

Marsden, E. W. *Greek and Roman Artillery: Historical Development.* Oxford, UK: Clarendon, 1969.

Marshall, C. W. *The Stagecraft and Performance of Roman Comedy.* Cambridge: Cambridge University Press, 2006.

Maxfield, Valerie A. *The Military Decorations of the Roman Army.* Berkeley: University of California Press, 1981.

Menninger, Karl. *Number Words and Number Symbols: A Cultural History of Numbers.* Cambridge: MIT Press, 1977.

Meyer, Marvin W. *The Ancient Mysteries: A Sourcebook.* San Francisco: Harper and Row, 1987.

Miller, James Innes. *The Spice Trade of the Roman Empire.* Oxford, UK: Clarendon, 1969.

Milnor, Kristina. *Graffiti and the Literary Landscape in Roman Pompeii.* Oxford: Oxford University Press, 2014.

Morley, Neville. *Trade in Classical Antiquity.* Cambridge: Cambridge University Press, 2007.

Morris, Ian. *Death-Ritual and Social Structure in Classical Antiquity.* New York: Cambridge University Press, 1992.

Mosshammer, Alden E. *The Chronicle of Eusebius and Greek Chronographic Tradition.* Lewisburg, PA: Bucknell University Press, 1979.

North, J. A. *Roman Religion.* Cambridge: Cambridge University Press for the Classical Association, 2006.

Nutton, Vivian. *Ancient Medicine.* New York: Routledge, 2004.

Ogden, Daniel. *Magic, Witchcraft and Ghosts in the Greek and Roman Worlds: A Sourcebook.* Oxford: Oxford University Press, 2009.

Olson, Kelly. *Dress and the Roman Woman: Self-Presentation and Society.* New York: Routledge, 2008.

Poliakoff, Michael B. *Combat Sports in the Ancient World.* New Haven, CT: Yale University Press, 1987.

Potter, D. S., and D. J. Mattingly. *Life, Death, and Entertainment in the Roman Empire.* Ann Arbor: University of Michigan Press, 1999.

Ramage, Nancy H., and Andrew Ramage. *Roman Art: Romulus to Constantine.* New York: Abrams, 1991.

Rawson, Beryl. *Children and Childhood in Roman Italy.* New York: Oxford University Press, 2003.

Rawson, E. *Roman Culture and Society.* New York: Oxford University Press, 1991.

Reynolds, L. D., and N. G. Wilson. *Scribes & Scholars: A Guide to the Transmission of Greek and Latin Literature.* New York: Oxford University Press, 1991.

Reynolds, P. K. Baillie. *The Vigiles of Imperial Rome.* London: Oxford University Press, 1926.

Rives, James P. *Religion in the Roman Empire.* Malden, MA: Blackwell, 2006.

Roberts, Colin H., and T. S. Skeat. *The Birth of the Codex.* New York: Published for the British Academy by the Oxford University Press, 1983.

Robinson, O. *Ancient Rome: City-Planning and Administration.* New York: Routledge, 1992.

Rodgers, Nigel. *Life in Ancient Rome.* London: Southwater, 2007.

Salzman, Michele R. *On Roman Time: The Codex-Calendar of 354 and the Rhythms of Urban Life in Late Antiquity.* Los Angeles: University of California, 1991.

Scheidel, Walter, Ian Morris, and Richard Saller, eds. *The Cambridge Economic History of the Greco-Roman World.* New York: Cambridge University Press, 2007.

Schneid, John. *An Introduction to Roman Religion.* Translated by Janet Lloyd. Bloomington: Indiana University Press, 2003.

Simkins, Michael, and Ron Embleton. *The Roman Army from Caesar to Trajan.* London: Osprey, 2000.

Sirks, A. B. J. *Food for Rome.* Amsterdam: J. C. Gieben, 1991.

Stephens, Janet. "Ancient Roman Hairdressing: On (Hair)pins and Needles." *Journal of Roman Archaeology* 21 (2008): 110–132, http://www.journalofromanarch.com/samples/v21.110_adj.pdf.

Stevenson, James. *The Catacombs: Life and Death in Early Christianity.* Nashville: T. Nelson, 1985.

Stewart, Susan. *Cosmetics & Perfumes in the Roman World.* Stroud, UK: Tempus, 2007.

Taylor, Rabun. *Public Needs and Private Pleasures: Water Distribution, the Tiber River, and the Urban Development of Ancient Rome.* Roma: L'Erma di Bretschneider, 2000.

Toner, J. P. *Leisure and Ancient Rome.* Cambridge, UK: Polity, 1995.

Toynbee, J. M. C. *Death and Burial in the Roman World.* Ithaca, NY: Cornell University Press, 1971.

Tracy, Rihill. *The Catapult: A History.* Yardley, PA: Westholme, 2007.

Turcan, Robert. *The Cults of the Roman Empire.* Oxford, UK: Blackwell, 1997.

Turfa, Jean MacIntosh. "Votive Offerings in Etruscan Religion." In *The Religion of the Etruscans,* edited by Nancy Thomson de Grummond and Erika Simon, 90–115. Austin: University of Texas Press, 2006.

Vermeule, Cornelius. "Minting Greek and Roman Coins." *Archaeology* 10(2) (June 1957): 100–107.

Walker, Susan. *Memorials to the Roman Dead.* London: Published for the Trustees of the British Museum by the British Museum Press, 1985.

Ward-Perkins, J., and A. Claridge. *Pompeii, AD 79.* Boston: Museum of Fine Arts, 1976.

Warrior, Valerie M. *Roman Religion.* New York: Cambridge University Press, 2006.

Watson, G. R. *The Roman Soldier.* Ithaca, NY: Cornell University Press, 1985.

Webb, Matilda. *The Churches and Catacombs of Early Christian Rome: A Comprehensive Guide.* Portland, OR: Sussex Academic, 2001.

Webster, Graham. *The Roman Imperial Army of the First and Second Centuries A.D.* London: Adam and Charles Black, 1979.

Welch, Katherine E. *The Roman Amphitheatre: From Its Origins to the Colosseum.* Cambridge: Cambridge University Press, 2007.

White, K. D. *Greek and Roman Technology.* Ithaca, NY: Cornell University Press, 1984.

Whitehouse, David. *Glass of the Roman Empire.* Corning, NY: Corning Museum of Glass, 1988.

Wilkins, Alan. *Roman Artillery.* Princes Risborough, UK: Shire, 2008.

Williams, Burma P., and Richard S. Williams. "Finger Numbers in the Greco-Roman World and the Early Middle Ages." *Isis* 86(4) (December 1995): 587–608.

Wilson, L. M. *The Clothing of the Ancient Romans.* Baltimore: Johns Hopkins University Press, 1938.

Wistrand, Magnus. *Entertainment and Violence in Ancient Rome: The Attitudes of Roman Writers of the First Century A.D.* Göteborg: Acta Universitatis Gothoburgensis, 1992.

Yegul, Fikret. *Baths and Bathing in Classical Antiquity.* Cambridge, MA: MIT Press, 1992.

Zanker, Paul. *The Power of Images in the Age of Augustus.* Ann Arbor: University of Michigan Press, 1988..

INDEX

ABOUT THE AUTHOR

James B. Tschen-Emmons earned his doctorate from the University of California, Santa Barbara, and currently teaches history in the Social and Behavioral Sciences Division at North Idaho College; he also teaches mythology for Northern Virginia Community College's Extended Learning Institute. James has written for ABC-CLIO since 2003, producing well over 300 entries on topics ranging from ancient Rome to medieval China, contributing to *The Olympics Resource Book* (2008), and, more recently, acting as the review board moderator for ABC-CLIO's Enduring Questions, part of the World History: Ancient and Medieval Eras academic database. Among other publications, James penned a chapter, "Spiritual Landscapes: The Late Antique Desert in Ireland," for *The Rhetoric of Power in Late Antiquity: Religion and Politics in Byzantium, Europe, and the Early Islamic World* (Tauris Academic Studies, 2010), a Festschrift for H. A. Drake. James has also produced articles for Oxford's *Dictionary of the Middle Ages* (2010) as well as bibliographic work and book reviews for CSANA (the Celtic Studies Association of North America) and the *Maryland Historical Magazine*. Previously, he worked as a special collections librarian and manuscript curator at the Maryland Historical Society. His major research field is early medieval Ireland, especially the relationship between native and imported narratives about holy people. James is also interested in medieval European intellectual history, the ways in which medieval people constructed identity, and the evolution of European martial arts.